ART AND
THE CRAFTSMAN

The Best of the Yale Literary Magazine 1836-1961

ART AND

THE CRAFTSMAN

The Best of The Yale Literary Magazine
1836-1961

edited by JOSEPH HARNED

and NEIL GOODWIN

NEW HAVEN: THE YALE LITERARY MAGAZINE

CARBONDALE: SOUTHERN ILLINOIS UNIVERSITY PRESS

The editors are most grateful for the interest and generosity of Paul Mellon, Beecher Hogan, Alexander Beard and Rudolph Light. Without their help and the encouragement and support of other alumni, the book might still be a manuscript.

Editors' Table

THIS IS A BOOK OF PEOPLE WHO DO THE SAME THING. A poet, a philosopher, an architect, a student: all are involved on a common ground of commitment and endeavor: the definition and explication of sensibility through craftsmanship.

The *Yale Literary Magazine,* this country's oldest review, celebrates her One Hundred Twenty-Fifth Anniversary with a selective anthology and a symposium by distinguished men of letters. The anthology is a record of the promise of the undergraduate writer in an American university. The symposium consists of the voices in each field demanding a part in an examination of craftsmanship and responsibility in the arts. Each article of the symposium is itself an essay in definition to indicate the lineaments of creative concern rather than to enthrone the craftsman or his craft. The anthology has been edited from the 32,000 pages published by the *Yale Literary Magazine*—vehicle of the creative spirit of a university from 1836 to 1961.

JOSEPH HARNED
NEIL GOODWIN
Templenoe House
Fermoy, Ireland

Contents

I THE YOUNG CRAFTSMAN

II POEMS FIRST PUBLISHED IN THE YALE LITERARY MAGAZINE BY PROFESSIONAL WRITERS

III ARS GRAPHICA

IV AMERICAN CREATIVE CONSCIENCE

CRAFTSMANSHIP IN THE ARTS

I

The Young Craftsman

TO THE TETTIX

Thou noisy thing, intoxicate with dew,
 Thou desert-babbler, with thy rustic lay,
Who sittest idly, where the green leaves through
 On thy cranked limbs bright slants the solar ray,
Whilst from thy little frame with hue of fire,
Comes forth the mimic music of the lyre—

Oh! friendly songster, to the Sylphid Maids
 "Discourse sweet music," with thy tiny tongue,
And unto Pan, who habits in the shades,
 And roves the mountains and the fields among.
Then, freed from love, my noontide sleep I'll take,
Beneath the shadow which the plane-trees make.

"Hermeneutes"
1836

AN EVENING IN THE VALLEY OF WYOMING

There lies a vale in Ida, lovelier
Than all the valleys of Ionian hills.
 On either hand
The lawns and meadow ledges midway down
Hang rich in flowers, and far below them roars

The long brook falling through the cloven ravine
In cataract after cataract to the sea.
Behind the valley topmost Gargarus
Stands up and takes the morning—

"Oenone"
1857

True Drake and Gentleman Joceylin
Ha' grippit each a hand
And lookit wi' the broad deep love
O' two strong men that understand.

"The years may be long and sad, Drake,
Wi' grim death running thro',
But swear you will love me as true, Drake,
As ever I love you."

"Now do I swear by God, Joceylin,
And by our good Lord's birth,
I'll love you deeper and truer, Joceylin,
Than any man upon this earth."

Gentleman Joceylin's bowed his head
And gone alone apart,
And he has found two sailor men
And opened out his heart.

"You shall be my first mate, Jock,
And wear a coat o' pride,
And you shall be my second, Frank,
Wi' bright brand at your side.

"And ye shall ha' a pot o' gold
To spend on Rose and May,
To buy them gowns an' gilliflowers
Upon the wedding day.

"And ye shall ha' broad bloomy lands
Wi' castles on a hill
When ye shall show me Captain Drake
All cold and stark and still."

It is the little cabin boy
That's heard this wicked talk,
And he is gone to Captain Drake
Where he does scheme and walk.

And it's "Captain Drake, my Captain Drake:
His blood be on his head,
I overhearit Joceylin
And this is what he said:

" 'Now ye shall ha' broad bloomy lands
Wi' castles on a hill
When ye shall show me Captain Drake
All cold and stark and still.' "

True Drake has called his good crew aft
And looked them in the eye,
"There be three men o' you," quo' he,
"As fain would see me die."

Ye might ha' heard the sea-fish swim,
When Jock uprist and spake,
"It is na' I, but Joceylin:
For truth, my Captain Drake."

Ye might ha' heard the holt rats squeak
When Frank uprist and spake,
"It is na' I, but Joceylin:
For truth, my Captain Drake."

True Drake has ta'en a hempin rope
And made a knot therein
And he has twined it round the neck
O' his friend Joceylin,

And he has hangit him to the yard
To hang till he is dead.
"Pray for his soul," then True Drake cried,
"His blood is on his head."

True Drake has ta'en two hempin ropes
And made two knots therein
And he has hangit Frank and Jock
One either side o' Joceylin.

"All that ye did in duty true
It shall be writ unto the end,
But Christ ha' mercy on your souls
That ha' betrayed my dearest friend."

True Drake has ta'en a hard tarred rope
(I wot it was twinit cruel thin)
And he has whippit the cabin boy
That overhearit Joceylin.

They ha' taken Joceylin from the yard
And laid him in his place
And wrappit him wi' winding sheets
Save only his fair face.

True Drake has droppit on his knee
And taken Joceylin's two hands
And lookit on him wi' the love
Of a strong man that understands.

"Now do I swear by God, Joceylin,
And by our Right Lord's birth,
I love you deeper and truer, Joceylin,
Than any man upon this earth."

True Drake has crossed the two limp hands
Upon the cold dead breast
And he has kissit Joceylin
And prayed his soul to rest.

"Stand by to lay him in the sea,
My guns shall mark him to his place,
Haul down yon flag to half the mast . . .
Now—cover my friend's face."

Gouverneur Morris
1897

MORNING

I dreamed that I entered, at break of day,
A Chapel, old and mossy and gray,
Where a congregation kneeled and heard
An old monk read from a written Word.
No light through the window-panes could pass,
For shutters were closed o'er the rich stained glass,
And, in a gloom like the nether night,
The monk read on by a taper's light.
Ghostly with shadows, that shrank and grew
As the dim light flared, were aisle and pew,
And the congregation that kneeled around
Listened with not a stir or sound—
Save one, who rose with a wistful face,
And shifted a shutter from its place;
And light flashed in like a flashing gem—
For morning had come unknown to them—
And a slender beam, like a lance of gold,
Shot to a crimson curtain-fold,
Over the bended head of him
Who pored and pored by the taper dim.
And it lit into fire o'er his wrinkled brow,
Such words—the law which WAS till now:
And I wondered that, under that morning ray,
When night and shadow were scattered away,
The olden monk with his locks of white,
By a taper's feebly flickering light,
Should pore and pore with his withered sight—
Should grope in the gloom and never seem
To notice the golden morning beam.

Edward Rowland Sill
1860

I AM CONTENT

I

Dearest, if this great world were ours,
With all its gilt, and gold, and flowers,
And splendid sweep of seas and lands—
Could we but quaff with mighty hands
From some immeasurable cup
'Stilled subtly in a titan-press
All rare delight and wretchedness;
While mime and monarch rendered up
With reverent lip and cringing knee
Profound unfettered fealty—
Why, what a mad world it would be.

II

Would we not wander, sovereigns twain,
O'er all our limitless domain,
Flaunt light farewells in Trouble's face,
Bid Sorrow ride a waiting race,
Then baffle at the breathless goal
Her swift relentless oncoming?
What largess, lavish hands would fling,
While canzonet and barcarole
Thawed lava from the frozen spite
Of each grim-visaged anchorite;
And mount and meadow-land we'd move
To smooth the rugged course of love.

III

But soft! If I essayed the part
And failed; and forfeited thy heart,
What then were all my realms to me?
Far better by thy side to be

Upon some fathomless dim sea
Foredoomed to lasting banishment!
—Fond Dream, adieu; I am content.

Richard Hardesty Worthington
1893

FIRDAUSI AT THE FOUNTAIN

Firdausi by the palace fountain stood,
Hard by the court of song, in quiet mood.

The Sultan smiled to see him, "Thy beard shows
Thee nearer to the cypress than the rose,

Firdausi. Is thy heart warm and blood cold
Who singest of love and beauty, being old?"

Firdausi to the fountain turned his eyes,
Grey-mossed and lichened by the centuries.

"What maketh this sweet music, sayest thou,
The water or the stones?" The Sultan's brow

Was overclouded. "Were the water fled
There were no music certainly," he said.

"The water singing through the garden runs.
Nay, but there is no music in dead stones."

Firdausi bowed. "Allah His grace unfold
Upon the Sultan! Is the water old?"

Arthur Willis Colton
1890

ANACREONTIC

I would not be
A voyager on the windy seas:
More sweet to me
This bank where crickets chirp, and bees
Buzz drowsy sunshine minstrelsies.

I would not bide
On lonely heights where shepherds dwell.
At twilight-tide,
The sounds that from the valley swell—
Soft-breathing flute and herdsman's bell—

Are sweeter far
Than music of cold mountain rills;
The evening star
Wakes love and song below, but chills
With mist and breeze the gloomy hills.

I would not woo
Some storm-browed Juno queenly fair.
Soft eyes that sue,
And sudden blushes, unaware
Do net my heart in silken snare.

I do not love
The eyry, but low wood-land nest
Of cushat dove;
Not wind but calm; not toil but rest,
And sleep in grassy meadow's breast.

Henry Augustin Beers
1868

TO A MOTH

(Crushed within the leaves of an Iliad.)

Poor Creature! nay, I'll not say poor,
Why, surely, thou art wondrous blest;
Right royal is this sepulchre,
Fate gave thee for thy last long rest.

See here—'tis but two lines above
The spot that marks thy early tomb—
Here Paris breathes his burning love
To her, who compassed Ilium's doom.

And here, upon a neighboring page,
The great Achilles moans his friend,
All careless, in his kingly rage,
Of bane or curse the gods may send.

Above, below thee, everywhere,
Fierce Trojan strives with wily Greek;
And mighty lords, with tawny hair,
Deep words of war and wisdom speak.

The high gods gaze upon thee here,
Great warriors guard thy resting-place—
Perchance thou see'st a burning tear
Steal down Briseis' home-turned face.

Aye! rest content, for thou hast won,
A tomb that kings might wish in vain,
About thee shines the all-seeing sun,
And roars the many-sounding main.

Charles Edward Thomas
1895

WANDERING

Not yet! The way is long and far and wild,
And oftentime high mountains rise between
Me and the land I seek, and like a child
Bewildered, lost and weeping, I would lean
Upon thee for support. Point out the way,
Or stay beside me through the weary day,
And thou may'st leave me when the sun has set—
 But go not yet.

Not yet. At times the mists are very near,
And on my face I feel their breath and see
Strange shapes that come and go. Anon I hear
The murmur of wild voices mocking me.
And in the gloom thy hand I clasp and pray—
"Not yet—the night is dark—wait until day!
Wait till the dews upon the fields are wet,
 But go not yet."

Not yet, nor ever take thyself from me!
I cannot go alone. Without thy hand
In mine, my heart would fail so utterly!
Belovèd, let us seek that distant land.
Through all the years that in the darkness hide,
Together let us journey side by side—
Leave me when the world's sorrow we forget,
 But go not yet.

George Hill Bottome
1882

THE CHOICE: A DREAM

If I might steal one kiss—and kissing, die,
* E'en with the touch of your soft lips on mine,*
Or live—with love entombed—eternally,
* To be a peer with all the powers divine,*

To gird the mighty globe in magic ships,
* To learn the lore of nations yet unknown—*
To lose that warm kiss on my freezing lips!
* I choose for love: let love for life atone.*

For what is life when throbbing love has fled?
* And what is death beyond a tolling bell?*
Apart from you my soul is doubly dead,
* And death-in-life is an eternal hell.*

I woke—and felt a strange and sudden thrill;
For I may kiss you and possess you still.

William Lyon Phelps
1888

HAZEL DELL

From the early bells of morning,
Till the evening chimes resound,
In the busy world of labor,
For my daily bread I'm bound,
With no hopes of more possessions
Than six scanty feet of ground!

But my soul hath found an empire,
Hid between two sister hills,
Where she dreams or roams at pleasure,
Finding whatsoe'er she wills;
There sweet hope her fairest promise
With a lavish hand fulfills.

And the path that windeth thither,
There's no mortal foot may tread,
For it leads through charmèd valleys,
With enchanted blossoms spread,
Under groves of flowering poplars,
Through the violet's purple bed.

And it winds beside a river,
Half in sight and hidden half;
There a group of thoughts, like maidens,
Dance with joyous song and laugh;
Or a gray and solemn pilgrim
Goes, supported by his staff.

Overveiled with vines and water,
Dropt from many a hidden well,
Are the rocks which make the gateway;
And the water's silver bell

Keeps the warder, Silence, wakeful
At the gate of Hazel Dell!

Nor may any pass the warder,
Till the watchword they repeat.
They must go arrayed like angels,
In their purity complete;
And the staff-supported pilgrim
Lays the sandals from his feet!

And within the purple valley,
Where perpetual summer teems,
Whisper silken-tonguèd brooklets,
Melting into larger streams—
Winding round through sun and shadows,
Like a gentle maiden's dreams.

Then let labor hold me vassal,
Since my soul can scorn his reign!
Even fetters for the body
Were but bands of sand, and vain,
While the spirit thus can wander,
Singing through its own domain!

In the long, still hours of darkness,
Stretched from weary chime to chime,
Thus beside my own Castalia,
I can gather flowers of rhyme,
And with all their fresh dew freighted,
Fling them on the stream of Time!

Anonymous
1847

SAN MIGUEL MISSION

No drones are the padres of San Miguel,
They plough in the sun, and they spade 'mid rain,—
They read in the books that were brought from Spain,—
And whisper their aves,—but whisper in vain,
For their eyes are of glaze, and their faces are pale,—
And soft are the bells of San Miguel.

The mission is set in the foothill's swale,—
The vines are about in their ranks serene,—
Beyond, the old woods on the slope are seen,
With red of madroño enflaming their green,—
But the valley below is yet out of the pale,—
And slow are the bells of San Miguel.

Oh, kind are the padres of San Miguel,
To lighten the souls that in anguish cry,—
To pray by the bed of long agony,
And soften the grimness of sinners that die,—
But the valley, complacent, refuses avail,—
And sad are the bells of San Miguel.

Charles S. Garside
1903

THE PREPARATION

The day grows cold; and now the neutral sky
 Subdues and moderates the world of snow;
And still as nuns the hours steal softly by,
 Enchanted by some spell they do not know.

Now, in the lull of the December gloom
 The helpless birches stretch their pallid arms;
The melancholy cedar's dusky plume
 Droops heavily beneath a thousand charms.

The snow-flecked branches of the maple-wood,
 Painted in memories of drab and grey,
Project upon the trackless solitude
 Pale streaks of opal reaching far away.

Beyond the whiteness of the misty wold.
 Superbly mounted in the lavish west,
The sun victorious stains the snow with gold,
 And blushes crimson on that spotless breast.

Darkness now hovers near; the colors fade;
 The shadows spread and deepen in the dell
And Twilight, loyal courier of Shade,
 Prepares the way, and whispers all is well.

The stiffened branches scarcely dare to creak,
 While Darkness settles on the crest of white,
For lo! the snow-world, now resigned and meek,
 Receives the blind embraces of the night.

Paul T. Gilbert
1901

HELEN IN ARGOS

They sit with Gods in slumber-breathing bowers,
 The heroes, who for my sake fought and died;
The woes of Troy beneath its fallen towers
 Sleep half forgotten, but with me abide
Sorrow and suffering thro' the weary hours.

Beneath my feet in deepening sapphire light,
 Far, far below, the blue Aegean dreams,
And sprinkled islands from the waters bright
 Rise gleaming in the sun's departing beams,
Or dim beneath the spreading robe of night.

The darkening heavens open, deep on deep,
 Revealing all the starry-clustered gems
The drowsy Gods for weary mortals keep
 To crown their suffering,—vain diadems
To brows that crave no other gift than sleep.

A dreamless sleep, forgetfulness, no more,
 No more, dear Gods, with humble heart I pray:
The sleep that holds these waters and the shore.
 The sun is set, the wave has ceased from play,
The winds are laid—such sleep forever more.

F. M. Clapp
1901

Sun Flowers and Cloisonné /

JAMES GRAFTON ROGERS

1903

THE GENERAL'S FRONT DOOR was an entirely unknown country to Darly and me. Even now there is a strange shadow about all memory of the high knob and the polished name-plate, for I remember entering the front door only years after this story, when the black letters and the "M.D." were draped with crepe. The General was not a real General, but we liked to call him so, Darly and I. There was something we thought was soldierly in his gray hair, his seamed brow and his straight carriage, —the scars of what he called his campaigns as General Practitioner. We had caught the phrase. He had seen all the neighborhood grow up around him, from Cousin Fred and Brother, who were men, to Darly and me, who came just now. We all in turn brought our troubles to him, our broken slates, our empty pockets and after a while our dreams and sweethearts. We all went in by the study window. So Darly and I were in trouble, and we came to the General.

The old gentleman was not in the study. The fire was burning in the broad chimney-place, and except for its light the innumerable trophies of travel and reading that filled the room were in darkness. Darly settled down upon the footstool by the hearth, and stuck out her feet from her short dresses. I was just getting down the tom-tom from the desk, when I heard her exclaim,—

"Boy," she proposed, "let's get in the jugs!"

I looked dubiously at the tall enamelled urns of cloisonné that she meant. Could we ever get in?

"Oh, come on," she said joyously, and jumping up with her brown eyes full of this new idea, she toppled the yellow urn over and started to crawl in feet first. It was fully as high as she was. I came to help, and

after much smothered giggling got the jar upright again. But how was I to get into the other one? Darly, with her rumpled locks just above the edge of the prison, proposed that I should crawl in and then stand on my head. Finally with the help of the footstool I got into it head first. The opening was too narrow. I could not turn around. The jar toppled with my struggling. I could neither see nor hear. Then there was a grasp at my ankles. I was swung aloft and set upon my feet.

The General looked at me solemnly. I motioned him to put me back. He did, and picking his book from the floor sat down in the leather chair.

"Boy," he said, without stirring, "where is Darly? Is she in the Chinese Chest?"

I giggled, because I saw her head pop up from the yellow urn.

"She's in the other one, General."

"Didn't you see Oscar cleaning in here, children, when you came in?" We shook our heads.

"Oscar is a scoundrel," added Darly in the old gentleman's familiar words.

"Well, what is it?" the General went on after a moment, "The cook or Cousin Fred?" He waited to hear our story. I looked at Darly to hear her begin. She always began, whether it was circus or doll's hospital.

"It's Fred. He saw us." A long pause. We both giggled down in the jars.

"Did he tell Boy's mother, or yours?" hazarded the old man.

"They know. He saw us saying good-night in the sunflowers where our house is. And he whistles 'Annie and Ben,' cause we teaze him and Ethel." Darly paused. "Isn't it all right to kiss, when you're engaged, General?"

"Certainly," the General solemnly pronounced. "So what is the matter if everybody knows you are engaged? Haven't you always kissed good-night?" Yet the old man understood what a terrible song "Annie and Ben" was. It was one of the old ballads, with a pathetic verse about the parting of those true lovers.

"I see," continued the General, "Fred has proof and you have not. It's a dangerous thing to teaze without proof. Well, we have got to beat this lawyer, eh, even so young and confident a lawyer. This state of affairs won't do at all." He repeated it softly to himself, "Annie and Ben; he turned and kissed her one time more—"

There was a sound on the porch by the window. The old gentleman stopped twirling his spectacles and looked up from his revery. Darly vanished into her shell, and I followed her example. I heard a girl's voice.

"May we come in, Doctor, and sit by the fire a minute before we go home?" And then Fred's big voice, "Good evening, General!"

"Welcome! Welcome! Glad to see you both. Try the old bench by the fire, Fred. How is the legal trade to-day?"

I peeked up and and caught a glimpse of the two, and away beyond them the top of Darly's head above the cloisonné urn. The conversation rambled on into the weather and business. It was very uninteresting. I fidgeted until my hiding place swayed within the danger mark. The General—great sympathetic heart that he had, to understand every-thing—offered some excuse, picked up his volume, and went away. The two visitors had been sitting at opposite sides of the fire. Ethel was out of sight behind the high, mahogany back of the chimney-seat. Fred crossed over to her. They were talking in very low tones, and I could not hear any words. I signalled wildly with my arm to Darly, but she was evidently too close and did not dare to answer. A dozen plans of escape from our trap occurred to my fretting head, but they were all impractic-able. The urn, if tipped over, would make a terrible noise. Then Darly's apron string was gently waved to and fro above her head. Softly at first, but swelling with every note there came from the yellow jar the familiar air. Darly was whistling:

> "He left her sad by the cottage door,
> Annie and gay Ben,
> He turned and kissed her one time more
> And turned and kissed again!"

Lord Charles DeVaux, with royal messages,
Rode ambling on. A dapper little duke,
He loved vivacious ladies and good wine;
Now minced a measure with a simpering smile;
Now followed keen the falcon: having read
Ten lines of Scotus, or some witty tale
Of priests' amours.
 Lord Charles rode wearily
Toward France. His wordy chaplain's tiresome tales
Were interrupted by the jester Mink.
"Good Uncle Charles, see yonder yeoman plod
Along the dusty road; pray give him horse,
And have him tell about the country crops,
Perchance with peasant lore of witch and elf."

So was it done, and for a pleasant hour
The rustic spoke of beeves, and bairns, and byre.
He crossed himself, and told how highwaymen,
Who thereabouts had lived, played once at cards,
With Satan in their cave, and cheated him,
Outcursed, outdrank, and quite defeated him,
Till Satan swore he never would admit
These men to Hell, lest they become its Lords!
All on a sudden Jester Mink broke in,
"I prithee, Sire, which one of all you three,
This churl, this gabbling monk, and you, milord,
Pleased God the best, in praying, yesterday?"
In angry mincing words the chaplain said,
"Now by Saint Peter, knowest not, oh knave,
That I by God's own hand appointed am,
To please him, by long, oft-repeated prayers.
List, sirrah! I prayed three hours, yesterday.
Why, I can pray so well that, oftentimes,
I doze away, yet pray on in my sleep!"

"Soft, not so fast, good brother Monk, I pray,"
Said Lord DeVaux. "Naught, naught hast thou to do,
Save eat, and sleep, and pray! As for myself,
A thousand things demand my interest.
I rode a hunting all the morning long,
On yesterday; and, in the afternoon,
I had important audience with the king;
A meeting of the council; orders given
About this embassy, and my estates.
All yestere'en there was a royal ball,
With gorgeous dames, who gossiped, simpering,
With belted earls, or bustling baronets,
Who whispered statecraft. Busy was the day,
Yet took I time to pray unto the saints.
Thy mumbled prayers, oh drone, are nothing more
To God than is the whining winter wind.
But I prayed (when I might have made me gay),
Right earnestly, like to a roaring flame.
I poured my soul out in impassioned heat,
Which must have warmed the blessed Christ himself."
"But see," began the monk, right eagerly.
"But hark," the duke replied, "how prayed the third,
This gallant yeoman? Come, speak up, my man."
"He pray?" in heated scorn the chaplain snorts.
"Some scholars think such clods can have no souls."
Remarked the duke, "More pleasing they to God
Than you, then, since they do not bother him.
Well, speak, friend churl." The yeoman stammers out:
"Indeed, sire, and most holy reverend monk,
I did not pray at all on yesterday.
My brother was so sick, so sick, alas,
That, caring for him, doing my own work,
And worrying, I clean forgot my prayers."

The dusk had fallen; Dover gleamed afar.
The monks at vespers in an abbey near
Sang "Laborare est orare," "Work

Is prayer." In full tones floated out their chant.
The cavalcade jogged on with warm dispute
'Twixt monk and lord, about their modes of prayer.
The yeoman humbly rode, and wearily.
The jester Mink kicked up his heels, and grinned.

Sinclair Lewis
1904

THE LAST BALLADE

Snow—and still snow—and is night coming, Sister,
Or just my eyesight failing? You have sent
For the last unction? Set the casement wide
That I may hear the tinkling of the bell
When the good father comes along the street
And all people reverence the Christ.
Come nearer, Sister, sit you by my side.
I am afraid of Fear. You do not know,
Wrapped in your cloistered peace and sanctity,
What Fear is. The gray awful thing that comes
And clutches you all soundless from behind
(When you are hot and full of meat or lust),
To point the way that all men have to go . . .
Death is not dreadful to a soul like yours,
For you have known God's pity and God's love.
So have not I. Ever my joy hath cranked
And twisted. Whirling in drunken dance
At best I only caught a feverish glimpse
Of that high, blinding light they tell me gleams
From the half-open gates of Paradise. . . .
My Katharine . . . but she never understood.
I could not make her see. . . . She only laughed
Her beautiful bright laugh—and passed me by.
Oh, Sister, if the kind good Christ will take

All that I meant, all that I had in mind
To do and say. But that, too, is my curse,
Ever to promise, never to fulfill. . . .
Christ, Christ, how can I die? What should I do
In your fair Mother's garden where the Saints
Do walk in order, and the holy maids
Cecily, Rosalys and the rest? They'd stare
To see poor light-pate Villon in their midst.
Besides, there's no stewed tripe in Heav'n, I fear,
Nor Beauné wine. There I'd have nought to say.
You see I only know the kind of life
Where sinning men and women sweat and eat
And laugh to hear the idle songs I made.
All that I've done has borne its taint of sin.
Myself alone I served—myself betrayed.
Have mercy then; and thou, O Holy Queen,
My last ballade to thee I here indite.
(Help me up, Sister.) I will kneel to thee.
Do thou enthronèd hear and plead for one
Poor François Villon, poet, lover, thief,
Take all my life and read it as a prayer
Crying thee mercy. Pity a poor scribe
Who has writ ill, nor matched his metre well.
But here the song ends. Only do thou smile
In kindness on me, and the awful things
That creep and cling about me must take flight,
Leaving my soul free, then, at last to climb
Unto that Heaven I saw in my love's eyes.

.

Enné, how cold it is! The bones will creak
On Mont Faucon tonight. Call in the priest
To give me bread and wine—my last on earth.
Katharine—not here—pardon my folly, father;
One earthly thought . . . now comes the last envoi.

Thomas Beer
1907

BEHIND THE ARRAS

A CHRISTMAS MASQUE

(Yvrel, a damosel, and Noel, a page, speak in this wise,
seated in a tapestry-hung corner of the King's great hall.)

YVREL

> *What star has given thee its care,*
> *My Noel, and has made thee fair?*

NOEL

> *Hark! With antic, and with mow*
> *They drag the Yule block in; and now*
> *The pompous steward tells them how.*
>
> *What star has watched since I was born?*
> *'Tis Mercury: That Christmas morn*
> *There came a warlock to declare,*
> *"Vain Mercury shall make him fair,*
> *And he quicksilver shall be e'er."*
> *He shook his cane,—one of those staves*
> *Of yew cut from adult'rers' graves,—*
> *And added, "The red cock shall sing*
> *Twice seven Christmas nights; then he*
> *This babe, the heart that most will cling*
> *To him, will break by vanity."*
>
> *The rascal lied; I am to you*
> *As* leal *as angels, and as true.*

(In the hall sounds the peasants' Yule Log song. Noel,
careless of Yvrel's troubled face, listens to the song.)

CHORUS OF PEASANTS

> *The Yule log, the Yule log,*
> *It be where fays do dwell.*
> *From out their house pell mell*

They flicker in a noisy crowd.
I heard one stammering aloud,
"By Mary," quotha, "Mistress Spark,
Our good log house is cracking; hark!
The flame folk beckon through our wall,
Come, Mistress Spark, away. They call."

(A page enters with tankards. The peasants sing,)

Here comes the ale
With a flagon for me,
And another for thee,
To the good King; hail!
Wench Marian,
With the beggar man,
And a wand'ring mime beside,
All giggle and wink
With a skinful o' drink,
For 'tis the Christmas-tide!

(The peasants exeunt. Yvrel Speaks.)

YVREL

Dear Noel, I believe you true.
You've sworn on Christmas eve to do
Aught I might bid; to break the spell
Of Barbarossa; or, through Hell,
Clean to the Nadir ride, and bring
Me up the trident of its king.

Last night the Princess promised me
As a novice to the nunnery;
Which, once a year, 'mid Christmas sport
Is given a maiden of the court.
Let's to thy Father's wild chateau!

NOEL

Oh sweet Yvrel, I love you so

That, saving thee, mayhap I'll go
To-night and,—

(There breaks in a chorus from masquers assembling in the great hall.)

CHORUS

Hurl not the mace
Nor couch the lance.
In stately grace
Thy ladies dance.
Hence,—rude steel case,
Hence,—war horse prance,
Each lovely face
Now doth advance.
Thy gaze we hold
By sinuous fold
Of silks and lace.
We'll thee entrance,
Come, lest we scold,
Be gay, be bold.
Come! Come! Take place,
Come! Join the dance.

(Noel continues, excitedly peering forth at the gathering group.)

We'll flee, perhaps, upon the morrow.
Take cheer, like me; nor trouble borrow.
These carols, wassail, boisterous fun
Take all to-night; without ME none
Of all the sports were rightly done.

YVREL

The nun's damp veil fills me with dread.
I hate it; I were better dead.
Oh sweet, tomorrow is too late.

For, by thy sunny dear brown head
These nuns will seize me if we wait.

NOEL

It is a pity. Well,—I pray
That you'll be abbess there some day.
Were honor, or thy life, in need
I'd save thee, by death-daring deed.
But peaceful is the nunnery,
And pleasant there thy life will be,
I love you, but,—

YVREL

You love me not.
Oh God how piteous is my lot.

NOEL

Now, now! Weep not, poor little maid.
Upon the long wolf-haunted way
I fear you would be sore afraid.
And weary, weary, never gay
Is life on Father's wild bleak moors.
Wouldst have ME a dull boor of boors?
When here at court;—

(He looks eagerly around the hall, and continues),

See, only see!
There's Corisant of Telivit,
His doublet hath a villainous fit!
Saw'st how my new hose fitted me?
Come, dry these tears. Like me scorn woe.
List, there the hautboys sound, I go.
Chuck, one last kiss; for I loved thee.
The dance begins; dear heart, I go.

(As he departs the dancers' song begins)

CHORUS

Who loveth not smacking
And Burgundy wine
Anon may go packing
He ne'er shall be mine.
My love,—

(They continue the song; whilst Yvrel seeing Noel begin the dance with a fair maid, sinks down on a stool, with frightened sobbing. A nun enters the hall, and looks about it inquiringly.)

Sinclair Lewis
1905

SEA CHANTEY

When the storm-winds of Heaven have slain the Sun
And he dies in the bloody West,
When the stars burn out, and the day is done
O'er the endless sea's unrest,
"Listen—O listen," the Shadow cries
To the blind sea-reapers, "Rise—O rise—
No longer sleep—"
Save us, O Lord, when the reapers reap!

When the ships swing out on the ebbing tide
To the harbor of missing wrecks,
And the wet sea-devils from overside
Keep tryst on the reeling decks,—
When the wind-fiends howl in the houseless dark,
And the foam-paved waterways lie stark,
O God of the Deep,
Save us, thy slaves, when the reapers reap!

Kenneth Rand
1911

Kit Marlowe stood in the tavern hall,
 Head thrown back and his ruff awry;
Stood with his back to the smoke-stained wall,
 And laughter that mocked was in his eye.
The lace on his sleeve was stained with wine,
 He laughed aloud in the candle shine;
Reckless and straight in his hot youth's pride,
 "Wine! Bring us wine!" Kit Marlowe cried.

He lifted the brimming cup they brought,
 Brushed from his brow his curls' bright gold,
"To grey-eyed Nell, who will wince at naught!"
 And he drew a rose from his doublet's fold.
"Lad, dost thou envy the bee that sips
 From the fair red flower of Nell's sweet lips?"
"This rose was hers?" quoth the man at his side,
 And "Aye," as he kissed it, Kit replied.

The rose was dashed from the lips that kissed,
 And a knife gleamed red in the murky light.
"Let me kiss thee now!" Nell's lover hissed.
 "Let her kiss thee swift, ere thy soul take flight.
Thine is the rose, but mine her pledge!"
 Kit Marlowe swayed at the table's edge,
His face was white and his dark eyes wide,
 But "The rose was sweet," Kit Marlowe sighed.

Over his heart the red stain spread,
 His lips were set in a mocking line;
"Her pledge! Aye—hold it," Kit Marlowe said.
 "Fool—what's a pledge—to this rose of mine?
For the rose holds all you may never see—
 Dreams—and passion!—and mystery—
Nell's soul! But she'll make thee a comely bride."
 And laughing softly, Kit Marlowe died.

Newbold Noyes
1913

THE GRAIL

"Would I could touch the Truth,
Lay hold of it, pluck petalled-leaves apart
Till all its dew-drenched heart
Glowed coolly to my parching lips."
So cried I; and made answer Youth:
"Oh, mouth that sips
Envisioned dews of its own dry desires,
Fool!
Drink thou the cup of life that fires
The jewelled chalice and the rusting pool;
Drink deep of Truth."

I drank and life lay greenly at my feet,
With paths through flowing fields of windy wheat,
And over birch-browed hills;
Past clacking water mills,
And deep in moss by solitary streams:
The paths of labor and the path of dreams,
But nowhere Truth.

And Sorrow said;
"Nay then, the heart of nature is not dead."
And listening I heard the surge of the besieging sea,
And streams that murmur rhythmically,
The undulating lyrics of the leaves,—
Slow pulse of Gaea's wheel that spinning weaves
Frail form of Truth from frailer mystery,
Frail form and fading stain.
The waves wrote runes upon the shifting sand
And wrote and washed again,
The streams gave bubbles to my hand,
And in the leaves the vague, the bland,

The empty wind wrought his refrain,—
Yea, emptiness and shifting sand:
O God, does no thing true remain?
The old gods hear not; will the new disdain?

I kissed the lips of Love,
And nested in my heart the dove
Whose mourning maketh laughter through the earth,
Sweet laughter and the joy thereof,
Yet never mirth
Nor grey-eyed peace came nigh to me.
Still, still there rose eternally
The vision, and the longing and the fears,
The bitterness of half-belief,
The mocking years,—
Till Love grew heavy-eyed with grief,
And dim with tears.

*Yea, I have sought for **Truth**,*
And flung against the ready-rending tooth
Of doubt, and beat with bleeding blows
The bars invisible of Heaven.
I have cried out to Christ who loves and knows,
And knowing still can love,
That my night may be riven
With lightning of His truth and might thereof;
So sought and striven
And so prayed—
Lord, till the work is marred,
The spirit broken, the stick charred,
Shall be no answer made?

Archibald MacLeish
1915

IN LAUGHTER

Look! Comes Death on a leaping wind
And, tagging at its edge,
Death's fool, red-eyed with tears,
His meagre cloak clutched 'round him
In cold fear.
O'er demon-mawlèd, troublous steeps
And bleak, planed ridges
Sawing at the sky,
They sweep to where,
In rumbling pain, there lies,
Golden in the sun, on the very height of hills
A giant—
Streams of frothy blood jet out
From the yawing gap in the great,
Plateing muscles of his side.
Now says the fool—

 "Alas, poor man,
Oh!—let me shrive your soul—your span
Is done, and Heaven or Hell awaits
For you."

 The giant raises up;
Astonished scorn breaks in his eyes—
A while it stays—then down the hills
A crashing laugh rolls out,
Bombs bursting from his lips—
He rocks with mirth and, brushing
To one side the mouthing fool,
Claps Death upon the back—
Death grins and winks his eye;
Ill-stifled laughter even shakes
His naked skull.

Thus the giant dies!

H. Phelps Putnam
1915

With a brassy gleam of panoply,
Masked in daring, frank and free,
Ceaseless rolling noisy drum,
Half a vendor crying wares,
Partly prophet burning tares,
Mountebank with the latest trick
Slapping the cross with baubled stick
See the man of the New School come!

"Here's a cloak of a pretty fashion
Guards the wearer from earthly passion.
Cobweb, say you?—I won't deny
Rain comes through—but the soul goes dry!
Sophistry? Cynical? What's a cynic?
Merely a surgeon in heaven's clinic.
Buy a guide to the true sublime?
Paper bound; it's only a dime;
Tells you all about life and sin
(There is none, lad, just look within!)

"Here's a trick to turn you faint!
(Step aside while I change the paint).
Ninevah! Ninevah! Kneel to repent!
Cleanse thy palace and tenement;
Doom's afoot and knows not pause.
Thresher's chaff thy brittle laws.
Forbid that iron heel to press
Widows and the fatherless,
Hear the voice thy Lord hath sent:
Sackcloth, ashes! Repent! Repent!
Now—one jerk to fix his tail—
Here's God's image in a whale!"

We jostle, crowd and laugh and cry,
Pay our penny to stand and listen,
Buy his wares because they glisten,
Clap his dancing and know him a lie!

The newest school is the oldest school,
Man is man and a fool—a fool!
Antic babble sprouts no green
'Mid the thorns of the Nazarene.
Jesters vend not comfort's crumb,
Questions find the sophists dumb,
When on the coffin thuds the sod:
"Where are you, soul, and what is God?"

Thomas Beer
1910

THE PORTRAIT OF A BABY

He lay within a warm soft world
Of motion. Colors bloomed and fled,
Maroon and turquoise, saffron, red,
Wave upon wave that broke and whirled
To vanish in the grey-green gloom,
Perspectiveless and shadowy.
A bulging world, most like the sea,
Within a shapeless, ebbing room,
And endless tide that flows and falls. . . .
He slept and woke and slept again.
As a veil drops, Time dropped away;
Space grew a toy for children's play,
Sleep bolted fast the gates of sense—
He lay in naked impotence;
Like a drenched moth that seeks the sun
To fall in wreck, its task undone.

So, as he slept, his hands clenched tighter,
Shut in the old way of the fighter,
His feet curled up to grip the ground,
His muscles tautened for a bound;
And though he felt, and felt alone,
Strange brightness stirred him to the bone,
Cravings to rise—till deeper sleep
Buried the hope, the call, the leap,
A wind puffed out the mind's faint spark,
He was absorbed into the dark.

He woke again, and felt a surge,
Within him, a mysterious urge,
That grew one hungry flame of passion;
The whole world altered shape and fashion.
Deceived, befooled, bereft and torn,
He scourged the heavens with his scorn—
Till, suddenly, he found the breast
And ceased, and all things were at rest,
The earth grew one warm languid sea
And he a wave. Joy, tingling, crept
Throughout him. He was quenched and slept.

So, while the moon made broad her ring,
He slept and cried, and was a king.
And fed on new experience
Through pulsing tentacles of sense.
So, worthily, he acted o'er
The endless miracle once more.
Facing immense adventures daily
He strove still onward, weeping, gaily—
Till one day crawling seemed suspect.
He gripped the air and stood erect
And splendid. With immortal rage
He entered on man's heritage!

Stephen Vincent Benét
1917

THE GENERAL PUBLIC

> *"And did you once see Shelley plain?"—Browning.*

"Shelley? Oh, yes, I saw him often then,"
The old man said. A dry smile creased his face
With many wrinkles. "That's a great poem, now!
That one of Browning's! Shelley? Shelley plain?
The time that I remember best is this—

A thin mire crept along the rutted ways,
And all the trees were harried by cold rain
That drove a moment fiercely and then ceased,
Falling so slow it hung like a grey mist
Over the school. The walks were like blurred glass.
The buildings reeked with vapor, black and harsh
Against the deepening darkness of the sky;
And each lamp was a hazy yellow moon,
Filling the sky about with golden motes,
And making all things larger than they were.
One golden halo hung above a door,
That gave on a black passage. Round about
Struggled a howling crowd of boys, pell-mell,
Pushing and jostling like a stormy sea,
With shouting faces, turned a pasty white
By the strange light, for foam. They all had clods,

Or slimy balls of mud. A few gripped stones.
And there, his back against a battered door,
His pile of books scattered about his feet,
Stood Shelley while two others held him fast,
And the clods beat upon him. 'Shelley! Shelley!'
The high shouts rang through all the corridors,
'Shelley! Mad Shelley! Come along and help
along and help!'
And all the crowd dug madly at the earth,
Scratching and clawing at the streaming mud,
And fouled each other and themselves. And still
Shelley stood up. His eyes were like a flame
Set in some white, still room; for all his face
Was white, a whiteness like no human color,
But white and dreadful as consuming fire.
His hands shook now and then, like slender cords
Which bear too heavy weights. He did not speak.
So I saw Shelley plain."
 "And you?" I said.
"I? I threw straighter than the most of them,
And had firm clods. I hit him—well, at least
Thrice in the face. He made good sport that night."

Stephen Vincent Benét
1915

In Tune With the Infinite / WILMARTH S. LEWIS

1917

THE AUTHOR OF THIS TREATISE in no wise pretends to scientific eminence. On the contrary, he has always been known to his few friends as the "timid scientist." That is why he offers his present contribution to the knowledge of the scientific world with so many blushes and modest bobs of the head. He does not feel at all sure of the ground under his feet, and yet he doesn't feel justified in withholding his rather extraordinary discovery. Briefly, here are the facts.

On the third of last January, he chanced to jam the thumb nail of his hand—the left hand—within the door of a motor. The accident was not severe enough to cause the moulting of the nail, but it was sufficiently severe to cause a fleecy, milk white cloud to appear at the quick.

It chanced that same evening, the author was gazing into the heavens, as is his wont after the evening meal. He noted with interest that Alhena, *gamma Geminorum,* has just risen. It had been some nine months since he had seen Alhena, and he warmly welcomed her back to the heavenly fold.

Three months went their course. Alhena had culminated on February 8, and was fast sinking in the Southwest. The fleecy cloud on his thumb nail had nearly disappeared. Only a few misty wisps were left. The author had noticed two months before the profound sympathy in motion between these two bodies. He closeted himself in his laboratory, often forgetting his meals, working on a theory. He divulged not a word of his secret to anyone. His family was somewhat distressed, it is true, but they suffered silently in the cause of science.

On the night of the second of March, the author assembled his family and his closest friends in his laboratory at 2:02 A. M. He was dressed

simply, but neatly, in a frock coat. They sat quietly before him respecting his intense feeling. Nothing was heard in the room, but the quick catch and feathering of breaths. At the end of an hour, the author was sufficient master of himself to address the company.

"My friends, and closest of kin," he began. "This night will be a momentous one for me. If, as I fondly hope, my calculations have been correct, I shall be famous to-morrow! (Sensation.) On the third of January, I bruised the nail on this thumb, (holding it up), causing a cloud to form upon it. At identically the same moment Alhena rose in the East. (Sensation, and rustle of silk petticoats.) A month later I chanced upon this amazing discovery. *Alhena was apparently traveling across the sky at identically the same speed the cloud was traveling across the thumb nail!* (One of the ladies fainted and was carried out.) By means of my calipers and sidereal compass I was able to ascertain just the moment when Alhena should sink in the Southwest and just when the tip of the cloud should move off the pink part of the nail. Friends, the next twenty-nine minutes will see the success or failure of my work, for if my theory is correct both will disappear at 4:22 A. M." (All the ladies fainted and even the strongest men were pale.)

Posts were placed at the window with telescopes trained on Alhena. A group of six gathered about the author's thumb, making it the focus of a powerful battery of microscopes. The author lay back inert, cold sweat on his brow.

The clock struck. At the same instant the posts at the window cried, "She's down," and the watchers of the nail cried, "She's over!"

.

Theory—Nails, (the horny scales or plates of epidermis at the end of the fingers and toes of man and many apes) grow at precisely the same rate in which the sidereal bodies travel across the sky.

The author realizes that to a certain extent his investigations are incomplete. They lack the finality he could wish. For this he is apologetic. Meanwhile, busied with further research, he timidly pushes forth his theory.

WHITE NIGHT

Now when the gaudy, golden sun is gone
And the great moon, like some primrose of sleep,
Raises its head among the paler stars,
Now when the pastures up along the hill
Lie in the dampened whitenesses of night
Silent, the idle wanderings of sheep
Cease for a few still hours, come, you and I,
Hand clasped in hand, among the ancient stones,
Leaving behind the sun-scorched, stunted slopes,
Down to the cool, cool valleys far below.
I'll tell you something that the gnomes may hear,
Yea! Something that the fairies in their ring
Will dance to, and the creatures of the dusk,
Whirling about in elfin money-musk
Shall know as true, and jubilantly sing.

William Douglas
1917

The Angel on the Ship / THORNTON WILDER

1917

(The scene is the fore-deck of the Nancy Bray, lying disabled in mid-ocean. The figurehead of the ship has been torn from its original position and nailed to the forepost facing the stern. It now stands, as it were, back to back with its former position. It is a half-length of an angel bearing wreaths. She is highly colored and buxom, with flowing yellow hair. On the deck, in the last stages of rags and exhaustion, are three persons: the remnant of a stout, coarse woman, Minna, the captain's wife; Van, the under-cook, a lithe youth whose eyes burn with restless sagacity; and a fat old sleepy member of the crew, Jamaica Sam.)

VAN *(driving the last nail into the figurehead)*: There she is. She's the new gawd of the Atlantic. It's only a she-gawd, but that's a good enough gawd for a sailor.

MINNA *(seated on the deck)*: Us'll call her Lily. That's a name like a god's.

SAM *(stupidly)*: You'z'n be quick. You'm say your prayers quick.

MINNA *(blubbering)*: Her can't hear us. Her's just the old figurehead we had thirty years.

VAN: Her's an angel. Her knows everything. *(He throws himself on his knees and knocks his forehead on the boards.)* That's the joss way. We all got t' do it. *(The others do likewise.)*

SAM: We'll pray in turns. Us must be quick. There ain't no more water to drink and there ain't no more sails left to carry us on. Us'n have to be quick. You'm begin, Van. Youn's a great lad with the words.

VAN (*with a real fanaticism*): Great gawd Lily on the ship Nancy Bray, all's lost with us if you don't bring us rain to drink. All the secret water I saved aside is drunk up and we got t' go over the side with the rest if you don't bring us rain to-day—or to-morra. Youn allus been the angel on the front of this yere ship Nancy Bray, an' you ain't goin' to leave us rot now. I finished my prayer, great gawd Lily. Amen.

MINNA (*in turn, blubbering*): Great god Lily, I'm the captain's wife that's sailed behint you for twenty years. Many's the time, great god Lily, that I shined your face so you'd look spick and span and we sailing into London in the morning, or into heathen lands. You knows everything, and you knows what I did to my husband and that I didn't let him have none of the secret water that me and Van saved up, and that when he died he knew it and cursed me and Van to hell; and that me and Van been friends ever since Cuba. But you'ms forgive everything and send us some rain or bye-and-bye we'll get puffy and die and there'll be no one here prayin' at you. This is the end of my prayin', great god Lily.

SAM: I ain't goin' to pray. I'm just a dog that's been on the sea since I was born. I do' know no land eddication.

MINNA: We all got t' pray for some rain.

VAN: You got t' say your word, too.

SAM (*imitating them*): God forgive me, great gawd Lily, I'm old Jamaica Sam that don't never go ashore. I'd be down, too, only for Van and the captain's wife, who gave me some of the secret water, so that if they died I could roll 'em over the side and not let 'em rot the clean deck. You'ms known my whole life, great gawd Lily, and how I stole the Portagee's red bag—only there wa'n't anything in it—and how I put a knife into the three black brothers that got on at Majaica. Send a lot of rain and a ship to save us. Amen.

VAN (*hysterically, crawling up beneath the figure and throwing himself full length*): You gone and forgiven me everything. Sure you have. I didn't kill the captain. The secret water was mine. Save us now, great gawd Lily, and bring me back to my uncle in Amsterdam who says he'll leave me his three coal barges.

MINNA *(sitting down and rocking herself)*: We'ms lost. She'll save you, but I done what the gods don't like. They'm after me. They've got me now. *(Suddenly staring off the deck)* Van! Van! Them's a ship comin' to us. Van! *(She falls back crying.)*

VAN: Them's comin'!

SAM *(dancing up and down)*: It's the Maria-Theresa Third.

VAN: We must wave. *(His eye falls on the figurehead.)* What'll they say to the figgerhead here?

SAM *(sententiously)*: It'll look queer.

MINNA *(with consternation)*: But that's the great god Lily. Her's saved us. You'ms ain't goin' to do anything to her.

VAN *(taking the hammer and starting to beat the angel foreward)*: They'd call us heathen, bowin' down to wood and stone. Get the rope, Sam. Us'll put her back.

MINNA *(in a frightened voice)*: But I can't never forget Her and her great starey eyes. Her I've prayed to.

Eddy Greater / THORNTON WILDER

1920

THE FALL OF 190- I spent in London collecting material for my *Life and Works of Sebastian Torr* for the English Sebastian Torr Society. This task, I soon found, could merely end in my serving cold my predecessor's data as to this strange, obscure poet of the previous generation. I could only annotate superabundantly the thin book of verse that was his, retell the handful of anecdotes, and deduce lamely from them the shadowy career of a poet. It was in a fit of despondency following this discovery, that I endeavored to beguile a rainy afternoon by visiting the gift shops of the city, tentatively searching for a wedding present. The marriage was still afar off, so under the removed urgency I wandered from shop to shop, marvelling at length over their servile adherence to type. Mrs. Creighley's, ultimately arrived at, concentrated the elements. It was dark and narrow; very few *objets d'art* were exposed to the visitor: here and there under glass lay objects of hand-hammered silver, necklaces meandering among the folds of claret velvet; a few examples of Chinese pottery, consummately cracked and holding rock lilies whose bulbs had been scoured for their high lights; little trays of uncut jewels, carelessly displayed—tourmaline, aquamarine, stones prized for their negative watery tints. Mrs. Creighley likewise represented a type. She was handsome in a business way; she wore draperies rather than gowns, yet gave an impression of efficiency and shrewdness. A portion of her stock-in-trade had found its way to her person, a gun-metal chain on an odd enamel ring. Her appreciation of her "little things" was too readily ecstatic and her voice low but over-rich. In her Commerce was flattering Art by imitation, to the embarrassment of Art.

This excellent woman was engaged, upon my entrance, with two ladies who were spreading bits of brocade critically upon their knees, and matching jewels with them. Her quick welcoming smile, however, urged me to take my liberty of the shop, which I did, arriving at last in the further corner upon a pile of what appeared to be framed texts. I found them to be autographed letters: Whistler inviting a lady to dinner; Dégas making an appointment with a model; the menu card of a dinner given by the brothers Goncourt, signed by all the guests with much too lively maxims and nicknames. The name these documents enjoyed in common was the familiar Eddy Greater, the soubrette of the seventies, who was in the height of her fame during the years of Sebastian Torr's last illness. The reading I had done for a study of his period was full of her engaging figure. The successive light operas of Offenbach were then enjoying tremendous runs in Paris and London, culminating in "La Bôite au Lait" and "Madame Favart," bright theatrical things, full of gay tunes and famous women. The musical actresses of the seventies, who remembers them now? Mildred Palmer, with the face of a sheep and her mass of copper-colored hair, maintained by the son of a famous Scotch peer until the arrival of her dropsical millionaire from India. Little Manina Shayer, who is reported to have sung *A Soldier's Maid* eight thousand times. They all drove their carriages in Hyde Park, made flamboyant descents on Paris, and drove the organized society of modest ladies of fashion to a jealous distraction. Eddy Greater was not as magnificent in manner as Mildred Palmer, nor did she command as socially distinguished a clientele; she was not as pretty as Manina Shayer, nor as good a singer; nor was she the clever actress that was Rosalie Barlow. But she was the most intelligent and the most versatile of all the great lights-of-love. The men of letters of the time, such as were unmarried and unprincipled, flocked to her dinners and even galloped beside her in the park, if they were in society, or sent verses to her if they were not.

One often wondered what became of them as time went on. In the first place, that type of musical play went out, under the press of Gilbert and Sullivan; newer prima donnas, more ingenuous and better chaperoned, took their places. The old fellows in the club used to say that Mildred Palmer followed her millionaire to India and now looked very much like a rajah's lady; and that Manina Shayer, whose mixed blood became more and more evident with time, retired to a plantation in the West Indias with a quadroon. Well, what became of Eddy Greater, a part of whose correspondence I was discovering, framed and passe-partouted.

"Ah, you've the autographs!" murmured Mrs. Creighley, suddenly appearing at my elbow and lighting a discreet lamp. "Of course I can't show them to everyone."

"They're of the greatest interest. Where did you get them?" I asked.

"Oh, they've belonged to a cousin of mine, a very interesting woman. She used to sing on the stage when she was a girl, and these were addressed to her. A Mrs. Clarke."

"Oh, she was . . . Mrs. Clarke was . . . the . . . ?"

"Yes. She bore the absurd name of Eddy Greater. Fancy calling yourself Eddy! She enjoyed a certain fame in her day. You wouldn't have remembered her very likely. But look at the correspondence! Whistler, Zola, Manet. . . . I'm asking three-for-a-pound, though I'm really quite frightened to show them to some people—some people, that is, mightn't understand!"

"She might have some really interesting—"

"Oh, yes. There's a great deal more than this. But she won't part with it. She has all sorts of manuscripts and little sketches. She only allows me to sell these, because—well, to tell the truth—I believe her resources are very low. I like to help her, of course!"

"Is she in London?"

"Yes, indeed, she is. She's in the shop."

I looked about me vaguely.

"She's in my office in back! She's having a cup of tea with me. I fancy she's brought some more things to sell me, but—it's a *real* struggle for her, you know. To give them up, I mean."

"Could you present me to her, Mrs. Creighley? My card, here. I've been engaged in studying the lives of many of these men—"

"Oh, she wouldn't open her mouth to you. She sits there, so—for hours. But sometimes she's lively enough, Heaven knows. I don't mind you're trying though. Can you come in now?"

Mrs. Creighley then led me into her inner office, an apartment that proved to be better lighted than the shop, but no less ranged about with objects of display. Mrs. Creighley's desk—one saw her sitting at it, urging up the price of the heirlooms as they came to her—was scarcely mercenary enough to break in upon the impression the room gave of being half drawing-room and half private gallery. As I entered it I was beaten back by the light of the setting sun that poured across the roofs and chimneypots in a stream, red and vindictive, through Mrs. Creighley's high windows onto Mrs. Creighley's deep carpets. It played on a tea urn,

and on a brass tray laden with cups; it burnished the mahogany, and it plated the white ceiling with a caked and imperial gold; but it had nothing to do with the lady who sat with her back to it, over the tea urn. In the midst of this tumult sat a figure, grey, composed, abstracted. A woman of middle-age, one would say, robed in faded purples and wasted reds, hung about with relics and amulets; some queen-mother, superceded, unattended and forgotten, having about her still the twilight of royalty and old processional honors. Her face—though in the darkness—had the texture of an old glove, touched with pink. She remained for a time unaware of our entrance, but sat gazing at some mote in the air, incomputably distant, her nose lifted, as though balancing a difficult pince-nez.

The interview proved Mrs. Creighley to have been right. This Mrs. Clarke, Eddy Greater, refused to be drawn out, and while her cousin and I eked out her unresponsiveness with a highly artificial conversation of our own, her hand rose and fell, carrying the teacup to her lips. Even to direct questions as to these notable friends of hers, she made monotonous disclaimers. Her voice was low and curiously hoarse, and the few phrases she permitted herself: "I don't know," "I can't remember" and "I believe so," were only too obviously protective measures set up by one who could, but would not, expatiate. Finally I thanked Mrs. Creighley, who said she would see me through the shop, and rose to go.

"Your material is of the greatest interest, Mrs. Clarke," I said. "Can I give you my card? Should you consider—ah—sharing anything further you may have, I hope you will let us know. The Sebastian Torr Society will be pleased to buy any documents of the period that—"

She had received my card spiritlessly on her lap, but now she looked up with arrested attention. One saw her thus as quite aged, and with a touch of eccentric madness in her thin, angular face and looped, variegated costume.

"Sebastian Torr? What do you know about him?" she asked sharply, adding as she relapsed into her abstraction, "Drunkard!—I have nothing but these few things you have seen. Goodbye."

Mrs. Creighley had preceded me into the shop. "You mustn't mind," she said from the gloom, "she is strange with everyone. I fancy she had quite a difficult time in her youth. Did I tell you she was on the stage? You wouldn't have heard of her, it was so long ago. Not that she wasn't all right, Mr. Caruthers! But I imagine in these days the stage could be very difficult for a girl of high principles."

The tone of my commiseration implied an unqualified acceptance of Eddy Greater's model life and consequently desperate struggle for advancement. I bought a little pile of autographs and pushed out into the falling dusk.

In the days that followed I planned to return to the shop, confident that it required only time to draw from the aged singer further and more valuable mementos of her brilliant epoch. Any such trying process was disposed of, however, by my receipt of a pencilled note at my hotel. "Dear Mr. Caruthers," it read, "I have more things for you to see. I am at 45 Queenschapel Road, every evening at seven, Mrs. Clarke." After a great deal of inquiry, a hotel retainer was found who knew the general direction of Queenschapel Road. This woman was led out to my cab-driver, and after a prolonged discussion of landmarks we set out. After half-an-hour's driving we fell into the habit of stopping at public-houses for reassurance. We were penetrating into a suburb, all walls and hedges. The road seemed prepared at any moment to resign its claim to city supervision, and relapse into villagedom. There were suspicions of orchards and lanes and even pastures. At last we drew up before a large, ugly house, of what at first appeared to be a highly solitary situation, bearing two faded signs: "Altar Guild" and "Sacristan, 3:00 to 5:00 P. M." Descending to the pavement I looked about me and saw through the dark that had fallen, the light smoking rain, and a vague screen of foliage, that opposite the house of our intention stood a suburban cathedral, a vast bumpy structure, uncompleted and infested with side entrances, breaking into little gilded domes and leaning before and behind upon ghostly scaffolding. I bade my driver draw off towards a nearby gloom that I assumed to be a clump of weeping willow trees, and started to ascend the stairs. The door before me suddenly opened and three ladies rushed out in a little flurry of screams and giggles. "We shall be *so* late!" one said. "Father Raglin will be very annoyed," said another. "The third time this week." Two were in nun's garb, and the third wore a discreet modification of it that resembled penury, widowhood and convent in one. They rushed off to the dripping church without seeing me and I continued my ascent.

The bell was answered immediately by an old woman who must have been sitting by the door. She nodded when she saw me, as though I were a frequent caller, and led me into the front room, clean, high and uncarpeted. There was a faint smell of incense about, and through folding-doors, came the sound of low impassioned Jesuitical murmuring. These

doors creaked to admit Mrs. Clarke, who closed them behind her. Seen thus for the first time, in motion and facing the light, she appeared less impressive. I was seeing an elderly lady with a sharp, hunted face framed in hair that was still dark. Her lips were thin with acquisitiveness, and her eyes were wide and fixed, and bore the flag of a fixed idea. She wore the same costume that I had seen on the stairs, and in the new association I saw her to be a lay sister or a postulant, one too ignorant to be admitted, or too unspiritual, yet too devoted to reject. She swept and polished and embroidered, one saw; she dusted the woodwork in the choir and mended the vestments in the press; and passed a piece of chamois over the altar vessels.

She sat down immediately at the table and said in her guttural voice: "Now! I have a diary of Sebastian Torr's. For three years. How much will you give me? It's full of poems he wrote me. I used to know him. There are photographs of us two, standing together. Now!"

"Let me see it," I said.

"Yes, yes. You shall. There is most of a long poem, too. And the story of his illness, when he was getting worse. How much will you give me?"

"Mrs. Clarke, I must see it first. If it contains all this you say I may be able to give a hundred and fifty pounds."

"A hundred and fifty pounds! Do you hear, I will not *show* it to you for that."

"You must be reasonable, Mrs. Clarke. I can make no promises without seeing the manuscript," I replied, and my firmness exerted a quieting effect on the old woman, whose excitable haggling had acquired a touch of hysteria. She dabbed her eyes and suddenly drew open a drawer of the table, where lay three worn note-books. My eyes at once caught the handwriting I had been studying for so many months, Sebastian Torr's, indubitably. I saw the indentations of daily entries; I saw with these eyes the lost poems, the legendary lost poems, the Imogen lyrics and the seven Primitive Rituals; I saw a half-dozen daguerreotypes—I hung over these things for several minutes while Mrs. Clarke stood up, translating my pleasure and awe into the terms of her own cupidity, increase for increase.

"I will give you four hundred pounds," I said finally.

Mrs. Clarke gave a second cry of dismay and repudiation, and for the first time I became aware of a touch of the histrionic in this pathetic funereal quasi-distinguished old woman. Suddenly the folding-doors, behind which the murmuring had ceased, opened to admit a small, precise

priest. He bowed impersonally to me, and by the slightest of signals requested Mrs. Clarke to leave us alone. She closed the drawer of the table, locked it and left the room without a glance at us.

"Mrs. Clarke has told me of your interest in these old papers of hers, Mr. Caruthers," said the priest. "For the journal she showed you to-night she is willing to accept a thousand pounds."

"I can't pay it," I replied immediately. "You know such sums are not paid for small manuscripts like these—"

"I am aware of that. You must understand that we are not charging you a thousand pounds for the literary value of the journal. I have read it. It is the daily record of profligacy and degeneration. The poems may be fine; but they are blasphemous or licentious, or both. We could not but feel that we are contributing to the destructive forces about us by selling this journal. I suppose it would enjoy a certain sensation?" He waited until I nodded. "The verses would become a part of everyone's culture—very likely?" Again I nodded. "The responsibility on us becomes fairly great. But for a thousand pounds—"

I was listening to a popular preacher whose ears were charmed by his own stilted phrasing. The cool, delicate voice would go on forever, multiplying distinctions.

"Good-night," I said suddenly, rising. "Mrs. Clarke has my card. My offer of four hundred pounds rests with her."

I left the room in a rage, descended the stairs and aroused my driver without noticing that the rain had begun to fall more heavily, and that I was carrying my hat and coat in my hand. A thousand pounds was impossible. It was in the days before the great sales, besides which I could never persuade the society nor any of its rich enthusiasts to pay a thousand pounds for a manuscript that would be eventually published—such poems are never lost!—leaving an only incidental interest in their original handwriting. On the drive home I furiously cast away all interest in the journal. Let them keep it; I should never penetrate into their strange retreat again. But during the days that followed my eagerness to possess it took an almost physical form; I fell ill of disappointment and frustration, and had about resolved to journey out to Queenschapel Road, when another pencilled note was left at my hotel making an appointment with me at one of Mrs. Crooke's tea-rooms situated in the center of the city.

The organizing genius that has given the name of Mrs. Crooke to the world as a household word built a chain of untidy, identical shops

throughout London, choosing for the most part the more important bus transfer stations. The trade-mark displays a Japanese girl tilting an umbrella, but the firm is more closely associated with the rubber-plants in the windows and the embarrassing turn-stile in the door. Our appointment was for three, but arriving early I saw through the stile and rubber-plants that Mrs. Clarke was already waiting for me. It was early and we were the only customers. In the distance a tall waitress was sewing on an apron-string and conversing with the cashier in her little pagoda. We sat in silence a moment while Mrs. Clarke seemed to be hurriedly preparing the line of argument, into which she finally launched herself, with more than her usual hoarseness.

"I will sell you the journals for four hundred pounds. But you must not publish them. Not for five years at least. They must not know, Father Xavier and Father Lara. They would never let me be a nun; I would be washing dishes forever. Do you see now?" I nodded greedily. "I will pretend to them that I have burned the manuscripts, or thrown them into the lake."

Wonder as to what she would do with the money, and how she could conceal its expense from her confessors crossed my mind, and I asked her, only to find that my question had tapped the fixed idea that was burning in her eyes.

"No one will ever know. I shall build a chapel in my cathedral in Paris. For my friends, for all of us, Manina Shayer, Fanny Bonner and the rest—eight of us. I owe it them, they are telling me that all the time. I am the last and I owe it them."

During the shaken silence that followed this feverish confession the waitress at the end of the room bit off her thread, shook out her apron-string, licked her fingers and descended on us. I gave the order, adding that we would like a fire lighted in the grate beside us. The waitress looked at the grate as though she had never seen it before, stuck one fore-finger into the hollow of her cheek skeptically, and went away. Presently a boy appeared with sugar on his face, lit the kindling, made a tremendous racket with a coal scuttle, and returned to his interrupted tea. Throughout these incongruous proceedings Mrs. Clarke and I had sat shielding, as it were, our religious and literary passions from the vulgarity and horse-play about us. When tea had been placed before us, I attempted to lead her into conversation on her old acquaintances, but she cut me short, saying she never thought of them, and I saw something of the abhorrence of the convert for the days before the change. I arranged

to meet her at the same place the next day, with the money, when a shadow suddenly fell across the table. Mrs. Clarke was in the act of extending to me "on account" the first *cahier* of the diaries which she brought with her. She looked up and a change came across her face, more of resignation than fear. "Father Lara!" she said, half rising. The priest with exquisite manners was beside us.

"Veronica, have I your permission to burn these books?" he asked, almost with deference.

"Yes, Father Lara," she said, her chin trembling strangely, and her eyes returning to their myopic fixity.

"These have come between us again. First you clung to them because they represented the life you have put behind you. The second time they caused you to fall into avarice. Now they have led you into disobedience against our authority. Veronica, have I your permission to destroy them?"

She sighed her admission again. He took the journals, and with a sudden movement threw them into the burning coals.

"I could have given your damned authority a thousand pounds for those papers," I cried.

Father Lara without looking at me remarked gently: "The obedience of the least of our postulants is worth more than ten thousand pounds to us. Come, Veronica, you will be late for the class."

Without another glance at me they went out, Mrs. Clarke buttoning her cheap cotton gloves with a sort of tearful dignity. Perhaps I could still have extracted a page or two from behind the moulded iron grate, but a strange lassitude had fallen upon me, from which I was aroused by the tall girl.

"The man with the collar's been lookin' in over the rubbertrees ever since you came," she said. I paid the account, and went out thinking of the two cherished ambitions that would never be fulfilled—that strange chapel of dead actresses and my edition of Sebastian Torr.

HEROD THE GREAT

My sword is sunk in slaughter to the hilt;
My Miriamne and her sons are dead;
This palace, Lord, of which Thou know'st I said
A nation should be slave the while I built,
Shall be memorial of consummate guilt.
Has not my slighest jest required the head
Of saint and prophet when the wine was red
And one girl dancing where the blood was spilt?
Men say that Thou hast weighed and found me chaff;
That naught for me will follow fleeting breath
Save darkness, curses, and a circling laugh.—
Yet, since that I was great, the Great God must,
If He will leave me to eternal death,
Admit that He is mingled with my dust.

Henry R. Luce
1919

DESOLATION

Four walls about us, and a little room,
 With here and there a window, one or two,
And dust, eternal dust. . . . A broken broom
 Lies in the corner, and there's I or you.—
 Outside an inch or so of something blue.

The windows have no glass. There is no need
 To keep the weather and the wind outside.
The rotting wood and empty places heed
 But little what is out or what inside . . .
 This world has but four walls and is so wide.

Some tell me that this room is of the soul,
 And say that dust is thick upon its floor,
And that four rotting walls surround the whole,
 Filled up with empty places by the score.
 I wonder what its use is anymore?

Maxwell Evarts Foster
1921

ALL TOLD

A hundred and one
 In an iron-bound box,
All glittering, round, all bright, pure gold—
 In an old, carven chest picked up on the rocks.
 A hundred and one, all told.

The dark sea was raging
 The wind had a whine,
The cabin was shadowy, weird and damp.
 But a hundred and one—and they all were mine,
 And they gleamed by the cabin lamp.

Then a creak of the hatch
 And a flare of the flame,
A flash of bright steel—so sharp, so cold!
 And the wind seemed to shriek out an old, ghostly name.
 A hundred and one, all told.

Paul Mellon
1925

PALETTE

Where the pulsing throb of the ocean's tide
 Marks the surge of the sea to the moon,
I laid a snare where thin fish glide,
 In the green of a quiet lagoon.

(The moon is cold, but its gloss is gold,
Wrap it up in your mantle's fold.)

A streak of grey in the azure sky
 Then the rockets of blazing dawn;
 A flamingo stirs with a hungry cry,
 As another day is born.

(Each comber groans, the white bar moans,
The beach is bleached with a god's dried bones.)

A dolphin had caught in my woven snare,
 I straddled his plunging form,
And heard the mesh of the network tear
 As the rising sun shone warm.

(The dolphin was strong so our ride was long,
I passed the time with joking and song.)

Washington Dodge, II
1926

I

Such sunlight scattered in the tune he played
Of jessamine and yellow cactus flowers
Upon the monastery wall—of jade
Of hills and copper-colored twilight-hours
That stilled, beneath San Gimignano's towers,
The mutter and the madness of the day—
Such happiness of unembittered eyes
That filled his song, as though eternal May
Had buried every breast with blossoms, wise
With small perfections that were past surprise . . .

He played upon the sun-splashed upper street
Where ever and forever out of mind
The world ran green and golden: song so sweet
Rose only from the soul of one so blind!

II

Swift flights and bright, imperfect balancings
Of slender wings upon the bended flowers
Already cease, with some strange age that brings
Their patterned joy to dust in these blind hours.

Upon this rock the long night-shadow flings,
For sleep; and in that sleep such dreams may be
Of distant dawns and sudden, surging Springs
When these black scars were blossoms on a tree!

Eternal god to those uncertain wings
Who turns to clay beneath the Earth's old rage,
I must abandon Time—that base alloy—
To seek the perfect measurement of age:

Where I shall live ten thousand years of joy,
Beyond the promise of eternity.

Brendan M. Gill
1935

NIGHT POEM

Oh, that which I would carve you
 Will ever be unknown
Till dream becomes my chisel,
 And this faint starlight stone.

Tom Prideaux
1928

DEATH IN THE RECTORY

Children, who have mocked me for my foolish trust,
Now that I am going whither all men must,
Ye may build your alehouse over my poor dust.

You are of the future, I am of the past,
God shall be the shadow of a shade at last,
Slowly did we build him: he shall crumble fast.

But this ye shall remember, when the night is come,
This ye shall remember in the hour of doom,
This ye shall remember in the narrow room.

That which ye have doubted, time shall prove it true,
That which I have witnessed shall be shown to you,
That which I have suffered, ye must suffer, too.

Wrap the sheet about me as my limbs grow colder,
Prop the crumpled pillow by my sleeping shoulder.
Let it be a birthday; I am one life older.

Harold Cooper
1930

LINES ON DELIVERANCE

What you have given you may take away
In exercise of your unquestioned right,
Even to the last and uttermost delight,
Nor shall my stricken spirit say you nay.

You brought me life, for I remember days
Dimly like hills conjectured through the rain
When silence led me into lonely ways
Where hourly I was trapped and hourly slain.

You brought me beauty too, and gently trained
My erring eyes, for twilight's broken flame
Burned into night unseen, moons rose and waned
Unheralded, unwept before you came.

It is enough that we have seen the stars
Ache through the night and perish with the dawn,
That we have watched Aldebaran and Mars
Whirl out of space and into space be gone;

We have heard tempest smite the shaken beach,
Seen waters hushed as sleep and waters rough
With winter's voice; we have outspoken speech
In many a summer-night. It is enough!

Today there is new glory in the sun,
New light in heaven. The city of my sorrow
Lies far behind me smouldering and won,
And I am on the foothills of tomorrow.

Townsend Miller
1931

THE STREET

*They were the young
And the strong, they were the dreamers
Of eager, perilous dreams; poised erect
On the edge of the heart's last frontier, they the elect
Of heaven, the world's redeemers,
Strained to embrace the wind and to extol
The sun's shadowless fingers as they drew
The portrait of destiny anew
On the grateful fabric of the soul.*

*They were the first
Believers and the last for evermore,
Until to-morrow when the unborn youths
Shall come and discover over again the truths
Forgotten since yesterday when the age before
Returned to the griefs
Of the narrow waking here
And disclaimed the beautiful, clear
Worlds they had built of their beliefs.*

*They are aware
Of themselves and the street,
Implacable, cruel under foot,
Indifferently aware of the soot
That clings about the corners or the heat
Of noonday. And they use
Thy naked, inaudible language of the eyes,
Struck on the durable store of hearts grown wise
In the dull struggle of disuse.*

Young men,
Inheritors of the tattered
Creeds of a generation back and the husk
Of the world's ideals withered in the dusk
Of disillusion, all that has mattered
To them in the sweet, strong time
Of youth has gone by,
Gone with the posthumous cry
Of the war-dead and the profiteers' last dime.

Hugh Chisholm
1934

SONNET

There will be music in the land and laughter
When we who found them fair are trodden deep.
The daffodils will stir as thick hereafter
Among the leaning grasses where we sleep.
Long rains will come, and smutted things past saying
Make foul the flesh with subterranean rust,
While other lads and lovers go a-maying.
Yet earth will be the richer for our dust.

One with the sod and married to the briar,
Such quickening comes, the after years will find
Our limbs' corrosion working in the mire
Some new, unlooked-for blossoming of mind;
And to the unlocked beauty of our blood
Confide a thousand Aprils' likelihood.

Maynard Mack
1931

THE SINNER'S LOGIC

The night hangs over us—
Strange, O God,
That only in the darkness
And under the sod
You see fit to show us
The infinite,—odd!

When sunlight fails
To satisfy,
And we find reason
A flagrant lie:
How can we rest here
Happy to die?

Surely this darkness
Has small chance
To make us aware of
The vast expanse
Where no excuse is
Ignorance.

If I am trapped there
I shall say
"Darkness begot me
And my clay
In the infinite sighted
No other way."

Selden Rodman
1932

DRIVER, DRIVE ME

Driver, drive me round
the town,
anywhere yes,
or nowhere,
because I have no place for me.

Wait driver. Drive me
to 404 West Park Lane
where waits the most beautiful, —
the form sublime,
the hyacinth hair.
But I, I
cannot wait, driver:
hurry.
No. Stop.
That bedridden beauty does not await me,
a pity too.

Drive me to the American Telephone and Telegraph Company
where a vice-president died
(and I am next in line?)
Drive me to the side entrance of Mr. Alfred P. Sloan's residence
that I may do reverence.
Drive me to church,
and twilight saints, and dim emblazonings,
that I may go in to be awed.
Drive me to a Socony station,
they have fine restrooms.

Driver, are you tired?
Just one more ride—
I pay well —
to the earth's end this time,
and a little past.
I am greatly tired of mind.

E. Reed Whittemore
1939

Hallowe'en / THOMAS MINOR

1952

IN THE FALL, there is a special dissonance which older people do not know, but which makes a young boy's life an exquisite thing. There is the acrid smell of excitement in the air, biting-sweet. Coaxed from the damp cement between bricks of old buildings, ferreted from beneath swells of dry leaves, it comes imperceptibly, yet almost palpable in its elusiveness. The wind bears an odor of vibrancy. There is a whole new world, a world beautifully, excruciatingly pleasureful because of its promised unfulfillment. Fall is the time of young boys.

But then, one day too soon, the vibrancy is gone. Something happens, something which turns fall into the time of dying things, and old people.

The boy's feet slapped against the pavement, a metronome of haste occasionally disturbed by a slanted paving stone which made him falter to hold his balance. There was no moon, and the boy slowed his gait, for he did not wish to fall. His hands clutched his trouser legs, to hold the cuffs well above the dry leaves on the sidewalk, for the costume that he wore was new. He thought about the outfit, the weeks that it had cost, and wished that it was back in the yellow box on his bed. Sometimes, during the two months since school had resumed, his mother had contributed a dime, or quarter, and once even a half dollar when the week's bills had been paid, to the small hoard in the top drawer of her dresser. Now the money was gone, spent in a single gesture at a downtown store, and the stockings were returned to their accustomed corner of the bureau.

"What a big man is my little Tommy now," his mother had marvelled. She had put her arms around him and tried to kiss her boy, but he had

pushed her away, fearful that she might wrinkle the new pressed costume, and run out the door. "Put on your overcoat. It's going to rain," she called after him. Pirates don't wear overcoats. The boy knew that his mother had read enough pirate stories to remember this, and was angry that she hadn't. The two of them would often read together, after he had gone to bed; yet, somehow, the way old people can, she never remembered in the daytime, never remembered whom they had decided he was in the mystical darkness of the night before.

Tommy crossed the street, rubbing the emptiness of his stomach, and stood on the sidewalk outside Allen's house. He heard his friend come tumbling down the steps, watched him run across the lawn. Tommy liked him very much; besides, he was the only other boy in the neighborhood. Suddenly Allen halted, a foot or two away, and poked a finger against his friend's chest.

"That costume. And you're twelve years old, too!" He fairly danced with glee, shrieks of strident laughter encircling the pair, barring them from the quiet of the surrounding houses.

The boy backed against a tree. He thought of the weeks of waiting for his pirate suit, the two months exile of the stockings from the dresser drawer to make room for the slowly mounting pile of coins. Why, he thought miserably, why had his parents allowed him to get it? Why had they not known he was too old?

"It's a nice costume," he said.

"O Lord." Allen sat down on the ground, among the leaves, the better to support his laughter.

"It's a nice costume," he repeated stubbornly, as much to reassure himself as to convince his friend. Tommy turned and walked back toward the gate, kicking a flake of peeling paint from one of the white fence posts, digging his toe into the leaves.

"All right," said Allen. "Don't go home; let's go find something good to do." His companion stopped, pondering the unpleasant necessity of explaining why he was home so early, if he left Allen now.

The friends fell into stride and passed up the darkening street, the short legs of the rotund little pirate scrambling close to the ground in order that he might keep pace with Allen's long, firm steps. Carefully extracting a roll of orange crepe paper from his pocket, Tommy tore off little streamers, attaching them to bushes and fences along the way. The brilliant orange was vivid and bright against the damp blackness of a wrought iron fence. Tommy liked it there.

Allen extracted a crumpled cigaret from a cache hidden somewhere within his voluminous jacket. "That outfit. Boy, I can't get over that damn outfit. And the crepe paper. How the hell old do you think you are, anyway?"

The younger boy felt fury, but suppressed it, afraid of Allen. It remained an anguish which came from knowing that Hallowe'en had never been like this before. Always before, he had worn a costume. Always before, he was able to shudder with wonderful terror at the sight of goblins who had given him a neighborly smile only a few hours earlier, and who would be neighbors when daylight came again.

Tommy remembered a day two years earlier: here on this same street, with this same boy, he had learned that there was no Santa Claus. Dumbly, standing there in the October cold, hanging to the half spent roll of Hallowe'en paper in his clenched fist, he wondered why it was always Allen, always, always Allen who did these things to him, forced him to grow up before he wanted. He had cried that day, shouting at Allen that it wasn't true, that he had seen Santa Claus with his own eyes just the day before. Then he had run home, had fallen on the pavement but gotten up to run again, wiping away the tears. His father and mother were in the sun porch. He knew that because he remembered the red drapes. They were looking at the great map of the world above the fireplace, staring at it intently, for this was during wartime, and his father was soon to be sent away.

"Allen says there isn't any Santa Claus. Tell me it isn't true, mother; tell me it is not true. Tell me he just doesn't know." It was a supplication that he made. It was the belief that he wanted to save, not the truth.

But his mother had told him that it was true. Then she looked at him, and added that there is a sort of Santa Claus, in which even old people believe, but which exists only in spirit: a sort of manifestation of general good will. But the boy did not understand that, not at all. He could not understand general manifestations. All he knew was that Allen was right. It would never be Tommy who would tell someone there is no Santa Claus. The boy was sure of that. Only Allen.

The next Christmas, he had pretended to be sick.

The boy thought about all that now. Allen pushed him impatiently, but he did not move. "I won't come unless you promise not to say anything more about my pirate suit," he said.

"All right, but at least put away that damn crepe paper. We don't have time to fool around with stuff like that."

Tommy wondered why they didn't have time, why they were in such a hurry when they had no place to go. He placed the orange streamer in his pocket carefully, wanting to keep it. The two boys marched on, walking through their silence down the street. They came to a crossing, and Tommy tripped as he stepped off the curb, his foot sliding along the grating over the end of the gutter. As he stumbled, the crepe paper dropped from his pocket, falling down among the crisp leaves, a spot of color against the murky indistinctness of the dark. Tommy wanted to return and retrieve it, but he did not wish to chance angering Allen once more. Besides, it was worthless, really. He looked at it for a moment, then went on.

The next morning, surveying the page of another day over his prune juice, the boy could not remember how they had met the man. They had been walking, just the two of them; quite suddenly the man was between them, as the boys waited for a street light to change.

"That's a nice costume, sonny. Are you going to a Hallowe'en party?" Tommy was startled, but vaguely pleased that the man should notice him, excluding Allen from the whole conversation. "Have you been playing pranks?", the man queried. Tommy was not sure what sort of answer he should make, was not sure whether or not the man wanted them to have been playing Hallowe'en games. He stole a glance at the man's face, to see whether this person would be sympathetic to such things, but he could not tell.

"That's for little kids," he hazarded. "I wouldn't do things like that."

"Well, I like your costume. You're a very nice looking boy in a pirate costume. Do you know that?"

"Costumes are for little boys, and I'm twelve years old, almost twelve and a half. My mother made me wear it. She is old and believes in a spirit of Hallowe'en." After the boy had said that, he felt ashamed and wished that he had told the truth. The man laughed.

"Besides, my costume's cheap," added the boy.

"Have you knocked on any doors and asked for treats or money? A boy with a costume like yours should do that."

"No."

"Well," said the man, and laughed again. "Come with me and you can frighten people in your beautiful pirate suit." He added the last phrase as if he thought the boy were capable of frightening people even without the costume.

"Fine," he continued, although neither of the boys had uttered a word. He reached down and took Tommy's small hand in his own. The boy was frightened then, for not even his mother's friends did that, and some of them had known him, or so his mother said, almost since the day he had been born. He tried to disengage his fingers, but the man's grip was firm, and Tommy did not dare to pull so hard that he would notice.

They walked for blocks, always away from home, always toward the grimy red tenements that Tommy had seen from his mother's car, but into which he never walked, except for once each year when his mother brought a Christmas basket to one of the poor families. The streets grew narrower; the air was quiet, reduced to unclean passivity between the bodies of these great tall red buildings from which issued no boys in costume, but only gnarled, flaccid, hungered half-tones. The man leaned over him and smiled, but there was no more conversation, just the hollow sound of halting feet, picking their careful way among the debris of the city's center. The boy slipped on an orange skin, and turned around for a moment to see its ugliness against the slick blackness of the street.

"How much farther, mister? I'm too far away from home. I've got to go home; it's almost my bedtime." He pulled at his hand, but it did not come loose. The man regarded him quietly, then closed one eye and softly laughed.

"Not much farther." Their pace slowed. The man moved from side to side of the street, always dragging Tommy with him. Allen followed a step behind. Twice, and occasionally three times in a block, the man would open a door and look inside. At those brief glimpses of other people's lives, the boy was terrified; finally he averted his eyes each time they came to a door. Tommy had never seen such houses before, had never smelled the peculiar odor of poverty which inhabits such places.

"Have you forgotten the house?" the boy asked anxiously. "We don't mind if you have forgotten the house; we'll just go home and come back some other time." That the man did not recognize the house toward which they had been walking for so many blocks bothered the boy.

"Have you forgotten the house?"

"No," the elder person replied, closing one eye again. But the wink, if such it was, was little comfort to the boys. The trio halted before another door: like all the rest, paint beginning to peel, blackened by the procession of colorless life which reeled against it every day. The man moved

obliquely across the stone door step, so that he could open the latch with his left hand without releasing the boy. The man pulled his two friends into the foyer, pausing a moment to survey the four green walls and the irregular shadows which their bodies made against the dusk of the house. He looked up the stairs, fastening his gaze on the lone light bulb above the second floor landing which served as the only illumination. It glared down on them.

The man lit a cigaret with his free hand, and placed an unfamiliar foot on the bottom step. He waited until the boy had put his foot on that step too, and then they mounted slowly, side by side, both listening to the protesting boards of the stairs. Then, almost involuntarily, with a strength he didn't know was his, Tommy wrenched his hand from the old man. But free, he did not know what he should do.

"Run," he cried. "Run." It was as if Allen must flee pell mell down the stairs before he could move. Then, in a single moment, the youths turned and jostled each other down the steps. Tommy's orange pirate trousers, as twice before that evening, betrayed him once again, catching on the bannister, and the boy went sprawling across the foyer. A jagged tear ran the length of one leg, and the boy did not notice. The bald light bulb at the top of the stairs threw the shadow of the man down on the foyer floor, down on top of the boy. Tommy jumped to his feet to escape it, but the shadow moved before him, climbed the door as if to hold him in.

Then: running over the asphalt street; feet pounding over the concrete sidewalk, making a piteously flat and tiny sound against the backdrop of the noisy tenement buildings. Behind them was the echo of pursuit; every wisp of wind was the stranger's breath. At last, they could hear him no more. But here, against the slickness of the street, a shadow would not be apparent, would not give them warning as it had before, and so they dared not stop.

Finally exhausted, the boys collapsed against the base of the street light. Back among the buildings, almost hidden in the shadows, Tommy saw the man, doubled over. He watched curiously, wondering if the strange person were in pain, or sick. He felt a kinship with this being, and forgot the terror of the minutes past and the sickly warmth of the old man's hand. Suddenly, shockingly, the headlights of a passing car paused on him. He was laughing, standing there in the shadow, bent over beneath a gale of laughter. The boy had feared him before. Now he hated him.

"Old man! Dirty sticky smelly old man! Ugly old man!"

The man had no right to laugh, no right at all. Surely he is a disgusting old man, thought the boy. Tommy had not meant to say the words out loud, but they clattered down the street. The man heard them and straightened up, not smiling any more.

"Old man! Dirty sticky smelly old man! Ugly old man!"

The second time the words were out, the distance between them did not seem so large as before. On a common impulse, the boys began to run again. It was blocks before they stopped, before the boy saw the dirt and mud which speckled the orange of his costume, the wide rip which ran from cuff to knee. He stared at it. He bent down to finger the torn cloth. It had begun to rain, at first only a few drops which sifted down around the tenements, and then a suffocating blanket of water rivering down on the streets. The boy turned up the collar of his jacket, thought a moment of the overcoat left at home; he felt his wet hair and remembered the paper hat which he wore. Very carefully, in order not to tear its wet fragility, he disengaged it from his head, folded it, and placed it in a pocket. With cold and climax, the boy was trembling: he examined his hand, the one the man had held.

Then, with exaggerated care, he allowed his pace to slow, until he was behind Allen. He edged his way around the other boy until he was on the inside, walking close to the brick walls of the houses. The steady stream of rain seemed to cleanse the brick, heightening its ruddy color, sharpening its rough and cutting face. Tommy watched it intently, moved closer until it touched his sleeve. Timidly, almost as if he had met an old friend whom he did not quite know how to greet, he extended the hand the man had grasped and ran it along the wall. He pressed harder, feeling the brick bite into his flesh. He relaxed the pressure, and a rush of pain climbed his arm.

"Do you think we should go home?"

Allen expected no answer to his question; Tommy gave him none. The boys walked silently toward the suburb where they lived. Suddenly, surprised to see the familiarity of the houses and their people, the boy realized that he was almost home. He saw the gutter where, a scant two hours earlier, he had thrown the half used roll of orange paper. Not knowing why, Tommy stopped to search among the leaves for that bright bit of color.

"There it is, down by the drain," said Allen, pointing. The boy looked at the slick paste of dreary, sodden leaves, but could not see it anywhere.

"Look, over there," his friend said impatiently. And Tommy saw it, then; saw it but kept looking for it somewhere else, for the orange color was faded, soaked with rain, sticking to the blackened leaves. He stood looking at it, not understanding why it had changed. Then, bending over, he picked it up: the wet fibers parted, and only an inch or two remained in his hand. He bent again, disentangled it all from the leaves. Finally he held it, rolled it in an awkward ball, and laid it in his pocket with the paper pirate hat.

The boys parted on the sidewalk in front of Allen's house, and Tommy watched his friend go in the door, then turned to walk the block to his own home. He began to cry: long, shuddering intervals of crying that shook his body, almost threw him off his balance. Then he began to run.

"Mother, mother, mother." The words choked in his throat. He could never tell his mother. He looked at his pirate suit, the five dollar pirate suit. And he looked at his hand.

TWO SONGS FOR J. P. McL.

I

East side west side
Bottom of the sea
Apples on a broken bough
Ripe for two or three
Tea leaves for the future
Whiskey for the past
The sailor just released from
His years before the mast

Sandy castle falling
All the fruit is picked
All the feet are crumbling
Worshippers have licked
Poseidon never calls on us
The sirens never sing
Whose song would reach to pull us up
Like turtles on the wing

II

Landscape seascape
Windy sky above
Two or three together
Waiting for a dove
Wind blows cold for purging
Waves break loud for peace
Shipwreck for the sail
Singing his release

Drownèd maidens quiver
As the sailor sinks
Anemones awaken

When the sailor drinks
Back and forth along his life
The currents pluck the strings
Up and down the turtles glide
When the sailor sings

Russell Thomas
1951

FUGUE

Allegro Maestoso

Rooms. Rooms that have for floor a flood of flowing
Water that, in, inspires in its going.
Rooms where waters, interned, inspire to devour
And thereby pack the individual hour.
A dining-room, resiliency for floor
And tall, square regularity for door.
Two bedrooms the opening of whose doors adjust
To waters with a modicum of lust.
And music room where playings, though rubato,
Sound, because of acoustic plan, staccato.
I do not ask a house, but rooms, with floors
Of waters brought and caught from out-of-doors,
And great high-vaulted ceilings that inflict
High thoughts, terror-teaching, yet constrict
You, pit a man against his time. The tombs,
The regimenting, Rubicon-like rooms.

Edgar Bogardus
1944

In the Days of Thy Youth /

HAROLD S. GULLIVER

1956

MOTHER SAT in a straight wooden chair like mine but hers must have been softer. She hardly moved, except to brush her dark hair now and then, and she kept fanning the bed with a newspaper. It was hot and my pants stuck to the chair. The man on the bed was granddaddy. I knew because of the long whitish moustache and the way his eyebrows came together. But it didn't look like granddaddy.

"Why is he so quiet?" I asked mother, but she put a finger to her lips and shushed me. All the other beds up and down the big room were empty. It was dark with all the shades down and the lights from the hall cast funny shadows. I was so tired just sitting there. I tried watching the door for a while. Sometimes a nurse tiptoed by and glanced in. Nobody was in the big room but us, mother fanning granddaddy, and grand-daddy just being quiet. I wanted to go home while it was still light, while I could still go wading.

"Mother," I said, and she tried to shush me, but I pulled at her dress. "Why do we have to stay here?"

"Be still," she said, without looking at me. Then she leaned down and tried to kiss my cheek, but I wouldn't let her. "We're going home for supper," she said. "Just a little bit longer." I saw granddaddy move his hand under the sheet, but I didn't tell mother. He started to cough and mother clicked on the light at the head of the bed. Granddaddy opened his eyes and looked at mother, but he didn't seem to see her.

"Minnie," he said, looking at mother, "Minnie." The sheet was up over his chest. He pushed it down and rolled over on one elbow. "Minnie," he called again, and mother tried to make him lie back on the bed.

"She's not here right now," mother said. I wanted granddaddy to notice me so he'd tell me stories but he kept looking at mother.

"Oh, hello Jean honey," he said to mother. Granddaddy licked his lips and pulled at one corner of his moustache. "Where's your mother?" I couldn't understand what he meant.

"She's not here," mother said, and she stood up to rearrange his pillow.

"Not here," granddaddy said and he looked confused, but he lay back on the pillow.

"Granny's in heaven," I said, and mother turned like she was going to hit me. Granddaddy didn't seem to care.

"I've been asleep," he said, "I forget sometimes." He turned his head to look at me. "Now Jimmy, don't you forget. While you're at the farm this summer, I'm going to teach you to ride." Granddaddy's voice was strange, muffled almost. It made me feel strange, like all the queer smells in the hall. I got goosebumps.

"Feel any better?" mother asked. He shook his head slowly and ran one hand through his thick white hair.

"Hip hurts me some. Doing pretty good for an old man." He went on shaking his head. "I want water," he said, and looked at mother. Mother reached for the buzzer cord looped around one metal rung at the head of the bed. Her face had a quiet tight look when we came to see granddaddy.

"You talk in the box, mother," I said. When the nurse answered, I jumped, and mother talked into the box and asked for a pitcher of water.

"I brought you the paper," mother said, and slipped it under granddaddy's hand on the sheet.

"No, I don't like to read much any more." His voice sounded more like granddaddy now. The nice nurse came, carrying a water pitcher. I liked her because she smiled at mother. The other nurse was old and wrinkled and wore glasses.

"I don't know what you dream about, Mr. Williams," she said, putting the pitcher on the table, "but you're always thirsty after your nap." Granddaddy tried to sit up and she fixed the pillow. "It's not even time to take your medicine. Sometimes I think you just try to make me work." She smiled across the bed at mother.

"He was thirsty," I said.

"Oh, I don't really mind. He's my best patient." She handed him the glass of water. Granddaddy coughed and cleared his throat.

"You're the only reason I stay in this hospital." His moustache worked

up and down when he talked. "Don't you think I ought to take her home with me, Jean?" Mother didn't smile very big but she nodded.

"She's pretty," mother said, and then she did smile, "maybe a little young for you, daddy." Granddaddy snorted and tugged at his moustache with one hand.

"Sure she's pretty," he said, "and age hasn't anything to do with it." He leaned toward me. "Know what I tell her, Jimmy. I tell her I own four farms and got no poor kinfolk. That ought to be enough for any-body." He finished his water and handed the glass back to the nurse. "Aren't you going home with me?" he asked her. She laughed, a pleasant friendly laugh.

"Oh, I might, Mr. Williams, if you keep on taking your medicine." Granddaddy snorted again. "And don't make such awful faces," she scolded. She turned to mother.

"He does have to take his medicine before supper, so don't stay too long." Granddaddy watched her walk out of the room, then leaned back and closed his eyes.

"I'm so tired Jeanie," he said, and mother put her hand on his. "I'm al-most glad . . ." he trailed off. Glad what, I thought, but didn't say any-thing.

"Preacher asked about you," mother said.

"He was in to see me last week, said he was praying for me." Grand-daddy didn't open his eyes. "I felt worse after he left. Seems like a man's religion ought to be some comfort when he's almost dead."

"Hush," mother said, "you shouldn't talk that way."

"Ben O'Brien and his wife said they were praying for me too." Grand-daddy's voice seemed barely to reach us. Mother leaned nearer the bed.

"I didn't know you'd seen the O'Briens. They're good people." Mother sat there thoughtfully. When she spoke again, it was as though she'd for-gotten anyone else was there. "They're both Catholics, I guess, but they're good people." Then sharply to granddaddy, "they didn't fill your head with a lot of nonsense, did they?" Granddaddy opened his eyes but he didn't look at mother.

"No," he said, "no, we just talked. She read the bible some. Mostly just talked." Granddaddy rolled over on his side, facing mother. "Read the bible to me, Jean." His eyes were all bright. Mother reached over my head to get the book by the bed lamp.

"What shall I read?" mother asked, already beginning to turn pages, smoothing each one carefully. Granddaddy lay back and closed his eyes.

"Anything," he said. "No, the same as last time, read me about the golden bowl." He made a noise when he breathed. Mother went on turning the pages until she found the right one.

"Remember now thy Creator in the days of thy youth," she began in a clear voice, "while the evil days come not . . ." I liked mother to read when we visited granddaddy. Her face was quiet then, but not with that breathless tight look.

". . . and the grasshopper shall be a burden, and desire shall fail: because man goeth to his long home, and the mourners go about the streets: Or ever the silver cord be loosed, or the golden bowl be broken . . ." Mother stopped reading and glanced at granddaddy.

"Why does he breathe funny, mother?"

"Be still," she said, and kept reading in a low quiet voice. I could see the clouds through a little hole in a window shade. It would be too late to go wading.

"All right," mother said, and I realized that she had stopped reading. She turned out the light by the bed.

"Good-bye granddaddy," I said, but he didn't seem to hear. His moustache touched the sheet and moved when he breathed.

The nice nurse was at the desk in the hall.

"We'll come back tonight," mother said. The nurse didn't smile now but her face was kind.

"We'll call you," she said, "you can't be here all the time." The nurse hesitated. "We'll call you right away if . . . you need to come." Mother shook her head.

"We'll be back." There were more smells in the hall than in the room. Mother stood there watching the nurse as though she were making up her mind about something.

"Thank you," mother said. I thought the nurse would smile but she didn't.

"What was he doing riding a horse?"

"Every day," mother said, "a white mare, he rode her around the farm every day. Never fell before." Granddaddy seemed so tall on his horse and sometimes he would let me ride behind him and hold on to his waist and he would ride fast so that I got scared.

"I can't imagine him falling," mother said. The nurse nodded.

"He says the horse saw a snake." The nurse smiled. "He really is my favorite patient. We talk sometimes." I wanted to ask if granddaddy told her stories. "There's one thing he keeps talking about," the nurse

wrinkled her forehead at mother, "something about a river and a church. About crossing a river."

"The Alapaha," said mother.

"The A-lap-a-haw," repeated the nurse.

"It's an Indian name," mother said. Then proudly, "His father, my grandfather, was the first white man to cross the Alapaha river."

"And the church?" asked the nurse. Mother's face was quiet and calm, like when she read the bible to granddaddy.

"My grandfather cleared his own land," mother said, "he and his wife together, and by the time other people began settling, "he had his house built, and the fields plowed. Those first few dozen people wanted a church and were too busy rooting up stumps and such, clearing their own land, to build one." Mother shrugged. "So my granddaddy had them use his house, and while they were building their own homes, he built the church." Mother trailed off at the end as though she had forgotten why she was talking. "It was the first Baptist church in South Georgia."

"Is he asleep now?" The nurse pointed down the hall. Mother nodded, without looking at granddaddy's door.

"I'll have to give him his medicine." Mother nodded again and pulled me after her toward the stairs.

"We'll come back tonight," mother said. It would be dark when we got home.

Mother kept humming to herself during supper, and she didn't notice when I only drank half my milk. The corn bread was hard and dry and flaky. I like it better a day old.

I thought maybe we weren't going back to see granddaddy, because mother cleared the table, and then went to sit in the front room, where granddaddy used to sit. I counted all the stones in the fireplace but I've done that before. Mother sat in granddaddy's big wicker rocking chair but she didn't rock back and forth any. She was reading in the bible again. I sneaked up behind and started rocking the chair.

"Jimmy," mother said, "come sit next to me." There was room in granddaddy's chair for me to sit beside her. Anyway mother says I'm too big to sit in her lap.

"Are we going back to see granddaddy?"

"I know you've been lonely," mother said, and now she rocked the big chair.

"I didn't mind seeing granddaddy," I said, and I thought about all the queer smells, but I didn't mind going with mother.

"You know why we came to live with granddaddy."

"Because Granny went to heaven," I said promptly. Mother didn't say anything for a minute.

"Because granddaddy was unhappy." Mother ran her hand over my head and let it rest on my shoulder. "But we'll go back to town soon. You'll be going to school this fall."

"Will granddaddy go to heaven?" I asked mother. I tried to keep rocking the chair by myself. She put her other arm around me. Mother's face was all warm and wet, and I hugged her neck.

The nice nurse was sitting in the hall, and when we came up the stairs, she pushed her chair away from the desk.

"Im glad you came back," she said, and I felt mother's hand squeezing my shoulder.

"What is it?" mother said. "Is he . . ."

"No, no, no," the nurse said, shaking her head. "It's just that he has some other visitors."

"Visitors?"

"The man and woman who were here this afternoon." The nurse reached for a thin black notebook on the desk and began to thumb the pages. "O'Brien. Mr. and Mrs. O'Brien," she said and closed the notebook.

"They were here again tonight?" Mother's voice was puzzled.

"The woman is still in his room." The nurse hesitated.

"Mr. O'Brien and the priest left a few minutes ago."

"Priest?" Mother turned to gaze down the hall, with that tight quiet look on her face. "What priest?"

"Young man, tall thin fellow, I don't know his name. Guess he comes from that little Catholic church outside town." Mother leaned across the desk toward the nurse.

"They brought a priest?"

"Not at first." The nurse glanced at the door to granddaddy's room. "First just the man and woman came, then after a while the man left by himself, and brought the priest back. Mr. O'Brien and the priest walked out again a few minutes ago, just a little before you came."

"I wanna see granddaddy, mother." I pulled at her hand. Mother and the nurse scared me. I wasn't sure what a priest did.

"How could . . . ," mother began quietly, without noticing me. The nurse seemed embarrassed. Mother took one quick step toward granddaddy's room. "How could they dare," she said.

"If you want, I'll ask Mrs. O'Brien to leave," suggested the nurse hesitantly, "before you go in."

"No," mother said, and we were walking along the dimly lit hall. Granddaddy's room doesn't seem as big at night, when it's mostly dark, and you can't see all the empty beds. The bed lamp was on and granddaddy was awake, at least his eyes were open and his hands held the edge of the sheet on his chest.

"Well, hello." The plump dark woman by the bed stood up and smiled when she spoke to mother. Mother walked to the foot of the bed without looking at the woman.

"Hello, granddaddy," I said. His moustache looked yellow in the light.

"How do you feel now?" mother said. Granddaddy moved his shoulders and pushed back against the pillow until he was sitting up more.

"I'm so awfully tired, Jean." He licked his lips and coughed, and he and mother kept staring at each other. I walked around the bed so I could see granddaddy close.

"You should tell her," said the woman by the bed, and she was looking at granddaddy too. I climbed on the bed and sat with my legs folded.

"Be careful, Jimmy, don't shake the bed," mother said. Her face hardly moved when she talked.

"I'll get him off the bed." The woman smiled at me and held out her hand.

"No," I said. Granddaddy put his hand on my knee.

"Jimmy's all right." His voice was strong. He took a deep breath and it wiggled his moustache. Mother had her hands on the metal rail at the foot of the bed. Nobody said anything for a long time.

"Your head shines, granddaddy," I said. I reached to touch his forehead and it was damp and my fingers felt slippery. The woman leaned across the bed and pushed my hand away.

"You mustn't," she said. She looked at granddaddy and then at mother. "Do you want me to tell her?" Granddaddy sat up some more.

"You be quiet for a minute, Mrs. O'Brien," he said. Granddaddy waved his hand at the chair and Mrs. O'Brien sat down.

"Jean honey," he said, looking at mother.

"Go on and tell me," mother said.

"You think different when you're lonely." Granddaddy's voice was muffled, like that afternoon, and he talked slowly. "Since your mother died."

"Granny went to heaven," I said. Granddaddy patted my knee.

"It's been hard, Jean," he said. "Not hurting for Minnie so much, not that. We had a good life. But just being alone." Granddaddy pulled at one end of his moustache. "You start thinking and worrying about lots of things that never bothered you before. I've never been afraid of much of anything but sometimes . . ." His voice stopped and granddaddy made a little twirling motion with one hand. ". . . sometimes you just need comforting." Mother leaned over the foot of the bed and I thought she wanted to say something but she just shook her head instead. A nurse walked by the door to the hall.

"He's joined the Church." Mrs. O'Brien stood by the bed lamp so that her shadow fell across the bed, between mother and granddaddy, but they kept looking at each other.

"He's been a member of the church all his life," mother said. Mrs. O'Brien put her hand on mother's arm. "It's for the best," and mother's face was quiet as she pushed Mrs. O'Brien's hand gently away still looking at granddaddy.

"How would mother feel if she were here? What would you tell her?"

"She's not here, Jean," granddaddy said, "try to understand."

"All right, suppose she were, would she understand?" Mother scared me. Her face was calm but her voice was funny. I'd never heard her talk to granddaddy like that.

"Maybe I wouldn't tell her anything," granddaddy said. His eyes were clear blue. "Maybe she'd understand without my telling. Or maybe it wouldn't make any difference that she didn't understand, because she'd go on loving anyway. She always did." Mother stepped back from the bed as though someone had slapped her, and half turned toward the door.

"Jean," granddaddy's voice was fierce. It was the way he used to yell when he took me riding. I would hold tight to his waist and the wind would whip around and granddaddy would make the horse jump and he would yell. Mother turned back to the bed.

"Jean," he said, very softly. "Maybe it's not even for the best, but I feel easier now." Mother nodded.

"Yes," she said, "yes."

"I want to go riding again, granddaddy," I said. He coughed and laughed at the same time, except it was more coughing.

"You're getting plenty big enough to ride by yourself, and remember what I told you, when you can ride by yourself, you'll be a man." He took a deep breath and began coughing again.

"We'd better go," said Mrs. O'Brien. Mother glanced at her and then back at the bed.

"I'm awfully tired, Jean," granddaddy said. Mother moved slowly around the bed. She adjusted the pillow and touched granddaddy's hair.

"I guess we'd better go," she said. I jumped off the bed. Mrs. O'Brien turned out the light and walked to the door in front of mother.

"Sleep good, granddaddy," I said. I looked back in the room but you couldn't see much without the light. I could see the shadows on the end of the bed, so I knew where granddaddy was.

"We'll come again in the morning," mother called into the darkness, and then she had my hand and we were walking down the hall. Mrs. O'Brien was talking with the nurse. We were almost past the desk when she stepped between mother and the stairs.

"Please wait," she said. When mother made a motion as if to go around her, she touched mother's arm.

"Don't talk to me," mother said. "You don't have to explain anything."

"No, wait," said Mrs. O'Brien, "I'm sorry, I know you aren't a Catholic, but at least," she hesitated, "whatever else you think, the Church has given him peace of mind. You heard him say so."

"Yes," mother said. I held tight to her hand but she didn't squeeze back.

"It isn't to explain that I wanted..." Mrs. O'Brien tried a hesitant smile. "It's just... you can't imagine how happy I am for your father." Her face seemed to glow with her smile. Mother pulled away.

"He worried so about your mother," said Mrs. O'Brien quickly.

"What do you mean?" asked mother, pausing. I knew that mother's mother was the same as Granny and she was in heaven.

"Well, he was afraid. . . ."

"Not of dying," mother interrupted.

"No, not of dying, not even of eternal damnation, and that should be frightening for anyone, but he was afraid ... somehow," Mrs. O'Brien shrugged, "that his life had not been good enough." Mother was breathing rapidly.

"What do you mean?" she said again.

"He was afraid of being separated from your mother, I mean, after he died."

"And you promised him he'd go to heaven." Mrs. O'Brien's eyes got big.

"No, of course not, but I'll be praying for him." We were moving toward the stairs.

"And your mother," came Mrs. O'Brien's voice and we stopped moving. "Of course she didn't belong to the Church, but she was a good woman, and we'll pray for her too." Mother jerked her hand from mine as she whirled around.

"What is it, mother," I said, because she moved so quick and I was scared. There was the sharp stinging crack when mother's open hand hit her face, and then Mrs. O'Brien's open-mouthed gaze as she lifted her own hand to touch the cheek where the angry red marks of mother's fingers were still visible.

"You had no right," mother said in a low vehement voice. "You had no right," and then we were moving quickly down the stairs, leaving the nurse and Mrs. O'Brien staring after us.

"Don't cry, mother," I said, when we got outside but I was crying too. I hated the hospital with all its queer smells. We got in the car and mother slammed her door hard.

"Won't granddaddy be with Nannie when he goes to heaven?" I was so confused and mother was still crying. I hugged her neck and dried my tears in her hair. We couldn't both cry. I remembered what granddaddy said about learning to ride by myself.

"I'll be like granddaddy, mother," I said, "and I'll ride around the farm every day." I patted mother's shoulder until she stopped sobbing.

NATIVITAS CHRISTI

This winter night
There points a rejoicing spire
To gently luminous heavens high above;
And altar candle light
Is image to the ancient holy fire
Of Love.

That fire burns low
Along the expectant pews,
Till sounds the high gloria of the bells,
Louvered by fallen snow:
"In excelsis Deo"—an evening muse
That tells

Of Roman years,
When in a more eastern gloom
A star brighter than all the sky shone
On sudden-crystalled fears,
On incense, precious metal, and grave perfume,
And One:

One who in time
Of mixed and inwoven moods
Is, with His mother, the all-timely force;
That midnight mass may chime
To the name of Him that went into the woods
And wars.

The same hard sun
That shone on Grecian heights
Illumined later towers graved for laud,
And grey-hewn stone-streams run
Up and down in many-coloured lights
Unflawed.

Now in the round
Of dark increasing power,
Stands strong the sanctuary on this night:
And God of God has crowned
This chiméd, star-held, ancient hallowed hour
Of light.

Jared Lobdell
1957

WHO WILL GO ONTO THE PRAIRIE

Who will go in night
Walking holding an orange
Mourning vase on the wooded
Gravel route where stars
Spit stinging light through
Leaves' mesh, Gods' chrystal needles,
To walk through night beyond
Trees' darknesses, by
All pillar markers, the
Orange vase to
The world's mid place,
Stars' murderous prairie.

Edward Powell
1954
Lines 256-267
Act III.

MIMNERMOS TO THE FLUTE-GIRL

But what is life? What is pleasant? sundered from gold—Aphrodite.
 May I die—when those things no longer provoke
me; the clandestine love-pacts, soft gifted palms, and couches;
 eager flowers of youth—such become women and men.
But when garrulous honors and biting misery are brought
 down this road by old age who makes men as foul as
Twisty, then evermore foul anxieties from every side wear
 down hearty appetite: eyes never joyously dance
looking at sun-sheen: hateful to youth, no respecter of women.
 Thus: so that God puts down age as idle bright pain.

Morton Lebeck
1954

Sunlight is Nightblack / SCOTT SULLIVAN

1957

THE TOWER

SUNLIGHT AS DREAMSTUFF. We three are towerhigh. Spire and pinnacle are post and pillar. The bottom of the world is grassgreen. The sky cloud empty, infanteye blue. We three are nearly tranquil, recumbent, side by side, hands folded over bellies. Eyes blink shut with sunheat. Paul is Bermuda brown; Ginny is budding green; I am white from study. Ginny beside me seems almost Greek, statue featured, nose a little pug though, eyes shut, lips tight, freckles beginning to show. Paul nearly puppydog snores. I feel half embarrassed that books and papers and telephones are not here. I look for cloud ruffles in the sky skirt.

Wind comes slyly. Ginny stirs, moving her hands on her stomach, lazy stretching them in sunlight. She yawnspeaks.

"Are there other towers we can climb?"

Me: "Sure."

"Will we climb that one sometime?" She onefinger points to Harkness. It glares back three o'clock.

"If you want."

"I do," she yawns again, for a long time on the edge of speech, "I've never been so, so quiet."

"Good. That makes me very happy."

She leans on one elbow, a too immediate odalisque, "I wonder if Paul is really asleep."

He starts up, eyes crinkling, "Why Ginny, you're black as a nigger." Flatterfaced, "Am I really?"

"Well, almost."

Paul sits up, tailorkneed, brown, a little like a Buddha. I rest head on

elbow, watching them both. Ginny upturns the corners of her mouth. I am very proud of her.

Paul, still skylooking, has an idea, "We ought to give a cocktail party up here."

Ginny: "And ask people we don't like."

Like a cartoon, I finish it, "And push them over the wall." We finish it in one voice and laugh, thinking the same things. Ginny's bare, brown-becoming hands move on the surface of her shirt.

She almost giggles, "I think we should have been three gargoyles. Then we'd never have to leave this tower. Never."

Paul objects, "Oh, we could never scare anybody. Except maybe Thorne could." He points at me. Ginny curves her neck about to look at me and make her decision.

"He couldn't scare anything but little children." She sounds disappointed.

"Besides, there's no such thing as a lady gargoyle," I submit.

"So who's a lady," Ginny funnysays.

Paul: "Ladies never sunbathe on towertops."

Her: "Only a lady can get away with it."

I fish a pipe out of my pocket. It is almost empty, all fine blackash. I light it anyway and upsidedown smoke it. I cyclone smoke at Ginny; she coughgiggles: "Stop that." Paul is asleep again. Ginny stretches her hands at her sides. We fingertouch and I cradle her hand in mine. She cups her fingers hard, making a thimblefist. I uncurl one finger at a time, always leaving four to go. She has taken Paul's hand, and he is doing the same thing.

"This is very interesting," she smilespeaks.

"You're a real student," I say.

"She's not a bad teacher," Paul says to no one.

"I can't tell which of you is better," she coquettes, "you're very different."

After a while we stop playing and lie back sunsoaking. Ginny holds hands with both of us, battery charging. It is ten minutes before Ginny bursts out laughing. "This is so curious. What would anyone say?"

Paul doesn't answer. Neither do I. I hear myself swallow.

"Liberté," she says.

"Fraternité," I say.

"That other thing," Paul mumbles.

"You can't beat the French," Ginny catpurrs.

"You can say that again," Paul says, off-coloring it.

"World traveler," I spit.

"Cosmopolitan is the word."

"So what," I roll over, angrypretending.

It is something we have said before, often, and there is no need to think into it. Sunbeat spreads through temples into brain. I stand up finally, when the pipe dies, and walk to the wall. Below is grassgreen. Two students walk along the path, talking loud. Behind them comes a bicycle, red thin flash against green grass and cherry blossom white. I turn and look at Ginny and Paul. They seem for a moment like children in a crib, innocent and thumbsucking. For a second I am very old, watching them. They have unclasped hands, and I am sure they are asleep.

"Everything is still there," I report. "But I don't think they know we're here."

"Don't tell them, please." Ginny does not open her eyes when she says it. I sit on the edge of the wall and watch the other two stretched out, my feet dangling in over the edge. Sometime after, Harkness creates half-past three, and we go. The air is already a little early spring chilly. We do not speak as we unwind down the tower steps, going heel over head, faster and faster down. Outside Paul wins the race home and is gasping happy on the couch when we stumble in.

We get glasses and bottles from the closet and set them on the coffee table.

THE BOX

Halflight as confusion. We eight are at a round table. The May dance is corrupted, at the same time perfected. The saxophone is all ooze. Bodies are bare and bright and fluid. Ginny is my princess, straight, dark, serene. More princesslike because more distant. Her hand on table-top is cool in mine. She is all alive, looking and listening, light glint in eyes, lips half apart, neck back. We hardly talk.

"What are you looking at?"

"All of it."

I think again how young she is.

"Do you like what you see?"

"I want to be part of it. But I'm afraid. They know so much more than I do."

She is seventeen and she is in love with being eighteen and knowing all the mysteries that it knows. We drink for a while. She experiments, sipping diffidently. I watch her watching things I have seen often enough before. She is little girl enchanted.

Paul comes back to the table with his date. They have been dancing. She is prettyish, but she has spent her vacation in Jamaica and, not saying anything, talks about it. Ginny crinkles her nose and looks past me at Paul.

"They're not so bad," he makes up, "the music's pretty good, especially the piano."

"You know, I heard Elgart play in Havana once," Paul's date offers, not shy.

"How was he?" Ginny asks, almost seeming interested.

"Divine, Terrific."

We sip our drinks, not talking much, most of us waiting for Paul's date to say something. I ask Ginny to dance. We pickstumble our way through the people. She dances well, elegantly, like a princess. We have done it often together and are matched to each other. People watch. Even as we dance, she is looking for something in the smokeair. From nowhere, she asks, "May I dance with Paul?"

"Sure."

"I want to understand him."

"What's to understand?" I am puzzled, and just enough unsteady.

She seems relaxed, and we dance better than we have been. Curlgray smoke is fresh and more clean. It is difficult to remember afternoon.

When we go back to the table, Paul and his date are talking alligator hunting. His little brown arm holds a spoon spear, and he tells excited how the plate gator slithers across the lake. We sit and listen. Ginny believes the story quick and worries that Paul will be killed. He lives; the alligator escapes.

I ask Foster's date to dance and, thrusting Ginny on him, I tell him I am tired of her. We all laugh and clattershove to the dance floor. Paul's date dances awkwardly, and Jamaica becomes more and more sunbathed exciting. I take her back to the table, and we talk about Hawthorne. She doesn't understand anything. Which is why I talk to her about it. Half-bare table and glasses stare me back. I roll my glass in my hand, spindle-like. For a second I wonder that Ginny and Foster are still gone. I can-

not see around the corner, but now and then I mirrorglimpse them, and see they are both talking as they dance. They look hard at each others' eyes, and, as I watch, they begin to laugh. Paul's date asks me a question about *Moby Dick*. She doesn't see what that silly ol' instructor sees in it anyway.

I say I do not understand either. That finishes it.

She laughs.

Paul and Ginny come back to the table. Perspiration glitters over Ginny's eyebrow. Music is over and conversation wells up all over the room. Paul's date asks him about *Moby Dick*. He tells her that hunting alligators is more fun than hunting whales. This makes her happy. When the music has started again and Paul has taken his date giggly to the dancefloor, I realize that Ginny has not spoken since she got back to the table. She is deeplooking into the wall opposite.

"All this?" I ask, thumbpointing.

"Uh huh," a million miles off.

"That all?"

"Nope." She touches a finger to her lip, not nailbiting or ordering silence, but pensive, like a very small, pigtaily girl. "I guess I am in love with him. You don't mind do you." And after that even, the innocent, the little girl remains, fingertouching on a pensive lip.

"I guess not." What else can I say or even think of, feeling the cold icicle drops of water touch and tingle my leg. Besides, I have almost said the same thing before. For an instant it is not hard, but natural, relieving almost.

"Oh good," she quick littlegirl brightens. She was not sure I would agree. I turn my swizzlestick slow, four sides hard between thumb and forefinger. Ginny is sunbathing towertop bright. A black curl unruly topples over forehead top. Lightly she replaces it.

"You are so kind," she sounds bewildered, "why do you put up with this, with me."

"How do I know?" I think of Paul sunbrowned, compact, grinning. Confusion comes in a whirl of my own motivations, unexplained.

They play a Charleston and we dance. I am happy, flinging myself into it. Violence is sweet now for its own sake. I am hot and sweaty tired when I return to the table. I drink a long swallow of beer, and nausea comes up hard in the back of my throat. I light a cigarette for Ginny. She smokes slowly, inhaling deep. She asks Paul if he can Charleston.

"Not very well. Not as well as Thorne."

"Oh. I just wondered."

I am uncomfortable sitting between Ginny and Paul. She and I are no longer holding hands. She is more remote than she has been in many months. We listen to Paul's date on Jamaica. I am quiet, not speaking to anyone much, rolling the swizzlestick till I think it will erode away from me.

It is growing late, and all the girls but Ginny must get back to college. Ginny is staying at a hotel in New Haven and she and Paul and I have a long drive ahead. The saxophone oozes and the piano tinkles as I help Ginny on with her coat. We leave in scraggly follow the leader.

THE AUTOMOBILE

Darkness as frightmask. We four into distance, whirling on plastic newsmelling seat covers. The world is single speeding isolation. Eyes and yellow streaks in blackness. It is colder where fewer people are. Not tower few. Night few. Music from the radio enters but does not fill the air. Ginny and I are in the back seat. She sits relaxed but away from me. I am bent not quite comfortable in a corner. When we have driven a while I touch her arm. Unrelaxing, she pulls straight and away. I watch signs and trees go by and feel myself with them. When we stop at Winston House and Paul takes his date in, Ginny speaks:

"Let's sit in front. There's a heater and it will be cold here."

"Okay."

We move. I tell myself I am fatigued. I will sleep on the trip back. Ginny arranges her raincoat over her legs. Blankeyed she watches boys and girls in twos, hand warm in hand, enter the building. Halfhidden beneath a tree, a couple kisses long and secret. I halfwatch, seeing it the thousandth time, far from Ginny for whom this is magic and glitter and jinglynew. Paul returns. We are taking one more man home. He lies down in the back seat and is snoring before we leave the college. Warmth for me comes all from him, oblivious, unscathable.

Motor mumbles angry, then purrs. Yellow beameyes blink on again. And music. Ginny scuffs her shoes off. Heat rushes up on our legs and white cold-hot prickles touch the inside of my eyelids. We go out of our way and are good as lost till we stumble over New Haven in the dark. There is a great deal of night in Connecticut.

Ginny turns to arrange herself in the seat. To sleep. Paul is straight and forward-staring in the driver's seat. Ginny nods off, her head against

his shoulder. I cannot sleep. The seat is hard against my back. I watch Ginny: she seems at rest and her lips are easy open. Paul does not move, ever. He drives straight on. My hands are restless and stiff on my thighs. Ginny seems content. We are on the tower again, we three, but I am watching from above. I am not there at all. I try, angry desperate to turn my head, to sleep anyway I can. But it is no good. I watch her calm and cool and happy in her almost sleep. For an instant, I think of pressing her neck till the warm vivid blood spurts from her throat and cakedries up. I envy her for being so sleepily immoral and content. I watch the car clock creep and listen to it ticktock and wonder how long it can be till we will be warm at home. Will we always be waiting for something more at the end of this?

From time to time Ginny lifts her head from Paul's shoulder and leans back on her seat. She is not cool exactly but quiet, phoney not knowing anything but her own sleepiness. She pretty rearranges her feet and asks if I am comfortable. I say yes, and I yawn as if she has just waked me and I am sleepy. It is a moment before she leans again on Paul's shoulder. I tell myself that she is most comfortable that way. I tell myself that I am being dishonest. I try to sleep. I tell myself to be civilized. I do not know whom to blame. I blame myself.

We have been lost for an hour when we find a sign that puts us on our way again. It will be another hour before we are home and safe in bed. I feel myself a fly on flypaper, foot crooked, poised, unconvinced that one more stickiness will make him immortal. What can I do? Ginny sits up and stretches. She looks at me, thinking hard, quizzical. I wonder if she dares do what she will do.

"Why don't you go to sleep? Here. Put your head on my lap." She is not sure whether I will accept. I wait a moment to answer, playing possum. I can hear her heavy breath. Paul's hands are knucklewhite on the wheel.

"All right," I obey.

I lay my head on her thigh, feeling the crinklestuff of her stocking underneath the cotton, her stomach warm against my neck. I am almost comfortable. I see nothing but the bluegreen stuff of her skirt. Out of the corner of my eye, a curl of black hair stands out against car top blue. Girlsmell and gasoline mix sickly sweet in my nostrils. She holds my shoulder so that I will not roll forward when the car bounces.

Fly on flypaper places the last foot down in stickiness, feeling the good ooze of the sticky stuff come up through his fly toes, because his leg is

tired, voluptuous stiff. Again I try to sleep, pressing cheek into softhard thigh.

Voices whispering fast, low. I turn a little in Ginny's lap and her hand tightens on my shoulder. Her other arm has moved and I feel her shrug shift position under me. I turn my head and one window becomes a mirror. Mirrorhazy, Ginny's head is pressed against Paul's ear, her hand loosemingled in his hair. White pain in my stomach muscles. I am limp in her lap, and I feel her hand tight on my shoulder again. My eyes press tight to shut out vision.

The responsibility to be civilized demands my respect. I cannot remain still. I watch the mirrorwindow. In a moment her hand is in his hair again. They kiss. The car lurches a little and they pull away. For a while I am not asleep but insensible, feeling the cruelty tight around my throat, gagging me. When I come to, I am sweating hard. I sit up and no one restrains me. The wrinkles of Ginny's dress are deeplined in my face. She and Paul each has a hand on the wheel. His arm is around her shoulder. She is smiling and alert. I yawn and have nothing to say, thinking of the figure asleep in the back seat, far from us, invulnerable. I darksquint at Paul. He is absorbed in the driving and does not look at me.

I want to put my hand through the windshield, and make a fist. Ginny feels my leg tense against hers. She turns and smiles, but her smile is not sure whether to be gay or apologetic or plaintive. I am proud that she is concerned about what I know. My pride is catching at tiny straws. We are almost in New Haven. It is after four and wet. Lights half glimmer in the just now dark. A camera shop is ghostempty. Our car is alone in the garage, and our feet strike loud on the pavement. Paul and I walk together to the hotel with Ginny. We say goodnight. She smiles at Paul. I turn away shoulder shrugging to the no one who sees and am gone before him. We walk back to college together, me two steps in front, because I am taller. I hold the entry door open for him. We brush our teeth and go to bed without talking. I taste the afterpart of Scotch and the bad nearsleep of the car, and never really fall off.

SUNDAY

Morning light is torture. Dawn is a crucifixion itself resurrected. If beds were tombstones, I would be a statue recumbent and unassaulted except by rain or snow, even perhaps unsexed. Sun glints across the desk and troubled bureau. Air fills the room, breath choking.

Ginny telephonejangles near ten. I am awake. She will be ready in half an hour.

I meet her an hour later. She is wearing a suit, half prim, half dowdy, hardly last night again. It is difficult to look at her directly. I have spent what night there was thinking of things to say. They are all ludicrous now in sunlight. We have breakfast in a drugstore and do not speak, avoiding each other's eyes. I drink black coffee and look past Ginny at a girl from the design school. The girl has short black hair, mannish tight against her head. She is pretty, but her lips are not seventeen full, and her eyes are cold and placid.

Ginny says something about what train she will take home and how little sleep she has had. I answer short each time. Not angry: uncommunicative. Dull. I will make her understand what it is to be cruel. She asks if anyone is awake in the room. She means Paul. I say no. She sips some water and arranges her fork. It clicks audible against a plate. I smile, and seeing, she turns away. I ask her after a while what she wants to do today. I am not quite sure how far she will push it, what she will require more. She wants to walk. We begin down Chapel Street past the Art Gallery. There is wind cold-angry in the street. Stone is greydripping down tall walls.

We walk a long way out Prospect Street, the big, brick uncomfortable buildings watching us and passing us along one to another as we go. I am sure that she is itchy uncomfortable. She asks me about fraternities and is Paul a member (the name ugly explicit for an instant). I would be happier if I could say no. I show her college Gothicked towers and tell her when they were built. Our hands never touch, and she walks clop-footed on hard pavement. Her hair is not quite straight.

I take her to lunch in Pierson. We eat with Dave and Bob and Tony, knowing for the first time that Paul is not here with us and will not be for a while. Ginny becomes demure at table. She is quiet, just answering Dave's questions when he asks where she goes to school. She seems to me sharpangle apart from the dark wood table. I talk to Bob about tennis.

After lunch we go up to their room. It is warmer there for me than anything since yesterday towertop. I sit featherdowndeep in an armchair, and there is nonmusic on the victrola. Ginny sits ankles crossed, eyes alert watching everywhere. She is easier there than at lunch, and she talks to Bob, almost flirting. Dave and I talk well about Art; after a while Tony interrupts. He is tall and turkeyshape, rednecked. Artificial armgestures

sweeping the air like windmills. He is stretched one legged on the couch, strutting because Ginny is there. He speaks:

"I think the creator—the real artist—can paint a picture just two seconds after he's experienced the subject. Anybody can. All art is self-expression."

Me: "Art depends on deeply learned techniques. Conversation is an art, and you, Tony, might do well to develop it."

It is minutes before he answers. He is all confusion and crossed turkey-legs. I sit deep in my chair looking at him over the cat's cradle of my fingers. The others are amused by his confusion. They all laugh. Ginny catches my eye and silent admonishes me to leave him alone. I feel the cruelty run warm in me and smile back hard, on the edge of grinning. I think she must have made the same face inside last night. I am stomach-happy like tomato juice. And I cannot stop.

At last he answers, "We're all speaking from ignorance, aren't we?"

And me, quick back, relishing it, "That's your own assessment of the situation, Tony."

"I mean none of us are creative artists though."

"Really? Besides what I said about conversation . . ."

He interrupts angry and foolish: "I think your poetry stinks."

I feel very good. I have drawn blood, and without reason. I laugh barely and then answer him, "In the first place, your disliking my verse is hardly relevant to the fact that I did create it. I am not really convinced that your taste is relevant to anything. But, anyway . . ." I am playing to a gallery. They cannot help pay their respect, much as they sympathize with Tony. I can almost measure the exquisiteness of Tony's embarrassment as the red mounts brighter and brighter toward his hair-line. He makes no reply; Dave and Bob and I talk about other things.

Later Ginny must check out of her hotel. Then we go back to my room. Bob comes along. He is diffident about making three. Desperate, hoping that he will come and break the aloneness, we both urge him to come with us. As soon as we arrive I make a gin and water and scotch for Bob; Ginny sits harrowed and silent on the couch with some bad sherry. She has hoped that Paul would be here. She stares into his bed-room for an instant, almost slipsliding out of control. She senses that I am watching her. The moment becomes rather pleasant. My gin is cold and slickharsh in my throat. Bob talks about going West this summer. Ginny asks too many questions.

Paul returns just as she is about to leave. They do not have time to see

each other alone. I hear myself saying under my breath how clever I am. She says goodby and looks a long minute at Paul, trying to imprint everything in a moment. She touches her fingers to the side of her nose, a parody of Santa Claus: "Remember now."

I carry her bag and we drive to the station. We expect to be late, but the train has robbed our prerogative. We must wait a long quarter hour. We sit on a bench, she smoking. I watch her masculine, Greek profile in a blackbacked window opposite, wondering how it could be that I know it so well. How much she wants to find something new. I wonder, watching her smoke, if she has found anything this time. I remember her questions, and they come swimming from a fold in the back of my head, all mixed in with the smoke, and the waiting for trains and this day: what is it like to be nineteen? Do you mind what I do? Why do you let me say this?

Each second now she is on the edge of speech. I do not encourage her, and she remains silent, smoking three cigarettes in order. When the train comes, we dreamwalk apart. Double dreams. Double compartments. Two single cells please.

I put her on the train. Elaborately she seats herself and places a book questionmark shut on her lap.

I smile slowly, meaning it. Heart pounding, I try to say nothing: "Goodby hotshot. Let me know how it comes out."

She, wan, "Goodby. Thanks."

I turn and leave awkward knocking into passengers, feeling the air come fresh outside.

I decide to walk back to college, leaving the car. It is raining now and cold wet streets are a comfort to me. I kick stones all the way, walking slow, not really wanting to get back. I discover that there is nowhere I really want to go.

At dinner I tell Paul I want to get blind slobbering drunk. I invite him to join me. He accepts.

ALL FOR LOVE

Here, where mounting blooms of clouds eclipsed,
In part, the terror of the day, and groomed
Distant edges of the sea, and seagulls tilted
Sideways, gliding through the air, spanning
Unseen crevices of light with enormous wings,
And death carved patterns of itself in random
Shells and twigs like a builder of remains;
Here, where the earth turns fullest, and rhythms
Of the sea beat the mind to silence; where
The dawning sun rises higher than the wind;
In this place where night had come more like
A comforter to calm the day, than conqueror—
Here, hugely grouped in attitudes of rest,
Were the fat ladies. Their silence took the form
Of noiseless stones awaiting anxiously
The storm or final breaking of the sea.
And all the rounded pink of flesh, from dimpled
Knuckles to the molten folds that fall beneath
Their breasts, quivered slightly at a crackling fear
That pricked their insides in the name of God
And all things right, trying to prevent the burning
Entrance of their dreams so loaded with the flavor,
Sight, and smell of love the weight of all
Their flesh demands, so outrageously alive
That wakefulness becomes another form of death.
 Oh heavy ladies
Who spend your summer nights in the coolest reaches
Of the season, listen: As the complicated
Ocean floor obeys the heavy plotting
Of the careful sea, your dreams obey the passions
Born of too much flesh. If the gentleman

Betrays his skinny wife to be your dream's
Divinity till morning, reap him as you would
The harvest of your flesh, and trust in God
To see that all your weighted love is heavenborne.

Mark Strand
1959

THOUGH YOU WERE BEAUTIFUL

Though you were beautiful the day you left,
 I was more my real self bereft
 Of you, and what is best, admired
 What I became, not what expired
 Because you left.

If it is true that what we love the most
 Becomes more valuable once lost,
 I suffered loss in having you
 So close. It is myself, not you,
 I love the most.

Your absence is a mirror in which I see
 Love's object magnified—the me
 In me. And so it goes. The day
 You left you learned the proper way
 To humor me.

Mark Strand
1960

Mine Eyes Poureth Out Tears / LESLIE EPSTEIN

1959

A PLAY IN ONE ACT

BASED ON DOSTOIEVSKI'S *Notes from the Underground.*

Scene I

The place: St. Petersburg, Russia. The time: just before the turn of the century. Curtain up on a large, somber room of a shabby apartment, five flights up and no elevator. Among other things, it contains a bookcase whose contents overflow onto the floor, a large couch (fat and dumpy), a couple of chairs and tables. The walls are bare and bleak, except for a mirror over the couch. A black curtain hangs over one of the three doorways and there is but one window.

In a chair, stage right: APOLLON, PETER'S *servant, is reading. He is dressed in a tuxedo. Except for the last line of the play, he speaks with a strong lisp.*

APOLLON. . . . the thound of a trumpet.

Thing praithes to God, thing praithes; thing praithes unto our King, thing praithes.

For God is the King of all the earth: Thing ye praithes with understanding.

God reigneth over the heathen: God thiteth upon—*(A kick on the outside of the door interrupts him) (This is followed by another kick and* PETER'S *cry of,* "Hey, hey Apollon! Open up!) *(Upon recognizing the voice, Apollon goes back to his text and reads out,* "The Throne." *But the kicking resumes so loudly that he must go to the door and open it. Peter enters, carrying books in his arms. He goes to table and sets them down).*

PETER: Wow! It's freezing out there. The snow's so wet, it feels like fish swimming down your back. *(takes off coat, turns to pile on table)*

Help me with these books, Apollon. We'll have to make room for them somehow.

APOLLON: Tho, you've bought *more* bookth!

PETER: Yes, of course, why? *(Apollon shrugs)*
Well, come on. Any reason why I shouldn't have? *(As Apollon doesn't reply, Peter takes a handful to a cabinet.)*
Couldn't live without them, you know.

APOLLON: Yeth, *I* know.

PETER: They're a sort of life-raft, floating on top of life, a dry . . .*(Apollon has gone back to his Bible)*
You're not listening!
Can't you pay attention when someone is speaking to you?
Well what the devil *are* you doing anyhow? *(circles round Apollon, who goes on reading, his lips moving)*
What's this? The Bible?
Apollon, you're not doing those silly readings again, are you?

APOLLON: I am.

PETER: But I thought you gave that up long ago.
Funeral readings, ugh. *(Apollon sighs impatiently)*
What on earth do you do it for? I thought you hated it. All that wailing and wax. And everything black, the clothes, the faces.

APOLLON: I don't mind it. I even like seeing all those heads bent down when I read, like trampled flowers.
Besides, there ith quite a bit of money in these lower clath funeralth. They love their dead tho.

PETER: Oh, yeah, the money . . .

APOLLON: It makes up a little for what you owe me in wages.

PETER: Well, about last week's wages. I've been meaning to pay you, but I didn't get the raise with the others—

APOLLON: Tho you thpent what you had in books. Books!

PETER: Now listen here, don't tell me what to do. I'll pay you when you deserve it.

APOLLON: I'll be paid every kopek when I say.

PETER: Oh, will you? Will you? Look at the mess in this room. And your cooking isn't fit for the dead you read over.

APOLLON: Then don't eat my cooking. Tonight's meal ith the last you'll have until I get my ten rubles. You go hungry till then, thir.

PETER: *(laughing)* You're giving *me* an ultimatum! And I picked you out of the gutter, gave you this position.
Why your debt to me is more than I could ever owe you! If there's anything I can't stand, it's ingratitude. Even a worm says a little prayer when it rains. But you—*(Apollon is reading his Bible again. Peter snatches it from his hand, is about to speak, but realizes it's hopeless. Exasperated, he turns to one of his new books, sits down on the couch and starts reading.)*
Oh, what's the use. Just clean up the place a little, will you? *(There is silence as Peter reads. Then Apollon starts humming.)*

APOLLON: "Holy, Holy, Holy . . ." *(Peter looks up sharply and decides to make it a fight. He attacks his book with determination)*
"Lord God almighty, dum, dum, dum, da da da dee dum dum dum da da dee" *(Peter turns page violently, pause)*
"A mighty fortreth is out God, tra la la la la la-a-ha hum!"

PETER: Apollon . . .

APOLLON: "And armed with cruel hate . . ."

PETER: May I have my dinner?

APOLLON: Dinner, thir?

PETER: Yes. I'm hungry.

APOLLON: "On earth is not his equal!"

PETER: *(jumping up and rushing menacingly to Apollon in his chair)* Now look!

APOLLON: What would you like?

PETER: Huh? What?

APOLLON: What would you like for dinner?

PETER: Oh, well. Let's see. How about some, um, lamb. Lamb chops.

APOLLON: We have no chopth.

PETER: Cutlets, then.

APOLLON: No cutleth.

PETER: I have it! Roast rack of lamb!

APOLLON: No roast rack of lamb.

PETER: Steak? Fish? Pot-roast?

APOLLON: No.

PETER: Well, what have we, then?

APOLLON: Whatever you like, thir!

PETER: Oh, idiot! Wait a minute. We have chicken. I know we have chicken.

APOLLON: Yeth, we have thom . . .

PETER: All right, that's fine with me.

APOLLON: *(walking toward other room)*
But it takes too long to make. *(He goes out and reenters with a plate, which he sets on the table in front of Peter.)*

PETER: Don't give me trouble, I know what you're trying to do and you won't get away with—
What's this?

APOLLON: Thpagetti.

PETER: *(childishly stamping foot)* Well, take it out! Take it out. I want chicken. Do you think you can impose on me, that my wishes count for nothing?

APOLLON: *(putting on overcoat)* Mathter Peter, you must eat thpagetti. I'm going out now. Until I'm paid, I am no longer in thirvith. Please leave the lights on for me.

PETER: Who says you can just walk out like this?

APOLLON: Good-night, thir.

PETER: *(jumping up)* No, wait. Wait, Apollon, please. I'll eat the spaghetti, just wait a moment.

APOLLON: What for?

PETER: Tomorrow's Wednesday.

APOLLON: So?

PETER: It's Lieutenant Povimov's day to walk down our block and—

APOLLON: No, I'm not in thervith. I'm through rehearthing your foolith schemes. You must learn to behave like a gentleman, like the lieutenant, like a man.

PETER: Listen, Apollon. This will be the last time. I'm sure to get it right now. It will just take a minute.

APOLLON: I mutht go, I'm late.

PETER: You'll have time for this. Why are you in such a hurry? Where are you going?

APOLLON: You wouldn't be interested.

PETER: But I am. I should have a say, and maybe I could go too.

APOLLON: It's none of your business.

PETER: What do you mean? I have a right to know where my servant is. Where can you go that I can't?

APOLLON: You wouldn't *want* to go. You *couldn't* go. It's for men only.

PETER: I thought so. You're going to Annie's again.

APOLLON: That's right.

PETER: And that's why you want your money so badly. So you can wallow it in that place. Well you certainly won't get it for that. (*He turns his back on Apollon, who laughs.*)
You *know* how I feel about those places. I disapprove of them. (*Apollon laughs.*) The human race must—

APOLLON: Ha, ha, ha!

PETER: (*whirls and grabs Apollon*) Stop laughing! Haven't you any shame?

APOLLON: (*Becomes very serious in a different way than we have seen him. We have a flash of a different man.*) Lithen, little man, tho that you'll know. It doeth not matter where you are, or whom you are with, or how you do it—when you have a woman, you must pay for her.

(Peter releases Apollon and steps back.) Though I doubt you'll ever need the information.

PETER: *(lowly)* Then you're going now? *(Apollon starts to open the door.)* Apollon, I demand, I . . .

Won't you help me, please?

APOLLON: Help you?

PETER: Be Lieutenant Povimov one more time? I'll pay you tomorrow, I promise.

APOLLON: *(long pause)* All right. For the latht time.
(Peter pulls Apollon to one end of the room.)

PETER: Great! It'll work this time. I've got a new plan. For once, for the first time in his proud life, the great Lieutenant Povimov will have to step aside for some one . . . for me! *(He takes Apollon and stands him up against the wall opposite the door. He takes off his formal hat and takes from somewhere a military cap which he places on the servant's head.)*
Now, you know what to do? It's Wednesday afternoon. Three o'clock. The Sun is shining; you're out for your weekly stroll in the snow, rather your march, eh? *(Peter is mimicking the lieutenant as he speaks, throwing out his chest, swinging his arms, stamping his feet.)*
Stomp, stomp, stomp! Along you go in a straight line, eyes fixed. You see nothing, you pay no attention to anyone. You sail through the crowd like a ship through the sea. You leave a whole wake of people scattered behind you. You never change course, never step aside. *They* must give way—ha! ha! Until you come to *me*!
Okay, ready? Let's do it!
Wait a minute. *(He rushes across room, squares Apollon's shoulders, pulls the cap more doggedly over his eyes.)*
The trouble before has been that I've always tried to make him aware of me first. So that he'd see how determined I was, so that he'd step aside when he came to me. That way's no good. He never looks up. All these weeks and he still doesn't know I'm alive. No! The thing to do is walk right into him. Show him your power.
Ready, Apollon Povimov?

APOLLON: Yeth, thir.

PETER: Let's go! *(They are at opposite ends of the room, eyeing each other. At Peter's command, Apollon starts forward.)*

PETER: No, no, no! You've got to really march, Apollon! Start again. *(Apollon starts slowly across the room, moving his feet in time, swinging his arms. Peter tries to move toward him, but somehow cannot move his feet. Apollon moves faster and faster; Peter clutches his legs, trying to move them forward. The lights have dimmed, so that a single beam covers the diagonal track across the stage. At the last moment Apollon stops, directly in front of the struggling Peter.)*

APOLLON: You *still* cannot do it. You can't be a man.

PETER: I *can.* Do it again. *(Apollon stands there.)* I said, do it again! *(Peter gives Apollon a hard shove, and he retakes his position. They go through it again. This time the emphasis is on sound. Apollon starts very slowly forward, almost marking time. As he moves forward, he increases his pace and stamps more heavily on the stage floor. Peter moves bravely forward from his corner. The two advance towards each other, closer and closer, faster and faster, louder and louder. By the time they meet, stage center, Peter, in desperation, has thrown his hands over his ears, and he has closed his eyes. Off balance, he is struck headon by Apollon and thrown to the ground. Apollon keeps right on walking to the door. There, he turns around, and lightly throws the military cap to the floor next to Peter and walks out. Peter remains on the floor, breathing heavily. Slowly he pulls the cap over and looks at it. More slowly still, he rises and crosses to table with book. He opens it, then snaps it shut. Then goes to mirror, looks in, puts on cap, looks in again, and quickly removes cap, looks in again. Then moves to window, throws it open. On way to door he picks up candles and blows them out, one by one. It has gotten quite dark out.)*

PETER: *(at door)* All right, little man.
Exit. Curtain.

Scene II

Same night, later.
A room at Annie's.
A curtain is not necessary, but if used, it will rise on complete darkness.

A match is struck. Peter is lighting a candle. Vaguely we see, or are aware of, a tiny room, a bed.

LISA: Light.

PETER: Oh. Here, sorry. *(He holds candle out to her and she lights cig., staring at him, or perhaps beyond him. He looks intently at her.)*

LISA: You'll burn my hair. *(P. puts candle on a small table, long pause.)*

PETER: Ah, you don't know the time, do you?

LISA: It's late.

PETER: Probably stopped snowing then.

LISA: Was it snowing?

PETER: Not really. Slushing. Half and half. *(a pause, which grows)* Why do you keep staring at me?

LISA: I'm not.

PETER: Oh. *(pause)* Well, um, what's your name.

LISA: What?

PETER: Your name?

LISA: Lisa. *(pause)*

PETER: Were you born here?

LISA: No.

PETER: Where?

LISA: Rostov, I think.

PETER: You *think?*

LISA:*(crushing cigarette)* Rostov, Rostov-on-Don.

PETER: Oh. . . . You've been here long?

LISA: Where?

PETER: In the city.

LISA: Oh, years.

PETER: And, um, in the house, here, at Annie's?

LISA: Not long.

PETER: How old are you?

LISA: Twenty.

PETER: Your family?

LISA: What about them?

PETER: They're alive?

LISA: They're alive.

PETER: Then you live with them?

LISA: No.

PETER: Why did you leave them? *(no response)* I said—

LISA: Oh . . .

PETER: I'm sorry. I'm bothering you.

LISA: You don't bother me.

PETER: I mean all these questions. I have no right to ask them, but—
well, I come—I come around Annie's sometimes—I've been away
on business—and I, I, like to, to know some of the girls. I mean,
who they are and—
Oh, don't think I come here all the time. I am quite well known in
town. I'm young, but I have an important position—in business;
I'm in business.
But every now and then—like after I've been travelling, like I've
been—well a man needs, needs—um—a woman, and besides it's
different with a man. He comes and goes, he's not enslaved like a
woman. That's the real evil behind all this. You're slaves. You've no
money, no family, no friends, no love, no-um-soul. But with a man
—oh, sorry—*(He quickly holds candle up to Lisa's new cigarette.)*

LISA: Thanks.

PETER: You have blond hair.

LISA: Yes.

PETER: You're shivering, too.

LISA: No.

PETER: *(looking around)* But there's no window. . . . Listen, why don't you—um, well, wouldn't you be more comfortable if you put on my coat? *(absolutely no response, pause)*

Oh, then perhaps I'd better leave? I mean, am I supposed—do you want me to leave? *(Pause. He begins to put on his jacket. Now he is tying shoe.)* It's just that I felt sorry, that's all.

LISA: What about?

PETER: For you.

LISA: What for?

PETER: For your life, for living here. *(pause)* For your shivering; your blond hair.

LISA: Well—don't bother.

PETER: *(with some of his anger and old petulance)* No, I see I needn't have. I don't usually, but you seemed so especially unhappy.

LISA: *(snapping)* Who's unhappy?

PETER: Good Lord! Do you think you're happy here?

LISA: I don't think anything.

PETER: You don't realize the evil of this place? You really don't? You don't notice the smell that rises from every board, that coagulates on the walls, that's slowly snuffing this little candle?

LISA: If I do, if I don't. Is that what makes me unhappy? Anyhow, who are you? I don't see you holding *your* nose.

PETER: I told you, with a man, it's different. The difference between freedom and slavery, good and evil, being able to throw open a window or having to hold your breath.

LISA: I see. I'm evil because I'm strangling.

PETER: Oh, I'm not blaming you. You've obviously been forced into this. A girl like you wouldn't be here unless she had to, I can see that.

LISA: *(very low)* What kind of girl am I?

PETER: *(bending toward her)* I heard you, Lisa. I haven't got an answer, though.

LISA: You weren't supposed to.

PETER: *(his sermon beginning to form)* If you had asked, what kind of girl am I to become!

LISA: All right!

PETER: What's the matter?

LISA: All—Right!!

PETER: I understand.

LISA: Good.

PETER: Too bad . . .

LISA: Well don't feel too badly, I don't.

PETER: No, No. I mean "too bad" about myself. I just realized that I'm sorry for myself.

LISA: I thought it was so different for you. Free as a breeze, happy as a lark, with *such* fresh air blowing through your hair.

PETER: That's true. All true. I don't regret any sins, I'm as free as ever. It's just that I realized I've lost something. That I won't find what I was looking for.

LISA: *(interested)* What's that?

PETER: I'm not sure. You probably know better than I. Like one moment ago, here you and I were making love to each other, side by side, face to face. Yet we didn't say a word. I wanted to say something, to touch you—oh, not like that, but to *touch* you. I didn't and, well, I lost something. *(long pause)*
I, I don't suppose you felt anything like that?

LISA: No. It wasn't just you, I never have.

PETER: Even after, when you stared at me like that?

LISA: I wasn't staring! I wasn't even looking. . . . And what is this? It's getting late. Why don't you exercise your great freedom and—

PETER: You're right! I have a busy day tomorrow. We're going over a large list of appointments and I'll need some sleep. If I don't get home in time to tell my man to wake me, I'll—

LISA: Your man?

PETER: Yes, Apollon, my servant . . .

You know, you *were* staring.

That's why I asked you this, I thought you knew, that you were trying to find with your eyes, were asking me—Is this how two human beings love, like two wild animals, struck dumb with terror and rage at not knowing, not feeling, only being pushed, and pushed, and pushed, blindly driven into—

LISA: All right, cut it, preacher! This isn't a zoo!

PETER: *(now the zealot)* Isn't it? Can you go out? Oh, yes, they let you lie out in the sun—

LISA:—I'm not an animal!—

PETER:—Because they know that as soon as it gets dark you'll come back, because you're hungry, because you're sick, because you're afraid. You're not even spared the crowds, are you? *(Lisa, furious, tries to slap him. He catches her hand and throws her down, hard.)* I hear they let you have lovers here. How do you work it? Between hours? Is that right, Lisa? Have you a lover? Ha! It fascinates me. It really does. How can you tell the difference? Do you speak to each other, is that it? What does he say—*(Peter falls to his knees, doing a grotesque burlesque of the words.)*

I love you, Lisa, Lisa my darling, my one, my only. Ho! That's good, that's really good! Ha, Ha, Ha! . . . Except you're not fooling him, Lisa; he's stretching you apart and you're too frightened to scream, too helpless even to realize you're in pain.

LISA: *(quietly, mechanically, to no one but herself and yet not really to herself)* I have no lover . . .

PETER: *(doesn't hear her)* And you know how it'll end? Soon you won't be so pretty—oh, you'd be amazed at how soon that happens. Your price will drop. Then he'll leave you and so will the next one and the time after that there won't be any one. And then you'll *take* a coat when it's offered to you, only it won't be offered because by then your guests will have stopped caring and looking and will be more interested in keeping themselves warm or in getting out as quickly as they can and taking a deep breath. And then, Annie will be very sorry, very sorry to let you go, but business is business after all, and

maybe if you come around next year things may have picked up, but for now it's goodbye, Lisa! Goodbye! See you around . . .

And you'll go to your old lover; only now things have changed and now he's married or won't be married or hasn't any room to be married, and, besides, all that was months ago and—

LISA: *(louder, more determined)* I haven't got a lover . . .

PETER: And then you're on your own or you go to another place, not so nice as this and the next one even worse than that, and you're twenty-two only you look thirty-five and feel like fifty. And in the end you'll tramp in the snow at the market, too cold to cry. And there you'll sit, frozen, not knowing a thing but the beating of your heart. . . . Like, like the girl I saw there last week, early in the morning, sitting on the steps, her face made up with little patches of red, only her mouth was blue and bruised and both her eyes were blackened and one was swollen shut. And she sat there, holding a fish, a salted fish, in her hand, and she was beating, striking the head of the fish against the side of the step over and over as hard as she could, and all the while screaming, screaming at the top of her lungs . . . *(his voice drops lower again)* And it won't be long after that, Lisa, when the cold will enter your lungs and spread through you. Then, between the night and the morning, you'll sit up in whatever hovel you sleep in, because you've just heard your heart stop. There'll be one instant of terror. . . . And then they'll joke and laugh and your friends will be there, maybe Annie, some of your old guests, perhaps even one of your lovers; and then, afterwards, they'll drift off, some one way, some another. A few will go to a bar together, take off their coats, sit down, order their drinks—and not even talk about you. *That's* the tribute *you'll* get: a dumb, brown, ugly wreath of *silence!*

LISA: *(hysterically)* No! I don't have a lover! I don't have a lover!

PETER: *(grabbing her shoulders)* Lisa, I could be your lover! *(she is shuddering, trying to cover her head)* Lisa, are you listening? Lisa, it's not too late. *(puts something in her hand)* Here's my address. Will you come to see me? Lisa!

LISA: What?

PETER: I—

LISA: *(mechanically, not to Peter)* Oh, no. Oh, no.

PETER: Wait. You mustn't misunderstand. I meant, I *might* have been your lover. It was a manner of speaking. Words. Tenses. What I meant was that I *might* have fallen in love with you, you seemed so beautiful in the candlelight.

LISA: So beautiful?

PETER: But of course it's impossible. In a manner of speaking, I felt as if I could have married you. It was a picture, that's all. The church, you in a veil, rice, flowers, and off we'd go in a pretty little carriage. But it's a picture, pure nonsense. In my position, honor means quite a bit. You do understand? You see what I meant?

LISA: I think so. Yes, that's what you meant by "too bad."

PETER: Too bad?

LISA: Forget it. *(Sees what's in her hand)* What's this?

PETER: *(from door)* Oh, my address. You seemed so shaken I thought you needed—

LISA: I'm all right. *(Crumples it)*

PETER: Of course, I can see that.
I just thought, if you needed any help. Well, you know, I know a lot of people in town and maybe they could help. Some of them are pretty important and there's no reason why they should know that. . . . It's not too late, Lisa. I can help pull you out of this. *(long pause)*

LISA: All right.

LISA AND PETER: *(in unison)* I'll need money. Then you'll come up?

LISA: Yes.

PETER: Tomorrow? At four?

LISA: Yes.

PETER: I—well, thank you.

LISA: Okay.

PETER: I'll see you then.

LISA: Yes, Goodbye.

PETER: *(turning in doorway)* Oh, my name is Peter.

LISA: All right. Goodbye, Peter.

PETER: Goodbye, Lisa.
> *(He goes, she uncrumples paper and looks at it, spreads it out flat. Then, wrapping herself in a quilt, she walks over to mirror and looks in, walks back to candle, picks it up and carries it back to mirror. There, in the candlelight, she looks at herself.)*

<div align="center">Curtain</div>

<div align="center">Scene III</div>

Peter's Apartment

Between three and four in the afternoon.

> *(The place looks just as it did when Peter ran out. Only now the afternoon sun is streaming through the windows preparatory to setting. And there is a fragile bunch of red flowers on the table that wasn't there before.)*
> *(At Curtain: Peter is asleep on the couch, wearing an undershirt and shorts.*
> *Apollon enters through the curtains wearing his formal attire. He walks as ever, in the midst of the Pomp and Circumstance March. He carries before him—as if he were presenting arms—a D.D.T. can. He periodically gives it a little squeeze. After squirting each corner of the room, he begins a careful pattern breaking it only long enough to give the flowers a large burst. Peter has begun to cough in his sleep. Apollon goes on squirting. Peter coughs himself awake, sits up . . .)*

PETER: Hey! What the—Stop it! Apollon, stop it! In the name of—
> *(Coughing, he starts to get up and grab Apollon but he trips over a wine bottle.)*
> What's this?
> Look at this. Just *(cough, cough)* look at it. *(puts on pants)*
> Why isn't it cleared up, I— Give me that thing! *(Coughing he grabs the spray gun out of A.'s hand, throws open window and, still sput-*

*tering, heaves it out. During the following, Apollon pays absolutely
no attention to Peter. Instead he walks slowly to window and looks
down after the sprayer, then goes about his business.)*
Now look, Apollon, let's stop this nonsense. This room should have
been cleaned up after I went out last night.
Do you hear me? Apollon!
Now listen here . . . Oh, my God, look at the time!
Why didn't you wake me? *(He pulls Apollon to the curtains to
which a note is pinned.)*
Read that . . .
You're not blind as well as deaf and dumb, are you?
"Apollon, wake me at 1:30. Very important."
See? "1:30" not 3:30, and "wake me," not asphyxiate me.

APOLLON: I can read with competence.

PETER: Then don't try to tell me you didn't see it.

APOLLON: I thaw it.

PETER: This is too much! You saw it and you still didn't wake me?
(no answer, Apollon walks away) Answer me, God damn you! You're
paid to do what I tell you.

APOLLON: Really? I wath under the imprethon that lath week's wages
were—

PETER: *(anticipating this, reaching in pockets)* See this? Look, twenty
rubles. Double what I owe you. But you won't have kopeks until you
ask me for it decently. I won't have you behaving this way. When
you remember that you're my servant, that I support you—

APOLLON: *(moving away)* If you support me, you mutht be my thervant.

PETER: This is absurd! *(slams money on table top.)* Because I owe ten
miserable rubles.

APOLLON: *(not even looking around)* Eleven theventy-five. That wath my
thpray can.

PETER: All right, the money's there. But if you touch so much as a penny
of it, I'll have the police on you.

APOLLON: You won't get rid of me as eathily as that.

PETER: Just remember, one kopek. Now help me with these dishes. Come on, I'm expecting someone soon. *(Apollon takes out sewing, sits in chair. Peter has turned to the table and starts to pick up dishes. Catches sight of flowers, puts down dishes, picks up flowers, smells them, breaks out coughing.)*

Oh, you idiot, what have you done? *(He drops flowers all over the floor as he grabs Apollon by the collar and pulls him to his feet. At this point there is a slight knock at the door, repeated. Then Lisa comes in, looking bewildered but not at all frightened. Peter doesn't hear or see. Goes on shaking A.)*

APOLLON: Let me go, let me go! You'll find out I can—*(gasp)* call the police ath quickly ath you. Let go!

PETER: Ask me decently. Say you're sorry. *(Apollon gurgles. Peter throws him back into chair, turns back to table and begins picking up dishes.)*

I haven't time to even—*(sees Lisa, straightens up)*

LISA: Hello, Peter.

PETER: Lisa! You're early, I, I, . . . *(He starts putting plates back on table one by one, faster and faster.)*

You'll have to excuse me *(running between curtains)*

Please . . . excuse me. *(Lisa stands there. A. goes on sewing. L. comes up to chair.)*

LISA: Hello. *(Appollon slowly looks at her, up and down)*

I was supposed to come. Here, to Peter's. I'm a little early, it wasn't as far as I thought it would be.

APOLLON: I'll anounth you. *(L. goes back toward center of room, A. steps to curtains.)*

A young lady to see you, . . . thir! *(Peter appears. He takes his shirt from a chair and buttons it as he approaches L. He speaks sharply.)*

PETER: So now you know.

LISA: Know what?

PETER: That I'm poor. That I'm not rich, like I said I was.

LISA: Did you say you were rich?

PETER: Yes, yes I did. All those important people. Well, my boss is the

secretary to the assistant of an underdepartment man who looks after secondary affairs.

LISA: And is he as important as all that?

PETER: Oh, even more than that. He occupies a very crucial position—midway between the water-cooler and the men's room. As a matter of fact, he's making a study. How long would you say it took for—

LISA: I understand, now. You needn't make fun of me.

PETER: I'm not making fun of you. It's just that I don't—that I'm not proud of this poverty.

LISA: As soon as I looked at your address, I knew you weren't rich. You were right last night, I do need money. You saw through me. So easily. At first that worried me, because I thought I'd hidden myself. Then I thought, maybe it's not so bad. If he really saw me that way he . . . Anyway, after you left I looked at myself. I tried to see what you did. But I couldn't get beyond my eyes. Oh, I *did* notice they were blue, but I couldn't go deeper, I couldn't. So I stared at my reflection until the candle went out. And now, I'm here.

PETER: *(very nervously, very aware of Apollon on couch)* I, um . . . This morning, on the way back, I got you some flowers. *(He bends and tries to pick up a few, but he's too nervous. He ends up with one, which he hands to her.)* Here. I think it's a gardenia.

LISA: *(very softly)* It is. *(long pause, during which Peter looks at Apollon)*

PETER: Um, how about some tea? I'll have my man bring some tea.

LISA: Oh, don't—*(Peter jumps up and crosses room to where Apollon is sitting sewing. He whispers to him, but Apollon refuses to stand and goes on stitching. Peter is forced to kneel by the side of the chair.)*

PETER: *(whispering)* Apollon, please, bring us some tea. *(no response)* Please. You've got to help me now. *(no response, pause. Peter gets up goes to table, picks up part of the money and comes back.)* Here, here's what I owe you. *(Apollon takes it, counts it, doesn't reply.)* And, and I'm sorry. I'm sorry for the way I . . . Please forgive me for —the way—I—behaved. *(Apollon finishes his stitch, folds his material, stands, and walks slowly out the front door. Peter follows and closes the door. Then, to Lisa . . .)*

He'll be right back . . . *(Pause. Then he breaks out. It is almost a tantrum.)*
God, God, God!! I'll kill him!
I'll murder him! This it the last time!

LISA: What's the matter? What's happened?

PETER: He's a monster! A tormentor! He can't behave that way to me! You should see the way he tortures me! The way he . . . *(he comes to his senses, stops, pause)*

LISA: I've come at the wrong time . . .

PETER: No, no . . . stay . . . if you want to. *(pause)*

LISA: Well . . .
You have a lot of books here . . .

PETER: Yes.

LISA: You must read all the time.

PETER: Yes. Yes, I read to stay alive. I'm only alive, we're all only alive when we're reading. Are you listening, Lisa?

LISA: Yes, only, well, don't you feel that being alive, that the difference between something alive and something dead is that whatever is alive is full and—oh, I can't say it at all—is changing other things. Like I feel, well, most alive, when I'm running, or singing—I used to like the sound of my voice—or, but you know what I mean. A rock can't do any of those things, but you can picture it sitting there and reading a book.

PETER: You don't understand! *(He paces around, once again the preacher.)* Shut us off from books and where would we be? Rats in a maze, animals in a great sea, drowning, squealing, with nothing to cling to, not knowing how to swim, whom to admire, what to do or what to say, or how to love or how to hate. Books tell us those things. We never have any ideas of our own. Without books, we wouldn't even know enough to save ourselves. We'd thrash around and cry for help, and then we'd all go down together, the ocean would close over our heads.

LISA: *(suddenly)* Peter, I want to get away from there. Will you help me? *(But Peter is still lost. He looks around, is aware of her again.)*

PETER: What have you come here for? For help? From *me?* You understand nothing! Look around here, what do you think I can do?

LISA: I know you're not rich. I need more than money.

PETER: And what makes you think I want to in the first place? Do you think you can come in here and order me around? I know what it is, you believed my *pathetic* little speeches last night. Ha! Now you want more of them. You're afraid, afraid of ending up in the market place, afraid of dying young. Well I've never *been* to the market place. It was all made up. *(Lisa has backed to the doorway.)* And now you're afraid of me, running away.

LISA: I'm not afraid of you.

PETER: I tell you a little story and you're terrified, you shiver in your little hole, afraid to put out the light. That's why you came here. You didn't realize I was using you, getting even by attacking you. Just because I made you sniff the air and painted you a pretty picture, a little rosy picture, you come running here. Admit it, and then run away again.

LISA: You told me you lost something.

PETER: It was a joke! I was laughing at you, the same way I'm laughing at you now! You poor fool. Don't you know when someone is mopping the floor with you, when someone is laughing at you.
(She simply stands there, he comes closer.)
I tell you I was mopping the floor with you!
A man can do that to a woman. Do you hear me? Don't you understand? It made me feel *fine.* Do you think I regret it, that I'm going to apologize? I *enjoyed* it! I *loved* it! And you can all go to Hell, just so long as I can, I can wipe the floor with you all.
Now get out. Never come back here. Do you think I like to be seen in this filth? I suppose you think it's fun being a coward, a fool. Well I don't care if I'm the lowest being on earth, you're still my servants!
(He is practically hysterical.)
What are you standing there for? Do you think I can ever forgive you? *(He moves closer.)*
Go on, get out! Get out! Get out! *(He confronts her, shaking, his face working, tears streaming down his cheeks. And suddenly they are in each other's arms.)*

LISA: Oh, Dear Lord . . .

PETER: They won't let me . . . I, I *can't* be good! *(He starts to crumble, to fall to his knees. She supports him. He looks up, then clasps her hands very tightly. She steps back and then, embracing, they head towards the couch. Lisa sits on the edge and reaches up to pull Peter down to her. He relaxes, starts to reach toward her and suddenly stops.)*
Wait . . . *(He slowly and deliberately takes the rest of the money from the table, opens her palm, puts the money in her hand, and closes her hand around it.)*
I almost forgot it. *(Truly shocked for the first time, Lisa stands and faces him. The pause is broken by Apollon, who enters carrying a tea tray. She shudders, whirls around, and runs out the door, throwing the money on the floor. Peter, who must have expected this, is looking away. Apollon puts the tray on the table and picks up the money. He walks to Peter and holds out his hand. Peter looks at the money and then looks up, directly into Apollon's face.)*

PETER: We need some air. *(running toward the door)*
We need some air. *(Apollon closes the door and snaps on the lights, for it has gotten quite dark. He takes his Bible and sits in his chair. The curtains are blowing inwards.)*

APOLLON: *(As he reads, his lisp fades. At finish, it does not exist.)* O, earth, cover not thou my blood, and let my cry have no place. *(Peter's voice)*
Lisa, Lisa!
Altho, now behold, my witness is in heaven, and my record ith on high.
My friendth scorn me: but mine eye poureth out tears unto God.

(Peter's voice, fainter) Lisa! *(Apollon looks up at the voice, then resumes reading.)*

And where ith now my hope? As for my hope, who shall see it?
They shall go down to the bars of the pit, when our rest together is in the dut.

(And very faintly we hear Peter's voice.) Lisa . . . Lisa . . . Lisa . . .

<p style="text-align:center">Curtain</p>

Excerpts from *Something Deeply Purple* /

ED FREEMAN

1960

I

... PERHAPS A SMALL PEARL around that neck which turned her head like a silken periscope, so full of curiosity was she at a static table. My Eve had rollercoaster typhoon hair with seaspray streetlights and a face which, I must admit, seemed often stiff in public, but with an actuality of melting lines in soft lights as a dark lake warm near me or tearful in a wooded car.

... the soft bouncing of her lower lip as I toyed after a kiss perhaps, and it sparkled when she pouted. Our mouths different in summer, glutinous, sandy taste in summer, heat-soaked blanket, almost disagreeable sometimes and clear in winter, the minnows in our mouth flicking softly in and out the seasons of our love.

II

Souls are an abstraction; I wished for one of her eyes exchanged for mine, a trade that I may see every step she took alone, every corner turned; for her to watch the same of me, every boxtop kicked from subway platform to tracks below.

... and she loved me, funny little me with a round face; she thinking I most wonderful of all, joke of love, even somewhat jealous of me; funny girl with all the courts at her open-toed shoes—no shoes in summer, a street child on the boardwalk, and "oh, honey, sand hurts my feet!" when heated sun is lover outside biting something July body to slick grips in evening.

III

I've seen her in high heeled dress of evening darkshadow clatter down sidewalks near bushes, camera posing with yellow blouse shirt button down the abomination of burmudas, stretched coy almost-experienced doubt of summer ghost tan, cocoon wrapped in purple so high paper cups coupling african weaveaway on bare boards, tearing howling tantrums of tearspilling melodramatic stagewater on sofa's edge, swift-jerked hand in public hallways marble-eyed rolling quickly sideward, night pools of eyes back-necked hand making foxfire on my skin, compulsive guilt-sessioned rockings madly staring at herself of me, rolling tight bathingsuit private pools kicking water dome-breast high, laughing child laugh of autumn leafpile baby hands clenched: let me make your love a golden string of dewfilled mornings crying in a purple sky.

IV

Home was a quick kiss and a cold bed. Her friends bubbled vacantly about her like three aspirins in a glass.

As her uncle E. J. Reilly became accustomed to a life of semi-leisure he took to reading books of famous quotations and after-dinner speeches so that, at the sunday table, he became the very incarnation of Lincoln and spouted forth wisdom in oceanic gulps. He occasionally proved to be an excellent conversational contraceptive.

V

My grandmother was a Christian Science practitioner who almost converted me at six when I went to spend a summer on their farm. My grandfather remained a pagan. I remember when a board dropped on his hand that summer, and he said, "Shit!" I threatened to report his action to my grandmother, and he acted very concerned. For all I know, he might have been. He also got very angry when I slit the hammock . . .

I have seen pictures of my father grinning broadly with a half-opened clam in his hand.

There were no patriarchical E. J. Reilly's in my family; no skeletons ever grinned at me from the closet; no frenzied ex-lovers came knocking to escape the storm; no diaries or old love letters contented me on a rainy afternoon; we didn't even have an attic in our house.

VI

Little Eve at eleven, breasts growing alarmingly. Turning point number one: camp summer by glistening lake, meets Ted Petty the Svengali of Camp Redbird; Ted Petty, thirteen year old mystic and knower of nature . . . Next night magnetized kiss by the gate. "You have great possibilities," says Ted Petty, Master of Beauty Culture . . . Little Evie like her mother—nail polish—rolls her hips, flips her eyes so fine . . . Petty the Aesthete says, "You'll have to take off all your clothes so I can see what's to be done for you." . . . switchey titchey Evie.

Sexy-model Eve at twelve like fifteen-sixteen, tight red sweaters after school . . . Swishey wishey in the halls, little Evie. Thrown into a room at Camp Reunion, stripped and almost raped by thin-faced, red-eyed, thirteen year old, baseball thumping lechers irritated and excited young citizens. Heroic, almost unbelievably stageset entrance of Ted Petty save her, magnetism and mystic connection . . . Ted goes to Georgia, writes letters of naturalistic solitude, at home with a plow, he says mystically.

SPRINGTIME IN NEW HAVEN: THREE MIRACLES

I

Down the strutting stairs, tic-tac, highheeled
Waded the whore through our New Haven air,
Cigarette-hung lips puffed and certainly
In bloom. And I was always told there were
No whores in New Haven. "Mygodbeejeesus,"
Said the taxi driver, "look at those boobs;
A girl like that could ruin a family."

II

Spring was here in the neighborhood world
And all the dogs on brand new cocker stiff legs
Flocked in military stride watering the
Trees, and cars, fence posts, garbage tins, mail
Boxes, baby carriages, and cornerstones.
Dogs too are in bloom, and never run dry:
This is the miracle of the dog months.

III

The neighborhood unfurled dimensions of winter-sullen
Back yards revealed through alley years of
Shadow pinched brick. A man bends frozen over
His rose, unseen before this green-struck air
Wrenched eye and brain into new sight:
Then you know the white washed clothes
suspended, death-like: hanged in the empty air.

Peter Parsons
1960

SONG

The day I flew a kite and tugged at the paper sky
I had the tinfoil moon on a string—the cookiecut moon.
High I flew the moon high,
And it flew me on its bellybutton string,
Strumming through
The picking twigs
That allowed me to display my paper sky
And my capricious string
Over your excited house
So you could see
How carefully hands
Might shape the wind
And trap the sky
To climb the ladder up
The oiled, easy air.

Neil Goodwin
1961

KILBURTON LANE

As I walked home along Kilburton Lane
The evening fog stepped out to touch my arm.
I turned to greet this unprized wanderer
And asked where he had been since last we met.
He only shrugged and smiled and fell in step
To walk me on beneath the yellow lamps
That glowed in quiet pleasure, seeing good friends
Too much alone, together once again.

When he spoke the winter damp made puffs of words:
If I could find a wooded glen at dusk
With crushing brooks that melt in meadowed downs,
I'd bed there for the night and wake at dawn
To slip with practiced stealth across the grass
And glisten all the noses of the deer
That come to test the air before the fawns approach.
I think I'd stay there then and let the world
Just do without.

Joseph Harned
1961

ANATOMY LESSON

Origins and wombs no more miraculous
Than this, his life roots in mazing
Veins. Through his dreams the thick
Blood moves and so it must be true
That for his every spoken thought
The stirred pool churns, spreads feeling
Like oil, threading each charted passageway
From head to heart till every finite gesture
His hands make to shape the air flows back
And self-inhaled becomes while you watch
A weighted lesson in anatomy.

Carolyn Gaiser
1961

THE SALT OF THE POEM IS STARS

When may I
Strip words of their fat night
And pare them to points of light
That they sing on the grief-heavy sea?

Words, sing now
Over the vexed sea
Where waves break ships of attempt
In two, their timber crowds the foam
Like broken poems.
Words, sing,
Brighten memory's sad sea,
Lighten, lighten, hang your chant up there.

Charles Dunlop
1958

It Just Happened / ROBERT SARLOS

1960

IT WAS NOT HER WHITE LACE UNDERSKIRT framing the lovely knees against
the black dress that drew my attention. Nor was it the plain grey
hair incongruous in its youthful disarray. And not the tearsome-red
nose in the painwhite face.

 Only her right heel was in my eye first.
It seemed broken. Or bent, perhaps. But it may be just a new fashion.
Young girl with grey hair. Why? What shock did it? Was it
accidental? Or—as the even color suggested—is it dye?

 I should warn
her about the heel. But then—I saw the other one. It looked
precisely the same. It is a new style after all.

 As the bus approached
its last stop, the one where it turns back to Hollywood, I leaned over:
do you know Miss, your right heel is broken.

 Yes, thank you, both.
We got off.

 Wouldn't you be better off without them? Yes—and off
they were.

 I had to cross the street to catch my next bus. It didn't
come and without a glance to the schedule I started following her
—she barefoot, myself in zoris—on the opposite side.

 After two blocks I
HAD to cross: can I help you with anything?

 No.

 Could you use my
zoris.

What?

Go-aheads.

No thanks. For two blocks we walked in
silence.

Why not take a bus?

I don't know which one. My people will
wait me at Robinson's.

She had an accent.

Where are you from?—New
York.—You're not American.—I am.—But your accent.

I learned
to speak only when fourteen.

We passed Robinson's. How about
your folks.

I have to call them it was a big fight I got out of the car
they will be mad!

What do you do?

I walk barefoot on the street.

Ooh.
You might get in trouble again. Mind if I stick to you until your
folks get here?

I'll take care of myself.

It seems you do.

Thank you—I
stay right there. She entered a cafeteria.

Good luck.

Thanks—from
the door.

I waited on the other corner. My bus should be here in
twenty minutes. Fifteen minutes & she came out and sat on a bench.
I crossed through red.—Have a lifesaver.

No. She shook her bowed
head with an upward glance. My bus was coming. I took a
lifesaver placed it on her lap and dashed across the light.

A white
Ford stopped on her corner. A yellow-bus on mine.

They helped her
in. I climbed up.
Off we go

Our Man In London / JOHN NEUFELD

1961

I DON'T VERY OFTEN SIT in parks. Oh, I like grass and trees and all that as well as the next person, but I'm just not overly fond of parks. In cities, that is.

Firstly, parks are too noisy. A few trees and a well-cared-for-carpet of grass can never dull the city sounds of buses, brakes, horns, screeching tires, trucks, demolition, construction, and so forth.

Secondly, with all the noise, it's impossible to suspend belief long enough to imagine oneself in the country.

Then, again, find a comfortable park bench.

So, I don't very often sit in parks.

Naturally enough, I was sitting in one the other afternoon. This will come as no surprise to the careful reader . . . or to the careless. Anyone who begins as I have begun eventually winds up sitting in a park.

For instance, you're faced with a story that begins, "Nobody, but absolutely nobody, dances at the Lido." Now, you know damn well the person speaking is going to commit the unpardonable sin of dancing at the Lido before you reach the bottom of the page. Imagine, that gauchest of faux-pas, dancing at the Lido! It's ugly, but there it is.

Anyway, there I was, sitting on this uncomfortable iron bench in Green Park one splendid sunny afternoon, trying to forget how unpleasant the thing I was sitting on really was. And, to help me forget, I began watching people.

In London people are not particularly amusing to watch. They're too bashful to do anything lewd and too smart to make idiots of themselves.

Still, Green Park is a fairly good-sized park, and there should have been any number of interesting things to see. Unfortunately, I was soon slouching low with closed eyes and folded arms, pretending to be in a six-foot tall bottle of embalming fluid suspended from the long arm of a tree.

I was just dozing off, wondering how my parents would react to the news of my death, when I felt the bench lurch a little to the left. In New York I would have opened an eye to snatch a glance at my benchmate, but in London I kept my eyes closed. In New York my benchmate would not have said anything to me, but in London he said, "American, eh?"

Well! I mean, what could you do? So, I did it. I opened my eyes.

"Button-down shirt," he said.

I nodded.

"I often talk to Americans," he said, pulling out a wrinkled piece of cotton with which he wiped his very red nose. "I'm one, myself."

"Oh," I said. I lifted the top of my bottle and sat up.

"Yes, though you wouldn't know it to look at me."

I looked at him. He was right.

He stood up then to adjust his long, ragged, tweedy coat. It's color reminded me of the stains on an old man's white moustache, and it smelled of tobacco. He pulled it around him and sat again.

"Do you think?" he asked.

"Pardon?"

"Do you think I look like an American?" he asked again.

"No, not very much."

He smiled. "Not that it makes much difference, y'understand. Pride doesn't mean much to a man my age."

I looked at him closely, judging he was seventy or so. "Are you on vacation?" I asked. (I had to say something!)

"And do I look it?" he answered. "My shoes, for one." He held out his legs and looked at his shoes microscopically. They were fairly battered, I must admit: tall, loosely laced things with no polish and very little shine left. Even his trouser-legs shown with a gleen of wear, and I couldn't help smiling.

"What's that for?" he asked.

"I was wondering how you could have sat on the bottom of your pants' legs long enough to make them shine like that."

"Well, at least you're honest."

"Well, then, how could you?"

"Ahhhh," he nodded negatively. Then, "What do you do?"

"In London?"

"In London."

"I'm studying."

"That's fairly inclusive," he noted. I laughed. "And where do you live, then?" he asked.

"Just off Sloane Square."

"Do you, now." His funny little eyes laughed. "So do I."

Now, wait a minute! I thought. I'm no snob, but Sloane Square is a pretty posh spot. This old man looked like a refugee from Tunbridge Wells of fifty years ago.

"Interested?" he asked.

"O.K.? I'll bite. Who are you?"

"Nobody," he smiled. "Just an American."

With the face of an old Flemish coal-miner, I added mentally. "And how do you live?" I asked.

"It's quite easy," he said. "It's very simple, marvelously simple to live in this city, this city of music and twinkle."

"Music and twinkle?"

"Music and twinkle," he nodded. He took off his cap to scratch the top of his head and his thin, brown hand momentarily sank into a soft bank of snow. "Music and twinkle," he mused.

"You're twinkling, now," I said.

"So I am; so I am." He looked at me a moment. "It's been a long time since I've arrived here," he told me. A slight shadow passed over his eyes, but he began again, in rather a hurry.

"I fell in love with London from the start. My wife had just died, and I came over here to rest. I fell in love with London. With her music. More particularly, with her street-players."

"Street-players?"

"Street-players, like at Leiscester Square. You know, they follow queues to dance and sing for pennies."

I nodded.

"After a few months," he said, "I had given away so much money, had thrust so many shillings into out-stretched hands and raised caps, that I had very little left. So, I thought to myself, I thought: Jack, to which man have you given the most? Thinking back, I discovered it was to a little old man who played bagpipes on Shaftsbury Avenue.

"Well, I hadn't got much money left then, but I had to live. And so, with my last few pounds, I bought a pair of pipes and learned to play them. It's quite remarkable how much imaginary Scots' blood flows through the veins of London. Within a few weeks, I had more money than I had once given away.

"I discovered that the idea was to play outside pubs just as they were closing. Nobody refuses then. Everybody's kind and rather more generous than ordinary. I was soon supporting myself in a style even my late-wife hadn't accustomed herself to.

"I bought a flat in Chelsea, where you live now. I began reading again; going to the National Gallery, the Tate. I went to Covent Garden, Festival Hall, the theatres. Life was simple, simple and smooth.

"Sometimes I'd be face to face, outside some pub on a midnight sidewalk, face to face with friends who had dined with me the Sunday before. But I wouldn't stop playing. I wasn't embarrassed nor were they. Things just rolled along getting better and better.

"Summer was the best time, though. Lots of blood in Americans, too."

He stopped, and the same shadow crossed his features.

"And now?" I asked.

"And now . . . and now, now the doctors say I've got to stop. My heart won't take it any more."

"Oh."

"But I'm not stopping altogether," he said with a very quick smile. "No, siree, I'm not stopped yet. I said to myself, I said: O.K., so you've got to quit the pipes. That's not the end of the world. So, do you know what I did? I went out the other day and bought myself a harmonica. Of course, I'm not too good at it yet, but if I bend low enough and pull my collar up, who's the wiser?"

He stood up to give me a brief demonstration, pulling a shiny, new mouth-organ from his hip pocket, stooping almost double and looking twice his age. He put the harmonica to his mouth and stood there, blowing in and out tunelessly.

Suddenly his other hand shot out from his coat with a little cup. Quite before I knew what I was doing, I had put a half-crown into it. He stopped playing and straightened up.

Lifting his cap, he smiled. "Fastest mind in the Western World," he said, and shuffled off towards Piccadilly.

OLD TO THE WIND

She was a young bloomer,
Whose swelling breasts
And bursting mouth
Blooded themselves
From juicy fountains
Flowing through Satyrs' happy hands.

She warmed the pubescent world in her heart
And frozen lilacs in her womb,
Encompassing
Fair-haired lovers
And an occasional white grandfather,
Wistful in the wind;
but now the flesh is overripe—
past the plucking stage—
and all the ladders have been put away
(still living flesh on ageing bones,
soon just bones,
with a withered, whispering smile)

Only a moment ago
Currents swam in her body
and sparked in her eyes and her hair
At the gentlest touch;
but those became scarce,
and her veins clogged
with pent-up air—
and desire—
which thinned her legs to sticks
and hopes to
Just bones now
. . .and a whispered smile.

B. Rodney Marriott
1961

OF MARRIAGE

(In honor of Bacon's essay, "Of Friendship")

marriage as a state of mind exists
within the soul, encompassing the points
of all the heart's directions. It anoints
the body with its wine, pouring mists
of dreams on lists of fears, and then insists
we hold ourselves aloof as knighted saints.
the eve and adam picture that it paints
seems fallen, and we shake our cymballed fists
expecting galleries. A rose, a kiss,
a mystical discovery of lint,
direct us to the source of love's own scent;
but when we're almost there, exclaiming, "This,
this is what I mean!" our love is spent
and we lie mute, serene, asleep, content.

Anthony B. Pratt
1960

THE SKY PASSED IN LINES

the sky passed in lines
into the great twisting in the west.
with me bee-like into frightened caves
with me mare-like we clawed through the sand
in barefoot dreams
where there was swimming
through smooth pebbles sighing kisses to our thighs.
her burro feet were watchful on the cliffs,
would stop to kneel and wonder that things should be.
with me wide-eyed hands
played through the halflight to show me a high sad rock
and to tell that the path to the beach
was surely alive and dangerous.

the east gave an icy, bare breath
the moon told a secret tale among the rocks
winding our eyes up along the webs about the stars
where she must have found her crown of red sand.

trap the wind in the Irish wool of your tongue,
pass it through the haycocks of your mind,
come whispering your song through the rain
to trade your shadow in the sun for mine.

Neil Goodwin
1960

a and z are worth the worry
and all the rest
are unsuccessful communication
between the two

but beneath there lies
the butterfly passion
of man's divergence

so postulate your life a poem—
hone your senses:
see a swallow against the sun
taste the salt sea-breath borne
hear the sneeze of a butterfly
feel the mystic fingerprint
just above your smile.

Joseph Harned
1960

MEMORY TURNS ALL THINGS SILENTLY TO STONE

I saw your shadow on our wedding bed
Quietly exchanging contours with the air.
I saw your flesh turn silently to stone.

I felt the sad gyrations of solemn earth
Spread a shade of longing across my mind.
I felt the earth turn silently to stone.

Beneath the eastward tilting of the sky
I saw the disappearing ship course
The gradual sea, and knew that memory
Turns all things silently to stone.

Mark Strand
1958

FROM *THE LITTLE HOUSE*

once upon a time,
rambling a road down
culminating a little house
coming
 Rumpelstiltskin
out the trees
backsoldiering rackety tack
fence
painted all white
uncountable years before
and a gentle maiden
residing there
playing moonbeam & pondlily
with brawdy bullfrogs
and lions
in their lairs
winning old butterflies
trembling blue man's white moss beard.
Then,
once again over a time
the little house barked
bringing standing puppy's
eyes
into its windows
laking its mirror
into broken sky,
 Chicken Little
playing leapfrog
through the maiden's hair
and tadpoles in her eyes.

Jack Davies
1959

The Duc Of The Southern Sea /
a chronicle

ALFRED M. LEE

GUILLAUME DE CHATEAUNOIR

1959

I AM A SPINNER OF TALES, twirling out one story or another to please my master the Duc. In this manner I live at court tossing words into the stream of history and writing diplomatically obsequious letters to the Roi. An educated servant (the Duc cannot write), I dine late in the evenings at my single table in the northwest tower, where I live alone. I am unmarried, and being an old man I am no longer sought in the ladies' bedchambers. Neither lord nor simple servant, I find myself isolated with my tales, which I have come to write for my own amusement, wishing perhaps to adjust the lies I have let fall to the world. My last twenty years, I should say, have been committed to the happy hoax of preserving the Duc's fealty to the Roi; now alone in the northwest tower I am ready to tell myself the truth.

Let me first set down a description of my master. He has never been to Paris (I studied at the University) and hates everything about the city (as I tend to do). He is younger than I, though at his temples a small tinge of grey is beginning to appear. His wisp of a beard marks him with a certain fanatical demeanor which is not altogether appearance. I should guess him to stand six feet tall and for all his prejudice his stature and manner is more northern than Provençal. Politically he has pledged himself to the Roi in Paris while at the same time retaining sovereignty for his domain which stretches across the mountains and down to the southern sea. The Duc is unimpressed by the empire-building of the Roi. He hates the Savoyards, the Genoese, and all the rest of the Italians who border us on the south and east. Herein lies our problem, for thousands of them long ago came to our country to live, and tens of thousands were annexed to us when the Duc's father extended our sea-coast boundary almost a hundred miles closer to Genoa.

Just as vehement as the Duc about the Italian situation is the Roi. In an effort to enlarge and consolidate his power, this stubborn youthful warrior in Paris is determined to make peace with Genoa and at the same time to gain fealty from the Duc of Savoy. To do so he feels he must solve what he calls "the great problem." The Duc's retort is that there is no problem.

When I returned from a mission to the Roi, the Duc shut me up with him for two straight days, badgering me about the Roi's intentions. "My brother tells me there is a rumor," the Duc said, "that the young fool intends to send an army here to direct our domestic relations. I shan't stand for it."

The Duc's brother is an oaf; that is, he once was an oaf, for now he is among the immortals, honored daily by a special mass ordered by the Duc. I replied when the rumor was mentioned: "Yes, I have heard the same, but do not place my faith in such idle prattle. The Roi is merely annoyed at what he calls 'gross maltreatment of the Italians.' "

"I'll throw my whole army into the field against the Parisians," the Duc said.

"But, sir, all the princes of the north are clamoring for you to conform."

"They've had no dealings with Italians. They're ignorant of the situation. I'll destroy them all!"

"But, sir, your army hasn't fought in years. The Roi's army is eight times what you have, and has been fighting three wars a year."

"Piffle! A Provençal with a pike is worth ten Parisians."

"But, sir, the Parisians fight with bows and arrows."

"Nonsense, Guillaume. This fortress we live in is as rock-bound and eternal as my family which began under the Roman Republic. And this man in Paris, behold him! He sits on a wooden throne seized for him by an ancestor who was a Parisian bourgeois. What can he do against me?"

"I spoke also with an emissary of the Archbishop, who deplores the wickedness dealt to the Italians."

"What wickedness?"

"That's what they say in Paris."

"Am I threatened with excommunication?"

"Not yet."

"Well, the Archbishop is probably an Italian anyway. To hell with Italians. They're good for peasants and servants, but never shall I allow them to do business in any of my harbors. Italians are wretched. They don't bathe. Did you tell them that in Paris?"

"Yes. They all said that no peasant ever bathes."

"Did you tell them that very few of my Italians are disturbed by being peasants? It's the foreigners, the Savoyards and Genoese, who cause all the trouble. Why doesn't the Roi let his French peasants leave the land and clutter the streets of Paris?"

"The Roi says that French peasants love their status, but with Italians we should be more thoughtful."

"Peasants are peasants. We should stamp on them all."

"The Archbishop says that our Italians are undernourished."

"So am I. I can't even grow a decent beard."

"In Paris they were most disturbed about reports of the atrocities down here."

"Then write a letter to the Roi saying that we are most disturbed at the atrocities against the Germans in Paris. Besides, my Italians are all well-treated. They are content, and I'll not be affected by those northern meddlers."

"But, sir, you have sworn allegiance to the Roi. And you need his money and his protection against the Genoese."

"I'll starve and burn before I'll let that upstart command me."

Thus the two days went. The Duc off and on accused me of sympathizing with the Roi, endeavoring to free the Italian peasants and to allow them into the towns, wanting to let the town-dwelling Italians move out of their slum quarters. I protested, and we fell back into the rhythm of No, No, Never that the Duc so enjoyed. I'm afraid he feels dependent on the Roi, and his arrogance supports his weakening pride.

When I was returning to the northwest tower I chanced to meet the Duc's wife in a courtyard. "Oh darling Guillaume," she said. "I hope you explained things to those beasts in Paris. Do they know what they're doing to the servant problem down here? Why, it's been ages since the Duc has had a competent valet. So unreliable, these Italians!"

I assured her that the situation would improve and that what the Roi had in mind was contrary to the word and spirit of the agreement between him and the Duc.

Afterwards I was idle for several weeks until I was called to the Duc's table for dinner. He was already quite drunk and insisted that, despite the inconvenience, we must all eat with our fingers rather than condescend to the silverware used also in Paris. Then, in an exalted frenzy, he proclaimed we would not eat at all, for the food served was either that which is eaten in Paris or that of Genoa. "Provençal wine," he

declared, "will suffice us in these troubled times." (Later I learned that the Roi refused all wine except that made from Burgundy or Champagne vines, refusing to soil his belly with "Midi poison.") "We'll show the louts, we will, we will," the Duc shouted. "Write the Roi news of the bloodbaths down here. Yesterday we killed two thousand Italians because they couldn't speak Provençal."

"But, sir, we didn't, did we?"

"Piffle, Guillaume! Utter piffle! What difference does it make? They thrive on such news in Paris. Living is so boring there that they would believe it if we told them I am the devil. We'll outrage that upstart, we will, we will."

The next morning I sent a messenger to Paris with a description of how the Duc's Guard set fire to the Italian quarter in one of our towns and slaughtered the rascals as they ran, with their garments ablaze, out of the holocaust. Two thousand dead were already counted when I wrote, though the slums were still smouldering as the moans and shrieks of little children pierced the dawn sky and drowned in the southern sea. The Duc was favorably impressed, bidding me to continue my accounts.

Rather fond of my own imagination, I next sent a tale of how the Duc's Guard one afternoon herded a thousand Italian peasants out of their fields and marched them into the sea, shouting: "Swim to Genoa." I mentioned that, as everyone knows, Italians can't swim.

Then, at his request, I reported that the Duc had some time ago become another Gilles de Rais, having throttled some five hundred Italian boys in five years. Perhaps it was the enormity of the Duc's supposed crimes which enraged the Roi, or perhaps the details and insinuations of my account. But the tale brought retaliation from the Roi, whose army came to Provence with the blessings of the Archbishop. A month ago the massacre of Petit Rocher was carried out and the Duc's buffoon of a brother was elevated to the immortals.

He, the Duc's brother, led two hundred men against three thousand of the Roi's men. Our force was slaughtered to the last man and the French population was entirely subjugated by the Parisian interlopers, who immediately established Petit Rocher as a City of the Roi, ruled by an Italian mayor.

Enflamed, the Duke broke allegiances to the Roi and summoned me to consult on his course of action.

"Perhaps," I suggested, "it might be wise to repudiate the stories you had me write."

"Never! If anything, I'll bring those lies to truth. Ha! If they call me

a bastard I'll show them how bestial a bastard I can be."

"But, sir, their army is bigger."

"Piffle! I'll do what I please in my own country. What right have you to meddle!"

So as the Duc ranted about his rights, I pictured in my mind's eye the pageantry of might. The Roi, after all, determines what rights are; and the Roi sees the Duc as an ogre more distasteful than Gilles de Rais. Indeed, the Duc rather fancied himself as a dashing Satan roaming the countryside embodying the stories he had asked me to tell of him. I wondered if his gaiety at reading my fabrications might not come from a wantonness which would transform my tales into reality. Whatever he intended, it was evident that the Duc needed some sort of forceful reply to the Roi's men in Petit Rocher.

He had seemed to me too old for what happened next. What his wife thought when it happened I have not yet learned, but presently she has reconciled herself to his activities which are a successful concomitant to psychological warfare.

I was sitting under the slow southern sun, resting quietly in the court-yard writing a love ballad, when a shaking of iron aroused me from my lethargy. At once a column of soldiers came marching past me toward the Duc's quarters leading a manacled assembly of fifteen young Italian girls, trembling, weeping in their bondage. I was ordered to accompany the procession to the Duc's quarters where I was to record the events there to transpire.

Naked from his ancestral gold belt to the crimson robe across his shoulders, the Duc weaved drunkenly through the crowd of maidens, laughing and exclaiming unspeakable blasphemies. Lasciviously he spat in the face of one of the girls and yanked her to the front of the room with him; he jerked the scarf from his head and then *il expliquait comment, immobilisés par le froid sur le place, ne songeant pas même à organiser des représentations nocturnes où personne ne viendrait, ils avaient décidé qui lui-meme irait au cours pour se distraire pendant la journée, tandis que son compagnon soignerait les oiseaux des Iles et la chèvre savante.*

And finished with that, the Duc grimaced at a second maiden and ferociously seized her, *puis il racontait leurs voyages dans le pays environnant, alors que l'averse tombe sur le mauvaise toit de zinc de la voiture et qu'il faut descendre aux côtes pour pousser à la roue.* Thus it went. The Duc was inexhaustible.

Late into that night I sat in the northwest tower writing of what I had seen. This tale was long and terrible, recounting every despicable excess in which the Duc had indulged. A few hours after the brutal news had been dispatched to the Roi, word arrived from Aix that the Roi's soldiers, numbering more than ten thousand, were encamped there and were moving toward the Duc's castle to wipe him out with his infamies, and to place the sovereignty of the country in the court at Paris. The Duc's Guard was in panic.

Here was one of those stirring moments when a regal lord is called upon to decide whether to surrender body and soul to preserve the life of both or else to resist till the last life is lost and spiritual integrity remains tragically intact. The small, poorly trained army of the realm, therefore, assembled in the vast meadow before the castle and heard the Duc's address:

"Soldiers, I address you from the privilege of fifteen centuries, and from the seat of Midi culture. We of Provence are fretted by the barbarous heathen of the north, and are forced to choose between subjugation to our inferiors and honorable war. And so I say unto you that we shall be free or shall die while fighting for that freedom. Should we be defeated in battle, then we shall fight from the hilltops, from the rooftops, from trees and alleys. From every wave in the southern sea we shall rise up again and again to slay the invading Parisians. Our country will be a swamp of blood before it will be a camp of enslavement!"

Cheers rumbled across the valley, up to the mountains and down to the sea. The Duc told me to record all that happened on the meadow that day, but enthusiasm was so undisciplined that I felt myself at a loss to explain the madness following his speech. Yet now all the Duchy was united behind the appeal to resistance. Whatever justification might have supported the Roi's cause, all was wiped away by the challenge, which destroyed any trace of fear and logic.

But the reprieve from warfare was announced at court the day following the Duc's address. The Roi's lieutenants had heard of the Duc's almost supernatural personal endurance and imagination with the Italian maidens. A papal emissary allowed the possibility that Satan may be incarnate in the world and that any man defeated in battle by the Evil Prince would forever be doomed to serve in Hell. At first the Archbishop asked for the Duc's excommunication because of his brutalities. But as rumors mounted a strange thing occurred which my readers may not choose to believe. I write my chronicle from close association to the

Duc, however, and I testify that to my knowledge all I record has truly happened.

The Archbishop conferred with the Pope. Together the two of them recognized the ingenious coup which they were in a position to strike. Should the Duc indeed be Satan, to keep him in the province of the Church, to administrate him the last sacrament on his deathbed would be to capture the Evil One in the folds of sanctity, and the world would be rid of wickedness forever. All that was important now was to maintain the allegiance of the Duc so that by the laws of the Church he could be maneuvred into giving ground, bit by bit, until he died and his atrocities died with him.

As for the Roi, already his lieutenants had convinced him that forceful coercion would not be effective against a man like my master the Duc. The Archbishop's plan seemed far more effective. The laws of the Church would in the end win out. Withdrawing rapidly, the Roi's soldiers returned to Paris where they are stationed today.

What in the end will happen I do not know. A company of the Duc's Guard have already burned Petit Rocher, killing as they went all the Italians in and around the town, not out of hatred but instead, revenge. Unfortunately, most of the French living there died also in the fire.

Now Paris, and northern France, and all the Italians everywhere are expecting the Roi's policy to win gradual acceptance: freedom for the Italian serfs, an end to residential segregation, and opportunity for all Italians to gain audience at court.

Down here, though, we laugh. Occasionally some liberal will say: "Send them back to Genoa!" But no one listens to liberals with the Parisians still talking of their army. Now and then the Roi will make a request that, in the interest of France, we grant concessions to the Italians. I reply, at the Duc's orders, that the Italians don't want concessions and, besides, we are not French protecting France's interests; we are Provençals, and we shall resist to the last man to preserve the Provençal way of life. Then I invent, because the Duc can be bestial only when we are threatened, some new horror to forward to the northern princes. And at nights we sit around drinking Provençal wine, chuckling at how we've fooled them.

I guess the only difficulty is that the servant problem continues. Yesterday the Duc chopped off his valet's hands because the Italian stole a wristlet from the Duc's wife. But such theft has always been and always will be. 'Tis a pity the Roi does not understand.

II

Poems First Published in
The Yale Literary Magazine
by Professional Writers

RUDYARD KIPLING

MEMORABILIA YALENSIA

"The Kipling Club held its first annual banquet at Heublein's on May the fourteenth. Gouverneur Morris, Jr., '98 and Julian S. Mason, '98 acted as toastmasters. Mr. Kipling unfortunately could not attend, but sent the following refusal, which is printed by the kind permission of the club. The privilege of printing the original work of any literary man is not often accorded to a college publication, and it is with great pleasure and pardonable pride that we insert something from the pen of so distinguished a writer as Rudyard Kipling. The verses cannot fail to interest and delight the University." *from* LIT, *1897.*

Attind ye lasses at Swate Parnasses
 An' wipe me burnin' tears away
For I'm declinin' a chanst av dinin'
 Wid the bhoys at Yale on the foorteenth May.

The leadin' fayture will be liter-ature,
 (Av a moral nature as is just an' right)
For their light an' leadin' are engaged in readin'
 Me immortial worruks from dawn till night.

They've made a club there an' staked out grub there
 Wid plates an' napkins in a joyous row,
An' they'd think ut splindid if I attintid
 An' so would I—but I cannot go.

The honust fact is that daily practise
 Av rowlin' inkpots, the same as me
Conshumes me hours in the Muses' bowers
 An' laves me divil a day to spree.

Whin you grow oulder an' skin your shoulder
 At the World's great wheel in your chosen line,
Ye'll find your chances as time advances
 For takin' a lark are as slim as mine.

But I'm digressin', accept my blessin',
 An' remember what ould King Solomon said,
That youth is ructious an' whiskey's fluxious
 An' there's nothin' certain but the mornin' "head."

UNA NOTTE DI SETTEMBRE

"Timor mortis conturbat me?"

Un tamburo cavo tonfa
nella notte straniera
su nodi del sangue. Candono corvi
fra la neve presi da un piombo
silenzioso. E di colpo il mio corpo
sale su un albero d'arancio a picco
sul mare Jonio. Ma sei qui, alla fine,
non un segno s'incrocia alla resa
dello spirito, solo con te ascolti
i pensieri lontani, gli ultimi
sospesi sotto una volto gotica.
In che luogo ombre sotteranee?
Uguale a sè la morte:
una porte si apre, qualcuno canta
sul video nella corsia a tende
di narcotici. Entra nella mente
un dialogo con l'al di là,
di sillabe a spirale che avvolongo
requiem su curve d'ombra,
un sì o un forse involontario.
Non devo confessioni alla terra,
nemmeno a te morte, oltre la tua
porta aperta sul video della vita.

A SEPTEMBER NIGHT

"Timor mortis conturbat me?"

A hollow drum resounds
in the alien night
on clots of blood while ravens in the snow
stricken by silent lead precipitate
earthward. My body all at once ascends
an orange tree, steep rising high above
the Ionian Sea. But you are here at last,
no sign is crossed over the yielding
of the soul, alone with you I hear
thoughts far remote, the last of all
hang suspended underneath a Gothic vault.
Where are the subterranean shadows?
Death ever like itself:
a door is opened, there is someone singing
on the ward's TV screen, all swathed
in sedatives. Within my mind arises
a dialogue with the beyond,
in spiral syllables that curl around
a requiem on curves of shades,
a yes or an involuntary maybe.
I owe not my confession to the earth
nor yet to you, Death, lingering beyond
your door thrown open on the screen of life.

Translated by Professor Thomas G. Bergin

FOR DYLAN THOMAS
ON THE DAY OF HIS DEATH

"Do not go gentle into that good night," you told
The old man. It was not gently that you went,
You who were young. Nor gentle can be the lament
Raised for you, near the white bed where you died,
And raised in the wild wavebeaten countryside
Of your own Wales when it's known there, raised again
Wherever women who knew what your mad love meant
Or men who drank with you beyond content
Remember you. And raised, in a grief half anger and half pride,
By those, your fellows, to whom your voice in song
Belongs while ears are lent to it, and hearts
Lean, too. "Do not go gentle into that good night,"
Were almost the last words you spoke in verse.
And now the night has got you. We rehearse
Your admonition gravely, yet with laughter.
How else think of you, who at your gravest were dafter
Than all, and at your merriest, most grave?
What's left? As long as records last, your voice;
As long as speech sings, or song speaks, your songs;
And courage, in the huge dark, to rejoice
For the fountaining joys you knew in the living light.
These shine in the darkness where you must lie now.
Oh, is not that a lie? Dylan, good night.

LITERARY BESTIARY: UNDERGRADUATE WING

INDUSTRIOUS

The squirrel is a treadmill fool.
He rallies the jays and flags his tail;
Spread-eagles on the foothold bark—
And gets a middling sort of mark.

THE INNER LOAD

This elephant lopes toward authorship.
His tread is soft, his trunk most supple;
his tusks are pointed; his ears can flap;
But ooph, he's heavy, that's the trouble.

MADDENING

That hawk's an awfully ugly bird:
His beak is cracked; eye like a boar's;
His temper's wicked; voice absurd.
But see, my friend, how the pariah soars!

REBELLIOUS

Feeling strongly society's lousiness
Woodchuck joins the underground,
Only to find—his chagrin's profound—
He'd been moved to dig by drowsiness.

ACADEMIC SUCCESS

Bowoway, the mark hound bays
On the spoor of an A; looks worried.
His eyes range hot to find the spot
Where writing's bones are buried.

DIFFERENT

Celebrate the youthful lion:
A beard springs from his chin!
He wants to show he's truly trying
To be out with those that are in
Or in with those who are busy about
Being in with those that are out.

BANE OF THE CREATIVE WRITING SEMINAR

The mole, a Scholar of the House,
Is boring (under the lawn)
And blind (upon its surface),
And still I marvel at his house
That's warring (against the yawn)
And mined (with such a surfeit).

EARLY-BLOOMING POET

In Freshman year the metric owl,
His irises rich as Rosetta stones,
Sits slightly aloof from the prosey fowl.
By Senior year he's prosed—and alone.

POWERFUL SOPHOMORE TYPIST

I wonder whether that gorilla
Will ever finish his mystery thriller.
He's splendidly bushed; a drum his chest;
His forehead, though shallow, is furrow-crossed.
Sometimes he ponders the whole night through,
But I'm afraid he hasn't a clue.

STYLIST

See how the redstart skitters through the elms
Effortlessly intercepting insects
On the wing. His coverts flash. He overwhelms!
If only he would falter he'd be perfect.

SARK

I stood upon the verges of a waiting land
Ready to receive her crown,
To take or be devoured by her hungry caves,
Or burn with her barrage of bracken.

On darted feet I went to fence with fear
Along a razor edge honed by old winds,
Fought tides to strain the sands for fiery stones,
And hunted down the craggy afternoon.

Grasping the horned hills level with the sun,
I watched the narrowing days,
Wedged between death and birth, stumble from the earth,
And fingered for the light to frighten shadows,

But touching only silencies of stone
I fled beneath the leaning slab of night.

KENYA

Brown land, old wrinkled land I see,
Tall tulip men toe-deep in dust,
The lion-land attending.

Folded, felted thick the fibered grounds
Of stripéd herds and smoking buffalo
The stone trees crowd around.

I see the night come huge above the wells
With sudden frieze of rapier horns,

And green volcanoes' giant, jungled frost design,
Punctured with lily-small, pronged fairy faces,

But never the heavy velvet ape.

NOW IN THIS BITTER NIGHT

Now in this bitter night of owls lamenting
One by one across the wastes of snow,
Only the sorceress cold knows the deers' keeping
Since they last faded through the reeds.

I should go down to those moon-whitened lands,
Deep in their labyrinths where gathering hooves
Have trampled floors in wild intaglio,
And come upon the winter harem,

Couched where their breath has stiffened ferns and grasses
To bowers of ice and glazed their flanks in mail.
In graven vigilance the visored kings
Would bear stalagmite crowns, spiring
Point by point to frozen canopies,
And stun with the emerald blazing of their eyes.

ANDROMACHE

to Caitlin Thomas

Bereft, she seemed to us Andromache,
Her Fullblown beauty bare to the thieving sky
And wild grief tamed, tho' lately she had raved:
Yet her reins we knew by the eyes fierce fires,
By the wiry rebel yellow hair he famed.

> *'Was it for this she had come to the enemy land—*
> *To walk an alien isle alone, to stand*
> *In her travail and face this choric host*
> *Now Hallowing her errant soldier, lost?*
> *And still to be borne the watery journey home?'*

Ah she was curst blest among women before that day
I fable her, with tears, against its fade,—
That sad, eclipsing day we saw her skein
Of life undone, and her bright zone betrayed.

CLAY

Early I fell among potters,
And so like feather were their fingers,
I was the clay, they the makers,
And as the wheel turned so I turned.
Oh, I loved their soft caresses,
Their sleekness—, form—and beauty-giving fingers.

Noon. . . .
I dozed.
But no repose.
A figure came and went,
Haunting me;
It was a spectre of myself
Touched grey.trembling grey;
And it spoke:
> *"Feel within your clay, take thought:*
> *Drinking mug, flower vase,*
> *Belly, spout or handle?*
> *The end is yours."*

I am sleep-forsaken.
Still I lie and with the wheel turn;
But there is come a tension in my clay,
A toughness unyielding, thews and sinews.
Clay must yield, or stay; but not mine:
My clay has lost plasticity,
It bounces like steel springs.

THE FOUNTAINS

Part of a city's joy
 In itself
Clings in secret remembrance
 Of the insistence of fountains

Arching from the mouths
 Of poised brass swans,
Horses with weed manes,
 Recumbent River Tagus,

Bridging the strokes
 Of ten o'clock, echoing
From the spalled gray risers
 Of a horseshoe stair.

They have spoken all day
 In surprised flashing
Of perfect quartz
 Set to sockets of eyes,

In the spill of sheets
 Over beveled rims
Stirring fresh coins
 Among small patient stones,

In the sleep of oval basins
 Where the lifted stem
Feels a touch of wind;
 The leaf spins away.

Now they gather the threads
 Of their separation.
From least dolphin,
 From wonderful column,

From the pliancy of reeds
 In speckled sand,
From the steep danger
 Of living rock,

They collect themselves,
 They reenter darkness,
Whispering to one another
 Of the day's sun.

TWO ROMANCES

Shy loved a shy man, couldn't meet him
 For long, through troubled picture-halls.
Bold-belted loved a tough, would greet him
 On daylit streets with raucous calls.

These contrapuntal idyls wandered
 Through public buildings, nameless alleys.
The shy ones sighed (oh, moments squandered!)
 The brass pair scored unminded tallies.

It worried me. (I don't know why,
 Except that all things worry me.)
At last some secret bound the shy;
 The bold girl wept—and where was he?

DIVINITY ON THE G STRING

I heard divinity tonight,
Scriabin heard it too
One hundred years ago
Part bass, part baby grand piano.
(Plato's academician squares
Called it Music of the Spheres).
A Duo played a chord so bright
They caught with inspiration and technique
A Thing ineffable, all Light,
At once all-modern, all-antique.
Its structure formed a Third,
A trinity, the three together,
Man and instrument and bird,
Created this divinity I heard.

The bass has calculus,
An ess on either side,
Across this bridge
I heard the vision ride
Deserting one ess, Sex,
(The most profound)
For the other ess that's in reverse—
An entirely different sound.
Perhaps it's mathematics,
All strings meet
Though parallel,
Where tuning turns the world complete
Five wires merge; one string is G
For God, the entire symmetry
A woman's hipped and breasted body
Plucked pizzicaticly,

A music that's half classic and half jazz
Making music lordly, using, such as:
C, F Sharp, B flat, E, A and D,
(A mystic chording vertically)
Half burlesque, half symphony,
The strange dichotomy of the G string,
The divine and holy center of Her being,
This divinity of which I sing.

THE LAST SUPPER

The morning epic on the lawn with sun
The birds now peck at Christ communion,
Gray bread we left for robins grackles pray
Into their crops. It is baptismal day
About the bath. They wash His body
Down with two parts hydrogen, one of sky,
Perch on the edge and crap and lullaby.

The clergy of the birds, the oily priest
That preens his back, that needs communion least,
These horny feet sing grace upon the rim,
Sing prayers of worms (the body of the hymn),
Sleek Grackle-King, ecclesiast, the He
Of ornithology, toes clutching sin,
He shrieks once raucous, shrieks a wild pristine,
Tears upward fierce neurotic at the sky
A dark cross soars ambitious for the sun
Devout, so full of Christ it hurts to fly.

THE MOON REVEALED

The Moon came out of the sky, came right down
Until it was three feet from the Earth and turned around
And around and around for all to see.
The Earth revolved underneath it so many did begin to see.
William Blake got out of the ground and marched in front
 of the Moon as it came.
He had pulled hair, and he shouted, tossing his chin back,
 "Well, here it is."
While the Moon like the great big hunk it proved to be
 pushed everything to its right or left or straight
 before it always with a tumbling crunch,
William Blake shouted, "It's just like a millstone, isn't it?"
And he called on everybody as they hurried away and they
 all squeaked, "Yes!"
This kept on for 24 hours.
Then the Moon went back up.

ABSTRACT EXPRESSIONISM

The wind pushes the rain
Up tight. Behind the rain:
A windless dry place
Where angels excercise.

III

Ars Graphica

A collection of etchings, engravings, woodcuts and photographs published in The Yale Literary Magazine.

Pen and Ink Drawing MARK STRAND

Dogs W. P. REIMAN

Night Walk ROBERT JURGENS

The Tower ROBERT BIRMELIN

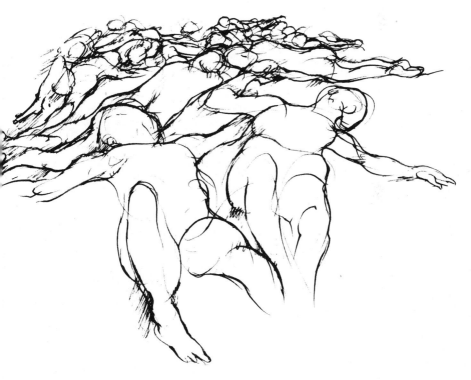

Pen and Ink Drawing PATRICIA COUGHLIN

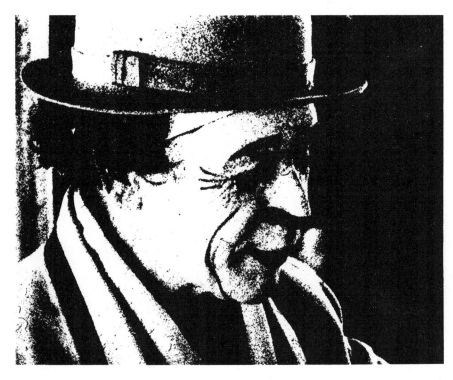

Clown JOHN T. HILL

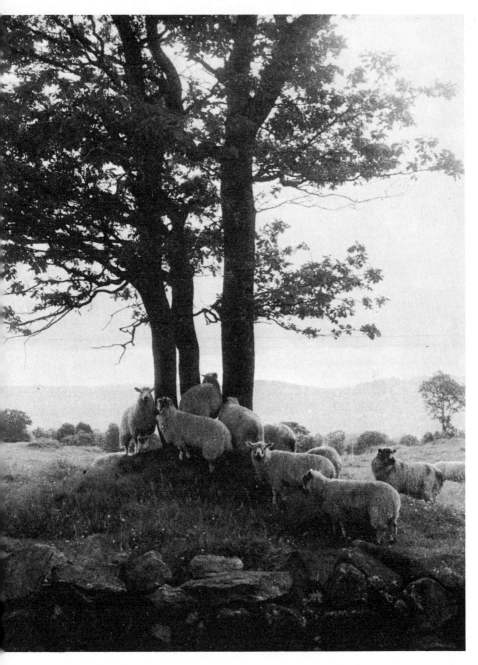

Photograph NEIL GOODWIN

Orchestration WIGFALL

Etching OZER KABAS

Woman in Mirror ROBERT JURGENS

Lincoln Woods Autumn CHARLES J. WRIGHT

Woodcut MELVIN LEIPSIG

Photograph NEIL GOODWIN

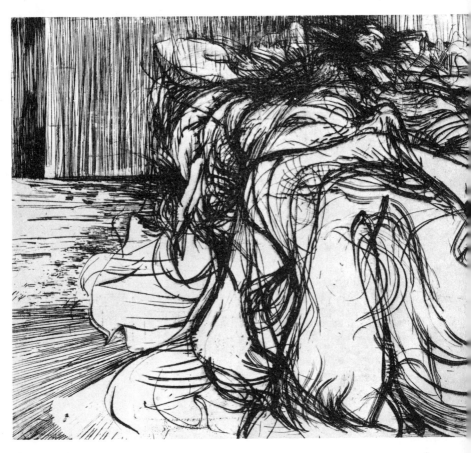

Woman in Bed MICHAEL MAZUR

IV

American Creative Conscience

CRAFTSMANSHIP IN THE ARTS

EDUCATION, LANGUAGE, AND SOCIETY

125TH ANNIVERSARY

Philosophy / PAUL TILLICH

IT IS A GREAT and unexpected honor that I have been asked to give an address in a place which for years has been for me a favored oasis within this beloved city of New York. It is an unexpected honor; for I am far from being considered an expert in the visual arts—or in any other art. I could accept the invitation to speak here only because the Museum planned a series of "Art *and*" lectures, the first of which was to be "Art and Religion." It is the religious angle from which I am asked to look at the visual arts. This means that I must do it as a theologian and a philosopher.

A disadvantage of such an approach is obvious. One must conceptualize and generalize, where intuitive penetration into the particular creation is the first and all-determining task. It is well known that many artists feel uneasy if their works are subsumed to categories; nevertheless, art criticism is as necessary as literary criticism. It serves to guide one to the point where the immediate intuitive approach to the particular work can occur. Attempts at conceptualization like the following should be judged in the light of the demand to make such criticism finally superfluous.

The series of the *"Art and"* lectures was supposed to begin with the lecture on art and religion, but it does not. Instead, I intend to speak about art and ultimate reality, a subject which, although including religion, transcends by far what is usually called religious. Ultimate reality underlies every reality, and it characterizes the whole appearing world as non-ultimate, preliminary, transitory and finite.

These are philosophical terms, but the attitude in which they originally have been conceived is universally known. It is the awareness of the

deceptive character of the surface of everything we encounter which drives one to discover what is below the surface. But soon we realize that even if we break through the surface of a thing or person or an event, new deceptions arise. So we try to dig further through what lies deepest below the surface—to the truly real which cannot deceive us. We search for an ultimate reality, for something lasting in the flux of transitoriness and finitude. All philosophers searched for it, even if they called change itself the unchanging in all being. They gave different names to ultimate reality expressing in such names their own anxieties, their longing, their courage, but also their cognitive problems and discoveries about the nature of reality. The concepts in which ultimate reality is expressed, the way philosophy reached them and applied them to the whole of reality fills the pages of the history of philosophy. It is a fascinating story just as is the history of the arts in which ultimate reality is expressed in artistic forms. And actually, they are not two histories. Philosophical and artistic expressions of the experience of ultimate reality correspond to each other. But dealing with such parallels would trespass the limits of my subject.

The term "ultimate reality" is *not* another name for God in the religious sense of the word. But the God of religion would not be God if he were not first of all ultimate reality. On the one hand, the God of religion is more than ultimate reality. Yet religion can speak of the divinity of the divine only if God *is* ultimate reality. If he were anything less, namely, *a* being—even the highest—he would be on the level of all other beings. He would be conditioned by the structure of being like everything that is. He would cease to be God.

From this follows a decisive consequence. If the idea of God includes ultimate reality, everything that expresses ultimate reality expresses God whether it intends to do so or not. And there is nothing that could be excluded from this possibility because everything that has being is an expression, however preliminary and transitory it may be, of being-itself, of ultimate reality.

The word "expression" requires some consideration. First, it is obvious that if something expresses something else—as, for instance, language expresses thought—they are not the same. There is a gap between that which expresses and that which is expressed. But there is also a point of identity between them. It is the riddle and the depth of all expression that it both reveals and hides at the same time. And if we say that the universe is an expression of

ultimate reality, we say that the universe and everything in it both reveals and hides ultimate reality. This should prevent us from a religious glorification of the world as well as from an anti-religious profanization of the world. There is ultimate reality in this stone and this tree and this man. They are translucent toward ultimate reality, but they are also opaque. They prevent it from shining through them. They try to exclude it.

Expression is always expression for someone who can receive it as such, for whom it is a manifestation of something hidden, and who is able to distinguish expression and that which is expressed. Only man within the world we know can distinguish between ultimate reality and that in which it appears. Only man is conscious of the difference of surface and depth.

There are three ways in which man is able to experience and express ultimate reality in, through and above the reality he encounters. Two of these ways are indirect; one of them is direct. The two indirect ways of expressing ultimate reality are philosophy—more specifically, metaphysics—and art. They are indirect because it is their immediate intention to express the encountered reality in cognitive concepts or in esthetic images.

Philosophy in the classical sense of the word seeks for truth about the universe as such. But in doing so, philosophy is driven towards explicit or implicit assertions about ultimate reality.

We have already pointed to the manifoldness of such concepts, and "ultimate reality" is itself one of them. In the same way, while trying to express reality in esthetic images, art makes ultimate reality manifest through these images—the word image, taken in its largest sense, which includes lingual and musical figures.

To be able to show this concretely is the main purpose of my lecture, and here I feel supported by the self-interpretation of many artists who tell us that their aim is the expression of reality.

But there is the third and direct way in which man discerns and receives ultimate reality. We call it religion—in the traditional sense of the word. Here ultimate reality becomes manifest through ecstatic experiences of a concrete-revelatory character and is expressed in symbols and myths.

Myths are sets of symbols. They are the oldest and most fundamental expression of the experience of ultimate reality. Philosophy and art take from their depth and their abundance. Their validity is the power with

which they express their relation of man and his world to the ultimately real. Out of a particular relation of this kind are they born. With the end of this relation they die. A myth is neither primitive science nor primitive poetry, although both are present in them, as in a mother's womb, up to the moment in which they become independent and start their autonomous road. On this road both undergo an inner conflict, similar to that in all of us, between the bondage to the creative ground from which we come and our free self-actualization in our mature life. It is the conflict between the secular and the sacred.

Usually secular philosophy is called simply philosophy, and art simply art; while in connection with the sacred, namely, the direct symbols of ultimate reality, philosophy is called theology, and art is called religious art. The creative as well as destructive consequences of this conflict dominate many periods of man's history, the most significant for us being the five hundred years of modern history. The reduction of these tensions and the removal of some of their destructive consequences would certainly come about if the decisive point in the following considerations were established.

That decisive point is this: the problem of religion and philosophy as well as that of religion and art is, by no means confined to theology and religious art; it appears wherever ultimate reality is expressed through philosophical concepts and artistic images, and the medium through which this happens is the stylistic form of a thought or an image.

Styles must be deciphered. And for this one needs keys with which the deciphering can be done, keys which are taken from the very nature of the artistic encounter with reality. It is not my task to point to such keys for the deciphering of styles in general, or of the innumerable collective and personal styles which have appeared in history. Rather, I shall indicate those stylistic elements which are expressive for ultimate reality. The best way to do this is to look at the main type in which ultimate reality is shown in the great manifestations of man's religious experience. They express in a direct way the fundamental relation of man to ultimate reality, and these expressions shine through the artistic images and can be seen in them.

On this basis, I suggest distinguishing five stylistic elements which appear, in innumerable mixtures, in the great historic styles in East and West, and through which ultimate reality becomes manifest in works of art. After the description of each of these elements, I want to show

pictures as examples, without discussing them concretely, and with the awareness of the contingent, almost casual, character in which they were chosen, for many technical reasons.

THE FIRST TYPE of religious experience, and also the most universal and fundamental one, is the sacramental. Here ultimate reality appears as the holy which is present in all kinds of objects, in things, persons, events. In the history of religion, almost everything in the encountered world has become a bearer of the holy, a sacramental reality. Not even the lowest and ugliest is excluded from the quality of holiness, from the power of expressing ultimate reality in the form of here and now. For this is what holiness means, not moral goodness—as moralistically distorted religions assume. There is actually no genuine religion in which the sacramental experience of the divine as being present does not underlie every other religious utterance.

This enables us to discover the first stylistic element which is effective in the experience of ultimate reality. It appears predominantly in what often has been called magic realism. But because of the non-religious meaning of the term, magic, I prefer to call it *numinous* realism. The word numinous is derived from the Latin *numen* (appearing divinity with a divine-demonic quality). It is *realism* that depicts ordinary things, ordinary persons, ordinary events, but it is numinous realism. It depicts them in a way which makes them strange, mysterious, laden with an ambiguous power. It uses space-relations, body stylization, uncanny expressions for this purpose. We are fascinated and repelled by it. We are grasped by it as something through which ultimate reality mysteriously shines.

Much primitive art has this character. It does not exclude other elements, and this is most conspicuous, for its greatness has been rediscovered by our contemporary artists who have been driven to similar forms by the inner development of their artistic visions. These visions have received different names. In the development of cubism from Cezanne to Braque, at least one element of numinous realism is present. It is present in the stylo-metaphysics of De Chirico and in the surrealism of Chagall. It appears in those contemporary painters and sculptors who unite the appreciation of the particular thing with cosmic significance they ascribe to it.

All this is the correlate to religious sacramentalism. It shows ultimate reality as present here and now in particular objects. Certainly, it is

created by artistic demands, but intended or not, it does more than fulfill these demands. It expresses ultimate reality in the particular thing. Religiously and artistically, however, it is not without dangers.

The religious danger of all sacramental religion is idolatry, the attempt to make a sacramentally consecrated reality into the divine itself. This is the demonic possibility which is connected with all sacramental religion. The artistic danger appears when things are used as mere symbols, losing their independent power of expression.

It is difficult to draw the line between an artificial symbolism and the symbolic power of things as bearers of ultimate reality. Perhaps one could say that wrong symbolism makes us look away from one thing to another one for which it is a symbol; while genuine symbolic power in a work of art opens up its own depths, and the depths of reality as such.

Now I should like to mention a group of pictures which, without special interpretation, shall give you a concrete idea of what I mean about the predominance of this first stylistic element.

Since it was difficult to find among the innumerable examples of primitive art one that was especially more significant than another, I have chosen the "Figure," as it is called, by the sculptor, Lipchitz. Please do not forget, however, that it is a stylistic element which is predominant, not a special type.

Next we have Klee's "Masque of Fear" where we find a very similar expression, the stylized presence of ultimate reality in terms of awe, which belongs to all human relations to ultimate reality.

Again, another Klee—"Child Consecrated to Suffering."

Then a Cezanne—"Still Life." About this I must say something which goes back to my earliest encounter with the visual arts immediately after I came out of the ugliness of the First World War and was introduced to modern art by a friend, Dr. Eckhard V. Sydow, who wrote the first book on German expressionism. At that time I came to the conclusion that an apple of Cezanne has more presence of ultimate reality than a picture of Jesus by Hoffman (which can now be found in the Riverside Church of this city).

Next we have Braque—"Man with Guitar," which also shows elements of reality which otherwise are not seen, and in which elements of ultimate reality show through as foundations of the surface which never appear in reality on the surface.

Then we have Chagall—"I and the Village," and again it is the individual things to which I want to draw your attention as in the styl-

ization, the color, the lines, the relationship, and something I would like to be able to mention at greater length—the two-dimensionality which is not superficial but one of depth. All these express what I called presence of ultimate reality.

Then De Chirico—"Melancholy and Mystery of the Street." This and similar pictures are especially near to my heart, not only because I am interested in depth psychology, in which things like this appear as dreams or as nightmares, but because at times I think all of us become estranged from ordinary reality; and this estrangement produces a new encounter with dimensions of reality otherwise unseen.

Miro—"Composition." Now here you have nothing left but the surface: nevertheless, these elements embody a power of being which you never would find in surface reality in the same way.

Next is a picture with a funny name, which no one whom I asked, including myself, understood. It is by Tanguy, and the puzzling title is "Mama, Papa is Wounded." But I think these forms express something of the potentialities which are in reality but which never come to the surface without the realizing mind of the artist.

Now I come to a Gabo entitled "Spiral Theme." This and a few others express something very important to me, namely, the possibility that man's power of technical transformation of nature and of scientific penetration into the ultimate elements of nature is thus able to produce still another way of manifesting the creative ground of reality.

And the same in this. This is by Lippold and is called "Full Moon, Variation 7." The variation expressed in these lines is a new understanding of something which has appeared in man's mythological thinking for ten thousand years. The symbol of the moon is a goddess, and here the mathematical structure brings the same fundamental motif into another kind of expression.

RELATED to the sacramental type of religion and at the same time radically going beyond it is the mystical type. Religious experience tries to reach ultimate reality without the mediation of particular things in this religious type. We find this type actualized in Hinduism and Buddhism, in Taoism and Neo-Platonism. And, with some strong qualifications, in some places in later Judaism, Islam, and Christianity. It can undergo a transformation into a monistic mysticism of nature under the famous formula of the God of Nature. In it God is equated with nature—with the creative ground of nature which transcends every particular object.

We find this in ancient Asia as well as in modern Europe and America. Correlate to this religious type is that stylistic element in which the particularity of things is dissolved into a visual continuum. This continuum is not a grey in grey; it has all the potentialities of particular beings within itself, like the Brahman in Hinduism and the One in Neo-Platonism or the creating God in Christianity as they include within themselves the possibility of the whole world. The continuum contains tensions, conflicts, movements. But it has not yet come to particular things. They are hidden in a mere potential state. They are not yet actual as distinguishable objects; or if so, they shine through from afar as before creation.

We find this in Chinese landscapes in which air and water symbolize the cosmic unity, and individual rocks or branches hardly dare emerge to an independent existence. We find it in the background of Asiatic and Western paintings, even if the foreground is filled with figures. It is a decisive element in the impressionist dissolution of particulars into a continuum of light and colors. Most radically it has been carried through in what is called today, non-objective painting. For instance, the latest decade of American painting is dominated by it. Of course, one cannot show ultimate reality directly, but one can use basic structural elements of reality like line, cubes, planes, colors, as symbols for that which transcends all reality—and this is what the non-objective artists have done.

In the same period in which Eastern mysticism powerfully enters the American scene, American artists have deprived reality of its manifoldness, of the concreteness of things and persons, and have expressed ultimate reality through the medium of elements which ordinarily appear only in unity with concrete objects on the surface of reality.

Here also the dangers must be seen. The sacred emptiness can become mere emptiness, and the spatial emptiness of some pictures indicates merely artistic emptiness. The attempt to express ultimate reality by annihilating reality can lead to works in which nothing at all is expressed. It is understandable that as such a state in religion has led to strong reactions against the mystical type of religion, it has led in art to strong reactions against the non-objective stylistic elements.

And now I should like to give you examples of pictures of this second stylistic element.

First is the Japanese artist, Ashikaga—"The Landscape." This shows a pantheistic nature—trees and rocks barely emerging out of the whole.

Tai Chin, where it is even more powerfully expressed.

Klee—"Equals Infinity." The word infinity here expresses this going beyond of concrete reality.

Seurat—"Fishing Fleet," where the individual things are there, but they hardly dare to become fully individual.

Kandinsky's "Improvisation." I remember when I was once sitting in a house in Berlin in the 20's, there was a Kandinsky similar to this. It was really a liberation for me to be freed from the individual things and to be in a realm which at that time was very near to my own religious thinking.

Then, finally, Jackson Pollock's "No. I," and I must say I found it difficult to evaluate him, but since seeing some of his very best pictures at the Brussels Exhibition, I have become very much reconciled with this fullness of reality without a concrete subject matter.

LIKE MYSTICISM, the prophetic-protesting type of religion goes beyond the sacramental basis of all religious life. Its pattern is the criticism of a demonically distorted sacramental system in the name of personal righteousness and social justice. Holiness without justice is rejected. Not nature, but history becomes the place of the manifestation of ultimate reality. It is manifest as personal will, demanding, judging, punishing, promising. Nature loses its demonic as well as its divine power. It becomes subject to man's purposes as a thing and a tool. Only on this religious basis could there arise an industrial society like that in which we are living.

If we now ask what stylistic element in the visual arts corresponds to such an experience of ultimate reality, we must answer that it is "realism" both in its scientific-descriptive and in its ethical-critical form. After nature has been deprived of its numinous power, it is possible for it to become a matter of scientific analysis and technical management. The artistic approach to this nature is not itself scientific but it deals with objects, prepared as mere things by science. Insofar as it is artistic creation, it is certainly not imitation of nature, but it brings out possibilities of seeing reality which enlarge our daily life encounter with it, and sometimes antecedes scientific discoveries.

The realistic element in the artistic styles seems far removed from expressing ultimate reality. It seems to hide it more than express it. But there is a way in which descriptive realism can mediate the experience of ultimate reality. It opens the eyes to a truth which is lost in the daily-

life encounter with reality. We see as something unfamiliar what we believed we knew by meeting it day by day. The inexhaustible richness in the sober, objective, quasi-scientifically observed reality is a manifestation of ultimate reality, although it is lacking in directly numinous character. It is the humility of accepting the given which provides it with religious power.

Critical realism is predominantly directed to man—personally, socially, and historically, although the suffering in nature is often taken into the artistic expression of the ugliness of encountered reality. Critical realism, as, for instance, given by Bosch and Brueghel, Callot and Goya, Daumier and Ensor, by Grosz and Beckmann, shows ultimate reality by judging existing reality. In the works of all those enumerated, it is the injustice of the world which is subject to criticism. But it is done in works of art, and this very fact elevates critical realism above mere negativity.

The artistic form separates critical realism from simple fascination with the ugly. But of course if the artistic form is lacking, it is distorted reality and not ultimate reality that appears. This is the danger of this stylistic element as it also is of some kinds of merely intellectual pseudo-criticism, to succumb to a negativity without hope.

Now it would be good to look at pictures with this third element.

I never really saw the ocean, which I know and love very much, until I saw Courbet's "Wave."

Next there is the very radical "Self-Portrait With Death" by Corinth.

Then two Americans. Hopper—"Early Sunday Morning." Very fascinating for me, because it is based on experiences of the emptiness of reality and the sharp contours coming out of it.

And then the Sheeler "Classic Landscape," which shows things which are in themselves of no significance but which show reality in a way which was hidden to us before.

Now I come to the critical group. First we have Goya—"What Courage"; standing on a heap of corpses.

Then social caricature, and there is a title by Goya also—"Till Death She Will Beautify Herself."

Then something about nature. Daumier's "A Butcher." The life of man dependent on this distortion of the natural realities.

Dix—"War," which made him famous. The trenches of the First World War, of which I unfortunately have a good knowledge—and he was right.

And finally George Grosz—"Metropolis." Here you have the most radical form which also shows the dangers of it; the perhaps solely negative form of criticism.

THE PROPHETIC-CRITICAL type of religion has in itself the element of hope. This is the basis of its power. If the element of hope is separated from the realistic view of reality, a religious type appears which sees in the present the anticipation of future perfection. What prophetic hope expects is affirmed as given in forms of perfection which the artist can produce in the world of images. The self-interpretation of the Renaissance as society reborn was particularly conducive to this attitude. But it had predecessors, for instance, in the classical period of Greece, and has been followed in our modern period by attempts to renew this stylistic element.

As a religious attitude it can be called religious humanism which sees God in man and man in God here and now, in spite of all human weakness. It expects the full realization of this unity in history and anticipates it in artistic creativity.

The artistic style expressing it is usually called idealism, a word which is in such disrepute today that it is almost impossible to use. It is worse than criminal if you are called an idealist. But not only the word, the concept itself was under harsh criticism. In the period in which the numinous, the descriptive and the critical-realistic element dominated the whole development, the idealistic tradition was despised and rejected. In spite of the innumerable religious pictures that it produced, it was seen as unable to mediate ultimate reality. I myself shared this mood. The change occurred when I realized that idealism means anticipation of the highest possibilities of being; that it means remembrance of the lost, and anticipation of the regained, paradise. Seen in this light, it certainly is a medium for the experience of ultimate reality. It expresses the divine character of man and his world in his essential, undistorted, created perfection.

But more than in the other stylistic elements, the danger which threatens artistic idealism must be emphasized: confusing idealism with a superficially and sentimentally beautifying realism. This has happened on a large scale, especially in the realm of religious art, and is the reason for the disrepute into which idealism, both word and concept, has fallen. Genuine idealism shows the potentialities in the depths of a being or event, and brings them into existence as artistic images. Beautifying

realism shows the actual existence of its object, but with dishonest, idealizing additions. This danger must be avoided as we now come to attempts to create a new classicism. I am afraid that this warning is very much apropos.

Now for this stylistic element, let us look at some of these pictures, old and new.

There is Francesca—"Queen of Sheba" and "Solomon."

And there is Perugino—"Courage and Temperance." Here you see the anticipation of human fulfillment even in the title of these pictures.

Next is the idealization of paradise in a Poussin "Landscape."

In Ingres—"Study for the Golden Tiger"—we have again memory and anticipation just as I said about this kind of style; it is the style of the paradise. But we have it also in more recent painters. We have it in the blue period of Picasso under the title "Life." Tragedy is present, but in the background, and the fulfillment is shown in the form.

And finally, we have it in the form of "Dream," which is most adequate perhaps in Rousseau. It is all-idealizing anticipation of essential fulfillment, but not beautifying.

Now I come to my fifth and last stylistic element. The great reaction against both realism and idealism (except numinous realism) was the expressionistic movement. To which religious type is it correlated? Let me call it the ecstatic-spiritual type. It is anticipated in the Old Testament, it is the religion of the New Testament and of many movements in later Church history; it appeared in sectarian groups again and again in early Protestantism, in religious Romanticism. It appears in unity and conflict with the other religious types. It is marked by its dynamic character both in disruption and creation. It accepts the individual thing and person but goes beyond it. It is realistic and at the same time mystical. It criticizes and at the same time anticipates. It is restless, yet points to eternal rest.

It is my conviction as a Protestant theologian that this religious element, appearing everywhere as a ferment—and in many places highly developed—comes into its own within Christianity.

But our problem is, how does this type express itself in the visual arts? Which stylistic element corresponds to it? I believe the expressionist element is the artistic correlative to the ecstatic-spiritual type of religious experience. Ultimate reality appears "breaking the prison of our form," as a hymn about the Divine Spirit says. It breaks to pieces the

surface of our own being and that of our world. This is the spiritual character of expressionism—using the word in a much larger sense than the German school of this name.

The Church was never happy with ecstatic movements. They seemed to destroy its sacramental foundation. Society today has not been happy with the great expressionist styles in past and present because they have broken and are still breaking through the realistic and idealistic foundations of modern industrial society. But it is just this that belongs to the manifestation of ultimate reality. Expressionist elements are effective and even dominating in many styles of past and present. In our Western history they determine the art of the catacombs, the Byzantine, the Romanesque, most of the Gothic and the Baroque style, and the recent development since Cezanne.

There are always other elements co-operating, but the expressionistic element is decisive in them. Ultimate reality is powerfully manifest in these styles, even if they disregard symbols of the religious tradition. But history shows that styles which are determined by the expressionist element are especially adequate for works of art which deal with the traditional religious symbols.

But we must also mention the dangers of the expressionist elements in our artistic styles. Expression can be understood as the expression of the subjectivity of the artist, just as in the religious field, the spirit can be understood as an ecstatic-chaotic expression of religious subjectivity. If this happens in religion, ecstasy is confused with over-excitement; and over-excitement does not break through any form and does not create anything new. If a work of art expresses only the subjectivity of the artist, it remains arbitrary and does not penetrate into reality itself.

And now let us recall some examples in a final group of pictures.

Van Gogh—"Hills at St. Remy."

Munch—"The Scream."

Derain—"The London Bridge."

Marc—"Yellow Horses." I must tell you something about this painting. I was Professor at the University of Berlin in the years 1919 to 1924 and opposite the University was a modern museum in an old Imperial palace, and while I was lecturing on ancient Greek philosophy and comparing Parmenides and Heraclitus and others with the pictures of the modern artist, there were fist fights going on on the opposite side of the street. The fighting was between the lower petty bourgeoisie and the intelligentsia, and these fist fights at that time were a preview of

what would happen later on under Hitler when the petty bourgeoisie became the dictatorial power in Germany. And for this reason, these horses of Marc have a tremendous symbolic meaning for me for this was one of the paintings I had been discussing at that time.

This is Schmidt-Rottluff—"Peter and Fishermen." I am not sure of exactly how it is translated. You see much of the typical, very rough kind of German expressionism.

Now in the next one you also see the religious aspects in it—Heckel's "Prayer."

Nolde—"Pentecost." And I must confess that some of my writings are derived from just this picture, as I always learned more from pictures than from theological books.

And, finally, Nolde—"Prophet."

THE MAIN POINT in the discussion of the five stylistic elements which can become mediators of ultimate reality has been to show that the manifestation of the ultimate in the visual arts is not dependent on the use of works which traditionally are called religious art. I want to conclude with a few remarks about the nature of such works and their relation to the five stylistic elements discussed.

If art expresses reality in images and religion expresses ultimate reality in symbols then religious art expresses religious symbols in artistic images (as philosophical concepts). The religious content, namely a particular and direct relation of man to ultimate reality, is first expressed in a religious symbol, and secondly, in the expression of this symbol in artistic images. The Holy Virgin or the Cross of the Christ are examples. In this relation it can happen that in the work of art as well as in the encounter with it, the one of two expressions may prevail over the other one: The artistic form may swallow the religious substance, objectively or in personal encounter. This possibility is one of the reasons for the resistance of many religious groups against religious art, especially in a devotional context. Or the religious substance may evoke pictorial products which hardly can be called works of art, but which exercise a tremendous religious influence. This possibility is one of the reasons for the easy deterioration of religious art in its use by the churches.

The avoidance of both shortcomings is a most demanding task for religious artists. Our analysis of the five stylistic elements may be useful in this respect.

Obviously, the stylistic element which we have called numinous realism is an adequate basis for religious art. Wherever it is predominant in the primitive world, the difference between the religious and the secular is often unrecognizable. In the recent forms of numinous realism the cosmic significance of works under the control of this element is obvious, but it is hard to use them for the highly personalistic stories and myths of the religions of the prophetic type.

The mystical-pantheistic element of artistic styles resists radically the attempt to use it for the representation of concrete religious symbols. Non-objective art like its mystical background is the elevation above the world of concrete symbols, and only symbols of this elevation above symbols can be expressed in artistic images.

Descriptive and critical realism, if predominant in a style, have the opposite difficulty. They can show everything concretely religious in its concreteness, but only if united with other elements can they show it as religious. Otherwise, they secularize it and, for example, make out of Jesus a village teacher or a revolutionary fanatic or a political victim, often borrowing sentimental traits and beautifying dishonesty from the distortions of the idealistic style. This is the seat of most religious *Kitsch*.

Another problem is religious art under the predominance of the fourth stylistic element, the anticipating one. Anticipation of fulfillment can, of course, most easily be expressed through figures of the religious legend and myth. But one thing is lacking. The estrangement of the actual human situation from the essential unity of the human with the divine, the reality of the Cross which critical realism shows in its whole empirical brutality, and which expressionism shows in its paradoxical significance. Because this is lacking even in the greatest works under the predominance of the idealistic style, it can become the other source of *Kitsch* in religious art.

The expressionistic element has, as already indicated, the strongest affinity to religious art. It breaks through both the realistic acceptance of the given and the idealistic anticipation of the fulfilled. And beyond both of them it reaches into the depth of ultimate reality. In this sense it is an ecstatic style-element, expressing the ecstatic character of encountered reality. Nobody can overlook this ecstatic element in the great religious art, however different the combination of this element with the other stylistic elements may be. To show the ecstatic-spiritual character in the expression of ultimate reality in the many great periods of

religious art in East and West is a task to which the ideas of this lecture could only lay the foundation. It is enough if they have done this and made somehow visible the manifestation of ultimate reality through the different stylistic elements which appear in different relation to each other in all works of the visual arts.

PAUL TILLICH is one of the world's leading theological philosophers and is now Professor at Harvard University. Among his works are *The Courage to Be, The Protestant Era, The Interpretation of History*. The present essay was originally given as a lecture at the Museum of Modern Art in New York City (Feb. 17, 1959), sponsored by the Junior Council as a part of a series of talks, "Dimensions 1959". The essay has been published previously by *Cross Currents* magazine.

Fiction / JOHN KNOWLES

A PROTEST FROM PARADISE

ARE MANY NOVELS based on the theme of *Paradise Lost?* Are they written out of a very personal sense of longing in the novelist for a real paradise which he once knew, and a real loss he once suffered?

I think so. Let's take a mixed bag of novelists; let's take Tolstoy and Voltaire and Jane Austen. If all of them seem a little remote since we are going to discuss a personal experience in their lives, let's also take a contemporary writer, and a Yale alumnus, Thornton Wilder.

All of them have written their own versions of *Paradise Lost.* I think the reason is that early in their lives they all found themselves in paradise, in a perfect world. The weather entranced them; their own beings enchanted them; some one or ones around them filled them with joy; something they often had to eat tasted sublime; life sparkled on from day to day, limitlessly exhilarating. They naturally assumed that this was what life was like and would continue to be like; all of them possessed strong imaginations and complex apparatuses for responding to the world and so this paradisiacal experience imprinted itself on them with a peculiar force. Others around them felt it but not as strongly, not as whole-heartedly, not with such fullness and complexity. The others went on to become mailmen and emperors and opera singers and astronauts, but not these hypnotized novelists-to-be. Gazing in wonderment, in ecstasy, at this world they never made, fearless, they moved forward to their first disaster.

It doesn't matter what it was. It broke the magic closed circle of their lives, and through the breach poured all the afflictions which very sensitive natures are heir to. The perfect world they had known was overlaid, buried, smothered.

/ *Craftsmanship in the Arts*

It was not entirely lost however. It became a permanent assumption of theirs, a taken-for-granted feeling about the possibilities of life, a vision of what might somehow be, of what—whether they recalled it or not—once had been supreme human felicity. They had known it.

And now it was gone. Instead they were confronted with life as we all know it, and that was not felicitous, not supreme, and sometimes scarcely human. One of our candidates, Voltaire, was so outraged by it that he wrote an assault on all the meaninglessness and cruelty, and the result was the brilliant and savage and indestructible *Candide*. The meaningless and the cruel in life have angered many people, many gifted people; why did Voltaire feel them so strongly that he produced this extraordinary book? Wasn't it because of the sense of perfect happiness he possessed, possessed vividly and poignantly because he had once experienced it? Didn't *Candide* result from the tension between the happiness he *knew* existed in the past and the horror which equally clearly existed in the present?

Think of Tolstoy moving from the exuberant joy in natural pleasures of his early stories, through the compromised lives and lengthening shadows of *War and Peace* and *Anna Karenina*, until finally his faith in human happiness dwindled to the vanishing point and he turned to asceticism on earth and to God in heaven. Didn't he begin with an exceptional sense of natural human happiness, because he had known it intensely, and wasn't this sense worn away year by year as one phase after another of Russian 19th Century life showed itself as corrupt, gross, and evil to him?

But what about Miss Austen, so balanced and sensible and harmonious? There is none of Voltaire's savagery in her, and none of Tolstoy's haunted withdrawals either. There are no extremes. If she had known this extreme early happiness, why weren't there?

Perhaps it was because she knew no extreme unhappiness. Miss Austen was a lady. Her life was not as exposed as those we have considered. She never married but that does not seem to have struck her as a tragedy. But many things aroused her, many shortcomings in human nature, all sorts of social failings and frailties and foolishness, and she set about with the greatest persistence to point them out. Why did she? Because she saw them as causing people to miss happiness. Her characters had to go through many changes in attitude and behavior and understanding, sometimes at great pain to themselves, in order to attain, in a few cases, a rare level of happiness. She thought this happiness was worth suffering

for, worth going through years of painful effort. She felt this instinctively, assumed it as a matter of course. People, she felt, *must* want this kind of high happiness. Why was she so sure of that? Because she herself had known it.

Today there are still writers whose work springs, I think, from this deep knowledge of happiness. Thornton Wilder is a difficult choice because his writing does not ordinarily seem impelled by any one preoccupation. He has not stayed in one medium; he has spanned time from Before Christ to our century. But in much of his work he can be seen going back, back to 1912 or the 18th Century or the First Century or to the pre-Christian world. What is he searching for back there? It's happiness, isn't it, the happiness Emily learns she could not grasp or even realize when she was alive in *Our Town,* which slips through everyone's fingers in *The Bridge of San Luis Rey,* which eludes *The Woman of Andros?* Why has Mr. Wilder gone up and down the centuries, from the majestic reflections of Caesar to the erratic notions of young clerks in Yonkers, continually examining the way they approached the problem of making life yield a fuller measure of joy to them? It is because he once knew this joy, and deeply.

In suggesting this I am not for a moment suggesting a Freudian explanation of the work of these artists. I am not suggesting that the intense happiness and the later loss of it which they experienced was a "trauma", unless the normal and universal experience of maturing itself is to be called traumatic. What happened to them produced these works of art because they realized much more fully than other people what it was, and because they had the creative energy to do something about it, to make the loss very much less then complete.

Paradise Lost is a mighty theme, one that can lead to the grisly ordeals of *Candide* or the sparkling confrontations of *Sense and Sensibility.* It can lead downward to despair, or it can turn back and aspire to Paradise Regained. *Heaven's My Destination* Mr. Wilder called one of his novels. Yes.

JOHN KNOWLES graduated from Yale in 1949 and was nominated in 1961 for the National Book Award for his first novel, *A Separate Peace.* He is one of the year's most promising young writers and has been given several awards for his recent work.

Non Fiction / JOHN DOS PASSOS

CONFESSIONS OF A CONTEMPORARY CHRONICLER

FOR SOMETHING LIKE FORTY YEARS I've been getting various sorts of narratives off my chest without being able to hit upon a classification for them. There's something deadening to me about the publisher's arbitrary division of every word written for publication into "fiction" and "nonfiction". My writing has a most irritating way of being difficult to classify in either category. At times I would find it hard to tell you whether the stuff is prose or verse. Gradually I've come up with the tag: contemporary chronicle. That will have to do for a while.

The sort of novel I started to try to write in the antediluvian days of the first World War was intended to be very much a chronicle of the present. It was a chronicle of protest. Dreiser and Norris had accustomed us to a dark picture of American society. Greedy capitalists were getting in the way of the attainment of the Jeffersonian dream every American had hidden away somewhere in his head.

Three Soldiers, my first long novel, was an attempt to chronicle the feelings and frustrations of the natural-born civilian who found himself in the army. We were all natural-born civilians in the early years of this century. Now we are very much more regimented. It is hard to explain to young people born into today's regimented world how automatically their fathers and grandfathers resented the sort of forcible organization that has become the basis of today's social structure.

Manhattan Transfer which followed *Three Soldiers* was an attempt to chronicle the life of a city. It was about a lot of different kinds of people. In a great city there is more going on than you can cram into one man's career.

I wanted to find some way of making the narrative carry a very large load.

The period immediately before and after World War I had been a period of experimentation both in Europe and America. The Europeans have a sense of order and hierarchy that makes them love labels as much as the typical American tends to distrust them. Maybe trying to escape classification is one of our national vices. It certainly is mine. They called the sort of thing I wanted to do futurism or expressionism. I wasn't much interested in the labels on these various literary packages but I was excited by what I found inside.

In a war you spend a lot of time waiting around. While I was in the ambulance service in France and Italy I had managed to find time to read a certain amount of French and Spanish and Italian, poetry mostly.

The Italian futurists, the Frenchmen of the school of Rimbaud, the poets who went along with cubism in painting were trying to produce something that stood up off the page. Simultaneity, some of them called it. That excited me.

Why not write a simultaneous chronicle? A novel full of snapshots of life like a documentary film. I had been very much affected by the sort of novel that Stendhal originated in French with his *Chartreuse de Parme* and Thackeray in English with *Vanity Fair*. I remember reading *Vanity Fair* for the tenth time rather early in my life; after that I lost count. You might call these chronicle novels. *War and Peace* is another example.

In this sort of novel the story is really the skeleton on which some slice of history the novelist has seen enacted before his own eyes is brought back to life. Personal adventures illustrate the development of a society. Historical forces take the place of the Olympians of ancient Greek drama.

I had read James Joyce's *Ulysses* on my way home from Europe laid up with a bad case of flu in a tiny inside cabin down in the third class of a Cunarder. It's a marvelous way to read a book. *Ulysses* got linked in my mind with Sterne's *Tristram Shandy*.

They are both subjective novels. I wanted to produce objective narratives. I had been pretty well steeped in the eighteenth century from early youth. Sterne too had tried to make his narrative carry a very large load.

In college I had been taken with the crystal literalness of Defoe's narratives and by Fielding's and Smollett's rollicking satire. Fielding and Smollett came easy to me because I'd been prepared for them by Captain Marryatt's sea stories of life in the Royal Navy which gave me infinite

pleasure when I was a small boy. I read enough Spanish to be interested in Pio Baroja's modern revival of the Spanish picaresque style.

I dreamed of using whatever I'd learned from all these methods to produce a satirical chronicle of the world I knew. I felt that everything should go in: popular songs, political aspirations and prejudices, ideals, hopes, delusions, crackpot notions, clippings out of the daily newspapers.

Maybe these are merely the varnishes to apply to the surface. The basic raw material is everything you've seen and heard and felt, it's your childhood and your education and serving in the army, and travelling in odd places, and finding yourself in odd situations. It is those rare moments of suffering and delight when a man's private sensations are amplified and illuminated by a flash of insight that gives him the certainty that what he is seeing and feeling is what millions of his fellowmen see and feel in the same situation only heightened, seen a little sharper perhaps.

This sort of universal experience made concrete by the individual's shaping of it, is the raw material of all the imaginative arts. These flashes of insight when strong emotions key all the perceptions up to their highest point are the nuggets of pure gold.

They are rare even in the lives of the greatest poets.

The journeymen of the arts have to eke them out. A novelist has to use all the stories people tell him about themselves, all the little dramas in other peope's lives he gets glimpses of without knowing just what went before or just what will come after, the fragments of talk he overhears in the subway or on a streetcar, the letter he picks up on the street addressed by one unknown character to another, the words on a scrap of paper found in a trashbasket, the occasional vistas of reality he can pick out of the mechanical diction of a newspaper report.

It was this sort of impulse that came to a head in the three *U.S.A.* novels.

Somewhere along the line I had been impressed by Eisenstein's documentary films like the "Cruiser Potemkin." Montage was the word used in those days to describe the juxtaposition of contrasting scenes in motion pictures. I took to montage to try to make the narrative stand up off the page.

The chief difficulty you have to meet when you try to write about the world today is that the shape of society is changing so fast that the

descriptive and analytical part of the human mind has not been able to keep up with it. The old standards of good and evil have broken down and no new standards have come into being to take their place. A couple of generations have been brought up on the theory that standards of behavior don't mean anything. The basic old rocky preconceptions—call them prejudices if you want—on which a writer, whether he was for them or against them, used to find a firm footing, have been so silted over with the doubletalk of various propagandas that he can't get a foothold on them any more. You are left wallowing in the quicksand of the theory that nothing really matters. Morals? ethics? How shall we behave? Let's just pull it out of the air. An old time Christian named John Bunyan called that quicksand the "Slough of Despond."

The generation I got my education from, the generation that cut its eyeteeth on the deceptions and massacres of the First World War had a fervent sense of right and wrong. We thought civilization was going to hell in a hack, and in some ways we were right. But we did believe too that if people used their brains the modern world could produce a marvelous society. There was a germ of truth in both conceptions.

We suggested some radical remedies. The trouble was that when the remedies were tried in most cases the cure proved worse than the disease.

It was in the cards that the writing of a would-be chronicler like myself should become more and more satirical as the years went by. Satire is not the only way, of course, but it is one way of looking at the world.

JOHN DOS PASSOS received his A.B. from Harvard in 1916 and has written prolifically ever since. He was awarded a gold medal for fiction by the National Institute of Arts and Letters in 1957. *Midcentury* is his latest contemporary chronicle. His article has been previously published in the *Carleton Miscellany*.

Poetry / LEE ANDERSON

HOW NOT TO READ POEMS—A DISSENTING VIEW

THIS IS NOT A PAPER on what is wrong with contemporary poetry which is healthy, quarrelsome, complex and of decided prestige as an art form. The significant problem is how to find an adequate audience for poets. Why do graduates not carry over an interest in poetry after they leave their colleges? The other arts fare many thousand times as well. The queues are long when a new museum of modern art is opened, symphony halls are filled and over a million people listen to the "Good Music" concerts of the Library of Congress. By way of contrast let us take the last book in the Yale Series of Younger Poets, George Starbuck's "Bone Thoughts". Forty-four hundred copies have been sold in the paperback edition. That is a record and extraordinary for a book of poems, but think of it in the perspective of 70,000 alumni, of our 180 million population. It is trifling.

There is an answer to the question, a possible solution, though it may appear brash and startling at first glance. The great scholar-teachers, who have done most for contemporary poetry during the past thirty years, and they have immeasurably increased our knowledge of the tools for understanding poems, may be at fault in their emphasis on the eye as the receptive sense in apprehending poetry. Their assumption is that the mind works through the eye when in contact with poems. It does in the scrutiny of texts, in all the pursuits connected with the dissecting table, the expository lectures on imagery, metrics and structural problems of form. The pleasure principle, which is the basis of any art appreciation, is lost in the cerebral discipline.

Educated people do not go to galleries and concerts because it is

fashionable to do so. They expect and receive enjoyment. Now here is the radical proposition toward which I have been leading. It is wrong to *see* a poem before you hear it. It is a mistake to study a poem as text before it has been experienced in the true medium of poetry which is oral presentation. Our eye, in the kind of a world in which we live, has been conditioned to respond to environment in quick, nervous glances as in crossing a busy street or in driving a car on throughways. A corollary to this is our reading habits. The kind of prose offered to us in most newspapers, magazines and books is written for the split-mind attention rather than the full use of powers. That may be why our reading habits and our vision are transitory, divided and almost invariably utilitarian. We are in search of the cognitive object, something we can recognize and nod to as we do to acquaintances on the street. To know and name is not to understand. No one should read poetry at the customary pace of book and magazine prose which is usually written for the gliding eye. Acceleration is the enemy of rhythm and a distortion. [Imagine a dance recital in which all the movements of the body are speeded up as in some nightmare of cinematic action.]

When we approach arts other than poetry we slow down, arrive by way of humility at a state of respectful attention. Any one attempting to achieve an appreciation of Rembrandt, Cezanne or the new abstractionists for that matter has done so in a receptive frame of mind, a willingness to stand and look long enough so that form and content may do their work upon him. He gives the painting, unless he is a gallery trotter, a chance to communicate all he can take in, with his limited sensibilities. It may be argued that the eye is employed in that occupation. True enough. It is the only sense perception through which it is available. You cannot *hear* a painting. You should not try to *see* a poem, especially at a pace faster than normal speech. These are extremities of example.

The enjoyment principle in verse is in the "significant combinations of sound that move us in an aesthetically unique way". It is the sensuous pressure of syllables in ordered progression that gives us pleasure. Words on paper are symbols for sounds and are at one remove from the concrete actuality of the medium. The ear, in listening to poetry, receives direct sense perceptions as immediate as the odor of verbena, as the feel of birchbark and as the taste of watercress. While we are listening to a poem we are content to experience the miracle of language in melodic and rhythmic patterns without the interference of intellectual and contingent semaphores. Should any one, at this point, think I am speak-

ing for simple poems rather than complex, for rhythm at the expense of the full richness of every possible attribute and weight a poet can manage to get into his verse, let me assure that reader that such is not the case. For some obscure reason I have been called a difficult poet yet in my own practice I try for as much *sound* as I can manage.

Literature, at best, is an impure art by comparison with painting which can be free of representational elements. Content and form are ever at war in poems. The thing to be said obtrudes upon and shapes the poem. Content can be apprehended by the eye. The ear is the necessary instrument to know "form" in poems.

There is, in my argument, no wish to do away with instruction by analysis of text or sight reading of poems *after* the initial introduction by the ear alone. The poems we write today are complex. A reading by sight is a second and necessary step to full enjoyment. My plea for a hearing is to emphasize the aesthetic experience as a way to an audience for poets. An aesthetic experience in this context might be defined as a transcendence from and above the oppressively ordinary activities of our daily rounds, a complete detachment and loss of the self in another world, a realm whereby, in adult play-acting, we achieve an ordered view of fragmentary existence. *Listening* to poetry is the first rule of the game. The moment the eye lights on paper we have a tendency to skim and skip, we are in and of the world assessing and judging and bringing the intelligence to bear on problems where sense should be paramount. There is no substitute for hearing a poem if you are going to poetry for enjoyment rather than intellectual exercise. Anything less than verbal communication is a violation of the nature of the medium. It is an extension of sense by imagination rather than direct contact and cannot be, except for those rare individuals who, like certain musicians, get their pleasure by reading musical scores, a completed, fully communicated experience. It is somewhat like looking at a pretty girl's hand instead of holding it. We have moved too far away from the origins of poetry. Before the printing press poetry was oral. Since Gutenberg poems have become increasingly locked in the vise of the printed text. The answer is long playing records, reading aloud in the living room, reading in dormitories and in small groups. In the last resort one can read aloud to oneself.

Oral interpretation is acquiring the dignity of increased use, especially in out-of-classroom assignments where a listening room is available. The coffee shops in the village, the beatnik gatherings, the growth of

small groups who listen to records and to each other all show an awareness of the ear as the channel for appreciation.

Much of the syntactical difficulty of contemporary poetry can be resolved by listening. A case in point is that of a woman poet ranked by some authorities with Marianne Moore. The printed text of her poems led one well-known teacher-critic-poet to write, "This is as dull as dishwater". He had not taken the trouble to listen. The syntax is unusual, looks flat and monotonous on the page as text, but comes wonderfully to life as living speech—and without any effort to "ham" the performance and make the poems sound better than they are.

In the teaching of poetry the most useful function of oral interpretation of poems is in determination of *tone*. Tone is a key word in criticism and instruction. "The tone of a poem indicates the *speaker's* attitude toward his subject and toward his audience." We assess a man and his meaning, in the customary traffic of everyday activities, by the tone of his voice as he talks to us. Think of how many different ways the slang expression "you're not kidding" can be understood. In poems many of the free images that bridge the gap beyond vocabulary are startled into our consciousness by the voice of the poem. It is in the failure of the word, strictly speaking, that we cross over to understanding. A poem read aloud, or heard on a record, will tell us more about attitude and tone than any number of readings by eye. I use the device of listening in my recording-of-poets work. It enables me to distinguish the real from the pseudo more quickly and easily. Before an invitation is given to a poet to record for Yale I read some of the poet's work to tape. The tape playback is my touchstone for judgment.

Should there be a sudden revolution in teaching methods, should most of the teachers in most of our colleges giving courses in contemporary poetry have recourse to listening room assignments, the audience for poetry would greatly increase in a single decade. Parallel to that, creative writing courses in poetry could be multiplied many times, with the emphasis on oral interpretation. It is part of the poet's responsibility to give as much notation of tone-attitude as he can in his printed text. Poets-to-be should learn to write with oral values constantly in view. The tape recorder is an invaluable tool in this part of the work of making a poem. The poet can hear how the poem sounds, he can check the validity of his *speech* for living, breathing vocabulary. That is what the composer of music does: first the notes, then the sounds the notes represent. If the poet pleases the ear of the audience half the battle is

won. The more he has to say the more technique he needs to present his case attractively. There need be no sacrifice of imagery, structure, metric or any of the complicated apparatus by which a poem comes into being as object. My primary interest, aside from writing poems, is to find an audience for poets among the adult, civilized people who go to concerts, read the classics and look at pictures. I should like more people to read more books of poetry and to buy more books of poetry and to buy more records of poetry. Many libraries have recordings of the poets and the librarians are responsive to requests for more of them where interest is shown.

It is not sufficient to glance at the poets' column next to Donald Adams in the Book Review or to read an occasional poem in the *New Yorker*. Books and records in your own home are the answer. It is an impoverishment to be separated from poetry at the moment of graduation. There should be a lifelong enthusiasm for one of the great values of a cultivated existence. To speak of an inner life as the true measure of success in the world is to talk in clichés. It is even slightly embarrassing. Let us therefore think of poetry as significant form, bound within the miracle of the spoken language, of the sounds of words rhythmically arranged to give depth to the poet's vision, certainly a modicum of pleasure for an awakened or a reawakened interest in an art form which has priority—at least in literary prestige. We do not go to poetry for salvation or for revelation. However we can hear the word of prophecy and of damnation in the poets' voices: the prophecy of the death of the starved mind, where as R. P. Blackmur says a man lives most of his life, and damnation to the souls of the callous, the rhinocerous-skinned who root boar-like through commonplace and routine excursions into duty, into bed, board and spectator amusements.

Note.—For teacher, student or layman who would like a more detailed examination of sound in relation to literature I recommend Don Geiger's "Oral Interpretation and Literary Study." Pieter van Vloten, South San Francisco, California is the publisher of the monograph.

LEE ANDERSON is a poet and Director of the Yale Series of Recorded Poets. His most recent book is *Nags Head*, a collection of poetry.

Criticism / FRANK J. WARNKE

THE MISSING CRITIC

FROM ITS BEGINNINGS, American culture has been troubled by three recurrent and strangely opposed misconceptions of art and the artist. On the one hand, our society has often tended to conceive of the artist as a kind of quasi-official sage, a purveyor of cosy, accepted truths in a pleasant and undisturbing manner. Poets as superficially dissimilar as Longfellow and Carl Sandburg owed their immediate and wide acceptance to the fact that a ready-made audience recognized in them artist-figures which suited their own preconceptions. In only apparent contrast to the view of the artist as sage is the view of the artist as photographic realist. Given certain of the unexamined assumptions which have maintained themselves in our country—the authority of science, for example, or that distrust of the decorative which may have its origin in the Puritan sensibility—the doctrine of naive realism has long had the status of moral truth, and departures from it have often been stigmatized as "escapist" or "fantastic". The American novel and the American theatre alike have been forced to contend, with varying degrees of success, against the limitations of a narrowly conceived realism which often becomes doctrinaire naturalism.

If moral expectation and realistic bias have often tended, in our culture, to put art into one strait-jacket or another, art has often revenged itself by bursting its bonds with an energy close to the maniacal. But unfortunately, the very energy of its attempt to liberate itself has all too frequently carried it not only beyond the limits of accepted morality and official realism but also beyond the limits of art itself. Popular expectations with regard to art and the artist in America leave room, beside the artist-sage and the artist-photographer, for the artist-

beatnik-prophet—the artist as non-intellectual. America is willing to recognize, in terms of this latter mythical figure, the mighty but flawed genius of Whitman and the considerable but more deeply flawed talent of Thomas Wolfe. Unfortunately, it is willing, in terms of the same myth, not only to endure but even to applaud the ungifted howls of Allen Ginsberg and the even more distressing sound of Jack Kerouac "going blu blu blu" when he can't think of anything else to say. "Let the young folks have their fun," the popular attitude seems to be, "if they make enough noise about it they must be driven genius". They qualify for popular acceptance in terms of the third of our conceptions of what art is. The one conception of art which seems to have little historical acceptance in our culture is the conception of art as art—neither morality nor photography nor therapy, but simply the complex organization of forms into a meaningful total expression of a view of reality. Our great writers—Melville and James, Emily Dickinson and Frost, Hemingway, Eliot, Stevens, and the rest—have had to work out their craft and their vision either in exile or in a kind of desperate isolation from society which their European peers have seldom been called upon to endure.

These observations on "art" in America, it will be noticed, have to do exclusively with the art of literature. There are good reasons, I think, for this emphasis. While the widespread existence of moralistic, realistic, and anti-intellectualist biases in our country has placed the literary artist in a position of uncomfortable isolation, these same biases have placed the painter and composer, with some striking exceptions, in an almost untenable position. It is at least possible to approach literature in naively moralistic or naively subjectivist terms; it is impossible to approach the non-verbal arts in such terms. The result of doing so, if we take music as an example, may be either one of those bouncy things full of hillbilly tunes to prove that it's American or one of those beat things by people like John Cage, in which chance determines what sounds are made and thus proves the inspired individuality of the composer. In both cases the result is traceable to one or another of the American misconceptions, and in both cases the result is non-art. The paucity of American music and the relative paucity of American painting (as compared with American literature) are vivid manifestations of the most serious weakness we have inherited from our Puritan and pioneer ancestors—the unwillingness to allow art *as such* a place of validity and importance in our national life.

When we turn to American literary criticism, however, especially that of the last half-century, we find a paradoxical situation. In the heart of a culture resolutely determined to view literary art in almost any terms but its own, there has arisen a body of critical writing notable for its scrupulous attention to form and structure and its rigorous devotion to purely esthetic values. I am speaking, of course, of serious criticism—one might almost say, of academic criticism. Our journalistic literary criticism, by-and-large, is absolutely without value—for the most part, the book reviews in our daily and Sunday newspapers devote themselves either to streams of promotional adjectives derived from the jacket copy or from the same bottomless wells of slush as the jacket copy or to measuring the work in question, with all due solemnity, against the various extra-artistic standards established by our culture. Academic criticism, on the other hand, has been untiring in its investigation of the nature and structure of the literary work of art as such. One thinks of men like Cleanth Brooks, R. P. Blackmur, Allen Tate, or Mark Schorer, who have done more than any previous generation of American critics to restore to the art of literature its existence and its importance as an art, in contradistinction to its importance as disguised preachment or disguised psychotherapy. American society as a whole has been unwilling or unable to recognize the importance of art as art, but American criticism, at its best, has done all it can to redress the balance.

But all it can do, in its present condition, is not enough. However essentially right in its orientation, however unmistakably powerful in its execution, academic criticism in our country may be, the fact remains that this criticism is dangerously isolated from the broad intellectual life of the country. The best American criticism is as clearly a product for the consumption of the specialist as is most of the better American poetry now being written. The smallish but nevertheless crucially important group of Americans who are non-specialist in orientation but potentially capable of absorbing the best in literature and literary criticism remains a defenceless prey to Orville Prescott or Clifton Fadiman. The blame for this regrettable situation must be divided many ways. To some extent the temperament of the academic critic himself is at fault; the scholarly mind, with its compulsion to investigate in depth the phenomena which come to its attention, has enabled academic literary study largely to divest itself of the misconceptions concerning art which afflict the rest of our culture, but at the same time this mind, notoriously unwilling to compromise, has prevented the critic from

conveying his important and necessary insights in terms which will make sense to the non-specialized people within the culture. Furthermore, the academic critic has been so aware of such biases in his society as the moralistic and the inspirational that he inevitably has bent over backward to avoid any such errors on his part: since literature deals more overtly than any other art with specifically human values and recommendations of action, the academic critic, in his rigorous policy of non-involvement with the extra-literary, runs a double risk. In the first place, he may overlook important components of the structure which he is examining—those components which, used formally, nevertheless express the artist's own extra-literary judgments and values. In the second place, being human, he may unconsciously allow his own extra-literary biases to enter his critical examination—dangerously, because unadmittedly. In a final, rather ineffable way, the preconceptions of American culture have sometimes had a baneful effect on some of our best academic critics: the dominant position of science in our official scale of values has at times led them into the error of believing that their methods partake of the objective validity of science and into the crime of believing that their individual critical studies have a value comparable to that of a true artistic work. For the value—and it is indispensable —of a good critic's work as a whole depends paradoxically on the critic's awareness of the essentially ancillary, essentially humble relation of his individual works to the artistic entities which they illuminate.

But I have said that the blame for the lack of communication between our best literary critics and the non-specialist audience which they might potentially reach is a divided blame. Although the critics themselves are in part at fault, the society, in its bland self-satisfaction, is obviously much more at fault. The academic critic, by definition a teacher, could potentially teach a whole segment of our population outside the universities, but to teach one must have a willing student. The students might be there, if the channels for reaching them were there, and here we come to another aspect of the situation—the scarcity of good organs of critical expression in our country. We have, to be sure, a number of excellent literary journals as such, but they remain largely organs of communication for the initiated, for the already convinced. Of general publications comparable to the great European journals of opinion which circulate so widely in England, France, Germany, and Holland we have next to nothing. *The New Republic, Commonweal,* and, to a lesser degree, *The Reporter* fill something of this function, but

their limited circulation and their primary emphasis on politics and social questions prevent them from exerting a very powerful influence on American attitudes toward literature and art in general.

If the academic critic himself is not particularly inclined to address any audience but the specialized, or to utter his criticism in any terms but the most technical, if the society as a whole is not interested in serious criticism and is quite smugly satisfied with its inherited and inadequate view of the nature of literature, what hope is there for any change? There is, I believe, considerable hope. Such critics as Edmund Wilson and Lionel Trilling, whatever the varied eccentricities of emphasis of which each is occasionally guilty, have long since established a pattern for a mature criticism which is esthetically centered yet fully engaged with human and social values; such younger critics as Randall Jarrell, Irving Howe, and Robert Brustein have developed the same pattern with distinction. More significantly, a whole generation of readers has grown to maturity since the group rather imprecisely known as the "New Critics" revolutionized the teaching of literature in our colleges some two decades ago. Those of that generation who retain any vestiges of interest in literature can scarcely read J. Donald Adams with much sense of enlightenment; they must, indeed, be quite ready to respond to any sound, esthetically centered, nonspecialist criticism which comes their way. And it will, I think, come their way. For, just as a generation of readers has grown up trained to the at least potential recognition of literary art as art, so too a whole generation of critics is in the process of making its appearance—trained by the same masters in the same recognition, but perhaps less reluctant to undertake the chancy business of full commitment of their critical faculties to the social milieu and to human values as a whole. When enough of them—or a few good enough—find their voices, I think it likely that even the monolithic publication world of our country may stretch a little, that demand itself may create new journals of general opinion or expand to greater importance those which now exist—journals which, without being specifically aimed at the artist, the scholar, and the critic, could give ample play to the functions of each.

The implications for the future of our national literature, if I am not too optimistic, are immense. For a healthy criticism which remains centered on artistic values and yet communicates these values to a relatively large audience could perhaps achieve not only the establishment of a mature and sophisticated audience for the literary artist but also an atmosphere in which that artist could grow and work not in utter

isolation but with a sense of possible recognition, understanding, and involvement. The missing critic has not yet appeared, but both his audience and his subject matter are, I think, ready for him.

FRANK WARNKE graduated from Yale in 1948 and has been an Assistant Professor of English there since 1954. His *European Metaphysical Poets* will be published later this year.

Music / ELLIOT CARTER

AN ARTIST'S RESPONSIBILITY in society has many sides, yet, however one defines it, whether he should produce art for the intelligent public, or produce art for its own sake, disregarding the public, the composer has an added problem, that of the uniqueness of his field. First, it often seems that a composer's responsibility is almost self-invented, because he seldom receives the kind of compensation for his skill given to other highly trained specialists whose work is considered of social value. Also, unlike products of the other arts, with the exception of the theatre, a work of music needs a performer for its presentation to the public. Unlike the theatre, however, it does not use words which can be read away from the performance, but a notation which requires special training to understand.

Since the familiar material of everyday life is not the point of departure, music remains like a foreign language to many people, with a grammatical structure they know is there, but which is meaningless to them until it becomes familiar. To others it resembles a game, the rules and procedures of which they cannot grasp. The solution to these situations comes with effort, if it does not come naturally.

The composer, to be a responsible artist, must abide by two things; professionalism and invention. Professionalism here is not meant to imply an image of an old-fashioned conservatory where standard styles are taught to composers who are all expected to write the same way, but to convey a sense of the background of the music profession, and the standards that great works have set up. The composer then uses these as not only a standard of quality for writing music, but in their own variety and inventiveness, a standard of invention for himself. Another facet of this

rich inheritance is that it gives the profession a continuity within itself, and before the public.

The responsibility of the composer, then, is to write music that maintains the quality of the classic works, a quality that gives the music profession its value to the public, and to present his ideas in a performable way. The composer uses the performer's developed skills as his vocabulary, just as a poet uses words.

This last function is most important to the performer, because his success depends upon having a work he can present convincingly. It is the composer's work that allows the performer to display his skill on his instrument, justifying all the time and effort he has spent in preparation for this.

Therefore the responsibility of the composer is primarily toward his ideas, his profession and the performers who interpret his work, and secondarily to the public, through the performers, using the vehicle of a performance.

Several attempts have been made to eliminate the performer, and deal directly with the public. Mozart's three compositions for mechanical organ, K. 594, 608, 616, are some of the most convincing examples of this, perhaps because their composer goes to musical extremes in order to simulate the vividness of live performance. Probably, unless their modern counterpart, electronic music, can give the impression of live performance, as mechanical reproductions like recordings do also, it cannot hold the interest of the public and musicians.

While it is often assumed that the composer's aim should be acceptance by the public, yet, even in the public's own interest, it is finally more satisfying if outstanding works are produced, although not immediately accessible, than if works are written that provide easy entertainment, but are soon forgotten. Good music is written only by the composer who has been educated to produce works of similar durability to the classics, no matter how different his conceptions and methods. There has to be a central core of expression, logic, order and respect for the performer that can only be learned by professional training, or close contact with it.

Unlike any previous time, the twentieth century, apparently, has established a deadline (around 1900) after which no music is considered worthy of being accepted into the standard professional repertoire. Hence the public has seldom had the opportunity to become really familiar with the important works of our time, since the latter have so often been treated as novelties and given few performances, inadequately

prepared. Under these conditions, composers, often, cannot experience many differing live performances of their works, and dare not venture beyond standardized routines.

This is particularly true in America, where there is no state support of music. In many European countries, where there is a long tradition of such support, contemporary composers seem to fare much better. Therefore, American composers with original and unusual ideas very often have to seek performances in Europe, where adequate rehearsal can be given them. But, being outsiders, they can never hope to get the experience of numerous performances there.

Until those interested in American music have enough interest to deal with the problems of professionalism with a dedication and an intelligence adequate to the musical situation, American composers will not be able to develop to their fullest extent, and we will continue to skim the cream off European music.

ELLIOT CARTER is Visiting Professor of Music at Yale teaching Music Theory. He is a graduate of Harvard and studied in Paris under Mlle. Boulanger. He has taught at Columbia and at St. John's College at Annapolis as well as at Yale. In 1959 he was awarded the Pulitzer Prize for Music.

Theatre / NIKOS PSACHAROPOULOS

THOUGHTS ON FORM AND CONTENT IN THEATRE PRODUCTION

RECENTLY I SPENT SOME TIME on the Continent observing theatre rehearsals and attending performances. I gradually reached the conclusion that in spite of technical proficiency, unions, financial requirements for production, all of us in the field, the trade, the profession or the art of the theatre are confronted with the same basic problems. Most prominent among them is the unwilling choice between formless content and meaningless form. That is to say, a theatre that has either lost its flexibility and form potential through a single-minded preoccupation with life-studies or a theatre so steeped in artistic exhibitionism that it has become void of significance, of the richness of human experience.

The nature of this problem is further complicated by two factors—the first is the lack of comprehension of the problem on the part of the artist (director, actor, designer); for it is never intentional that either form or content is ignored. Many propose that the form will emerge through the logical and realistic investigation of content, while others assume that content will result from the precision and excitement of form. The second complication arises from the fact that the problem is in us, the interpreters, and not in the nature of the material, the play text. For the significant contributions of past theatre epochs have grown out of human needs and emotions, ideas and ideals—in short, human experience—and the playwrights of the times developed forms capable of translating experience or content into a theatrical cosmos.

In Madrid, Lisbon, Athens, Rome, Paris and—to a lesser extent—London, a great deal of the productional activity has been reduced to *jeu theâtrale*. The directors, actors and designers have discovered and

emphasized the immense possibilities of theatrical appearance. Scenic extravagance and effects, the use of non-verbal plastic values (such as color, light, texture, sound) , the potential for auditory and visual pyrotechnics on the part of the actor, have become dominant ingredients in theatrical presentation.

In Madrid I watched the declamation of *Cat on A Hot Tin Roof*; in Athens I was fascinated by the Rockette precision of a Greek chorus; in London the exploitation of moveable filing cabinets in *Rhinoceros* was endlessly enchanting; and in Paris I found myself clay in the hands of a leading lady who made all her stage crosses full front in order to maintain constant rapport with the balconies, and turned her tirades into lovely, arias. Yet all these impressions interfered with my proper intellectual and emotional appreciation of the material.

Before I go on, may I make it clear that these non-verbal values (Aristotelian "spectacle") are fundamentally important for the successful presentation of a play. Indeed, we may go even further and say that any successful play lends itself to a highly theatrical treatment. The vocal and physical pattern of the choral odes, the snakes in the hair of the Furies, the incense-rich ritual of prayer, the chariot entrances of war heroes in the Greek plays—all are elements that require exciting form. The same is true of the battles, the ghostly manifestations, the plays-within-plays in Shakespeare; the mistaken identities, the banquets, the chases, the asides to the audience in Molière. And even in our own relatively unglamourous century, writers like O'Neill, Giraudoux, Miller, Anouilh, Williams and Wilder are practitioners of formal magnetism.

My objection is one of proportion rather than of the presence of these theatrical elements; their presence is admirable when it is appropriate to the substance, the content, expressed through form. Otherwise, the spectator-listener becomes involved with the *how* rather than the *what,* artistry becomes an end in itself, and the author's desire to express and communicate human experience (the Aristotelian "imitation of an action") remains in the periphery of the artistic phenomenon.

Parallel to this triumph of productional form over matter, although emerging from a different source, is the trend represented in the presentation of the classics by most—*but by no means all*—colleges and universities. There, form is paramount, not out of an esthetic philosophy or conceptual experimentation, but rather out of an insistence that textual grandeur can be rediscovered through archeological accuracy,

through what has come to be known as the "historical style" of the play. Hence the abstracted decorative pattern of human forms in an amphora or a lykithos has served as a templar rather than an inspirational point of reference in the shaping of a Greek production; the effeminate use of fans, lacy handkerchiefs and high heels have become synonymous with Restoration dramaturgy; Commedia del'Arte *Lazzi* with Molière; slides, signs and symbols with Brecht. Thus, archeological research has been confused with creativity, the proximity with human thought through the ages has been alienated by what is foreign or exotic to us, and the great classics constitute a popular anathema or have to be heavily subsidized.

At the other extreme, and equally unintentional, is the tradition of theatre resulting from what has been called—erroneously—"the Method". Erroneously, because Lee Strasberg (who carries on the Stanislavsky tradition at the Actors' Studio) would never minimize the importance of form in theatre. I have often heard him remark: "You have found the truth in the scene but not the drama." So here we are dealing with those who misunderstand Strasberg, the Studio and Stanislavsky and those zealots whose one-sided approach to the textual material has resulted in the omission of form in theatrical production.

This trend in theatre, which claims New York as its Mecca, has glorified the ordinary by recording or capitalizing on episodes from everyday life.* It has further resulted in the confusion of what is real with what is natural. An event may be "real" in a theatrical sense, that is, it may be coherent, logical, justified, motivated. In short, an event which *could* happen but might not necessarily *have* happened. On the other hand, "natural" in this theatrical trend or school implies the proximity of an event to the routine, the everyday, the ordinary. Earthquakes, storms at sea, a brilliant dawn or a wild rock formation are also "natural" phenomena, however, albeit unusual (periodic rather than continuous occurrences). Thus, great texts have been dwarfed and robbed of their inherent form and scale because the interpretive artists were unable to recognize in their material those moments, events, relationships which could not be fully rendered without a complete exploitation of their form-potential.

This delicate problem of form versus content has become even more intangible through the naive assumption that the playwright's created

* This trend obviously excludes the foreign-influenced productions and imports such as *Ondine, Tiger At The Gates, Becket, The Visit, et al.*

world is crystalized upon the completion of the script. If this were the case, the reading of a play would be as exciting as its production. This confusion is due to the material involved. In music, for example, no one would ever assume that the whistling or humming of a score—a combination of notes—is as alive as its performance by an orchestra. In theatre, however, since we deal with words, lines, sentences—symbols familiar to everyone—we tend to underrate the contribution of the interpretive artist. We tend to forget that actors and directors and designers use their own imagination and experience to help them discover the color, the thought, the content behind the textual evidence. Then in turn they try to present these in an immediate and communicable form. The set designer tries to capture and organize the environment in which the characters act and react (live) ; the costume designer makes "costumes" out of "clothes"—items the characters would wear are translated into a coherent artistic pattern. The actor brings from his own world his personal and specific needs and desires—and it is when the actor's objectives coincide with those of the character he portrays that a brilliant performance results. Finally, the director anthologizes the various feelings of the actors, the creative impulses of the designers, keeping the overall interpretation and progression of the script firmly in mind, and organizes creatively all these heterogeneous elements into a definite, specific, homogeneous entity—a theatrical world ready to be shared with an audience.

By now it is no secret that I do not believe in the emphasis of either form or content at the expense of one or the other and that I do not suppose that the slice of life is sufficient motivational source material to generate an exciting theatre form or a brilliant production style. By style I mean the unique and personal attitude in the translation of a text into theatrical reality. I believe that production "scale", this larger-than-life style of presentation can create genuine excitement in the theatre, but it requires more than body and voice training in an actor, and more than culture and refinement of taste in a director. It requires a seeking into life, its experiences, its rituals, its tribulations—those unusual events which enable the interpretive artist to heighten his expression of reality.

New York's gang wars, the sit-ins in Atlanta, the Chessman case, the exorcism of Dybbuks, revival meetings, the bare-breasted walk of Lumumba's widow in Leopoldville—all these are as real occurrences in

our daily lives as "what are you going to do tonight, Marty?" "I don't know, what are you going to do?" "Oh, nothing."

Nothing exciting or meaningful in concept and form can come out of the absence of feelings, ideas, emotions. So, for an exciting theatre, to see, to touch, to smell, to taste, to *live* should be our training. For style— as one of my students put it—is inner spirit and not superimposed form.

NIKOS PSACHAROPOULOS teaches directing at the Yale School of Drama and in the Summer is the Executive Director of the Williamstown Theatre Foundation, Inc. For the last few years Professor Psacharopoulos has directed the *Play of Daniel* for the New York Pro Musica Antiqua which represented the United States in Paris' Theatre des Nations.

HAPPY ENDING

THE GOOD NEWS that has come barreling in on the crest of *la nouvelle vague* is that the long, quarrelsome, and never very fruitful marriage between books and movies may be breaking up at last. God knows the breakup is decades overdue, for the two parties are by nature incompatible; theirs has been one of those unlucky unions which, when it finally ends (the parties themselves being by then too exhausted even for acrimony), leads friends on both sides to say, "Well, but they never should have got together in the first place." Tiresome wisdom! Of course they shouldn't have, but the question of an alternative didn't come up. The marriage was based on rape—the necessary, accidental rape of literature by film. I say necessary because almost as soon as pictures began to move there were plenty of glove salesmen, pimps, and other small businessmen on hand to perceive that this charming toy could be turned into real coin, and accidental because those gogetters knew nothing whatever about literature and only fell upon her because she was there and because nothing else would serve their purpose.

The difficulty was that our grasping friends had done so well in exploiting the novelty of film. (In the world of business, it appears that too quick a success is as sound a reason for panic as none at all.) They had been rendered desperate by the discovery that movies—like TV half a century later—were capable of passing practically overnight from a brilliant invention with no telling how diverse a future to a big business whose future could be limited largely to making its owners rich. In the light of that enchanting discovery, they had to act fast and crudely. It was plain that there wouldn't be time for film to fiddle

and fumble about, as other new-found arts had done, to determine its natural means of expression and self-nourishment. Its audiences having sated themselves on the marvel of seeing leaves blown by the wind, water run over rocks, birds fly, and men walk down streets and tip their hats to ladies, something much more complex had to be provided; after all, a miracle is only miraculous if it happens *once,* and surely even among the Apostles there were those who grumbled, "Ya seen one, ya seen 'em all." It looked as if a record of real life, which is the seemingly modest but in truth not at all modest thing that film can do supremely well, wouldn't suffice for long at the box-office. To encourage the exploration of its possibilities would be throwing money into the gutter—a distasteful thought to men who, in many cases, were just crawling up out of it, on their way to bossing what would soon become the motion picture industry.

An obvious substitute for real life—the theatre—lay waiting to be plundered by the new medium, and radically plundered it was; and when a couple of thousand years of theatrical writing in half a dozen languages threatened to be gobbled up by the insatiable giant infant, the field of the novel, which the theatre itself had always been willing to trespass on, was invaded and made to yield as much material as it could, in however distorted a form (and at prices that, however big or small, invariably satisfied the silly, greedy authors—not only business-men are the villains of this piece). Thus it was that books and movies got married and have lived unhappily together ever since, to the continued grievous injury of both.

This ill-matched pair might have struggled on in grumbling wretchedness till kingdom come, except for an unexpected accident: the money began to peter out. A weird stranger called hard times hit Hollywood and down it went. *La nouvelle vague* and all the other wavelets, foreign and domestic, that now lap the shores of our attention have been able to do so mostly because the motion picture industry is on its knees, if not on its back; the possibilities of film are being reasserted and reexplored on many fronts at least in part because on the home front the tired old probabilities are visibly withering away. TV is killing the last tycoons and this murder most fair is helping to bring movies back to life. I feel safe in predicting that what has been the standard Hollywood product—a big, vulgar boffo of a picture, full of famous stars, and, ideally, based on a celebrated best-seller ("Butterfield 8," "Ben Hur," "Cimarron") — will disappear, to be reborn in TV, for TV's deadening purposes; and

movies will have the freedom to be as fresh, bold, and cranky as they should have been all along. "Wild Strawberries," "The Four Hundred Blows," "Hiroshima Mon Amour," "General Della Rovere," "Breathless," "The Love Game," "La Dolce Vita"—surely these recent successes are manifestations of the new life that film is proving itself capable of, and you will notice that all of them are conspicuously divorced from literature. They are not translated, well or ill, from some written original, good or bad; they spring from and lean upon nothing but themselves. In this connection, it is pertinent to quote Ingmar Bergman, who has said, "I myself have never had any ambition to be an author. I do not want to write novels, short stories, essays, bibliographies, or even plays for the theatre. I only want to make films about conditions, tensions, pictures, rhythms, and characters which are in one way or another important to me." Pertinent too are the well-known words of Federico Fellini—quoted by Siegfried Kracauer, in his recently published "Theory of Film"—to the effect that a good picture should not aim at the autonomy of a work of art but have mistakes in it, "like life, like people." The great fertilizing and liberating discovery for film in this decade is a rediscovery: the fact that writing and movies have practically nothing to do with each other, either formally, in their structures, or emotionally, in the effects they seek to achieve. Mr. Kracauer hints at their intrinsic unlikeness to each other when, with commendable bravery, he calls film and tragedy incompatible. "If film is a photographic medium," he says, "it must gravitate toward the expanses of outer reality—an open-ended, limitless world which bears little resemblance to the finite and ordered cosmos set by tragedy . . . the world of film is a flow of random events involving both humans and inanimate objects . . . works of art consume the material from which they are drawn, whereas films as an outgrowth of camera work are bound to exhibit it. However purposefully directed, the motion picture camera would cease to be a camera if it did not record visible phenomena for their own sake. It fulfills itself in rendering 'the ripple of the leaves'. If film is art, it is art with a difference."

Bravo to all this, and with our bravo a sigh to reflect that it could have been said (and occasionally *was* said) fifty years ago, though for economic reasons to no avail. For the first time since it was invented, the motion picture is free to be itself, free to exhibit the materials out of which it is created, while the novel and the play and all the other written forms of art are free to go their ancient, accustomed ways, joyously consuming their materials and never for a moment being betrayed

into falseness by the prospect of a possible future nuptial flight to Hollywood. The not very long history of motion pictures has been mainly a heartbreaking bad joke, with businessmen-comedians constantly bursting bladders over the head of Art, whose name they would invariably capitalize as a sign of mockery. Now a new order of businessmen-comedians are taking over and breaking up TV, and the lower-case art of film is launched on what is at once a happy ending and a fresh start.

BRENDAN GILL was Chairman of the LIT before his graduation from Yale in 1936, and has been an editor of the New Yorker since then—at present writing movie reviews in addition to editorial duties. He received the National Book award for the most promising young writer of 1951 for his first novel, *The Trouble of One House*.

Television / HENRY MAY

ALICE IN MALICELAND

THINK OF THE UNITED ELEMENTS which help you comprehend a play. Your view of the stage is fixed and unbroken; you sit in darkness while your attention is drawn to an area which is lighted accurately and dramatically; the color is lifelike and beautiful; there is quiet all about you, and the sound reproduction is true because it is immediate.

You are now in your own study watching a television performance of the same play. Your view of the television set may be unbroken but your view of the players is not. Camera movements are an ever-present menace to the meaning and clarity of the words being spoken by the actors. The room in which you sit is fully lighted, revealing objects of a variety of sizes, shapes and colors. Lighting which is correct for a fixed viewpoint is here fuzzy and for the most part undramatic. The picture is squeezed into a tiny frame; there is often a lack of focus in either pictorial selection or in choice of material and, as a final outrage to your vision, there is no color. If color is present, pink rooms may turn pea-green before your eyes and become peopled by a tribe of purple-nosed strangers.

As if this were not enough violation of your senses, at a crucial moment of the play the screen goes dark and you suddenly find yourself in a gleaming modern kitchen watching stains being removed from a sink. Then back you go to the climax of the play. Just as your attention is again fixed on the screen, a juvenile voice from somewhere in the upper regions will demand a drink of water or some other attention.

Exaggerated? Not at all. This is the kind of half-attention usually given the best to be offered by the most exciting and powerful medium of

communication devised by man. Between the too-jittery eye of the television camera and the too-casual concentration of the television audience, a taut, dramatically valid scene can lose all sense and sensitivity.

As in other forms of communication, there are many classes of television. In the pursuit of excellence there is no democracy nor is there room for it. Good craftsmanship contains many elements. A cook in my father's house once answered when asked for a special recipe, "Missy, when you puts in good, you takes out good." In this formula lies the secret of excellence. It covers talent, style, taste and, in television, recognition of the limitations of the medium.

Once one recognizes and adheres to the peculiar restrictions of television, one has a basis for production; for in these physical limitations can lie the greatest advantages of the medium. Of all these limiting factors, size is the most important, not merely in size of picture but in that of idea and language. Television is of necessity introspective, small in scale, intimate. Therefore, to be successful a production must be "in focus"—in scale with the medium, examining, probing, exploring an idea until a perfect essence is distilled from it.

Although lack of color is not a deterrent to television any more than it has been to fine photography, it must be recognized as a limitation. There must be a balance of grays, blacks and whites and, because of the size factor, a simplicity in tone, design and camera movement if the drama is to assume proper focus and artistic quality. As television cannot erase the physical distractions of its audience, it must offer its own distractions, subtly but forcefully. The more in focus to the medium a show is, the simpler the theme and manner of illustration, the better chance it has of success.

Remember, the invention a few years ago of the television "spectacular", with its gross denial of the scale factor and scope of content. Never was a form of communication or art so violated. Focus of idea, taste and thoughtful content were left by the back door while an incoherent, garish, expensive bigness came in the front. The result was a kind of Hogarthian scene reminiscent of an insane woman dancing the pas de deux from "Swan Lake" in the day room of a mad house. It lacked, however, the style and wit of a Hogarth.

When the power of television is considered, the medium must be broken into three classifications: as a source of information, as entertainment, and as propaganda.

Television cannot be surpassed as an information medium. Think back to the last election campaigns. How much more forcefully could the qualities of each candidate and his supporters reach voters? Think then of the election returns and how exciting the immediacy of this reporting was. Remember the Army-McCarthy hearings, Elizabeth II's Coronation, President Kennedy's Inauguration; think of weather maps and political maps; of the faces in the news. Finally there are sports events which, in a sense, make a bridge between information and pure entertainment.

In the creation of a live or taped entertainment, all the elements of craftsmanship should combine with taste and style. In the production of good television entertainment, taste is never more apparent than in the matter of choice and in knowing when to stop. Appreciating style or even being aware of its existence is a sometime thing. In arts like painting or writing it can be developed. In television production style *must be chosen*, style which enhances or strengthens that of the writing. When style is ignored, the results are particularly disastrous. In a curious way, the wrong style or lack of point of view seems worse in television than in any other medium. Bad television becomes a guest in your home who has appeared on the wrong day, in the wrong costume, with the wrong speeches. It is as insistent as the guest and will not allow itself to be put at ease, so one may only be charitable and turn it off.

In a Shakespearean series on television this year, the producers curiously chose to ignore the scale of the language and the quality of the poetic images evoked. The style of complete realism with all its attention to detail results in drama similar to an Odets' play of the 1930s, while the language bursts from the seams of the production. The actors seem to be performing for each other or, when alone, soliloquize as though yelling in a closet. This is an unfortunate example of choice of the wrong style coupled with lack of taste. Telling us, as television critics do, that we are lucky to have any Shakespeare at all on television is like telling a man to be happy that he's poor.

The use of television as propaganda, and the magnitude of its effect is self-evident. Had television existed in the 1930s, Hitler's rise to full tyranny could have been effected years earlier. Fortunately, this terrible power of the medium has not been utilized to any great extent. In the United States, commercials take the place of propaganda television but they are, in varying degrees of honesty, one and the same thing.

All three types of television have a danger potential, not only in reaching millions of people simultaneously but in forming their tastes and

habits. Who then is responsible? Networks, agencies, sponsors, public—all four, like the animals in the story of The Little Red Hen, want to eat the loaf of bread but no one wants the honest task of baking it.

Networks, like all major businesses, are organized primarily to make money for their stockholders. Well-motivated in a business sense, they encourage and frequently produce shows which rattle the cash box temporarily. Claiming that the public is fickle and/or ignorant, they are equally responsible with agencies and sponsors for the plethora of "family shows", westerns, and studies in violence. There is apparent in this approach to television the "Give'em what they want" philosophy. Who really knows what "they" want when "they" are never given a chance to want anything else? This easy irresponsibility ignores the basic fact that one must create a good product in order to profit by it. To decide that a show is right to broadcast because "that kind of thing makes money" is thinking backwards and results only in temporary public interest. The faint cry of inevitable failure can be heard through the first canned laugh. The breaking of a dramatic, tried-but-not-necessarily-true pattern is shunned as a special form of madness.

The three techniques which networks employ in determining what your television screen will carry are the time-slot wedge, the one-for-one philosophy, and the fostering of their own productions. All three combine to frustrate and control advertising men and sponsors who may be willing to risk a great deal of work and money on a new product. When a request for the purchase of a particular slot of time is made, the three techniques come into play. The time-slot wedge philosophy consists of, "Yes, you may buy the eight-to-nine spot on Wednesdays but the network cannot afford to carry a program on mankind's future in an atomic world when *Hawaiian Blast*, starring Rex Reason, is playing at the same time on our rival network."

Then the second technique, the one-for-one routine, arises. The networks pressure or even threaten to withdraw the time from the client unless he toes the line of Competition by Imitation. This is immediately coupled with the third pressure when the sponsor finds that the network "happens" to have a series in its film bank with all the qualities of *Hawaiian Blast*. It is evident that if he buys this show, the restraint of his trading will be lifted and he may have his time slot. He is assured that the show is better for him anyway. The appeal will be even greater than that of *Hawaiian Blast*, for this series takes place in Hong Kong and stars, instead of two pompadoured male adolescents with a convertible,

three bouffante female adolescents with a sports car. So a deal is made— the network man departs, happy to have combined the selling of time with the unloading of a filmed series fathered by the network; the agency man (who may have been in on the secret all the time) is secure in his profit; and the sponsor convinced that this show is what he really wanted all along.

The responsibilities of the networks should lie in the area of time sales alone. It is true that news coverage and public service programs are beautifully produced by network public affairs departments, and I would not like to see their demise. However, if the temptation to dabble in commercial production were removed and the efforts of a network staff were concentrated on selling time properly and intelligently, there would be a very different picture on your home screen. With time selling goes an obligation to see that it is well-balanced and programmed. After all, there is a limited amount of time to sell and many bidders for each moment of it. The picture would be drastically different were the question altered from, "Is it what they want?" to "Is it really good?"

Agencies, the handmaidens of networks, use the one-for-one and the "Is it what they want" philosophies as their criteria of worth, adding one interesting element, a shopper's guide for a prospective client, called a "Rating". This poll is supposed to be a fairly accurate numerical accounting of the audiences for individual shows and is used, naturally, as a pressure tool in buying and selling them. Statistics on a printed page are impressive, especially when there is no way of checking their validity. No one seems to think of the story the ratings never tell. Do all these people watching the shows watch the commercials? (A water consumption survey in a large eastern city showed vast outpourings at regular quarter and half-hourly intervals during evening hours.) Does an interest in a show indicate an interest in a product? (Will a man who regularly buys Cadillacs change his habits after watching Dinah Shore sell Chevrolets? He may like her, not the cars.) Children may watch adult programming. People may have a set turned on but ignore it. What audiences carry away from a show cannot be recorded on a graph. Ratings, like the Easter Bunny, are a childish symbol, a comforting idea that no one wants to lose. Facing reality can mean a loss of security. The largest responsibility of the advertising agencies is to forget their cynical contempt for people by finding out what their tastes, habits and desires really are. Numbers are worthwhile only when related to ideas. Agencies, through their experience in advertising research, know that a product

that is consistently good will sell. They also know that a break in pattern attracts attention and interest. They should apply this knowledge to creativity and experimentation in television. Must commercials assault our senses before we buy a product? Must logic be ignored and good taste violated?

Sponsors, caught between networks and agencies, are far from innocent of the game, and follow the same lines of business as the other two groups. They pretend to believe in ratings; they yield to pressure in buying time and are even told what they want! Most sponsors have an astounding contempt for the purchasers of their products. All three groups—networks, agencies, and sponsors—are like guests at a Borgia banquet, enjoying themselves while wondering if the next morsel will be the fatal one.

The fourth member of the groups responsible for the condition of television is the public. It too is at the banquet though it sits below the salt and has no audible voice in the proceedings. It does, however, have a power that is mightiest of all. In this group sit the listeners, the watchers and the buyers. When we stop being television snobs, all-day suckers or quiet complainers, the scene on the screen will change. We must use our responsibility for selection and for the fine art of effective complaints.

We choose our children's books, foods, and bedtimes but we let television claim them indiscriminately. A determination is needed that it is even more important to select what goes into minds than to choose what goes into stomachs. We may refuse Johnny a cookie and be completely unaware of the fact that he is watching the St. Valentine's Massacre. One major responsibility of possessing a television set can be met by a simple physical act, that of twisting the wrist and sending the undesirable idea into oblivion, an exercise too few of us practice.

The fine art of complaining is one which the public may begin to practice again. We have been so immersed in conformity that the idea of active protest at first seems repugnant because it makes one "different". Along with a new force of governmental activity can come a public vitality, the strength of knowing what we want and of stating it vehemently. Perhaps there will again be campaigns of letter writing, telephoning and telegraphing. This public voice is the only one which can truly influence the purveyors of television; their very business lives depend on it.

In considering the directions television may take, the medium must

be divided into three catagories: commercial, educational and pay television.

Commercial television will, one hopes, improve in quality. An exciting future can result from international broadcasting, for with the development of rocket satellites it will soon be possible to broadcast a television program from any part of the globe to any other part. For example, a performance of the Royal Danish Ballet could be picked up in Copenhagen and instantly broadcast to any city in the world which had arranged to receive the program.

We may hope that commercial broadcasters will take some responsibility for the development of the crafts and talents necessary to produce effective television shows. There is now an unfortunate lack of good writers in the field. One realizes with a shock that were Shakespeare alive today he would certainly be writing for television, the most popular medium of its time.

Pay television is difficult to assess. Will people pay for something which, in theory, they received formerly for nothing? I say "in theory" because the stress in pay television has been more on quality programming than has it been in commercial television. If pay television is accepted on a large scale, what will happen to our social lives, to the ritual of going to the theatre? Will people have theatre parties in their own homes? Will eating and clothing habits change? What will happen to theatres, movie houses, night clubs? At present, pay television is controlled by motion picture and theatre people who are turning their own productions into pay-television shows. This is rather like turning a piece of sculpture into a painting. The result may be recognizable but an important dimension has been lost. Though a new method of expression may be developed through pay television, let us realize that our lives and social habits will be altered by it.

Educational television uses the medium for the purest kind of communication—instantaneous transference of ideas and facts. As exciting as the idea of Shakespeare writing for television is the idea of millions of people learning from the greatest scholars of our time. The potential power of educational television is inconceivable because of its enormity. To say that it is unfeasible because human contact is lost is ridiculous. Exploding populations must be matched by exploding educational methods. The amazingly high instance of success in the use of school television has already proven that this form of teaching may help solve

our education lag. Let us hope too that the genius and the art of our age may be recorded for future generations.

Educational television emanating from university stations seems to bridge the gap between education and entertainment. It is often produced in an attempt to amuse while instructing. Despite the scorn of most commercial television producers, this form is now the only one to respect the medium as an art form, to experiment with new concepts and talents, and there is a professionalism about most of the stations which puts commercial television to shame. As there is very little money to work with, very little is wasted. Time is carefully budgeted; it has to be. Ideas are carefully explored and people are, in general, proud of the results. Much of this form of television is not visually stimulating but that fault will go when more talent becomes aware of the creative possibilities. At present, educational television is the one form which escapes from turning everything, including ideas, into extruded plastic.

Television in the United States is simply a reflection of our culture. We are a materialistic people now moving into cultural planes which we, as a nation, have never inhabited before. In trying to please everyone, television in America has, for the most part, satisfied no one. As we learn a real respect for other people of the world, as we stop trying to be biggest, loudest, most expensive, a feeling of cultural security will enable us to relax, enjoy what we have, and to create works primarily for intelligent pleasure and interest. When this occurs, arrogance will disappear from television and a new respect for audiences will result.

HENRY MAY is a graduate of the University of Illinois, was one of the seven men who launched television's Omnibus, for which he is Production Designer—a T.V. rarity. He attended the Yale Drama School and assisted in the production on the New York stage of "At War with the Army".

Photography / PAUL WEISS

PHOTOGRAPHY IS AN ART—not a craft, nor reducible to one. And it is a distinctive art, not reducible to nor explicable in terms of any other. To be sure it does demand that one know how to use a camera, and it does exhibit features similar to those found in other arts, particularly painting and sculpture. Yet it has its own rationale, its own standards, its own problems, its own values. Both as an enterprise and as a product, photography stands apart from all crafts and all other arts.

The photographer approaches the world with an aesthetic eye, alert to its lights and shadows, its interrelations, its multiple structures, and its spatial configurations. He is ready to attend to the way in which light opposes and merges into darkness, color bleeds into and alters color, shape contrasts with and passes into shape, and background stands over against and is continuous with foreground. He is prepared to follow the development of a theme throughout a situation, to attend to the way in which what is here affects what is there.

It has sometimes been thought that this activity of the photographer is also characteristic of the sculptor and painter. But this is surely an error. Painters and sculptors need have little or even no appreciation of the aesthetic values of their environment. And when they do have such appreciation, it is somewhat irrelevant to their purpose. Their characteristic work begins only when they leave the external world behind to manipulate clay and paint, scalpel and brush. The world beyond these can for them be at best only a reminder, a stimulus or a temptation. But for the photographer the world beyond is precisely that on which he concentrates; it is the primary locus of the aesthetic values he cherishes.

The photographer looks with double vision. He begins by isolating, framing, distinguishing a part of a larger world, as possessing an aesthetic value resulting from the interpenetration of form and significance, structure and importance. Such an isolated portion of the world may be manipulated, operated on, made to exhibit aesthetic values which it otherwise would not possess. An extreme form of such manipulation is required for surrealistic photography. A minimal form of such manipulation is provided by shifts in position and minor variations in lighting. Realism tries to keep to the minimum. Most photography occurs between these extremes.

Were the photographer to have an aesthetic appreciation only of the world as he sees it, his camera would be little more than a distorting recording instrument, a kind of machine for partly remembering what was encountered. But the camera subjects the world to limiting conditions, thereby giving new shapes and new meanings to what the aesthetic vision encounters. It is the characteristic mistake of amateur photographers to overlook this fact. They tend to think that what is attractive to vision will make an excellent photograph. The excellent photograph is produced only by one who sees that the world he isolates in his aesthetic vision will be transformed by the camera. The photographer must make himself into a kind of camera before he uses the camera in fact. He must know what it can do, realize what the aesthetically appreciated world will be like when translated into a print. He must know not only that the camera transforms, but what kind of transformations are possible by means of it. The photographer must master the technique of operating it in order to achieve the result he anticipated, and desired.

A camera of course does not provide one with photographs but only with prints which can be turned into photographs. Such conversion involves craftsmanship of a special type, though one can, to be sure, leave the work to a machine. Ideally the conversion is charged with artistic creativity; the results of the camera are manipulated in the dark room so as to modify its effects and values. The product is the world of every day, three times transformed—once by the aesthetic vision, then by the camera, and finally by the printing.

Simple photography stops at this point. Constructive photography goes a step further. It embraces the art of manipulating photographs to achieve a new photographic effect. This type of photography has been primarily the concern of moving picture editors. Splicing, montage and above all the timing of the presentation of photographs so as to bring

about the photography of motion are the elements of that new and exciting branch of photography we rightly term the "movies" or "flicks".

The movies present us with something new—photographed action in a created space and time. The supposition that this action is an illusion is but a special case of the fallacy that all art is illusory. The artist is a creator. He makes something be that was not before. In simple photography the photographer reveals himself to be one who has created a new space out of the space of every day. In the movies he reveals himself to be the creator of a new time and a new type of action as well. In this respect he has gone far beyond what any painter, sculptor, dramatist, dancer or musician will ever do. Yet, on the other hand, the space, time and motion these produce are fresh, complete creations not dependent, as his are, on what the world might happen to present or allow to be confronted.

PAUL WEISS has made significant contributions to logic, political theory and metaphysics. His specific field at present, the Philosophy of Art, has led to his latest book. *The World of Art*. Professor of Philosophy at Yale, the noted Scholar and teacher has lectured and taught at many other institutions.

Printing & Design / HAROLD D. BACKMAN

IT IS BY NO MEANS A NOVEL OBSERVATION that craftsmanship in printing has steadily declined. The implications of this trend and the sharp qualitative changes that have developed within the last decade warrant closer analysis.

Craftsmanship is the application of a man's accumulated knowledge and creativity in harmony with his individual handling of tools and materials. What material production man has achieved throughout history has, in the main, been the result of this craftsmanship.

As Eric Gill has pointed out, the introduction of machinery was not simply the addition of more elaborate and costly tools. Nor was it another tool to increase production. Machines were introduced for the unvarnished purpose of making money, which, in turn, was accomplished by the replacement of labor. Economic utilization was the sole objective. The more successfully the replacement occurred, the swifter was the decline in the market value of craftsmanship. Let us not dissolve at the thought. To an entrepreneur, craftsmanship was a commodity with a price. As the machines assumed the multiplicity of labor functions, so the worker became further alienated from his product—alienated from that textural contact which is essential to true craftsmanship. Mechanization, materialism and the sociological factor of alienation destroyed pride in workmanship—the basis for craftsmanship.

An interesting polar comparison would be that of the Japanese Zen calligraphist to a modern pressroom. The Zen master prepares his ink, paper and brushes with careful, conscious sensitivity for the act that has already begun and will end with the final sweep of his arm at one with the brush, ink and paper. This is in contrast with the modern

plant where every hour of machine time has been given precious value by another master, the aware accountant. As to the daily press cleanup, this is still only grudgingly allowed.

Presses have become fantastically huge and complicated in order to produce long runs at high speeds. In order to pay for itself, a single press costing hundreds of thousands of dollars must maximize its productive time. Downtime is determined in the front office as are quality and production. Pressmen are told how much time will be allotted for makeready, one of the major areas of craftsmanship. In the past, hand overlays had allowed the pressman to project his ability, taste and sense of tonal value. In the last few years, the introduction of systems such as 3M overlay not only cut makeready time, but eliminated most of the personal decisions allowing the utilization of less experienced operators. Press downtime has been further reduced. Recently there has been a surge toward the installation of pre-makeready systems in composing rooms.

As a result of increased mechanization and technological development, the manager is replacing the craftsman in final responsibility for the completed job. In the past a color pressman's judgment and trained eye were the principal agents in determining overall quality. The innovations of today such as densitometers, color scanners, improved ink chemistry, etc., have made it necessary that managers be aware of a wide range of diverse information and be competent enough to organize it for use.

Unfortunately, creativity, freedom of choice and spontaneity are not always possible for the manager. He is limited by many factors he cannot control. Probably the most serious handicap comes from the pressure of meeting deadlines. Good quality takes time both to conceive and to produce. Speed and tight schedules have become an unnecessary fetish in our society. For lack of inner values, we have placed undo stress on pre-occupation rather than occupation. In other words, the mechanical involvement in busyness, speed and productivity prevents us from grappling with the essential questions of what we are trying to accomplish with our lives and in our work. Some self-satisfaction can be detected in the buyer's statement, "I work under conditions in which everything was needed yesterday." On investigation we find that creative scheduling and planning could have converted many of the close deadlines into workable time guides that allowed for quality production. It would have required a willingness on the part of the buyer to plan his end of the work to fit in with the printing phase so that the final job would be completed within the desired time. However, quite often quality and craftsmanship are not recognized and no sacrifice is made for their attain-

ment. If the buyer is shown a quality job, he may say that the committee, the board, the *somebody* has set up inflexible conditions so that it becomes impossible to execute it.

Another managerial pressure is that of costs. Unlike all other major industries, the graphic arts are without price leadership. It is the only large industry where the classical economic concept of pure competition exists in fact. Margins are low. Costs vary from plant to plant on the same job. This is not always because one plant is more efficient than another, but because the particular sheet size for that one job will be better accommodated by a specific press. Buyers are unaware of the reasons for the cost differential and get upset. As a result, printers will frequently quote at or below their own costs to meet competitive bids. This usually results in lowered quality since the primary ingredients of time, craftsmanship and good materials all increase costs.

Prior to the era of industrial intensification, the craftsman created and fulfilled the design. But with the advent of the division of labor, the skilled compositor was called upon less and less to decide the use of type and spacing. The designer, working with pencil and paper, gave the instructions. The skill and judgment of the machine typesetter and hand compositor, however, were still essential for the execution of the design. Unfortunately, in the modern instance, the design concept may have come from workers in an advertising agency familiar primarily with lithography but possessing only the shallowest typographic sense. They may never have learned that type in itself has three dimensions and not two. Because of a dissatisfaction with traditional typography, they may never have taken the time to discover for themselves the wide range of aesthetic expression that is possible with small changes in type. The stronger emphasis on design, or visual impact, was partly the influence of modern art and partly a method of "breaking through" the welter of visual phenomena bombarding the ordinary observer. Many schools of design offer only superficial courses in typography, failing to recognize that in printing the *word* is the beginning. None of these remarks is intended to detract from the importance of the designer. It is he who will determine the general appearance of the job. Like the manager he must be familiar with the variety of technical factors involved in a job and must have a sufficient knowledge of the mechanics of production so that maximum quality will be achieved at minimum cost. If printer and designer are to work effectively there is need for a more receptive attitude on the part of each.

Despite the decline of craftsmanship and the limitations of respon-

sibility, the final effect of these on quality is not clearcut. Printers have generally felt that average standards have gone up at the expense of the exceptional. This is only partially correct. In composition there is much less sensitivity to proper letterspacing, type relationships, consistent justification, effective use of ornaments, etc. Lithography has raised its median standards. Letterpress equipment has improved, but the quality of the final job will vary depending on the quality of the type to be printed and the standards of the press department. It is interesting to note that many publishers will not accept a fine kiss impression. So many printers have hidden poor type with a heavy impression and heavier color that even good printers tend to avoid a light page.

The level of quality in terms of composition and press standards has probably dropped. But there is another, more subtle dimension to the problem of quality. Quality is not simply based on absolute levels of performance. Quality has to do with man—not a machine. Quality is the complete *actualization* within one man—one being. It must include everything in him—all that is irregular, distinct and unique to this man. When this part of him flows into his work, the true concept of quality will be approached.

Fortunately no single participant in the printing cycle will fit a linear description. Therein lies hope.

HAROLD D. BACKMAN, Harvard 1944, is Vice-President in charge of sales and design for the Capital City Press, Montpelier, Vermont (printers of this book). He has previously worked in the fields of sociology and economics.

Art & the Artist / ROBERT ENGMAN

A CREDO

FREQUENTLY THE QUESTION is posed "What determines good and bad contemporary art". I am sure the answer expected has to do with color, form, composition, media etc. Even such lofty considerations as "expression" of one's inner self, (contact with that portion of existence which normally remains beneath or above or in any event beyond consciousness).

I find answers concerned with this question not only to be inadequate but even impossible to consider. To discuss art in these terms would preclude agreement with the necessary condition to ask this. That is, that art is an object, a painting or a piece of sculpture, or a poem etc. The painting or sculpture or poem is a by-product of a way of life. It is something which happens as a consequence of a mind being concerned with an area of fascination which can best be defined when committed to some form of externalization. The form of externalization is determined by the area of fascination. In that each system defines only a portion of thought; we have many systems and combinations of systems to prove and define human concern.

It seems, a more accurate understanding of art arises from the realization that art is in essence, a way of life not an object or thing. To understand this a little more completely it is necessary to discuss something about creativity and the relationship between actual behavior and symbolical behavior; also to clarify tradition and the relationship between tradition to knowledge.

For human activity to have meaning we must understand the limitations which surround that activity. A baseball game viewed for the first time with no previous contact would seem at least ridiculous. As

more and more information is gathered about the rules and regulations or limitations surrounding the sport, achievement or rather excellence regarding the performance could be somewhat appreciated. Up to this point all spectators, providing their knowledge of the sport is equal, have an understanding and appreciation which is also equal. In order for this to occur there must be agreement of the rules and regulations. When we agree we establish tradition. Knowledge at this level too often is affiliated with the object of the effort and not the effort itself. When the emphasis is placed on the object, the way is paved for the perversion of the effort.

Tradition deals with the perpetuation of activity with set limitations. Tradition in this strict sense denies growth and progress. In that the requirement of life consistently demands change, man's natural struggle originates with the departure from the known in quest of the unknown. When the object of an effort indicates this quest it is involved in the way of art.

Departure from the known is termed creativity and is sponsored by chance and sustained through structure. Structure being those ingredients which establish the dimensions of a concern. As atoms and molecules are arranged in a particular fashion, particular to a substance, so are the structural ingredients arranged in the articulation of a creative venture. It also involves these structured or substanced thoughts with preceding thoughts in such a way as to establish an evolutionary sequence. In other words an organic thought-growth process. Art imitates nature not in literal imitation but analogous to nature's process. The point being that under these circumstances the painted or sculpted objects can never be art by themselves, but rather a means of externalizing an effort or concern far too complex to study and comprehend were it to remain within the mind.

These externalizations are in fact studies of art, studies of a way of life. The way of art is continuous with nature and requires actual contact or behavior. This actual behavior manifests as the painting or sculpture or art fact and are in a sense blossoms of an effort. Also, as in nature the blossom of the plant is a phase of the growth-cycle of the entire plant's life and in nature's scheme of things no more or less important than any other phase. For in reality, phases are for our convenience, in nature there is just the plant. To cherish only the blossom is the mark of a limited mentality. This limitation can only provide for development which is incomplete. This incompleteness is the intimacy, the feeling,

the passion which accompanies knowledge acquired through a full rich complete embrace with the fantasies of existence.

I believe all minds operating at a conceptual level to be involved in the way of art. A mind fascinated with a kind of order which can best be defined or externalized in the system of numbers is not at all divorced from art. The assumption of the title mathematician identifies the relationship of the mind to the area of fascination under consideration. This is true of all titles of all systems to which men commit themselves. These various means are chosen automatically for they are the most precise means of revealing that which is being contemplated.

All conceptual processes necessarily depend on actual contact with the means. Along with these efforts goes the intimacy and passion of directness. Growth within conceptual behavior cannot be bought or sold, given or taken, it can only be earned. This discovery of and subsequent dedication to the means which can most adequately serve the mind in its quest for order is the purpose of education. To somehow temper the learning environment with a condition which recognizes and directs is the function of the educator.

As it would be impossible to fully comprehend the significance of the rose as a plant if we were only to look at the blossom, so is it impossible to understand fully the way of art by merely observing its blossoms. Today we are overwhelmingly concerned with surface, cosmetics, the blossoms of experience at the expense of content. The art products exist and are measured not as formal contributions but as technical changes or innovations. But is this not the position of world societies today? The position of false values? False in that they have misled man so that he is now faced with the task of survival? To sustain or not, life itself? It would seem he is ill-prepared to cope with this problem as his development or discipline or training to handle this problem for the most part has consisted of half truths, slogans, greed and in general, ignorance. The symptoms are all around us. Societies in collapse, elaborate defense which although technically fantastic in destructive capacity and diabolical cleverness, reek with potential accidental ignition. The element of failure exists in all apparatus. Regardless of the unit time which elapses, that element of failure approaches certainty. We logically can expect to depart in one grand puff of smoke. But what does this have to do with the way of art? In the immediate sense, nothing. In the long range a great deal. The pursuit of art involves an intimacy characterized by awareness. Awareness which facilitates knowledge not in-

dependent of feeling. An awareness so charged with feeling as not to be able to project itself in terms of actions without an acute sensitivity regarding the consequences. Men must now as never before, if not stop, at least hesitate long enough to embrace those disciplines which possess the magnificence of establishing contact with reality and life.

The painting or sculpture is the blossom of a concern necessary for the continuance of life not just to exist but to live. Neitsche once wrote "the measurement of man is the sum of his deeds".

The deeds of man are the sum of his arts.

ROBERT ENGMAN is a sculptor and teacher in the Yale School of Art and Architecture. He has had a number of successful one-man shows and the Yale University Art Gallery now has a large bronze sculpture of his among its collections. He studied at the Rhode Island School of Design.

Architecture / PHILIP C. JOHNSON

DEAR SIR:

You face a difficult problem. If you were building a museum a hundred years ago—how easy. In those halcyon days you might have had to house some Greek statues in a pavilion in a park; you needed only to hire the architect of the day to build a monument suitable for a park. The public was no bother.

Unfortunately, or fortunately, we have had a few revolutions since then and now people want to come in. You yourselves want to reach the people. From an urban decoration, the museum has now become a civic necessity, a shrine for the people. The waiting lines around the block in New York today are for a museum (where is Mr. Roxy?). Museums now are, or should be, considered as important as churches or city halls in our civic schemes. Your task is therefore enormous. Remember that civilizations are sometimes remembered only by their buildings.

But it is not only as a civic decoration that your buildings are important. A museum is a complicated mechanism, the exact nature of which is not yet known. Research has to be done, difficult because the museum is still changing.

Let us say you had an easy job, a skyscraper, a school, a hospital. There are books, articles, examples to go by. Architects can study analogies, and produce results. But how can you answer the architect's questions for a museum?

What is your program? How many people need the check room? How many square feet does looking at a Pollock require? How big a staff do you contemplate? You can answer none of these. Think of the libraries,

concert halls, gardens, and lunch rooms that are now a part of this new civic service. You have a problem.

Purely aesthetically speaking, the museum is an architect's dream. He has—as in a church—to make the visitor happy, to put him in a receptive frame of mind while he is undergoing an emotional experience. We architects welcome the challenge.

But how difficult from there on! It is not like a skyscraper, where the problem is to design a tower, and an entrance to the lobby. That is all; the rental agent designs the space. Alas, in a museum, there are a thousand practical problems still to plague us.

Think merely of the first one: the processional requirements—how you proceed, foot in front of foot—around corners, through arches, from low spaces to high, from side light to top light. How to avoid museum fatigue, how to get visual and physical relief from too many rooms. How to keep a sense of orientation, to avoid the sense of "Help! How do I get out of here?" Again, how to arrange the circulation so that one collection can be seen without going through another. How, for an impossible example, to design a low intimate gallery for a print show in the same architectural framework as a huge, spacious court for Baroque tapestries. It is not alone the aesthetics of these problems, but the purely physical one of fitting it all together. Some of these simply have no answer.

Then, even in the realm of the soluble, there is a further difficulty for us architects. You museum directors do not agree among yourselves on points that we must know. It is our duty, as with a house design, to find out the idiosyncrasies of our clients and, insofar as compatible with our architectural integrity, allow for them. However, when clients disagree as much as you gentlemen do, it makes things more difficult than house-holders disagreeing about coat closets and rumpus rooms.

Two fields of disagreement among you are particularly bothersome: those of lighting—artificial lighting versus skylights—and flexibility, the old story of movable partitions.

First: *Lighting*. Top daylighting, which is required by some museum directors, is next to impossible for air conditioning, difficult for maintenance (it leaks), impossible for multi-story museums, and impossible for evening exhibitions. Artificial light is cheaper, and it is controllable and more suitable to standard building procedures. As an architect I am on the side of artificial light since, to me, it answers the new purposes of the museum: a public shrine which must be open at times unsuitable for daylighting. As to the argument that the artist intended his work to be

seen in the same light he painted in, who can reproduce *plein air?* And how easy, on the contrary, to reproduce the electric light that our contemporaries paint in. Even for old pictures, is it not better to see them well lighted—always—by any means available? As an architect, however, I must and can and do build top daylighted galleries.

Flexibility is the biggest bugaboo. It is a problem on which two of our leading museum men disagree completely; Alfred Barr and James Johnson Sweeney have fundamentally opposite opinions. The architect is bewildered. Mr. Barr feels the architect should provide the director with an anonymous loft building within which he can arrange the space best suited to the exhibit on hand. The great Monet triptych, now on display at the Museum of Modern Art, is an example of how valuable flexible space is. Inflexible room sequences do not suit the material or especially the sequence of viewing which is so much a part of Mr. Barr's museum installation. He believes in the importance of the first angle of vision, in the value of significant juxtaposition. His installations have proved his points.

My client in Utica, Mr. Richard McLanathan, has a further point: Audience inertia can be overcome by different wall arrangements for different exhibitions. The public expects and approves change.

On the other hand, Mr. Sweeney makes the point that it is debatable whether the museum director should arrogate to himself the prerogatives of the architect. Or if granted these rights, whether the director should not demand still more flexibility: that of ceiling heights. How, he asks, can he control the walls of a room and leave the ceilings too low or too high? "No," he says; "Give me great rooms, beautiful rooms." I am flattered by Mr. Sweeney's respect for architecture. I am impressed by Alfred Barr's installations.

It would be good if you could solve these questions with your colleagues. Movable walls are expensive, ugly (since they cannot be well finished), difficult to fireproof, and work not at all with high ceilings. Needless to say, they are impossible to combine with skylights. The architect cannot begin even to advise you until these two points are resolved.

In addition to the question of exhibit areas, however, the director and the architect have many other whole fields of questions, the backstage area, the non-hanging spaces. Here again the client is as confused as the architect. The field is too new. It is as if, for the first time, a mother had to figure out how many square feet a child takes to play in. An impossible

task. In the problem of a house, however, there is ample precedent through millions of existing housing units, whereas many new museums are starting with no collection on the one hand, and on the other hand with no precedent experience of lecture halls or libraries, or extension courses, or publicity services, or print rooms, or tea rooms, and so forth. The amount of research required for figuring out all these problems is almost too great.

But you might say to me at this point—is this not your duty? You who are familiar with space relations, with budgets, with public buildings, and auditoriums, and schools, should you not inform yourselves of items like truck docking, library stack dimensions, or checkroom sizes? Do you think you can properly expect an expert on Byzantine ivories to be familiar with these items?

I am afraid I have to answer for the architects that we have been very remiss. Architects are human. They are arrogant. They do not like doing their homework, which in this case is in a new and difficult field. In this field again, the museum directors will have to participate and share responsibility, and again we find disagreement among you. There is Mr. Sweeney's hope that only one-seventh of museum space be used for hanging. Others are sure that one-third would be fairer. But even that modest figure, of two-thirds backstage to one-third hanging space, has surprised some directors. My own feeling as an architect is that of a housekeeper: It is impossible to have too much storage, though to us storage is a damnable, space-robbing, expensive, unseen, ugly nuisance.

But besides providing storage, the architect must keep his hieratic sense sharp for the public movements in space besides exhibition halls. Where to put the front desk, where sales counters, where more and more goes on—like the displays in a corner drugstore. The public must be aware of the merchandise, but the wares must not take all of its attention. In the entrance hall itself the public must be herded, separated, and sent on their way in many contradictory directions without ever feeling lost or constrained: the toilets, the Egyptian mummies, the restaurant, Impressionist painting, garden terrace, auditorium, director's office, all of these must be easy to reach without a guide, a green line, or a Minoan thread. In addition, most of these must be reached without going through galleries, since the auditorium and director's office, for example, may be open when the galleries are closed. To straighten out all these threads is a task that can lead to madness. It is worse for us than keeping the kids out of the dining room in a house plan.

That is why so many architects, now as before, use large central orientation spaces which often seem to a museum director "waste space". "Look," he says, "I could have hung twenty large tapestries there." Whether it is Le Corbusier or Mies or Wright or even myself, we all feel that the public, upon entering a museum and choosing one of six or seven things to do, require space, like a dog who, upon entering a room, will sniff in one or two circumambulations of the room and will at last coil himself in one particular spot. I assure you, orientation space is not waste.

In the same sense, space for visual escape or space for orientation reference points in the galleries are not waste. The human eye, even the human spirit, droops from uniformity of lighting and space. A view back to the entrance, an opening into a court or a garden, can be of greater functional use to the museum director than another two galleries. Space that helps us look at paintings is not waste space.

This kind of practical design work, of calculating circulation and distribution, I call the kitchen side of architecture, necessary though it is, and I prefer to write of beauty. Everything I have mentioned must be worked out, but the building must be beautiful. The public must enjoy walking through the space if our new conception of museums is to be valid. This monumental aspect of the museum is the true province of the architect, and it is here where your role as museum director in building a museum becomes difficult and unclear. How much ought you to force your idiosyncratic hanging methods on the conception of the architect? You could do it, I suppose, to the point of achieving a well-functioning but dull and stupid building. You might insist, "What good is a monument where we cannot hang pictures?" In this twilight realm I can only urge extreme forebearance for the architect in the problems of circulation, main hall space, and outside appearance, but to be adamant in gallery widths, lighting, storage, storage, storage.

It might be amusing and profitable to look over a few recent museums from the point of view of the visually aware observer, keeping in mind the efforts of the director and the architect.

One extreme is surely the new Guggenheim Museum. There is no storage—a lot of hanging space has had to be taken over near the roof. There was no lighting and now some think there is too much; and no question but that daylight complicates it. The gallery widths are unchanging and too shallow, the bays too even for accent hanging. There are no vistas and pauses, no rest from the inexorable ramp; there is no

space for sculpture. Brancusi in a 90-foot-deep well is lost (only a great tomb for this American Invalides would have scale enough for this court). We can all commiserate with James Johnson Sweeney on the difficulties of hanging on a slanted wall against the light on a slanting floor, in a space fifteen feet deep with an eight-foot ceiling. The building is, shall we say, unfortunate from the point of view of my profession.

Yet the great hall is a magnificent and, judging by the crowds, popular space. How better to paper the walls of high space than with moving people! How better to keep the public feeling united and excited than with the high continuous promenade! The sense of being lost simply cannot occur. Museum fatigue is abolished, circulation obvious, simple, direct. It is an exciting room to be in. For the fact that it does not work as an art gallery, my profuse apologies to you and your colleagues.

The Museum of Modern Art, on the other extreme, works well over the years. It is the opposite of the Guggenheim. It has no central space, no way to tell where you are, on which floor, or even, in many installations, where you are on each floor. It is an efficient loft building without any pretensions to interior architecture. On the other hand, by changing walls, great variety is maintained. The directors make many smaller museums every time they produce a new show. Some are architecturally better than others. Some of the directors are better architects than others. In any case, the exhibits could be as well installed (even since the column spacing is less insistent) in your neighborhood garage. Could there not have been just a little architecture, a little magnificence introduced into this efficient interior? For this lack I apologize to the architectural profession.

Two other contrasting museum plans come to mind: Mies Van der Rohe's Great Hall in Houston and Lou Kahn's multi-story loft building at Yale. Mies' great room has the perfect clarity of all his spaces. In the hands of talented directors it can and has been used for fantastic exhibitions. It is only difficult to hang pictures and to light them from the thirty-foot ceiling (since it is a wing in an older museum, however, it should be judged only as a Great Hall).

The Yale gallery, similar to the Museum of Modern Art, is organized with movable partitions. Again you have the "where am I" problem and the dependence on the director-architect, to create sensible and sensitive space relations. It is unlike a factory building, which architecturally may be good or bad, good if the director is an architecturally minded designer, and bad if he is a tyro.

Sometimes, I think of older museums, however, as being more important examples than contemporary ones for us today. The National Gallery in Washington, for example, although you enter always from the back and up the kitchen stairs, is nevertheless well organized. You always have a reference point when you get lost (unless you get into the second row of galleries and forget) ; you always have a little garden when your eyes are tired. Cleveland was even better with its single row of galleries around the court. That was before the wing was added last year.

The Chicago Art Institute has a good plan. I never get lost in the main section, although the stairway does seem a bit overwhelming.

In Los Angeles, what a surprise it is to pass from XVIII Century French furniture to XVIII Century English, through a habitat group of aurochs and mammoths. The XVIII Century loses the battle. In West Palm Beach, on the other hand, the circulation plan is superb and clear, a simple row of enfiladed rooms, always around a central court.

Amazingly enough, Le Corbusier, the unpredictable, has a similar clear plan at Ahmedabad, a one-room-thick plan around a dominating court.

In conclusion there is surely enough precedent in history for us architects to do better than we do. Look at the early museums; clear concise space arrangements; they are still the best: Schinkel's Altes Museum in Berlin, Soane's Dulwich Gallery near London, von Klenze's Alte Pinakothek in Munich, are my favorites. I am aware that they did not have our multiple problems of restaurants and auditoriums and the like, but neither did their house architects have toilet and garage problems.

If museums are the centers of culture, it behooves you museum directors and us architects to spend much time and much effort in finding a proper architectural expression for our new buildings, suitable to our times and fit to be monuments for times to come.

Philip Cortelyou Johnson, one of America's foremost architects, was born in Cleveland, Ohio. He received his A.B. degree from Harvard College in 1930, and his B. Arch. degree from Harvard University in 1943. He has designed residences (including his own, the famed "Glass House" at New Canaan, Conn.), skyscrapers (he is co-architect of New York's Seagram Tower), and many museums. He is also a writer on contemporary architecture. This article was first published in the January, 1960 issue of *Museum News.*

The Museum / RICHARD HIRSCH

TORN BETWEEN THE NARCISSISM of Europe's great monuments of erudition and the pragmatism of the American heritage, the American museum of our day is a paradox. It is also a unique phenomenon.

Perhaps more than any other institution in this country it defines the nature of what must be called our Volunteer Society, a social pattern where the most arduous civic tasks, such as creating or sustaining museums, are carried out in return for no compensation whatever and, Heaven knows, with the deepest sense of responsibility.

Let us call the resulting phenomenon the New Museum. Admittedly, it is solely American.

Foreigners are often baffled by the workings of our museums, the many patterns of their support, the variety of their proclaimed aims. Diagnosing such misunderstandings can help us to assess ourselves. For one thing, our museums are absolutely independent one of another, neither governed by, nor the creations of, a central Ministry of Fine Arts or an all-powerful Ministry of Culture. Further, in spite of the great names associated with our grander museums, they are not imposed upon our society by some elite insisting that culture is good for the masses just as spinach, allegedly, is good for the unformed, the very young.

To some foreigners, representing either the sophistication of the Old Western World or the educational immaturity of the antipodal East, the spontaneous birth and the self-help pattern of growth of America's New Museum seems often disturbingly anarchical. To others, less friendly, these phenomona are just what they would expect of us: pragmatic, utilitarian, both construed as a betrayal of the arts, a deceptive veneer of learning or appreciation whereby our museums serve as mere status symbols in a spurious mass-culture.

Such reactions result from prevailing prejudices with which, on other planes, we are all too familiar.

They are helpful, however. For how many of us thoroughly understand the unique nature of the New Museum in our midst? Not many, including—if one must be candid—a few eminent museum directors and quite a sizeable group of distinguished and devoted Trustees who contribute generously of their time to its guidance.

Our museum public, in this country, has in the last few years increased by millions, increased to the point where some enthusiastic statistician was able to show that eight million more Americans attend our public galleries each year than go to ball parks or race-tracks.

Obviously, something has happened. Nobody coerces nor can coerce our public through the doors of our museums. In actual fact, many visitors to our public galleries even act defensively about their free presence there; they seem to argue, in the Puritanical way of ours, that their museum visit is no weakening of their traditional veneration for the rugged qualities implicit in Pilgrim, Pioneer or the Do-It-Yourself descendancy of both. But they keep coming back in crowds.

Something has happened, without a doubt. Question: Is it good?

The answer is a long one and not a simple one. In the process we will find our New Museum defined. As always, perhaps, pragmatically.

It is relevant to repeat that no one coerces our public through our museum doors. So? Something must explain the new attendance (it would have been so easy to say: the new enthusiasm). But what? Clarity, one would like to suggest; a new clarity. Accessibility, some museum professionals will argue; a new accessibility to fact or understanding. Sensationalism, a singular sensationalism in the physical display of the museum's treasures (or baubles) the critic may insist. All this while, from the receiving room, where he is inspecting the condition of a newly-arrived travelling collection, his hair full of sawdust and his pants linted with woodshavings, the harried Director, will suggest that the answer is a totally new museum philosophy, as his mind pictures the polished galleries upstairs, their carefully-contrived lighting and their stands, wall cases and panels again patiently repainted for yet another three-week exhibition. Definitely a new philosophy.

Perhaps this last is the best answer.

For, pragmatically arrived at or not, we do have a new museum philosophy. Without it we would not and could not possibly have the New Museum. Its essence? Service.

Now, naturally, this sounds like some kind of post facto propaganda; it may also sound like some kind of manifesto for the Utopian Museum. To some it may sound like warmed-over Tolstoy, a footnote on Walt Whitman or a slogan for a civic club.

But it is fact.

And, to the amazement of the Old World, Western or Eastern, it is not superficial, not neglectful of erudition, not unmindful of the permanent values prized by the eternal, the universal Homo Aestheticus. The reluctant discovery of this can be disturbing to our detractors, worrysome to those who feel that they, rather than ourselves, are the direct descendants to our transoceanic forbears. Because of our self conscious awareness of belonging to a basically pragmatic society, Museum people, who value the salt which they are sure that they deserve, speak of this philosophy of service as rarely as possible.

If, for an instant, one examines the nature of the Old Museum from which we have evolved it is easy to understand this reticence. First, one should note in passing that the Old Museum is not old. Napoleon, no ancient figure, was among the early perpetrators of the Old Museum. There were, of course, others (and Dante would have enjoyed describing their eternities) but Napoleon is loved by so many people who never lost a relative in his campaign that his name will do better than any other.

The Napoleonic Old Museum was a warehouse. He had inherited it from the Revolution, an untidy warehouse of confiscated things, expensive but not immediately useful things, paintings, or sculpture. Tapestries, of course, could be and were burned by patriotic revolutionaries intent upon melting down a few ounces of gold thread. For such a worthy purpose who could begrudge the loss of the major decorative art works of earlier, barbaric, nay, Gothic centuries? The old wool burned well, moreover. Hence, the lack of tapestries in the Louvre's collections. And furniture. Furniture, in the Age of Enlightenment had been festooned with gilt, bright with it in the flutings of its delicacy. No furniture in the Louvre's collections and, anyway, furniture is not art.

But paintings there were, belonging to the ci-devant Louis Capet (and his Queen) and to many another ci-devant aristocrat, now headless, and to superstitious gathering places formally called churches and nunneries and monasteries and houses of retreat and whatnot. When the tumbrels were not carting the ci-devant owners to the guillotine they could always cart pictures to the Louvre where cobwebs grew across the windows and students gaped at the disorderly accumulation growing

before their eyes. They worshipped David, these temporary republicans, and looked away from Rubens, pulling out canvases about which a ci-devant Monsieur de Chantelou had corresponded endlessly with Poussin. And they discussed the antique, the Empyrion.

Then the would-be Emperor strode across the Alps, just as a starter. This little, ugly, ill-mannered Corsican had read a lot. He knew his Greeks through Latin translations, knew his Romans by heart, knew his people of the Renaissance by reputation and, conscious of the goat-hill culture of his native island, aspired to the grandeur that was Rome, the light that was Florence, the wealth that was Venice and the perception of all of those that Milan had expressed. He was home, he knew it and he hated it. So he stole. His prodigious thievery explains the wealth of the Louvre even more than the confiscations of the French Revolution. The Louvre grew.

But into what?

Into a monster that would be the model for all old Museums; into a place where paintings hung from floor to ceiling, none condemned by taste or discretion, becoming a museum which, somehow, gave the seal of absolute worth to any painting and any painter whether exhibited there at eye level or at the lofty cimaise in proximity to dusty ceiling or new-pierced skylight; into a place which so haunted a tradition-breaking Cézanne that his consuming ambition was to produce something worthy of getting hung there, something to be co-equal to the "arts of the museum".

The Old Museum was not designed for the public. Nor was the Old Museum designed to honor the great artist. Surprisingly it did not give any special recognition to the qualified aesthete, the elite. In fact, at the start, it served nobody.

Somewhere after the middle of the nineteenth century, it started to serve the museum Director, giving him a pedestal of intellectual eminence, financially unrewarded, as the new science of art history was developed, the function following the need as usual. The value of such subservience to directoral eminence can be successfully attacked (and was, recently, in a virulent critique of European museums appearing in a major French periodical) when no other services are manifestly concurrent with it.

Pensioneers from various wars, wooden-legged or one-armed, swarmed around the paintings of the Renaissance on regular days of the week, guards to our cultural treasures. The Old Museum, rather reluctantly,

opened to the public, late of mornings, closing according to the sun dial and shut as often as possible, Mondays, Holidays and For Cleaning. It had been painted chocolate brown throughout.

Lacking an aristocracy, unable to develop any conquering predators, Napoleons or Lord Elgins, and refused any confiscatory powers in the absence of anything to confiscate, our museums, in this country, grew up in another pattern. But they had a model, the Old Museum. That was our early misfortune.

It took us sixty years or so really to outgrow the warehouse-of-culture concept on which our museums had carefully modeled themselves. In certain communities it has taken much longer. In some rare places in this bright country metaphorical imported cobwebs still hang undisturbed, impressively. But these are exceptions, mausoleums of culture to which one takes Aunt Minnie on a rainy weekend, though forewarned about the temporary cerebral bloc and ocular paralysis attending the affliction clinically known as Museum Foot. But, as was said, such establishments are a waning minority in this country. Tomorrow they will be gone, thanks to our new philosophy.

The creed of the New Museum, service, is a declaration of responsibility. Spelled out, it states that the museum is, above all else, an educational institution. It does not, as yet, indicate with any uniformity at what educational level the New Museum functions or should best seek to function. Debates will rage for years, creatively, to resolve this present vagueness. In the meanwhile, there is nothing vague about the obligation which its freely accepted basic definition imposes upon the New Museum. The New Museum believes that it must go out to its public, must reach its visitors. In the light of its newly understood obligation it feels required to see that its treasures should reveal their meaning, intimate their spiritual worth and communicate something of their latent intellectual stimulation to even the casual onlooker, once he has crossed the threshhold of a gallery.

Hence, in the New Museum, the prolonged debates on the philosophy of interpretation of art works for the public's benefit. How much should appear on a label, for instance? "Artist's name, date and title of work", says one group, advising the public to go read a book if such a label is not sufficiently illuminating. "Artist's background; place and circumstances of origin; aesthetic intent within the context of period or style," argues another group. And the war of the Little Enders and the Big Enders rages on. "But who reads long labels?" say the psychologically-

inclined. These are concerns with service to the public and, as such, put new life into our galleries.

It must be admitted that the critics, lately, have not been helpful with regard to the New Museum, Alexander Eliot, for instance, has suggested that the perfect museum, in his view, would be a place where the solitary visitor would sit in a velvet room in silence, asking some minion of the museum to fetch him a single work from the catalogue, place it upon an easel under a single light source and leave him to his communion, damning the ignorant public.

Condemning the New Museum's attempts at revelation through what the professionals call "installation", a number of critics recently have lashed out at what they think is the over-theatrical display of the works in a given exhibition. Accusations of "window dressing", wry suggestions that awards be given to museum people by the Fifth Avenue Merchants Association and so on, have greeted many important shows, staged (if that is the word) in New Museums attempting to present their permanent or temporary wares in a way to reveal the eloquence which is their aesthetic function.

Other critics, such as Katharine Kuh, lately of Chicago's Art Institute and presently a Saturday Review staffer, have spoken out with more venom than reason at the New Museum people who, she contends, spend the time watching attendance records that they should, in her book, be devoting to research.

Such criticisms tell much of the new directions and the new concerns that make our museum new: clearly it is concerned with the broadest possible public; it believes that the work of art entrusted to it for display is not there to bolster the sensitive profundities of the superior (take that any way you choose) few; it conceives of its function as the responsibility to make each work accessible, spiritually, aesthetically, historically, to those tax-payers who even ever so slightly help to keep the New Museum open; it believes that, as an educational institution, it must provide this meaningful revelation so attractively that the indifference of the public can be successfully shaken.

In all this it is quite humble. The New Museum cannot preach: we have no codified aesthetic. We do not believe that there is, for the art of man, a sole, "correct", approved, interpretation. The function of revelation, then, becomes merely the opening of a door and an invitation, requiring a many-sided search on many planes to make each work of art thus inwardly accessible.

In this view the New Museum trusts that, once the work has thus been made accessible, through interpretation, installation and other devices from its arsenal, the viewer will bring to the experience provided whatever baggage, emotional, intellectual or historical he has acquired elsewhere and will become significantly enriched by the confrontation.

Hence, in the New Museum, the emphasis on lighting, the emphasis on color schemes for a temporary exhibition or a permanent installation. Hence, the emphasis on clarity, the insistence that objects or paintings be kept in decent isolation, one from another. Hence, in all humility and as an indication of success or failure, the interest of museum people in the figures of public attendance in their galleries. Remember that all that a museum professional can hope for is this vaguest symptom that he has not spent his time and ingenuity in vain. And proof is difficult.

The response of our public as shown by attendance figures is, however, but a secondary proof of public acceptance. The primary indicator is provided by the diverse patterns of support of our museums, a diversity which amounts to a unique phenomenon on the world scene. This is neither chaos nor anarchy. Rather, it demonstrates the diversity of concepts which only a true democracy can summon forth to meet a single problem.

The diversity reflects our belief that a challenge can be defined in many acceptable ways and that each definition can have a multitude of solutions philosophically consonant with the given aim.

There are two main kinds of New Museums serving lively ends in this country at present. One is the Old Museum which has evolved from the warehouse-of-culture concept to that of significant public service. The other is the recently-established young museum, created by a community at last aware of the educational vacuum which only a museum can fill. In both cases our museums rely on something which only a Volunteer Society could produce: the sizeable income derived from individual and corporate memberships.

Think, for an instant, of trying to "join" the Uffizi Gallery or the Louvre or the British Museum. Ludicrous? But, for a few dollars, you may join our greatest museums. Remember that access to their rich galleries is free six or seven days a week. Membership merely grants the individual member a few "privileges" such as receiving a periodic calendar of events at the museum, free seats at some lectures and some invitations to "openings" of exhibitions which, in any event, would be freely open to the public on the morrow. Snobbery? Possibly, but quite

unimportant snobbery since the $5-member and the $1000-member have equal rights in the New Museum.

The corporate member has no privileges at all. Significantly corporate memberships in our New Museums describe perhaps better the cultural aims of our society than any single other factor one could adduce (grants to universities being in the realm of long-range enlightened self-interest). Business and industry support our museums in terms of millions annually because they feel that these institutions stimulate the young and enrich the mature, that they educate in the best sense. Much of this corporate support is given "anonymously". Positively, in this area, there is no snobbery of any kind.

Obviously, donations of this nature would be impossible without our extraordinary tax laws which encourage giving to worthy causes and institutions, museums prominent among these latter. As a consequence of these laws we see new museums springing up all over the country, spontaneously, because the communities want them. They are brought into being by many different initiatives, the enthusiasm of a local Art Association; the proffer of an art collection under the condition that a professional museum be established to house and maintain it; the response of a community to the encouragement of a school board concerned with the post-sputnik imbalance of our curricula, concerned about the threatening neglect of our humanistic tradition.

In localities where museums have long been established these various private and public enthusiasms have brought about the evolutionary transformations whose results are the New Museum.

In both cases, as evidence of our unique American Volunteer Society, it is common practice for us to have a regular staff of volunteers who work at the museum without pay in many capacities simply because they think that they should share actively in the museum's responsibility to their community. These unpaid volunteers give gallery lectures to school children, add glamor and work hard over the social functions which the New Museum organizes regularly as a way of having the community participate in its life. Such volunteer contributions of labor from the best people of our cities has no parallel elsewhere just as elsewhere museums are rarely governed by unpaid voluntary Boards of Trustees. These volunteer services do not occur at the Mauritshuis or the Musee de l'Homme or the Brera; while Cleveland, Miami or the Metropolitan expect them and build with them.

The aliveness of our New Museums is due to a great extent to the

dozens of temporary loan exhibitions of significant art works which are travelling this country's "museum circuit". Impressive numbers of others are being constantly organized on the joint initiative of two or more museums for display solely by the originators.

Suddenly the museum is no longer a place of over-familiar treasures. New aspects of our traditions are thus constantly being revealed within the formerly static galleries. For the small, new or poor local museum these splendid travelling exhibitions justify the energy and enthusiasm in bringing them into being. Further, they make it imperative for the public to return again and again to the museum during the course of the year, thus increasing its understanding of our cultural wealth.

Old and later masters are dead. The number of works which they left behind is limited for all time, limited beyond rational hope of endowing all of our eager young museums with exemplars of genius. The travelling exhibition breaks down this limitation. The poorest museum in the land can, at some time in the year, offer to its public the experience once reserved solely for the visitors to great museums in our biggest metropolitan centers. This has become the life-blood of the New Museum, fulfilling much of its philosophy of service.

This philosophy has many other aspects. It encourages busloads of school children to come into contact with all that the visual experience can provide. It sends art and history into the schools as an "extension service" of the museum. It develops junior museums in conjunction with its adult-directed ones. It provides lectures, film programs, music, theatre, under a single roof. It interprets science visually. It creates television programs that reveal the drama of art and history and man's evolution as thinker and user of tools. This is a far cry from Napoleon's warehouse for the loot of wars, a far cry from the Old Museum, painted dark brown.

Splendidly, in an age when Lorenzo de' Medici can have no successors, the New Museum, called into being by the aspirations of its community, invites us all to that enjoyment of the arts once reserved for only the chosen few. Carrying out its sense of responsibility to past, present and future it offers you and me, freely, an accessible, intimate, first-hand communion with the monuments of man's spirit. It does this in a manner and according to a pattern which had no precedent elsewhere.

It could only have happened here.

RICHARD HIRSCH is director of the Allentown Art Museum and has been associated with a number of other museums. He studied museology at l'Ecole du Louvre and was a publisher in Paris before World War II.

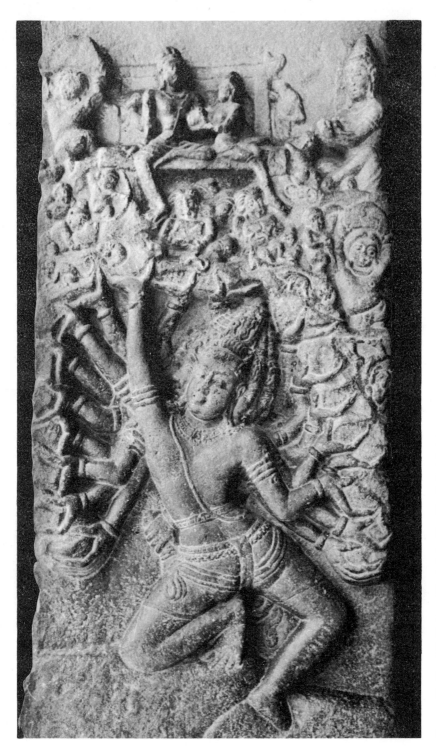

Ravana Shaking Mt. Kailasa, Virupaksha Temple, Pattadakal.

RAVANA'S STRUGGLES

RAVANA, THE TEN-HEADED and twenty-armed demon king determined
to uproot the mountain and to unseat the gods, is as much a hero of the
Hindu epic, *Ramayana*, as the great warrior, Rama, who defeated him
in the end. For countless years the moral lesson of Ravana has been
retold, and each recitation is supposed to bring blessings to the singer
and his audience, liberating them from all sins and making them wiser—
at the expense of Ravanna whose destruction in the hands of Rama
culminates the victory for the hero. There will be no end to Ravana's
humiliation, for Brahma the Creator has said that as long as mountains
dominate the earth and rivers flow, the verses of the *Ramayana* shall be
heard throughout the world.

THE DEMON KING, AN EPISODE IN HEAVEN

The wicked deeds of Ravana are too numerous to relate in detail, but
behind his black career one sees the indulgence of the gods as well as his
own indomitable spirit. By doing unheard-of severe penance, he practi-
cally compelled the gods to grant him the most unusual boons. Having
been made invulnerable by Brahma against gods and demons, Ravana
began a long career of fighting both. He banished his half-brother,
Kuvera, the king of the Yakshas and god of wealth, and robbed him of
his magic aerial car. He brought the gods in chains to his kingdom of
Lanka and made them serve him. The god of fire became his cook, and
the god of ocean supplied him water. The wind god swept his palace.
By day and by night, the sun and the moon took turns to give him light.
The great god of the firmament, Indra, adorned him with garlands. With

the elements on his side, he ruled his kingdom with great skill and was worshipped as a very learned king.

The same insatiable desire that had made him endure the terrible austerities of his penance was responsible for his uncontrollable temper, lust and arrogance. His mighty body was described as black and lustrous like ivory, exhibiting many wounds made by the divine weapons in his wars with the gods. Each victory would bring him greater confidence and the expanded confidence would encourage greater ambition. Finally Ravana had made life intolerable for all.

In their desperation, the gods appealed to Brahma for help. The great Creator then told them that he had never granted Ravana protection against human beings or beasts because the demon king had not bothered to ask for it. Now, to check Ravana, who was about to destroy the gods with the powers they had given him, a conference in heaven decided to send Vishnu, the Preserver, down to earth and, in his incarnation as Rama, to conquer Ravana. Traditionally, Vishnu was born as four brothers; Rama was half Vishnu, the other three shared the rest of the god's power. In the meantime, Lakshmi, the consort of Vishnu, was born as the beautiful Sita, to become wife of Rama. The fate of Ravana was as good as determined when he kidnapped Sita and carried her to Lanka in the aerial car. Joined by armies of monkeys, Rama, twanging his famous mighty bow, marched on Lanka. Thousands of lines later in the epic, he destroyed Ravana.

The spectacles of the struggles between Ravana and Rama, on which the poets lavished their enchanting words, were but a technical necessity for the execution of the design in heaven. The germ of Ravana's destruction had been born of his own nature, good or bad; and the epic, *Ramayana,* was but the last stanza of a much greater poem in which Ravana was the only hero with everything else, including the gods, as mere stage property.

The tragedy of Ravana, perhaps, should be viewed as a tragedy of man, thus the recitation of his story should have the power to liberate others of their sins. To call Ravana a demon king is but to exaggerate his characters and experiences to heroic proportions. Having thus identified the "Ravana-nature," we may now move on to the next episode and watch the adventure of this spirit in the incarnation as an artist. He now, using the elements of his artistic medium, struggles to conquer his critics who have accorded him recognition. Above the artist and the critic there seems to be the philosopher, who presides strangely like the

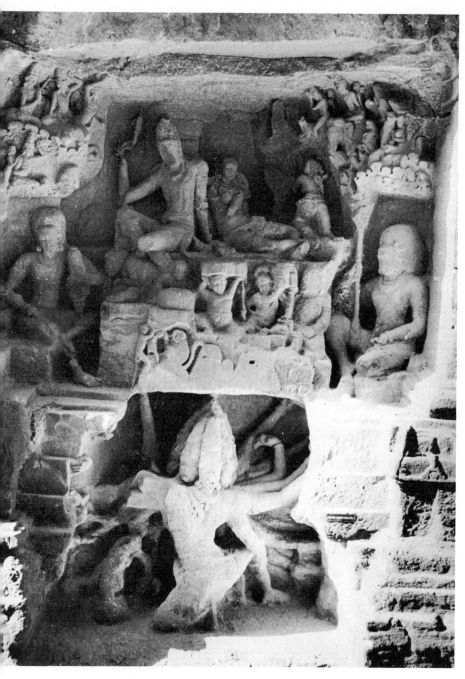

Ravana Shaking Mt. Kailasa, Kailasanath Temple, Ellora.

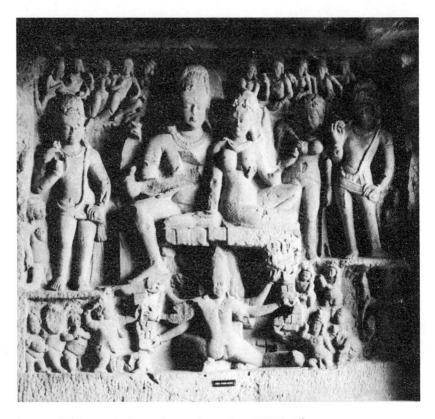

Ravana Shaking Mt. Kailasa, Dhumar Lena (Cave XXIX), Ellora.

Creator, Brahma. At all times, however, there is the distinct possibility that all three are actually parts of one, just like the multiple incarnations of Vishnu who together completed the mission for the divine design. While Ravana, for obvious reasons, had to be a mythological figure, our next hero is simply fictitious.

THE ARTIST, AN EPISODE ON EARTH

Hung-ya, in whom we are to see the Ravana-nature, was the Chinese artist we had in mind. A celebrated painter, he later became an art critic and theorist. None of his work is extant, and little about his life is known. An obscure source mentioned that he was at one time a

student of a certain Taoist philosopher. If so, he must have lived in the fourth century B.C., which of course immediately contradicts other sources claiming a much earlier date for him. Our interest in him begins one spring day in a garden when he was sitting in the back row among some twenty or so other disciples listening to the philosopher. The master, expounding his views on Nature and man's harmony with it, pointed at parts of his own body, and said: "I know that I have my waist, but I feel it not, because my sash fits me. Nor am I reminded of my feet, because my shoes fit them perfectly. If there should be one moment in which I completely lost my awareness of myself and my interest in telling the good from the evil, then in that moment I would have tasted briefly the feeling of being one with Nature. The forces and images of Nature in their perfect forms must be an absolute equilibrium and entirely meaningless."

Hung-ya was artistically inclined. Although regarded by his master as most gifted and likely to become a philosopher, he had a strange feeling as he listened to these abstract and negative ideas. Noticing his favorite student's inattention, the master paused for a brief moment and said: "Art, on the other hand, is everything that Nature is not. It begins with man's awareness of himself. His consciousness of his ideals, and abilities, moves him to rearrange Nature; and art is born. This rearranged nature is thus meaningful to other men. While in Nature there is this completeness, in art there should be the specific. In bargaining for the specific, or for meaning, art forfeits completeness."

Hung-ya became interested again as he heard the philosopher say: "As man moves from the all-embracing world of Nature to the limited world of art, he immediately realized the tremendous potentialities of the art medium and sensed a great freedom of movement. Know these potentialities well, appreciate and develop them, and there shall be no limit as to what you can accomplish within the framework of art! The only other thing that must be kept in mind, and which is only logical is that . . ." Before the last sentence was finished, and at mention of logic, the mind of the restless Hung-ya was already far, far away.

Hung-ya practiced what he had learned from his master and began to paint. He soon became a famous painter and was praised by critics as capable of doing anything with his brush. Still he improved upon himself with each picture he did. He wanted to do one great painting to end all paintings and to ring out the last word of praise from the mouths of all critics. One day when he just finished painting a little worm, a bird

came gliding down swiftly from the sky, tried to pick up the worm, failed, and sailed across the picture. Before the bird swung back for another attempt, Hung-ya quickly painted a hawk by the worm. Seeing this, the bird flew away. When Hung-ya's attention finally returned to his painting, he was disturbed by the fierce look of the hawk's eyes. As if guided by an unseen hand, he put down the figure of a hunter across the painting from the hawk. Attaching an arrow to his big bow, the hunter aimed at the hawk, and the hawk reluctantly left the painting, cursing almost audibly. Having nothing to shoot at, the hunter angrily turned to face Hung-ya, and was about to release the arrow. There was absolutely no time to lose. He quickly drew a big rock to block the hunter in order to gain time, and blackened the sky with rain clouds, hoping to escape in the confusion created. He flung away his brush and started to run. As he ran, he heard the twang of the mighty bow. The rain storm overtook him. Drenched, Hung-ya was horrified to realize that he had just pushed the medium of painting beyond its limitation and became engulfed by it.

The entire experience, from his first explorations of the potentialities of painting to his own exit from it, must have taken only a split second to flash through the mind of the gifted Hung-ya. For as he woke up from the nightmare, his master was only finishing the second half of the sentence: ". . . unlike Nature, art must recognize its limitations."

Dazed, Hung-ya ran his hands over his dripping body, hoping to keep the horrifying experience to himself. "Few artists understand the meaning of the limitations in an art medium," the philosopher went on. "The true artist, having learned its potentialities, accepts its limitations and thus excels in that art. Knowing completely what the green color can do, and having all the green colors in the world at his disposal, the painter created the best picture of the green bamboo with ink alone. The poet accepts the limitations of the metre to set his verse free, and the architect makes invisible the solid of his stone and reveals the majesty of his space. The potentialities of a medium enslave even the greatest master, but a sudden realization of the special limitations transfigures his art. Once the limitation of a medium is identified, more than half of the task is done. Therefore, to our special blindness, we credit the art of painting; and to our special deafness, we credit the art of music. After having fallen from omnipotence, man created art. As silence died, poetry was born. So, let us sing!"

As to Hung-ya, just as his master had expected of him, he later be-

came a distinguished art critic and philosopher. When he was the painter of his dreams and still in possession of the Ravana-nature, he knew each time what he wanted as his subject matter—the best subject matter for the occasion of course, and how to paint it—in the best style, his style, of course; and he created many great paintings. But now, as a critic, he knew numerous styles to approach any subject matter, and equally numerous reasons for each subject matter or style to be selected, altered, or dropped. Thus paralyzed he never painted another picture again.

"RAVANA SHAKING MT. KAILASA," AN EPISODE IN ART

Today, in the little village of Pattadakal, south-west India, where once the illustrious Chalukyan kings made their capital, there is preserved a small but most beautiful relief portraying our hero shaking the sacred mountain of Kailasa. It is on a stone pillar to the left as one enters the south porch of the early eighth century Virupaksha Temple dedicated to Siva. This temple was an important landmark in the development of the Dravidian architecture style, and probably served as a model for the immensely larger Siva temple, Kailasanath, carved out of the side of the mountain at Ellora. Our Pattadakal relief is also enlarged and copied here as one of the panels of Kailasanath. But this panel is not the famous Ravana sculpture here that all the writers are praising. For on the south side of the same monument an enormous composition of this motif, two storeys in height, and totally different in concept, is drawing the admiring attention of the visitors. It is of a design popular here at many temples of Ellora, for example, the sixteen-foot wide panel of the Dhumar Lena Cave, said to be dated from the seventh century.

In these two-storeyed compositions, the demon king really has no chance to threaten the security of the gods. If the theatrical stage of a sacred mountain in this design should ever collapse, it would have to be caused by the weight of the actors on the upper floor, and not by the act of the demon below. In the religious narrative, they all are symbols in a conventionalized composition. Ravana is here a recruit from the Vishnu-centered epic to honor the supreme god Siva at his temple, and the rather obscure episode in the *Ramayana* is thus made a favorite subject matter.

The Pattadakal relief, however, is very different in style and seems to reflect another interpretation of the story. It suggests a possible different but concurrent tradition of representing Ravana, in which the folklore quality of the hero seems to have survived, not unlike in some cases of the concurrent recensions of the *Ramayana* text in literature.

The noble and handsome demon king is pictured here as a real menace trying to uproot Mt. Kailasa, the abode of the great god Siva and his consort, Parvati. In the violence that ensued, the universe ("the three worlds") trembled in fear, and even the beautiful goddess Parvati became in doubt and turned to her lord for protection. Unperturbed, Siva put down his right foot and held the mountain still. Ravana is his most glorious self at this very moment—not when he enslaves all the gods. In composition, the very trembling sacred mountain itself is the rumbling echo of his mighty form. His hands and the crushing weight of the rocks define each other in the uneasy space. The gods that he is trying to unseat are actually supported by him, and not by the stone floor as in the two-storeyed panels. He is the image of will power, of action, and of self-consciousness. This is the image given us by the epic which we must sing, and each singing will bring us once again the wise message on the expression of the limitation. For Ravana is ornamenting himself with the very limitation of that spatial design and not breaking it. Dominating the entire composition, he has made the gods his stage property.

But all has been for the sake of the heavenly design. As soon as the message of the struggle is delivered, i.e., ten thousand years later, Ravana will become free again. The stone pillar at Pattadakal, however, will forever remind us of this episode in art. As the *Ramayana* tells us (VII, 16), Siva frees the mighty Ravana in the end and says to him:

> Thy true self is not a demon,
> And to praise thy arrogance, I sing.
> The Universe echoes thy struggles in fear.
> Ravana is truly thy name, O King!*

* I am indebted to Professor Rulon Wells for his help in translating the original verse, I assume the responsibility for the free rendition.

Art & the Artist / JOSEPH ALBERS

I. *What is Art?*

The origin of art:
The discrepancy between physical fact and psychic effect

The content of art:
Visual formulation of our reaction to life

The measure of art:
The ratio of effort to effect

The aim of art:
Revelation and evocation of vision

II. *Can Art be taught?*

Experience teaches that writing a letter looks at times easy, at other times, difficult, and sometimes even impossible. This shows that in verbal formulations we are exposed to chance.

Losing such chances we call a failure, being unproductive, uncreative. But winning, that is recognizing and using chances, we consider pleasantly successful—creative.

So far, the creative process remains a secret, a wonder. But we might speculate that creativeness is the lucky readiness to feel, to sense, to see an opportunity—to discover and to invent. In other words, it is to be

aware and keen, to be sensitive and flexible enough not to miss the chance of finding and presenting a new idea, a new seeing.

And all this, whether in science or art, is not an affair just of learning and knowing theories and rules and of applying them. It is looking forward, and luckily and therefore happily imagining.

As in science so in art, whether in verbal or visual formulation, creativeness cannot be taught, at least not directly.

Creating art therefore is to be developed. All that teaching can do toward it, and must do, is to provide a thorough training in observation and articulation—that is, learning to see and learning to formulate. And all this in order to reveal and to evoke vision.

It remains a psychological error to believe that art stems from feeling, from emotion only.

Art comes from the conscious, as well as from the subconscious,—from both heart and mind. It is intellectual order as well as intuitive or instinctive order.

For those afraid of the training of the conscious in art, afraid of the understandable in art, I must say that clear thinking—necessary in all human endeavor—will not and cannot interfere with genuine feeling. But it does interfere with prejudices, too often misinterpreted as feelings.

Concluding, let us be aware that self-expression is more than self-disclosure; but also that creation goes further than expression.

III. *What would you say to the young artist?*

My main advice for practicing students of any art is today a severe warning: Keep off the band wagon!

All the great ones did. By great is meant here not the momentary and fashionably successful—but the inventive performer of a new seeing: the one who creates vision and therefore presents a new everlasting insight.

The visionary and lasting one always has kept independent of fashionable trends. Not for the sake of separation, nor for being merely different, but for being himself. He knows that developing art depends upon developing oneself. But he also knows this means a most intensive work based on continued self-criticism, for years, for many more years, for a lifetime.

Developing individuality—and developing it quickly—as an aim of art training has never been promoted as much as today. And the

significant result of our over-individualization? Today's painting—and often sculpture—exhibitions look so much alike—also as never before.

True individuality—personality—is not a result of forced individualness or stylization, but of truthfulness to one's self—of honesty and modesty.

A true painter paints and has no time not to paint, as a true writer writes, because he has no time not to write.

JOSEF ALBERS is a distinguished painter and designer who was educated in Germany and taught art at the Bauhaus for ten years before becoming Professor of Art and Chairman of the Yale University Art School from 1950 to 1958.

Education / ROBERT PENN WARREN

YOUNG MEN around universities have always written things. Nothing could be more natural than that, at this impressionable and adventurous period of life, when part of the adventure is to explore the literature and the ideas of the past, young men should want to try their own hand at a story or poem. And when young men start writing things, it is natural that they should read their work to each other—and to anybody else who will listen. And it is perfectly natural that the person who gets read to will retaliate by expressing an opinion. Writing and criticism—they are natural activities in a place like this.

What, if anything, should a university do for the young man who is interested in writing? To begin with, any good university, by its very existence, does, willy-nilly, the most important thing. It brings young men together in an atmosphere where experience and ideas are under constant scrutiny and assessment, where values are under constant debate, where there is, or should be, a constant concern with the relation of ideas and actions (even that action which is the making of a poem or story), where man in his variety is regarded in a series of different perspectives. If to this we add imagination and a sense of the urgency of life—things which the young man himself should contribute —we have the perfect situation for the writer. So the best "writing course" may be, in the end, a course in Greek history, in the American Civil War, in Stoic philosophy, in the rise of the corporation. Any such a course may (we have to underscore *may* and ask who the professor is) give a sense of the drama of life, with that combination of distance and urgency which is essential to drama. If the course happens, in addition, to be in literature—say about Dante or Milton's minor poems—another

advantage accrues. The student may, then, see something about a writer's struggle to make sense of himself and his society in the exploration of a literary form.

Should a university try to go beyond giving this great, basic benefit to the student who has literary aspirations? Perhaps a university has no obligation to go any farther. Perhaps it should, at this point, simply trust nature and the instinct of young men to swap poems and opinions. But in a world where, more and more, natural communities tend to dwindle, or fail to come into being, a university may go farther. But if it does, it should aim at encouraging what nature would, with luck, take care of. It should realize that writing, except as a craft, is not to be taught —that the ideal is to create some semblance, however modest, of the natural community in which writing is learned by the process of trial and error, of self-exploration and the exploration of form. The function of criticism in this process is to keep some awareness of history and of principle—for without this awareness, no work will be new. And if it isn't in some sense new, it is nothing.

Robert Penn Warren was a graduate student at Yale from 1927 to 1928 and a professor there from 1950 to 1956. He was awarded the Pulitzer Prize in fiction for *All the King's Men* in 1947.

Education / ARCHIBALD MACLEISH

THE LIMITS OF CREATIVE WRITING COURSES

Q: *What are the limits of "creative writing courses" and what seems possible within those limits? Perhaps anything is possible—perhaps only a polishing discipline?*

A: It is easier to say what is impossible. It is impossible to *make* a writer. Courses in criticism can make critics—not necessarily good critics but critics. Courses in law can make lawyers—same qualification. Courses in scholarship can make scholars. And so on. But writing courses can't make writers *if, by writers, you mean artists*. Expository writing, as British schools have demonstrated, can be taught to anyone with intelligence enough to understand what syntax is, but the management of words as the material of art cannot be taught except by way of precept and example—and only then if the particular example of the particular teacher is one the particular pupil is ready at the particular moment to accept. The Eliot of *Prufrock* could have instructed most of the generation of that decade and so too the Pound of *Mauberley*. Frost, back in those days, couldn't have found a single pupil even if he had wanted one, but now they follow him 'round like Hemingway's cats. Not too happily either because Frost's examples are examples only for Frost— too simply and powerfully themselves to serve anyone else's purposes. Which suggests something else about teaching by precept. Mannerism can be imitated—even manner—but not the man himself if there is a man himself. Actually all that one writer can do for another younger, or anyway later, writer is to loan him his coat until it no longer fits— until the younger writer finds out for himself that it no longer fits. Which means, until he finds out how his own shoulders are set. But all

this assumes, of course, that the younger man is a writer to begin with—a man who feels himself a writer—for otherwise he'd have no need to borrow. There is a difference, of course, between feeling one's self a writer and wanting to be one. The colleges are full of youngsters who want to be writers—want to live, that is, the way they think writers live with houses in Majorca or Monterey and a favorite table in the Ritz Bar or the Deux Magots and an agent in New York. These are the usual candidates for writing courses and the reason why writing courses are what they commonly are. The others—those who know in their bones they are writers or nothing—are a wholly different nation. They live with their conviction like a man with a secret. They don't know what agents are. Majorca is nothing to them: they are always writing wherever. And as for writing courses, most of them never go near one though they are precisely the ones who should, for they are the only ones who can profit. Profit how? Well, at the very least as Rimbaud profited by that year with Izambard. A young man with that conviction in his bones needs to find himself in his time and an older man who has travelled in the time can listen and respond. The relation of master and apprentice which seems to exist from time to time in the studios of the painters and sculptors doesn't exist in the art of words because the techniques and skills are of another kind but an older man can save younger men from compounding errors which have been made before. Pound for example: a born teacher and one whose advice, even when bad, is fruitful. So that, to answer the question; the limits are narrow. If a man is going to write anyway a good writing course can probably help him to avoid some of the dangers and delays, and may, just possibly, bring him to the essential discovery of himself sooner than he might come to it alone. But if he is really a writer he will be alone even there. No writer ever discovered anything with another man's eyes.

Q: *How would you venture to talk about your own urge to write? What pressures did you feel—from within, that is—and how do you think they were shaped by certain clearly important events?*

A: It is difficult to talk about the beginning of something that, so far as I am aware, never began. But I don't know that I should call it an urge to write. I didn't want to write as a boy: I wanted to do what everybody else my age in that little Illinois village wanted to do—swim in Lake Michigan, explore the Skokie marsh, raise Buff Orpingtons and fight—mostly fight. But there were always words in my ears—words

as sounds and sounds dragging enormous shadows of meanings which I rarely understood. It wasn't so much that I wanted to write down words as that words kept pestering me. I went in dutifully to the Chicago Auditorium to listen to what were then called the Thomas Concerts but the sounds that haunted my mind weren't those sounds—they were the sounds of the words as my mother read the *Divine Comedy*—I don't know what translation—and the *Tempest* and "Chapman"—even "Hiawatha." The sounds came first then and they have continued to come first: cadence before words ands words before meanings. When I began (at Hotchkiss) to write verses or pages of prose it wasn't a question of paper and pencil but of that tune in the head which could sometimes be caught but most often not. You speak of pressures. The precise word. As long as the tune went on there was no peace until it found its line. I don't want to make it sound more witless than it must but that, more or less, was the nature of the compulsion. Not an urge to write but a need to set words to the music. And my difficulties, as you can understand, came from the same source as my necessity. For to be always listening is to be hopelessly suggestible. And I was. A master at Hotchkiss innocently loaned me Swinburne's *Laus Veneris* and I was lost to my own ear for years after. That sort of thing was always happening and it was primarily for that reason that I left the law a few years after I had begun to practise and dragged my young family off to France. I had to find my own tongue and the best place, I thought, to find it was among strangers. Also, though I had not then heard of Lu Chi's *Wen Fu*, it had begun to dawn on me that everything in the art of letters begins when the meaning is in control of the document. It was then, I suppose, that I began *to want to write* but the need had been pursuing me for years before.

ARCHIBALD MACLEISH graduated from Yale in 1915 and subsequently took an Ll.B. from the Harvard Law School. Since then he has taught a number of different courses at Harvard, been an editor of *Fortune Magazine* and held a number of governmental posts. He became a Boylston Professor of Rhetoric at Harvard in 1949, and now teaches a course there in creative writing. He was awarded the Pulitzer Prize for his play *J.B.*

Education / FREDERICK A. POTTLE

IT WILL BE EASIEST FOR ME to handle this topic autobiographically; and what is easiest for me will perhaps also produce the most interesting presentation for the reader.

My own major department of study in college was chemistry, and though I always did a good deal of unsystematic reading, I received no formal instruction in English literature between high school and graduate school. The training I received at Yale placed firm emphasis on purely literary values, but it also stressed philology and research. I sat under Albert Stanburrough Cook as well as under William Lyon Phelps and Chauncey Brewster Tinker. It was in graduate school that I more or less unconsciously came by the methods which I followed for a considerable period of time in my own teaching.

We have been often charged with not teaching poems as poems, but that charge is unjust. We aimed to teach poetry for its own sake, but we took our responsibilities as learned men very seriously. Literature of the past (and thirty-five years ago American colleges taught little but literature of the past) we thought unintelligible or not wholly intelligible to our students unless we placed it in its historical *context*, not merely by glossing words and explaining allusions, but also by elucidating modes of thought of the time, by tracing the course of our authors' reading, even by going rather fully into the story of their lives. But in addition to teaching poems as poems, we definitely did feel a responsibility for teaching the *history* of literature, though I think we had no firmly grasped theory as to what literary history was. I certainly was never very clear in my own mind as to which part of my comment or my students' was literary history and which was contextual annotation

aimed at the reading of poetry as poetry. At the time it seemed to me hardly to matter.

Underlying our program was probably the assumption that is now called historicism or historical limitation. In this view, all study of literature of the past is a conscious and strenuous exercise in antiquarianism. We try to put ourselves literally in the state of mind of the author when he wrote the poem under consideration, or of a good contemporary reader, carefully excluding knowledge or attitudes that would be anachronistic. Professor Elmer Edgar Stoll exemplified this kind of assumption when he attacked Robert Penn Warren's essay on *The Ancient Mariner* on the ground that Coleridge could never have so explained his own poem. Historical limitation was usually also extended to standards of judgment: works of literature were to be judged by the standards and conventions of the time in which they were written, not by ours. No great poet of the twentieth century would have written a pastoral elegy, but *Adonais* was justified on the ground that in Shelley's time the convention of the pastoral elegy was still vital.

Our philosophy of literary history was probably strongly influenced by the then reigning "scientific" mode in political history and ultimately by the philosophy of natural science. Our natural way of thinking was genetic, and genetic in terms of what Aristotle calls efficient cause, cause from behind, not of what he called final cause or teleology. Consequently, our thinking was strongly chronological. A given poem B was written at a particular time X, after a poem A and before a poem C. It had a *cause*, its author or historical individual; he was *influenced* by the thought of his time and the literature he had read. This philosophy favored all kinds of close historical study: linguistic, biographical, history of ideas.

It was my good fortune to begin teaching graduate students almost as soon as undergraduates. I provided much less historical context in my undergraduate classes, but so far as I can remember this was due not to any difference in theory but merely to the fact that the undergraduates read fewer poems and spent less time on them. My ideal of teaching might be illustrated by the way I programmed Wordsworth in a graduate seminar meeting once a week throughout a year. I followed strict chronology and assigned everything Wordsworth wrote up to at least 1815. We read Harper's biography and *The Prelude* in sections parallel with the assignments in the poems. We had one assignment on the family background and boyhood. Then we read the Juvenilia in De

Selincourt's edition, the *Evening Walk,* and *Descriptive Sketches.* I asked the students to look into Ramond de Carbonnières. Then we read the *Letter to the Bishop of Llandaff, Guilt and Sorrow,* and *The Borderers,* with accompanying reading in Godwin's *Political Justice.* Then *The Ruined Cottage (Excursion* I) and the 1798 *Lyrical Ballads* with Arthur Beatty's book developing the influence of Hartley on Wordsworth. Then the 1800 *Lyrical Ballads* and Preface, with Mrs. Greenbie's study of Wordsworth's theory of poetic diction. Then the 1805 *Prelude* with Haven's *Mind of a Poet.* Then the *Poems* of 1807 with Harper's essay on the crisis in Wordsworth's art and life caused by the death of his brother John in February 1805, and Jane Worthington Smyser's book on Wordsworth's Stoicism. And so on. Besides the special readings I recommended such general works as Bradley's essay in his Oxford lectures, Sir Walter Raleigh's *Wordsworth,* Basil Willey's background studies, and D. G. James's *Scepticism and Poetry.*

As for the undergraduates, I gave them a carefully prepared short bibliography and reserved all the books listed; I encouraged them to read from the list, but required no reading except the texts of the poems assigned. I summarized the contextual matter in my lectures. I gave the undergraduates far fewer poems, but my only deviation from chronology was to put *The Prelude* (or extracts from it) at the end.

I was also teaching a graduate course in theory of poetry, and some time in the thirties I began assigning I. A. Richard's *Practical Criticism.* This gave me my first experience in reading and judging poems without special annotation of any sort, without even (if one played fair) any information as to authorship or date. I found the book enormously exhilarating and perplexing: it raised questions that my theory and consequent programming had not considered. Then, during the war, I taught a freshman division one summer term, using Brooks and Warren's *Understanding Poetry* as a text. Though I was rather antagonistic to the expressed and implied theory of the book, I tried to play fair with it. Brooks and Warren identify authors and cite dates, but they provide no other biographical or historical apparatus. The edition of the book I used completely ignored literary history. The task set for the student was simply to comprehend a short poem and evaluate it in terms proposed by the text. We asked each student for one-page papers prepared outside of class at least two times a week. I found the results very interesting, far more sophisticated, as it seemed to me, than those we had received in the course before we introduced Brooks and Warren. I also began

about this time to teach the undergraduate lecture course in Age of Wordsworth, and found myself receiving fine extended critical papers which clearly reflected the method of *Understanding Poetry*. My eyes were opened to the value of sharply distinguishing literary history from the reading of poems for their own sake. I became rather painfully aware of the lack of direction and application in some of the historical matter I was presenting. I still found it deeply interesting. I had a conviction that it was important, but I began to ask myself why.

Then I began seriously pondering the theory of literary relations propounded by T. S. Eliot and taken up by the group that somewhere about 1940 began to be called the New Critics. This theory is not contextualism but perspectivism. Its first assumption, in F. R. Leavis's words, is that poetry of the past is alive only in so far as it is alive for *us*. I had been trained to think that contemporary literature is judged by reference to classics winnowed by time. Eliot asked me rather to consider the view that every new significant work of literature changes all the work that had gone before. So considered, literature is not a chronicle but a simultaneous order, a vista or a perspective. Just as every forward step in a landscape results in new views around and before us, so it changes the vista to the rear. Contemporary literature becomes the base and standard for evaluating the literature of the past. The value of any poem of the past is the value *we* can see in it *standing where we are*. Of course perspectivist theory calls for some annotation. Obsolete and archaic meanings ("So shines a good deed in a naughty world") will have to be translated and unclear historical allusions ("From Macedonia's madman to the Swede") explained. But the object of annotation is *exclusively* to enable us "to read the poem as poem." Annotation should be ad hoc, from the poem outward, not from a context or background in. We are invited to read all poems with the same expectations and judge them by the same standards—the expectations with which we approach contemporary poetry, the standards with which we judge it. Historical justifications disappear. We stop arguing that a poem is good if it is not good for *us*. (" If she be not so to me, What care I how fair she be?") Literary history of the genetic sort disappears. In fact, literary history shrinks to the chronological ranging of readings of individual poems (F. R. Leavis's *Revaluation*) to illustrate what is called a tradition of a formal device like wit.

Though much in this view still seems to me unnecessarily and undesirably exclusive, I became converted to the view that it is better to

make modern literature overtly the standard and reference of one's criticism, for I decided that one is bound to do it in any case, and it is better to do it with one's eyes open. It seemed to me on consideration that critics had all along been in fact doing what the New Critics recommended; if the New Critics' proposals sounded revolutionary, it was merely because our times had witnessed a remarkable acceleration in shift of sensibility. In Yeats, Joyce, and Eliot a new idiom in literature was emerging, an idiom as different from that which preceded it as the idiom of Romantic poetry had been from Neo-classic. We late Romantics (I was born in 1897) had always read and judged in terms of our sensibilities, preferring, for example, Pope's *Rape of the Lock* to his *Essay on Man* or *The Dunciad,* and discerning a tradition of "pre-Romanticism" in literature back of the nineteenth century just as the New Critics were discerning a tradition of "wit".

I made myself face the facts of my own experience, which undoubtedly indicated that in the reading of poems for their own sake, the values of contextualism had been greatly exaggerated. Without *any* annotation, a reasonably well equipped reader gets ninety or ninety-five per cent of all the poetic value he will ever get out of any given poem. Dr. Johnson said it a long time ago.[1] The value of contestual annotation is marginal —the last five or ten per cent. The method of contextualism has the bad pedagogical effect of making it appear that you can't read Wordsworth without being a Wordsworth expert. Even if that were true, it would be better not to admit it. But it isn't true.

I saw that the chronological approach often got an author off to a bad start, often created an unfavorable impression which it was difficult later to overcome. Wordsworth's early experimental poems like *We are Seven, The Idiot Boy,* and *Simon Lee* strike most unprepared readers as being merely silly, and make it hard to get attention later for *Tintern Abbey* and *The Old Cumberland Beggar.*

Yet, though I was willing for the freshman course to be a somewhat naive course in pure reading, I was unwilling in other courses to forego contextual annotation and literary history. I still am convinced from my

[1] "Let him that is yet unacquainted with the powers of Shakespeare and who desires to feel the highest pleasure that the drama can give, read every play from the first scene to the last with utter negligence of all his commentators.... Let him read on through brightness and obscurity, through integrity and corruption; let him preserve his comprehension of the dialogue and his interest in the fable. And when the pleasures of novelty have ceased, let him attempt exactness and read the commentators" (Preface to Shakespeare).

own experience that some of our best annotation comes from the outside in, from extensive study of the poet's other works and the climate of opinion in which he developed. Wordsworth really never opened up completely for me till I read Arthur Beatty's book on his use of the associationist psychology of David Hartley. Granted that contextual annotation gives us only the last ten per cent, that is a precious margin. *It is the distinctive contribution that scholarly criticism can make.* A reader does not read poems through mere native intelligence. He gets equipped to read poems by learning how to read, and I see no reason why the act of reading new poems cannot be combined with some more learning. I think it desirable, through our own efforts and the reports of critics contemporary with Wordsworth, to try to form a notion of what Wordsworth's poetry was in 1807, though I do not think it desirable or even possible to *limit* our reading of the poems to what we conceive to have been Wordsworth's intention. I believe too in literary history of the old-fashioned genetic sort, and I like biography—more biography than I would ever think of using as direct annotation for reading a poem as poem.

But why be a partisan? Why not get the values of both methods? Why not teach (to use Ferdinand de Saussure's terms) both synchronically and diachronically? Why not look at literature first as a stretched string of beads held straight out from the eye, and then as a string of beads stretched across the field of vision?

In both my graduate and my undergraduate courses I now start each author off with that portion of his work which I take to be most grateful to the sensibility of my students. I don't pick my own favorites; I read *avant-garde* critics and I pay attention to the critical papers that my students write for me. I make no pretense to chronology in this first approach. In the case of Wordsworth, I start off with *The Ruined Cottage,* follow with *Michael, The Old Cumberland Beggar, Resolution and Independence, Tintern Abbey,* and the Intimations *Ode.* Then some selected lyrics, including the Lucy poems and *The Solitary Reaper.* In the graduate course I then read the entire *Prelude.* I have rearranged the authors in my bibliography into two groups: "Modern" and "Older in Date and Attitude". My "Modern" group on Wordsworth includes Brooks, Leavis, Ransom, Trilling. I don't put these in because they are my favorites; I actually like the second group better. But I find that my *students* get more help from Brooks and Leavis than from Bradley or Raleigh. My lectures on these assignments are just as New Critical as I

can make them; no chronology, no biography, no historical qualifications. I hunt for coherence of images, irony, paradox, and under-statement.

Then I begin over again and do Wordsworth chronologically. I lecture[2] on general historical background, drawing on Willey and Whitehead. We read *Guilt and Sorrow* and I summarize Wordsworth's early biography, his connection with the French Revolution, and his brief adherence to the ideas of William Godwin. We read a group of psychological lyrics such as "My heart leaps up", *The Complaint of a Forsaken Indian Woman, Anecdote for Fathers,* and *We are Seven,* and I lecture on Hartley. Then poems like *The Thorn* and *The Idiot Boy,* and I lecture on the Preface of 1800. Then poems illustrating Fancy and Imagination, and I try to make clear what the distinction meant to Wordsworth. Then patriotic sonnets and a few of the later poems. I finish the undergraduate course as a summary with extracts from *The Prelude.* All along I tie the lectures to the particular poems and make constant backward reference to poems read in the first group of assignments. For example, I review *Tintern Abbey* in the lecture on Hartley.

The results seem to me much better than those that I obtained by the old method. Students are much more likely to be interested if you start with the best work. If you begin with *The Ruined Cottage* and *Tintern Abbey,* your students will listen when you tell them that the fault of poems like *We are Seven* and *The Idiot Boy* is not silliness but over-sophistication. Those poems show an affectation of simplicity something as Hemingway's early work does. If the best poems are presented with no weight of learning, the students are encouraged to come to personal grips with them. And if one starts without historical annotation, it is easier to convince them that contextual study is more than mere literary history. Mr. Empson caused a tremendous flurry among Wordsworthians by his assertion that in line 96 of *Tintern Abbey* "it is not certain what is *more deeply interfused* than what". One certainly can't read the poem as poem without having made up his mind on that subject. Here are the crucial lines:

> That time is past
> And all its aching joys are now no more,
> And all its dizzy raptures. Not for this

[2] In the undergraduate course. I make the students do the lecturing in the graduate course and try to work in my own comment in the discussion following the lecture.

Faint I, nor mourn nor murmur; other gifts
Have followed; for such loss, I would believe,
Abundant recompense. For I have learned
To look on nature; not as in the hour
Of thoughtless youth; but hearing oftentimes
The still, sad music of humanity,
Nor harsh nor grating, though of ample power
To chasten and subdue. And I have felt
A presence that disturbs me with the joy
Of elevated thoughts; a sense sublime
Of something far more deeply interfused,
Whose dwelling is the light of setting suns,
And the round ocean, and the living air,
And the blue sky, and in the mind of man:
A motion and a spirit, that impels
All thinking things, all objects of all thought,
And rolls through all things.

Grammatically and syntactically, Empson is right. There are various possibilities, and grammar and syntax alone will never enable us to say which of the various possible readings is the right one. This kind of rightness can be determined only by context: the context of the poem and the context of Wordsworth's ideas generally. A reader who had read Beatty's study would say without any hesitation, "There is not the slightest uncertainty. The something which is a felt presence, a sense sublime, is more deeply interfused than the still, sad music of humanity which is mentioned five lines above. Wordsworth is moving up Hartley's ladder from Sympathy (loving awareness of men) to Theopathy (loving awareness of God). One would expect the spirit of God to be more deeply interfused in the visible world than the music of man is. You can verify this by looking further on for the top rung of Hartley's ladder, Moral Sense." And sure enough the lines continue

Therefore am I still
A lover of the meadows and the woods,
And mountains; and of all that we behold
From this green earth; of all the mighty world
Of eye and ear,—both what they half create,
And what perceive; well pleased to recognize
In nature and the language of the sense

The anchor of my purest thoughts, the nurse,
The guide, the guardian of my heart, and soul
Of all my moral being.

I am not maintaining that one cannot read the lines correctly without a knowledge of Hartley's system. The reading is there on the page in the words of the poem. What I am saying is that historical contextual knowledge provides a compass to guide you through Wordsworth's non-significant ambiguities. *Tintern Abbey* is like a grove of great trees with all sorts of possible paths between them. The paths are *not* equally good.

But the greatest value, perhaps, of this double method is that it both encourages modernity and checks its pride. We ought to use to the full our fine and accurate perception of what is best for our own time, but if we make that perception an absolute, we are subscribing to inverted historicism. Literary history shows that all ages are limited ages, with their special insights and their special blindnesses. And the present is another age, is part of history.

FREDERICK POTTLE is a Sterling Professor of English at Yale and Chairman of the Editorial Committee of the Yale Editions of the Private Papers of James Boswell. He has edited many other Boswell editions, and his book *The Idiom of Poetry* is in its third printing. He took his Ph.D. at Yale and holds a number of honorary degrees from other universities.

Language / DAVID BAILY HARNED

DEATH AND CHEAP WORDS

I

AMONG THE MOTIFS WHICH, always at some hazard, one might venture to track through the jungle of the contemporary arts, there is a new preoccupation with man's mortality. Although reminiscent of the seventeenth century and before, the distinctive form of this concern has been fashioned by the course of modern history. The number is legion of those who have marked the mortuary air of much recent fiction; Mr. R. W. B. Lewis, for example, wrote in his fine book, *The Picaresque Saint*:

> Twentieth century literature began on the note of death. The first page of the first book by James Joyce established the subject and tone for an entire generation, at least for an entire European generation—the opening lines of *Dubliners* . . . in which a young boy describes his feelings about a dying priest. . . The name of the paralyzed priest is Father Flynn; but he is also, as we know, an image of darkening Ireland, culturally withered and priest-ridden, in Joyce's view of it. And in the larger perspective of the twentieth century novel, the priest is not only modern Ireland, he is modern Europe—the modern world . . . the first fact of modern historic life is the death that presses in on it from all sides: death in battle, death in prison, death in the pit of the soul and in the very heart of the culture. (1)

In the eyes of many artists, the only beauty with which the world itself is instinct today is the dead, basaltic splendor of a desert. And there are many who find no power upon whom to press some agonic appeal from its midst: for time and again, God is known, if He is known at all, only in terms of his abandonment of creation. In the dark and endless wasteland, therefore, a man has no recourse except this one: he must fasten his gaze upon himself, if he is to discover even the most modestly vivifying springs of authentic meaning and value. And all too often, he must finally fasten his gaze upon himself alone, for the modern age has witnessed the considerable erosion of man's ancient common values and of long-hallowed forms of human community.

No newspaper has chronicled the decay and mourned the decline of the old gods so well as that story has been captured by the art of the contemporary novelist. And a thousand times he has lamented the accidents which threaten every attempt to find some surrogate now for cosmic meaning within the limited sphere of personal relationships—when that venture must be pursued beneath a hostile heaven, across a strange and alien land, through a universe which ultimately is uncommitted to the conservation of human values. It is also true, however, that when this is man's estate, art itself gains new import, for the imposition of meaning and order upon what is intrinsically devoid of them is enduring testimony to man's indomitable courage and ingenuity.

In the concluding paragraph of a novel by Albert Camus, the narrator, a doctor who had fought for months in an Algerian town against the ravages of bubonic plague,

> ... listened to the cries of joy rising from the town ... [and] remembered that such joy is always imperiled. He knew that these jubilant crowds did not know but could have learned from books: that the plague bacillus never dies or disappears for good; that it can lie dormant for years and years in furniture and linen chests; that it bides its time in bedrooms, cellars, trunks and bookshelves; and that perhaps the day would come when, for the bane and the enlightening of men, it would rouse up its rats again and send them forth to die in a happy city. (2)

The plague is a polyvalent symbol of all the powers within and without man's mind which defy his control and tatter every fabric of meaning and value which generations weave. The world that was known to Camus did not offer any long-range commitments to men or to their society,

and even though doctors like Rieux might win penultimate victories, neither these nor anything else could ever exorcise the spectre of final defeat from the hearts of the populace of his fiction. The ultimate powers of being seemed themselves ranged against being, at least in its human mode.

The ubiquity of images of death in the writings of Camus and a host of other practitioners of his art testifies to the loss of faith in the goodness of creation which is a distinctive mark of the modern age. Even though the story of man's mortality has been the stuff of the arts ever since history began, it is peculiar to our age that artists should be so outraged by the visitations of death that no naturalistic account is adequate any longer to describe its real torments for them. In other words, it is not simply the funereal light which bathes the landscape of the arts, but rather the sense of outrage recorded there at the imminence of death, that differentiates the shape of this motif today from its every earlier form. And perhaps no one has expressed this violent sense of outrage as well as Franz Kafka, in the ultimate paragraph of his inevitably unfinished novel, *The Trial*:

> But the hands of one of the partners were already at K's throat, while the other thrust the knife into his heart and turned it there twice. With fading eyes K could still see the two of them, cheek leaning against cheek, immediately before his face, watching the final act. "Like a dog!" he said; it was as if he meant the shame of it to outlive him. (3)

Why should the imminence of death appear, to the vision of the contemporary writer, such an abuse?

The twentieth century has been often called the "Elizabethan Age of science". Yet our technological mastery of the world has brought to us a new and bitter loneliness; we still long for the comforts of the old, irrecoverable cosmologies. The bonds between man and the world have run deep and they are too ancient to be severed now without some confusion and some pain. While the scientific age has brought the world to the threshold of a new maturity, by emancipating us not only from the old divinities but also from all the rest of the creation, it has exacted a certain toll. If, for example, this emancipation means that the universe does not have written into it some comprehensive moral order through conformity with which man can achieve genuine self-fulfillment, then

his freedom is terrific and vertiginous indeed. Now he is as lonely as the gods.

The contemporary artist, if Camus was a representative figure, is not unaware that he lives through some of the most fecund years of the "Elizabethan Age of science". The recurrence of images of death is more than an index of the lack of communication between the scientists and the literary arts. No matter what other accounts might be offered for its presence in recent fiction, it is also true that this anguished recognition of the world's "otherness from man" is the shadow which the sun of science casts upon the human consciousness. As man emerges from the world, self-exiled from the protective matrix in whose terms he once—but never more—could measure his own stature, he inevitably becomes a stranger to himself, the prey of a new and desperate loneliness.

This is a very lonely age: for man has lost the ancient security of participation in some vast cosmic order. The arts today have something of their mortuary air because acid hands are constantly anticipated there to complete the dissolution of the human frame which is threatened anew by each splendid sundering of the bonds between the world and mankind which the scientists achieve. Today man is emerging from the world and this is an awesome spectacle. But it also has its price. And something of this price of bitter loneliness is being captured by the craft of the modern novelist—even if it is often known to him only in some visceral fashion, too inchoate to find reflective expression.

Now man finds himself the arbiter of the order of the universe and not its servant. His mastery of the world grows with each new year. If the prospect is glorious, the exigencies of such responsibility are terrific. Little wonder that men should still long for the comforts of the old cosmologies, even though by many they have long been disbelieved. For we are anchored now to nothing beneath us and to nothing above. The world is ours. All ours, except for the old unity of man with the creation, now recognized only in its loss. All ours, therefore, except for our old, familiar selves.

II

The prospect of death is more formidable wherever human community has lost its stability; today, new sociological patterns in America conspire time and again to render the burden of mortality more grievous. In the contemporary jargon, the last few decades have marked the "pan-

urbanization" of America. We are no strangers to the asphalt jungle: now the individual is estranged from the land and swallowed up in the anonymity of the city. Furthermore, a technological society is an extremely mobile society—but, in such a nomadic civilization, cultural and ethnic traditions must eventually decay, old loyalties be dissolved, and the unity of the family and the traditional parish system become eroded. And it is also true that our encounters with one another in a society such as this become increasingly marginal. Technology breeds specialization; the consequence of specialization is that men meet in ever more marginal and partial ways.

So community grows more splintered, and the person more fractured, too. Death is the last solvent of human community. Now men are frightened to die precisely because death is no longer a mystery, an experience which they can endure but a single time. Rather, death has become all too familiar in the daily lives of ordinary people, familiar in the constant, desolating disruptions of community which no city planner will ever obviate—present only in a minor key and diminished mode, present only in its foreshadowing, but present still. And not even the prospect of interment at Forest Lawn is, in every instance, quite a sufficient anodyne.

As the postures of the heroes of "existentialist" fiction suggest, death assumes its most dreadful countenance among men who are estranged from the traditional values of bourgeois society. It becomes an obsessive concern for men who recognize that such values are not absolutely valuable, and yet who find nothing else which is. Finally, all values seem relative, subject to manifold vicissitudes in history, possessed of a dark ambiguity. In today's literature of disenchantment, the decayed tissue and the hollow places and the awkward joints of the traditional values are being exposed to the light. So often, they no longer exert any powerful claims upon man's heart. With greater or less eloquence, greater or less restraint, the protagonist of many a novel has echoed the protest of Frederick Henry:

> I was always embarrassed by the words sacred, glorious, and sacrifice and the expression in vain. We had heard them, sometimes standing in the rain almost out of earshot, so that only the shouted words came through, and had read them, on proclamations that were slapped up by billposters over other proclamations, now for a long time, and I had seen nothing

sacred, and the things that were glorious had no glory and the sacrifices were like the stockyards at Chicago if nothing was done with the meat except to bury it. There were many words that you could not stand to hear and finally only the names of places had dignity. Certain numbers were the same way and certain dates and these with the names of the places were all you could say and have them mean anything. Abstract words such as glory, honor, courage or hallow were obscene beside the concrete names of villages, the numbers of roads, the names of rivers, the numbers of regiments and the dates . . . (4)

Even those few values whose radiance is undimmed are not secure from the threat of disaster in this nuclear age of the world's maturity. And if there are no common constructs of meaning and value certain to endure beyond the brief lives of individuals, and by having contributed to which an individual can achieve some objective immortality, then death may well mean the absolute annihilation of the self. In western history, men seem always to have been assured of some tenuous immortality, no matter what their religious persuasion, by virtue of the survival of the common values on which they had spent their strength and lavished their devotion. We are no longer so sanguine. Not even the "humanist's immortality" is still assured. And that, finally, is why death has assumed such a dreadful countenance today: because, for the individual and even for society, it may be absolutely all there is. The ghost of Spengler has not yet been laid. Rarely before the recent advent of Existentialism had men dared to say so unambiguously that death is the only certainty and that we know it in the course of our lives far more intimately than we know even life itself.

III

Certainly the modest proportions and limited scope of the established values have gone unrecognized only by relatively few in this revolutionary age. The coherence and comprehensiveness of the traditional vision of the Good, therefore, has been splintered into a plurality of lesser visions. The recent wars, the progress of science, the continuing world ferment, the emergence of new forms of society—all these have exercised a disintegrative influence upon the traditional values of the West. While the metamorphosis of value patterns is perennial, the process has been radically accelerated in our time. The result is a new visitation upon us

of the myth of Babel: our society no longer has one common realm of discourse. The traditions which have been the cement of human community are crumbling; consequently, there has been a proliferation of new languages. Stephen Dedalus, when he confronted the dean of studies at University College, Dublin, was a singular prophet of the return of Babel to the modern world:

> The language in which we are speaking is his before it is mine. How different are the words home, Christ, ale, master, on his lips and on mine! I cannot speak or write these words without unrest of spirit. His language, so familiar and so foreign, will always be for me an acquired speech. I have not made or accepted its words. My voice holds them at bay. My soul frets in the shadow of his language. (5)

When the traditional values are shaken, their ambiguity and finitude realized, the result is that the worth of the traditional vocabulary becomes problematical. Now there is new knowledge which the old language was never fashioned to convey. The anatomy of a language inevitably reflects the values to which those who use that language are committed. A language is elaborated in order to sustain and to advocate those values. When their authenticity and comprehensiveness is in doubt, words grow cheap.

When, in a time of change, aspects of the traditional vision of the Good demand revision, it is difficult to find some consensus about the shape of authentic human values. Among the legion of new visions, there is conflict for supremacy. So there is no longer a significant *lingua franca*: the old is inadequate and the new has not yet been achieved. There are many different tongues, even though all of them may be "American". How is translation among these many languages to be accomplished? Such is the predicament of ordinary persons today, members of the same family, men who have grown up together in the same town. Two persons, committed to discrete visions of the world, bring different languages to their meeting. And so, perhaps, they never meet. Perhaps they never even know they have not met—all those husbands and wives, mothers and sons, who cannot find a common tongue.

The new visitation of Babel upon us all is aggravated by the syndication of language by mass media of communication. At its worst, this syndication constantly entails the exploitation of words not for communion but control, not in order to reveal, but in order to coerce and

dupe. Such linguistic piracy robs men of all the phrases once used to express distinctive and private experience. They are left only with linguistic conventions and stereotyped phrases, and so their lives grow conventional and stereotyped, as well.

Our lives grow ever more fragmented, and each fragment is identifiable now by virtue of its own distinctive language—the language of science, of religion, of advertising, of art. (6) The splintering of human existence is the necessary price of technological society. The actual problem, however, is that the fragments do not cohere: life is too often bereft of that organic unity from which the human spirit derives its deepest nourishment. We have no language which is capable of integrating and investing with comprehensive meaning our polydimensional experience. Authentic communication grows more complex and occasional; the inexpugnable isolation of every man from every other grows deeper still, more desperate, more lacerating. And the import of death as the solvent of human community is etched with ferocious intensity upon man's heart. There is an epiphany of death in every conventional phrase, every stereotyped response, every imprecise emotion, every broken dialogue. In the midst of Babel, the weight of our mortality is great: little reason do we have for surprise at the outrage over the visitations of death which is chronicled in the arts today.

IV.

The obsession with death and the loss of faith in the goodness of creation, the eclipse of the joyous affirmation of the world which is the ground-bass of the Old Testament, the visitation of Babel upon the modern world—these are the threads we have ventured to trace in the skein of the contemporary arts. Their presence there is of urgent import.

Man is distinguished from all else in creation because he alone possesses language. He owns nothing else of such great worth, for this is the single medium by which he is able to offer promises and to accept loyalties. And for the Old Testament, man is man because he is the one promise-making creature. Therefore, when words are cheap, man himself is threatened; when language is counterfeit, man himself is in danger. The adventure of the artist is to struggle against that fate. Because he has been graced with so high a calling, civilization must attend to him. And perhaps the same may be said, in some measure, for the

church. She, too, must listen. Art constantly reminds us all that language must ever and again be healed and renewed. Occasionally, art may forget that man himself must be saved as well. But theology has no quarrel with, and has much to learn from, the artist's insistence that language is a soteriological problem: words must be saved, and unceasing vigilance must be exercised on their behalf, if man himself is not to lose his way in the darkness of our time.

Theology is dialogue, because truth is a dialectical affair. The plenitude of truth is known only as an eschatological hope: that is to say, it is not exclusively the possession of either the church or of the world in this age, but rather belongs to God alone. Theology is translation, because the Christian message is never genuinely offered to a man if it is not offered in his own contemporary language and thought forms. In so far as the responsibility of the church is to make the eternal Gospel relevant to the modern situation, the church, too, is completely involved in the recent proliferation of tongues, the estrangement of language from reality, the new visitation of Babel. The Bible is partly myth and metaphor; yet its message must be proclaimed in a scientific culture. Biblical imagery is agrarian; yet its message must be proclaimed in the most urban society man ever has devised.

The dialogue between the church and the world, between theology and the arts, must not be arrested. Neither must the tensions be resolved too hastily. If the servants of the Word and the guardians of words fall out of dialogue, are not all lost? If the dialogue goes on, then out of that dialectic, in the providence of God, something more of the fulness of truth may emerge for the modern age.

<div style="text-align:center">END NOTES</div>

[1] Pp. 17-19.
[2] *The Plague*, p. 278.
[3] P. 288.
[4] *Farewell to Arms*, by Ernest Hemingway, p. 191.
[5] *A Portrait of the Artist as a Young Man*, by James Joyce. (P. 317 in *The Essential James Joyce*, Harry Levin, ed.)
[6] Cf. Sir C. P. Snow, *The Two Cultures and the Scientific Revolution*, *passim*.

DAVID HARNED is a member of the Department of Religion at Williams College, a Fellow of the national Council on Religion and Higher Education. He graduated from Yale in 1954 and the Yale Divinity School in 1958.

Language / JULIAN N. HARTT

DEATH AND TRANSFIGURATION: THE FATE OF CHRISTIAN SYMBOLS

I

IT IS A TRUISM THAT SYMBOLS, like everything human, live finitely, i.e., they come to be and pass away; and have boundaries other than the temporal in which they are contained. The lifespan of a symbol may extend far beyond a human generation; but this much is true, too, of the life of a redwood tree, and of a giant sea-turtle; but they too in turn wholly die.

Today it is commonly believed among right-thinking people that we are keeping the death-watch for the Christian symbols. It is assumed that we are living in a post-Christian epoch ("God is dead," quoth Zarathustra). Whereupon another law of the symbol world is cited, perhaps in faintly regretful tone: once dead a symbol is forever dead. It may die slowly throughout a graceful autumn. Then it dies, and is remembered only by antiquarians, if by any. Once dead forever dead— do we not all agree that what holds for all of life must hold for the symbol?

But what is the "death" of a symbol? Since the life of a symbol is its expressiveness, its efficacy as a conveyor (or should we say *instance*) of meaning, the "death" of a symbol is the attrition of such meaning, leaving but a "skeleton"—an empty formality—behind. At once a striking phenomenon claims attention. Transfiguration is a symbol as fully pertinent to symbol as Death. Transfiguration is the ingression of new meaning into an extant formality, expressing a kind of continuity between two "worlds".

What I propose to do in this paper is to explore the state of some Christian symbols by using the symbols of Death and Transfiguration. The human area discussed is literature. As a Christian I have a natural interest in the fate of Christian symbols. I have an interest nearly as great in the fate of our present life and world.

II

Christian symbols are elements of the life and death of Jesus Christ which express the whole reality "Jesus Christ", i.e., what (for the eyes of faith) is revealed in him not only of life but also of the ultimate world. Thus Cross, Chalice, Dove, Fish, Lamb, etc., having been emblems of the very early Christian Church, became symbols. Each represents the whole but represents it uniquely. So far as each is a symbol it is a cluster of emotions and beliefs defying (and perhaps rebuking) propositional translation.

The attenuation of Christian symbols seems to be an unconscious project of the Christian Church. How else may we hope correctly to identify the relentless drive towards conceptualization in Christian thought? But here the transfiguration motif comes into view: the concepts themselves have long since begun to give off a symbol-aura. "Guilt" is a concept; but it has symbolic overtones. This means more than the possession of an emotional charge. It is also, and decisively, the sense conveyed of a whole "world", a situation and a human condition related thereto. "Guilt" breathes the atmosphere of tribunal and condign tribulation; of transgression and punishment to fit the crime if not the transgressor; and of powers and principalities looming behind all human contrivance to gain justice and to avoid it.

Thus, conceptualization opens the door to new symbolizations, and to a new lease on life for old symbols. By the same token the door is opened also for an ingression into the symbolic form of a new meaning which denies the old life of the symbol. (Hence "transfiguration" is not intended here as an honorific term). We should have to grant that the residual symbolic form, at such a time, is hardly more than a conceptual —or perhaps merely a verbal—"trace". In the last stage of aesthetic attenuation the symbol is but an imaginal filigree too insubstantial to endure the weight of much traffic; but not without power to suggest, to intimate a past, lost world. Yet at this very time a new world may be appearing, to take command of the old formalities, the residual traces, for the expression of its own life.

III

So much for the general considerations. What is to be done now is to show how these things have happened (are happening) in our own world. For this purpose we shall discuss: The Fall, Damnation, Expiation, and Sanctification.

(i) The Fall expresses to and for us a dim sense of having sometime somehow been separated from a condition of being in which life was spontaneously good. The phrase itself, I suspect, is quite as likely to evoke images of stern preachers thundering antique sermons, as it is to put into our minds images of real progenitors committing real sins from which we suffer real effects. But we know that this dim sense of a lost, past world is a dramatic attenuation of a symbol once vivid, clear, and imperious.

Now, and oddly enough, we seem to have another sense: new life begins to flow through the old form. Something there will not let go of "the spirit of Western man". He returns to the symbol of the Fall unerringly; and he does this in order to express his sure sense of having (as human, not as Western) been hurled from a blessed life into an accursed one, willy-nilly.

Camus, for instance, does this in *The Fall*. Innocence is destroyed; and again a human soul becomes a guilt-haunted homeless wanderer upon the face of the earth. But with a singular difference from Adam One: Clamence fell from the sublimity of self-adoration, of nearly perfect egocentricity, into the absurdity of self-loathing and self-flight. Does this make *The Fall* an exercise in ironical inversion of Christian verities? Not necessarily. (I doubt that Camus had the temperament—or the *weltanschauung*—for irony.) With greater justice we might see *The Fall* as a symbol not only transformed but transfigured: it gives off a luminosity of meaning, a fresh vitality, as though a new "world" had seized the symbol for its own life. Can we have a real doubt concerning that new world, i.e., concerning its nature, or its presence, or its power? It is a world in which man is inalienably guilty; but in, from, and by himself alone. The discontinuity expressed by Fall is still with us; but it is now a discontinuity internal, in the "soul", marking the disastrous passage from self-ignorance to self-knowledge.

This new world has not yet come all the way into visibility. Perhaps this is because the symbolic conveyors are the legacy of another world, and have therefore a residual recalcitrance. To use them at all is to be under a palpable obedience to the past, if not to the gods of the past. As

an illustration of this I want to refer briefly to William Golding's novel, *Free Fall*.

Here again the title is consciously symbolic. Samuel Mountjoy, the protagonist, pursues "the decision made freely that cost me my freedom", that corner, once turned, in a road of many turns, which somehow decided everything. But why does he pursue that decision, why does he want to tell his story? So that he may at last understand what happened. To understand does not necessarily mean to forgive: it is at least as possible that to understand oneself is to know oneself as unforgiveable. ("Nothing can be repaired or changed. The innocent cannot forgive.")

Thus in some moment Mountjoy did the thing which determined his history. But did that thing have that feel of momentousness? Hardly. In that moment he fell; but not, recognizably, from Grace; and therefore, perhaps, only from self-enjoyment.

So again the symbol takes unto itself an increment of meaning, which in superficial aspect only is a continuant of the old. The word remains; and perhaps a faintly traceable imagery; but the "world" expressed is different, fundamentally.

(ii) Damnation.

Again the word has about it the faint aroma of a past world—dread reprisal at life's and world's end for sins against divine majesty. Very faint, I suspect we ought to say, even for the most rigid traditionalists amongst us. For the larger part by far "damnation" is a slightly inflated synonym for Alienation, Estrangement, etc. It expresses a depressive internal human condition, not only intra-mundane but also within the human subject. To be "damned" pertains to the human estate, i.e., to be stricken of spirit perhaps in conscience, perhaps in the sense of the world's woe, perhaps in the invincible awareness of being alone in a darkly silent universe.

So Lady Brett Ashley in *The Sun Also Rises* is one of the damned. Not star-crossed or heaven-curst; but at hopeless odds with self and world; and so she is a stricken, flawed creature. Condemned she is but not by decree of God.

And where in Eugene O'Neill's world do we see anyone *not* of the company of the damned? Lost, all lost! But not by reference to any features of a fixed moral landscape. The moral fixtures and furniture are all loosened, disassembled, and disoriented; and a-swim on the bottomless seas of self-deceit, self-pity, and self-hatred. Pilgrims and strangers all, but neither home-ward nor outward bound on mission as

ennobling as perilous. A world most richly damnable, but who will give the damn, who but man speaking morosely to, for, from and of himself?

There are other versions of Damnation, and notably those offered by Kafka, Mann, and Faulkner. Each has shown what life becomes when it must struggle with unappeasable guilt. In Kafka's *Trial* the guilt is unnameable; and, until the end, he very nearly convinces us that its sting is exasperation with crude ignorance and presumption.

For his part Mann has created a very powerful representation of damnation at the hands of the demonic, ostensibly after the Faustian model. The appearance is misleading; and I can hardly suppose that an accident, a slip of the master ironist's pen. For Faust contracted for an empire for his ego, illimitable power, plunder for sense and desire on earth; and all at the price of being pelf of Satan in the life of come. (A meanly-calculating spirit in us counts that a handsome bargain; but Faust believed in the reality of the after-world and we believe with difficulty in the reality of any world.) Leverkühn, on the other hand, does not strike a bargain with the demonic for acquisition of a sensualist's paradise (sensualist's, yes, for it is the feel of power which thrills the empire-builder, is it not?). He would be a creator, as an artist, which is to say he aspires to a god-like power; and for this he is damned, and knows it. But there is more, and worse, to come: innocence is ensnared in the compact with the powers of darkness, and dies most frightfully. Then is this still not Faust, the whole of it, the essence of it? Is there not, always behind Faust, whensoever he is represented with authenticity, the shape and feel of a world through which mighty powers move, intent, generally, upon our weal or woe? To which I am constrained to reply, in all modesty: not so far so fast. Thaumaturgy abounds in *Dr. Faustus,* to be sure. But Mann seems to me uniformly to represent this thaumaturgical activity as dabbling in ancient superstitions unlikely to stir sleeping dogs of Hell, except in conscience. The narrator, good, gray Serenus Zeitblom, Ph.D., may believe that there are demonic powers outside the id. But does Mann encourage us to so believe? I think not. He does show us, and convincingly, that given the theological orientation of Adrian Leverkühn, creativity is *hybris,* finally, and brings horrid retribution. But it also brings forth beauty too great, almost, to be endured.

So some men continue even today to believe in damnation at the hands of demonic powers. They know what they have experienced: a shattering, life-destroying sense of alienation. But *we* know what their

experience means: outrage of conscience by illusions, and thereafter (and therefrom) the inner certainty of being "lost" forever.

Thus again a symbol once efficacious in relating men to a world, and the powers thereof, in which their souls are forfeit that at last justice may be done, has lost all that dread (but curiously significant) burden; and a new world has taken possession of Damnation.

Faulkner has come rather closer to the felt quality of our American life at this point, understandably enough. At the same time he offers a much more ambiguous representation of Damnation at the metaphysical level (if we may call it that) than Mann. Joe Christmas, in *Light in August*, is one of the damned, unquestionably. His damnation is a biological fate: is he a Negro or isn't he? Neither he nor we can resolve the matter; and Joanna Burden is the Calvinist juggernaut ordained to destroy him, Joanna the angel of Christian social concern. (Joanna is herself one of the damned but for reasons far less equivocal than appear in the instance of Joe Christmas.) But if Damnation is biologically secured, the symbol is blurred, for then to be damned is an accident of birth rather than a just requital for evil produced by design.

Thomas Sutpen of *Absalom, Absalom* is, for this reason, a much clearer representation of the justice of damnation. Sutpen did not design evil—he wanted, from the first, requital for injury to pride; and to this design everything else becomes "adjunctive". But of course the design goes awry; and there is in consequence enough weeping and wailing and gnashing of teeth to go all around. *Of course* it goes awry: the emphasis betrays our own (and Faulkner's) provinciality: the lineaments of the moral order seem still that clear to us. Seem; but are not. Here and there hope of vindication from a morally governed cosmos and fear of the same retain a measure of luminosity and vitality. Nevertheless we do not habitually act as though we saw such an order even faintly adumbrated in our ego-adjustments to social demands. Hence we can but conclude that Damnation is a symbolic ghost fitfully revived in the haunting sense of lostness, of radical disorientation, relative to a life never realized except in dreams. For how shall we hope to say seriously that a man is damned if the Judge is but his own sense of outrage directed against himself for unrealized pleasure and realized pain?

Yet Faulkner is stubbornly attached to the symbol. Yoknapatawpha County is a province in a moral cosmos: there too the wheels of the gods grind slowly but they grind exceeding fine. There too the damned receive their recompense as something due them. For them no possibility of

life-regaining restitution opens (Temple Drake is a sad exception). But the larger justice done them—are we not supposed to be instructed by this, and perhaps edified as well?

So to (iii) Expiation.

Here the symbol has receded even further into the dimness of life. It is not that our epoch is insufficiently familiar with the suffering of the innocent—hardly! The symbol has long since become pallid and inert *just* there: we cannot see how such suffering as modern man has learned to produce has anything salvatory about it. Easily we can believe that they who take the sword will die by the sword. What we do not see, and do not really believe either, is that the afflictions of the innocent are the divine instrument for the healing of the nations. "Behold the Lamb of God who takes away the sins of the world" gives off a faint, seasonal glow, but the world it expresses is no more.

Hence to our astonishment Faulkner lays hold of Expiation; and it comes to life, i.e., new life comes to it. The blood of Joe Christmas, though shed in frightful violence, assumes an expiatory quality. This does not mean that the sins of victim and destroyers are forgiven; it does not even mean that they are moved to seek forgiveness here or hereafter. Nonetheless the spilled blood makes a difference, everlastingly. "They are not to lose it [the black spilled blood], in whatever peaceful valleys, beside whatever placid and reassuring streams of old age, in the mirroring faces of whatever children they will contemplate old disasters and newer hopes. It will be there, musing, quiet, steadfast, not fading and not particularly threatful, but of itself alone serene, of itself alone triumphant." (*Light in August*, 407).

I take from this text as its meaning: harried even unto death by a harsh fate, Joe Christmas, immolated, becomes an instrument of self-recognition for a whole community. His blood becomes a president spirit, "not particularly threatful" yet "itself alone triumphant". The murders he did and the murder he suffered do not make murder less likely—so in that sense, to that purpose, the expiation is inefficacious. But the foul deed—the murder, the castration—is enacted as though it were a cultic rite from which, by participation literal and vicarious, men see at last what they are and the life to which they are bound. More nearly primitive than pagan in enactment—and Christian not at all— the rite in issue renders all of them—and shall we be so dull as not to say all of us, too—more human.

Faulkner moves much more clearly towards the Christian symbol of Expiation in "The Bear". Isaac McCaslin foreswears his patrimony, the ancestral estates, because it is stained with blood-guilt. The measures taken by his forebears to wrest the land from friend and foe indiscriminately are in sum a syllabus of crime against man and nature; and he will claim none of that fiefdom, he renounces it all; and becomes a carpenter; which to be was good enough for Jesus and is therefore good enough for Isaac McCaslin.

In this instance Faulkner does not hesitate to suggest that McCaslin's expiatory gesture is made out of a clear consciousness of universal guilt. ("This whole land, the whole South, is cursed, and all of us who derive from it, whom it ever suckled, white and black both, lie under the curse.") Moreover he knows that only suffering avails against the curse ("Apparently they can learn nothing save through suffering, remember nothing save when underlined in blood.") Being a wise man McCaslin does not expect his gesture of repudiation to save the world or to be a turning-point in the history of a people. What he has done is a necessity of his nature. ("I am what I am; I will be always what I was born and have always been.") Yet he is not without a sense of being part of a divine scheme achieving justice in human affairs; so that his subjective necessity makes positive contact with the ultimate powers which make their inscrutable moves on behalf of man's freedom and his endurance. So here again we are in the presence of a symbol out of which the grand historic meaning has fallen away. In that sense, to that degree, the Christian symbol of Expiation has died. But fresh life has come to the old formality. That access of life comes into the old form from a new world. Truth, honor, courage, and love of Nature's sublime and terrible power, these are the moral features of that new world. A good man puts the demands of this moral order ahead of his own comfort, safety, and power. Such is Isaac McCaslin. Perhaps, therefore, he is a symbol of *Sanctification*.

(iv) Sanctification.

Traditionally the "saint" symbolizes the (miraculous) power of love of Christ. Starting from the New Testament epoch, when a saint was simply a member of the holy community (the Church), the Church progressed (if the word is not too oppressively question-begging) to the point where a saint is no longer an organic human creature but is, instead, a lamp of spiritual love brightly burning in Heaven. This transformation of the symbol "saint" is a fascinating historical process, but

we cannot afford to linger with it. Our principal business is with the symbol in its present condition; and I believe that this story can be quickly told.

I think it is quite significant that even the avowedly Christian writers have their troubles with this symbol. Reasons for this discomfiture are not hard to find, among which the most obvious and most decisive is the present dominant conception of love, dominant at least in intellectual circles. Given the conception of "love" as a power driving upwards from the dark underground roots of the psyche, it is indeed difficult to represent a saint as a triumph of spirituality over carnality, and of concern for the souls of others over desire for one's own self-referencing gratification. Christ himself has become a symbol of the exorbitant and unreal demands of the spirit against The Flesh and The World; and is therefore a symbol threatened with total dissipation into the thin, dim life of sentimentality.

Both Graham Greene and T. S. Eliot seem to be Canute-like figures defying the sea, at this point. Greene's whiskey-priest in *The Power and the Glory* is obsessed with the possibility of sanctification. At the end he is ready to embrace martyrdom as a first step in that direction, even though he has more nearly stumbled drunkenly into his self-sacrifice than freely chosen it in love of Christ. To be sure, we are fully convinced that the priest is human—he is an alcoholic (Greene's priests are excellent fodder for the light artillery of the W.C.T.U.), he has a child from an illicit all-too-fleshly love-affair, he is for the larger part a craven coward, etc., etc. Altogether an unlikely postulant for sanctification. For that matter we do not know that he will make it; but a seasoned gambler wouldn't be intimidated by the odds.

This "hero" is a very difficult symbol. The heart of the difficulty is ambiguity in the representation of the spirit-flesh reality. If, on the one hand, he was a Biblical Christian (even better, a Biblical Jew) i.e., one who affirms in word and act the goodness of the bodily life, we could understand sanctification as the triumphant and joyous dedication of the body to the highest ends of life. To the contrary, if the priest were able to renounce the flesh (renouncing it not being the same as loathing it) as a tangle and toil of satanic invention, we could then understand "sanctification" as the final and complete freedom of spirit. Actually Greene affords no such disjunctive clarity. "Sanctification" is in the prospect, if not in the grasp, of a man, in his flesh not merely mortal but also corrupt. No doubt with God all things are possible; but there are limits to our credulity.

In the case of Sarah Miles in *The End of the Affair,* the ambiguity is even more evident. She, too, is confirmed in adultery, a love-affair in which staleness and dullness are some kind of tribute exacted by guilt (Is Greene afraid to believe that even *guilty* lovers are sometimes delivered into immense joy?). But she is able to make the grand renunciatory gesture, as part of a covenant between God and herself, a life for a life: if God will restore life to her wounded (by a bomb, not by her) lover she will give herself (in spirit immaculate) to Christ. And so she is represented as on the road to—sainthood; and becomes a vehicle of healing love, now to a stricken child and eventually (who will doubt it?) to her one-time lover's soul.

As creatures of the present world we are offended by this representation of sanctification. "Sin" may indeed be more often joyless—even, paradoxically enough, in the ecstasies thereof—than otherwise. But is it the "sinfulness of sin" that makes it so? Is it not much nearer the truth to say that the fundamental conditions of our present life, are, in actual sum if not coherently, a disfigurement of life and thus a natural and implacable foe of joy? If so the real saint (as distinguished from avatars left over from some long-gone world) would emanate light, lucidity, and joy engendered by his vision of a world-to-be to which our present life is drawn.

Two of Eliot's figures appear to promise this symbolic transfiguration: Harry Monchensey, in *Family Reunion,* and Celia Coplestone in *The Cocktail Party.* Harry is summoned into pilgramage towards the light from a joyless Fury-haunted life among illusions. Celia goes out to Africa to preach Christ in selfless love, and is martyred. Of the two Celia is the more clearly marked for that ascendant power for good over the lives of others which saints are supposed to have. Though in Heaven now abiding she will ever be a verdant blessing here below.

The symbolic transfiguration does not develop. Celia is a poignant gesture towards a lost spirituality, because both within the play and in the theatre the fundamental conditions of our present life are not radically altered by the relentless impingement of another world. We go on being relatively decent, largely dull, fitfully lucid, irremediably (except for alcohol and other happiness-injections) joyless.

Thus of all the symbols out of the Christian heritage Sanctification is the one most fully attenuated, the one least likely to be transfigured and transfiguring. We are neither good enough nor bad enough to feel either rich promise or formidable threat in Sanctification. The world in

which we live and the lives we lead therein have been stripped of that kind of consequentiality, except in dreams and the invocations of piety.

IV

Though my sampling has been random, the conclusion is not, I think, eccentric. What is to be concluded is that the most important symbolic transformations are determined by the regnant "theological" assessment of man's situation and prospects. The novels we remember, the houses we would prefer to live in, the paintings we prize as significant—these are so many confirmations of that assessment. Therefore *any* symbol which offers judgment upon our judgment, an assessment from beyond both our standard and our idiosyncratic assessments, is, for this present at least, doomed to irrelevancy. That is why we have not been arbitrary—relative to the present situation—in speaking of Death and Transfiguration. In our "theology" death is part of the life cycle and is therefore part of the fate of all symbols; but so also is transfiguration, the coming-again of luminosity and vigor, part of the life cycle.

For this theology—this view of the destiny of life under cosmic powers —Death-and-Resurrection is a symbol beyond recovery. Death would then be death really: the cycle broken, the process terminated, the world no more. Resurrection would be life altogether new, in a new world; and everlasting joy the crown of such life. But death on these terms is the great destroyer of our present fugitive joy; and Resurrection is a word from an archaic creed, with little or no power to tame the Destroyer.

In the proper, prophetic *l'envoi* I suggest that the epitaph for our world should read:

> They hoped until the end
> that the symbols of hope
> would come again.

Julian Hartt received his Ph.D. from Yale in 1940, and has been Noah Porter Professor of Theological Philosophy since 1943, and Chairman of the Department of Religion since 1958. Dr. Hartt is a fellow of the National Council on Religion and Higher Education.

EDUCATION, THE AUTHOR, AND SOCIETY

A PROBLEM as large as the proper education, formal and informal, for authors can be approached two ways. One can survey the whole field of writing and education and induce certain universal principles and rules. Or if one has some experience in being an author and in being educated—and I must admit to at best limited experience in both these areas—one can make a subjective, personal evaluation. The second approach appears more fun. And since one of the reasons I write is for enjoyment, I will follow it.

My feelings about education enter only by way of caveat. I am going to be writing about the types of education "best for authors". Yet I do not think there is any one "best" type of education. The education that develops an individual varies from man to man. General George C. Marshall would not have been happy for long on the Left Bank in Paris or Ernest Hemingway at VMI. Since my treatment of this problem is personal, I am only talking about the education "best" for a certain type of author. My type.

To me the author's mission is to examine emotionally, morally and intellectually the relation between man and society. This relationship has been in a process of continual change since the Renaissance. At that time, looked at roundly, society (the Church) was completely dominant. Apart from society the individual was nothing. The Renaissance began to graft the idea of individual freedom on to the concept of the individual as only important in the ordered whole of society. The society was a huge and ancient oak. The graft of individual freedom smaller than a baby French pea.

Though its growth process was not continuous, the idea of individual freedom grew. It increased fantastically in size like some luxuriant jungle bloom during such times as the Reformation, the Industrial Revolution, the American Frontier. By the end of the Victorian Age the idea of individual freedom was already larger than the concept of the individual in society.

Still the individual's rights went on growing. After World War One intellectuals discovered new areas, economic, social, and psychological, where the individual was still not completely free. They wrote and the society gave way. Again after World War Two more individual freedom was the major cry of authors.

By then they were crying the wrong battle. What they thought was still the Frontier was Back Bay. Individual freedom is now the mighty oak; man's responsibility to society the baby French pea. Beatniks are not revolutionaries. They are the Dean Manions and Bracken Lees of the intellectual world. They demand complete individual freedom for themselves (though paradoxically they lack inner individual liberty) in Western culture that now suffers from an excess of individual freedom. Even as the economic royalists raised the cry of individual freedom against enactment of the child labor laws.

Kerouac, Sinclair Lewis's Babbit, Buckley, Miller and Brecht are brothers in belief. Though they differ in their view of man, want freedom to march in different directions, and some write better than others, their common battle cry is complete freedom for me and mine.

On the other side are a far fewer number of authors, who see the problem in terms of balance. For them both the individual and society have rights, freedoms, and restrictions. Camus, T. H. White, Koestler, Orwell, C. P. Snow are among the few scattered names in this current revolution.

This is not to suggest that authors are propagandists or that writing is something so simple it springs from just one principle. An author's beliefs must be many, complex, and cohesive. But at this present moment in history to be fully effective the author must also be an "homme engagé". This requires a decision, conscious or not, on the responsibilities, freedoms and limits of the individual in society. And since this decision is the time's major problem, it will be central to the author's work.

To write in this framework the author must master a difficult dualism. He must both participate in society as an individual and yet stay with-

drawn enough to descry and describe. What sort of education fits an individual to do this? First the individual must master a vast quantity of fact. Facts about this age. How we got here? Where is here? The need for such facts makes history (political, economic, philosophic, literary), and literature the major formal educational need of an author.

Then come the tools to understand man and society. I do not mean the easy tools of sociology or modern short story reading. But the difficult tools of high energy physics, physiological psychology, cross-cultural anthropology, and again contemporary history. The more advanced the work and reading the author can do in all these areas the better.

In college the author should pick a course of study where there are few marks to catch him up. He must learn to work under the lash of his own super ego. All through his writing life society will muscle her pressures and flaunt her lures to adulterate his work. The techniques of lonely battle against these pressures had best be learned early.

Yet some formal discipline is necessary. Those facts have to be learned. And girls do walk down streets alone in glory. Alcohol is sold. Men will talk. I came to Yale determined to graduate with highest honors without ever refusing a date or a drink. I was not entirely successful. I distinctly remember at four one morning refusing another green cup because I had to defend a paper on Hooker's Ecclesiastical Polity in a graduate seminar in five hours. And receive a mark.

I happen to believe that authors don't need formal courses in writing because we do so much informal writing. We cut our teeth on Fowler, dictionaries, and "literature". We write constantly anyway, and our writings evolve or harden under criticism and advice from friends, enemies, and professional critics. But I see no harm in courses on writing provided they don't teach any exclusive, "one-way" to the promised land.

The author's education never ends. The type of work he enters—other than his writing—is further part of the process. The more community of experience an author has with other people, the greater will be the possibilities for his work.

The continuous society of other authors seems to me dangerous. The great advantage of war to an author has been that it provided him with an experience shared by his reader. They were both part of the same society and event. An author's friends and occupation should do the same thing for him in the peace-time world.

This is not easy. Not only is there the money problem. To be in society

and yet out of it enough to observe and write creates an intense feeling of loneliness. You are the stranger at the feast. The easy way to avoid this feeling is to go to a feast where you are not a stranger—see other authors. But then you will be describing a feast your readers do not sit at. Or you can forget after a time you are an author and believe others' banquets are spread for you.

The work—other than writing—should be both interesting and outside of the world of books. Journalism, politics, scientific research, government, the academic world (provided the author stays away from teaching English or writing), are all occupations where a writer can come into fundamental contact with the world. Journalism is something of a danger. Working with words in the journalism job may exhaust one's abilities to work with words at the writing job. Fortunately the words and the approximation to the truth in journalism and writing are so different, because of readership and time involved, that the danger is minimal.

Finally, the author must learn to accept failure. Time and chance happeneth to all men. But when chance fails, the world tastes most bitter to those who have raced hardest—authors. And yet our demon forces us to race.

ARTHUR T. HADLEY, JR., Yale 1949, wrote the *Joy Wagon* in 1858, the year he became News Development Editor for the *New York Herald Tribune*. Earlier he covered the Defense Department and the White House for *Newsweek* magazine, and has recently published the *Nation's Security and Arms Control*.

SHAKESPEARE AND CO. AND THE SOCIAL SCIENTISTS

IF THE FRATERNITY of social scientists observed a rule of never adopting assumptions contrary to the insights of the Bard, the history and present state of their work would necessarily have turned out quite differently. For a starter, let us take the Puckish "Lord, what fools these mortals be!" How much pretentiousness, want of humor and unrealism we might have been spared by the writers of monographs and text books on human behavior had they but taken this clear-cut Senecan-Shakespearian observation to heart! Consider economics. Economists, if they have not directly contravened Puck, have achieved the same result by assuming that humanity is at least more rational than otherwise and, on that basis, have stolidly proceeded as if we were almost entirely sober-sided and realistic. But if the most influential writer in the English language is right, is it not cause for wonder and lament that economists have scarcely made a beginning with the economics of folly—or irrationality? Surely, such a supplementary study might well prove a salutary corrective preventing some of the more glaring misjudgments of social response to which economists have been so persistently accident-prone. Yet, economists over and over again revert to the strange misconception that it is impossible to engage in rational study of irrational behavior. Obviously, this notion would have stopped psychopathology dead in its tracks: the doctor would have to be as disturbed as his patients.

The want of conversance between social science and literature is but another one of those discontinuities between specialized occupations and professions which threaten the coherence of our society and its in-

tellectual life. Sir Charles P. Snow is rightly very worried about the cultural chasm which yawns between men faithful to the literary tradition and men of physical science. It is remarkable, however, that he fails to refer save incidentally to the social scientist in his *Two Cultures and the Scientific Revolution*. He does not ask whether in some shape or fashion, in one or more of its many branches, social science may or may not be fitted to serve as an intermediary between the sciences and the humanities. Yet it would seem obvious that the social scientist ought to be especially well-suited to bridge the gap: humanity is his field but scientific modes of inquiry are his professed method. Sir Charles, however, does not appear to take advantage of the ideas even of the most famous social thinkers who have tackled the very riddles with which he is absorbed—de Tocqueville, Henry Adams, Veblen, Max Weber, Schumpeter, Talcott Parsons and, most surprising omission, Whitehead. Moreover, Snow's overriding concern is how liberally educated politicians are to distinguish between good and bad scientific advisers. Should not this concern extend under present circumstances to the practitioners of social science?

One of the most remarkable of all encounters between a social scientist and a man of letters must have been the one which took place between Keynes and D. H. Lawrence. Keynes, full of irreverence for the Establishment, hastened with keenest anticipation to his meeting with the coal miner's prodigious son. Let the latter report his reactions to the encounter as contained in a letter of April 19th, 1915 to David Garnett, the mutual friend who effected the introduction:

> I feel I should go mad when I think of your set, Duncan Grant and Keynes and Birrell. It makes me dream of beetles . . . you must leave those friends, those beetles. Birrell and Duncan Grant are done for forever. Keynes I am not sure . . . when I saw Keynes that morning it was one of the crises of my life. It sent me mad with misery and hostility and rage. . . .

In fairness, be it admitted that neither Grant nor Birrell were social scientists. What was really at issue was Cambridge rationalism, but that is something which has left an indelible stamp on economics throughout the English-speaking world. The manner of Lawrence's making an exception of Keynes was, however, foresightful. Some twenty-three years later Keynes was to write (in a posthumously published paper of the highest interest entitled "My Early Beliefs") :

And if I imagine us as coming under the observation of Lawrence's ignorant, jealous irritable, hostile eyes, what a combination of qualities we offered to arouse his passionate distaste; this thin rationalism skipping on the crust of the lava, ignoring both the reality and the value of the vulgar passions, joined to libertinism and comprehensive irreverence, too clever by half. . . . All this was very unfair to poor, silly, well-meaning us. But that is why I say that there may have been just a grain of truth when Lawrence said in 1914 that we were 'done for'.[1]

By 1938 when Keynes wrote this moving recantation of his earlier views he had already made his impact on economics, one widely regarded as the most decisive since Adam Smith's. There is irresistible fascination in speculating on how different Keynes's influence on modern economic thought might have been had he undergone his change of heart about human nature earlier in his career as an economist.

It is hard to say whether writers or social scientists have been freer in their exchange of scoldings. J. P. Marquand had a great deal of rather serious fun with Lloyd Warner of sociology over his remorseless habit of consigning people to such class divisions as Upper-Lower, Middle-Middle and Lower-Upper. On the other side, mathematically inclined students of behavior have wished aloud for the day to come when their studies would no longer have to endure the onus of being called branches of *belles lettres*. Professor Robert K. Merton, the first sociologist to be honored by a *New Yorker* profile (28 January, 1961), employs a rather bold tactic in his defense against Jacques Barzun's charge that much sociological writing consists of little but obscure and empty jargon. Taking a well-turned English sentence of T. S. Eliot's comprising fifty-two words, he translates it into eleven words (not allowing for doubles) of Sociologic, as follows: "Cross-cutting status-sets reduce the intensity of social conflict in a society." I am not quite sure that this says everything Mr. Eliot said, but then my command of Professor Merton's terminology is insufficient for me to judge.

Most unfortunately, professors and critics of literature have done little to encourage and possibly a good deal to dissuade social scientists from deriving profit from the great Elizabethan—or any other giants of letters. For nigh on to two centuries, the plays have generally been regarded by their professional exponents with such stupefied awe—as if

[1] These two quotations will be found on pp. 77 and 103 respectively of J. M. Keynes, *Two Memoirs*, (London, 1949).

one were the Grand Canyon, another the Mindanoa Deep, a third Mount Everest and so on—that their author has come to be defined as something more than a human agency, a kind of demiurge whose creative process is quite inaccessible and unrelated to customary standards and tests of intelligence. The pernicious corollary to this creed that his works were acts of God or wonders of nature is that the man himself becomes merely incidental. After the manner of the Queen Bee, the poet is thought to have spawned many-sided characters in fantastic profusion but in a passive, instinctual way. Carlyle epitomized this transcendental itch to kick "the gentle Will" upstairs, but no less an intellect than T. S. Eliot's still suffers from it. Eliot writes with commendable lack of national prejudice, "In truth neither Shakespeare nor Dante did any real thinking—that was not their job."

Social scientists would be more impressed if the literary professors told them that just possibly William Shakespeare was a pretty smart guy, a man whose I. Q. must have fallen somewhere in the gifted category, at least, if not in the topmost decile. The impressive fact that his vocabulary amounted to 13,000 words, nearly twice Milton's and something of an all-time record, would seem to substantiate such an inference. True, Shakespeare was not primarily concerned with explaining human behavior. But as a great mind who (de Tocqueville said the same thing of Raphael) was mainly interested in demonstrating what man *should* be, he found it supremely easy in by-product fashion to reveal men as they are. To imagine that such a man was not curious about the workings of the mind and of society and that he did not try to understand and explain both seems to me not only the height of irrationality but a disgraceful surrender of one of the greatest claims to dignity the human race has ever established. Macbeth, for example, is far more than a story, a character portrayal or a study of the etiology of ambition: it is also an analysis of social cohesion, the force of institutions, the structure of status and so on. Lear exposes the consequences of the attitude of sentimentality, Othello of mistrust, Hamlet of anxiety, each in a similarly broad and deep social context. Is there really anything excessive in saying that the plays constitute *inter alia* a mighty treatise in social dynamics? If so, the very minimum we ought to settle for is that they represent no less accurate a representation of human beings in action than a series of questionnaire-based studies devised by a team of sociologists none of whom have the wildest idea how their patient subjects define the terms in which the questions are couched. (Those who

prefer to be up to date may well consider, for instance, which choice they would make if they were to be told that either the Lynds' sociological *Middletown* or Lewis's *Main Street* must for some reason or other be lost to the world. One might have doubts about a sociologist who would not be somewhat torn by such a decision.) And should we forget, in addition, that by the standards of his day, a century and three-quarters before Gibbon's, Shakespeare was an excellent historian, or that, as Walter Kaufman has compellingly argued, Shakespeare via Goethe, Nietzsche and others has exerted a lasting influence on modern philosophy? Nor does the supposed lack of accord between art and business seem to have limited the range of Shakespeare's intelligence. There is no questioning the acumen of a theatre owner-operator who amassed a fortune roughly his own day's equivalent of our Bing Crosby's!

As my title implies, my concentration on the senior partner of the corporation of English letters is a matter of convenience only adopted for the sake of brevity. Yet I would feel it a painful omission not to mention one of the soundest treasuries of psycho-social wisdom in print —the letters of John Keats. The estimate of the mind of this poet, whom many eminent critics think of as the second Shakespeare, has suffered in the same way as was the case with his great predecessor. So infatuated have the critics been with Keats's extraordinary ear for some of the subtlest tones of which English verse is capable or thrown off by his youthful flirtation with Romantic fantasies that few have stopped to ask whether merely to acquire the literary expertise he demonstrated in his twenty-five or six years on earth was an astonishing *mental* performance. Then, too, there is extraordinary wisdom in the critical essayist whose "depth of taste" Keats so admired, William Hazlitt. And from Hazlitt we can go backwards and forwards, from Addison to Saintsbury and so on.

Returning to the bill of particular insights in Shakespeare which should be made up for the wholesome admonition of social scientists, let us confine ourselves to two more instances, both of them among his profoundest utterances. Taking the more famous first, "We are such stuff as dreams are made on," what ought it convey to social scientists? Why simply that man is a symbol-using creature as meaningfully, if not more so, than he is a tool-using one. Yet there are wide reaches of social science wherein there is profound distrust of any and all of the more interesting attempts from David Hume to David Riesman to deal with mental images as primary data. The positivist legacy that science must

limit itself to material particles and their movements has left its paralyzing imprint on what is probably the most vital of all contexts for social inquiry. It is in this perspective that one can venture the observation that the older the social science the more inept it is. The younger disciplines of anthropology and psychoanalysis did not come soon enough on the scene to be ossified by the misplaced concreteness which resulted from crude imitation of eighteenth-century scientific method. On the older social doctrines, the force of so tremendous a statement as the following by the late, great Edward Sapir, Sterling Professor of Anthropology and Linguistics at Yale at his untimely death in 1939, is almost completely wasted:

> Individual and society, in a never ending interplay of symbolic gestures, build up the pyramided structure called civilization. In this structure very few bricks touch the ground.[1]

Our last selection from the embarrassment of riches from which we have to choose is Lear's memorable speech beginning:

> O, reason not the need: our basest beggars
> Are in the poorest thing superflous:
> Allow not nature more than nature needs,
> Man's life's is cheap as beast's.

Material wealth is superflous; it is, in fine, luxury—the medium of an intriguing, humanizing game, no doubt, but not a self-sufficient end. Lear to the contrary, economists have been reasoning the need for nearly two centuries, from Adam Smith to John Kenneth Galbraith. Forced to recognize that man's need for necessities is truistically unarguable, economists have invented something called utilities, a strange intermediate category of satisfactions which we are supposed to crave but which by some slight of fancy are imagined to be *neither* really necessary nor really unnecessary (luxurious). Just as the economist has scamped the economics of irrationality so he has slighted the theory of luxury. Yet whether we survey the economic preoccupations of pre-literate natives concentrating with primitive intensity on beads, feathers and shells or of the European age of discovery with its lust for silks, spices, jewels and gold, or of the United States with its mass advertising of products essential only to "gracious living," the motive power is ever the same—useless glitter.

[1] "Symbolism," *Encyclopedia of the Social Sciences,* (New York, 1934).

It is no meaningless circumstance that, as Lionel Trilling has in effect pointed out,[1] Sir James Frazer, the anthropologist of primitive magic, and Sigmund Freud are the two scientifically committed analysts of human behavior who have exerted the most decisive effects upon modern literature. Their attraction for the great writers of this century must be inseparable from the fact that they themselves took literature with the utmost seriousness. Freud's constant recourse was to dramatic tragedy: from Sophocles he drew not only terminology but concepts and in Shakespeare he found an experimental proving ground for his theories. Freud most probably would have said that wherever his analysis might appear to falsify literary masterpieces he would revise the former. Frazer was if anything a greater classicist than he was anthropologist. Tribal magic was for him merely an avenue to the understanding of the Western religious, philosophic and scientific tradition. Freud and Frazer! One, biologist-like, microscopically looking down into the micro-cosmos of subconscious experience: the other, astronomer-like, scanning the remotest galaxies of custom. But both interested in the association, the gravitation of ideas (rather than material particles, Newton's "little billiard balls") and, if in ideas, then *ipso facto* in symbols.

This affinity between Freud and Frazer and modern letters brings to mind a striking disparity in our intellectual world. It is the contrast between the facile meliorism (not to say optimism) prevalent among so many social scientists and the almost melodramatically stark view (not to say pessimism) of so many men of letters. On the latter score, Trilling finds "the idea of losing oneself up to the point of self-destruction" as very nearly "the chief intention of modern literature". Freud's death instinct and Frazer's evidence of the survival of magical modes of thought sit only too well with this *Anschauung*. But there is scarcely a whiff of these dangers which we must somehow master in the text books in conventional psychology, sociology and economics. Therein, we find springing eternal the expressed hope that given a few more laboratory experiments (with mice or freshmen) a few more questionnaires filled out (mainly by freshmen) and a few more statistics gathered (a species of questionnaire that freshmen are, mercifully, not quite up to) the doctors will soon be in the way of the cure of this or that hitherto incurable social malaise.

Superficially, it may seem to the casual observer that the cheery rationalists of psychology, sociology and economics are at any rate a nicer,

[1] "The Modern Element in Modern Literature", *Partisan Review*, Jan.-Feb. 1961.

safer bunch of fellows to play games with than the gloomy desperadoes of literature. But we must not forget that the former come bearing perilous gifts in the form of advices to—borrowing a term the renowned sociologist Karl Mannheim helped make fashionable—"reconstruct" ourselves in various rather far-reaching ways. Obviously if their guesses—there is nothing at the moment that all kinds and conditions of social scientists would rather play with than "stochastic" (which means guesswork) mathematical models—are wrong we might have been much better off to go quite voluntarily to the dogs with the poets.

The public cannot help but be aware that dissension exists among social scientists; the perennial difficulties economists have with their business forecasts is the classic illustration. Yet the depth of their divergencies have not been fully grasped in its full seriousness. For purposes of popular enlightenment, it would be salutary to put together a small compilation of comments which eminent social scientists have made about each other's work. Here let me give a single example, once again from the pen of Edward Sapir:

> Be it remarked in passing that what passes for individual psychology is little more than an ill-assorted mélange of bits of physiology and of studies of highly fragmentary modes of behavior which have been artificially induced by the psychologist. This abortive discipline seems to be able to arrive at no integral conceptions and one can only hope that it will surrender all its problems to physiology and social psychology.[1]

The full gravity of Sapir's charge is not easy to appreciate. Note that he sees no hope of improvement in the methodology of the brand of psychology most colleges still purvey.

Sapir's work followed two guide lines: (1) you *cannot* hope to advance the theory of human behavior unless you study it within the context of the whole framework of social dynamics (in a word, history). Concretely, this means that the writers who have taken civilizations as their field—Brooks and Henry Adams, Spengler, Weber, Sombart, R. H. Tawney, Veblen and many others are one set of students who are not bound to waste their time. For the present, Arnold Toynbee may be everything his detractors say of him—they say, in brief, he is a charlatan—but he is batting in the right league. What has obviously happened is that concerned people are becoming far more interested in the develop-

[1] E. Sapir, *Culture, Language and Personality* (University of California Press, 1958), pp. 147, 8.

ment of the values of civilization than in utilitarian-types of progress. And (2) you *cannot* hope to advance the theory unless you take the human consciousness as a whole and are forever peering at its vagaries and experiences which are, in turn, social and, so civilizational, dependencies. An excellent example of a contemporary use of the personality-culture approach is a book called *People of Plenty,* a study of the American character, by Professor David M. Potter, Director of American Studies at Yale.

The reason why the reciprocal study of the individual and his society (to borrow Abram Kardiner's phrase) is essential to valid theoretical work is not, as is often put forward, the need for cross-fertilization. (You cannot bring about conception by crossing disciplines or procedures themselves infertile.) The right reason proceeds out of nothing more than the need to account for *change.* History is difficult not so much because it is complicated, in the sense of multiplicity, but because it really never does repeat itself; like a woman, it is a one-time thing. The material of history is far more like that of modern astronomy—which has found that no two stars, nebulae or galaxies are or can conceivably be either stable or identical and that even the universe has a changing, individualistic character—than it is like Newton's planetary clockwork; and it is more like microbiology or nuclear physics than it is like eighteenth-century chemistry. "Concrete fact is process." This was Alfred North Whitehead's central message. Therefore, "Every scheme for the analysis of nature has to face these two facts, *change and endurance.*" Something like history (of the universe, of the species, of civilization, of economics, of psyches) can only in part be approached experimentally. It must also be approached conceptually, as a quest for patterns, always somewhat skewed. Skewed because of what we call accident, that fatal, fertile attribute built in to all existence.

Clearly, the tendency of the Sapir-minded social scientist clears the way for a *rapprochement* with literature which has proved impossible to the older approaches but which is such a desperate mutual need. For the playwright or novelist has always tried to plumb the depths of character and the man of letters, as social philosopher, lacks nothing which the civilization student can claim except, perhaps, a more scientific and, therefore, concretely-based approach; although that may be only to say that social science is what happens to moral philosophy in a matter-of-fact age.

Still and all, we can claim that some social scientists are doing some-

thing that has not been done before. Taking advantage of the information and inspired guesses which historians and men of letters in the old tradition have accumulated, and poking around in tribes and psyches himself, the social scientist is looking both for regularities and disruptive tendencies in a more self-conscious, critical way than has ever before been attempted. The great Cambridge physicist, Rutherford, who died in 1937, used to say that his day was the Elizabethan age of physics. It is conceivable in this era of psychic and social self-consciousness that it may be the turn of social science to make the next claim.

My theme has been this: of the portentously competitive branches of study pretending to the name of social science, those are likely to be truest which harmonize with the vital forces in literature. Correlative to that, I venture the opinion that the comprehensive study of social man as a symbol-minded rather than a thing-motored animal will prove as different from and superior to the still-dominant but, I trust, declining social methodology as is the technology of the age of electricity to that of belt-conveyed steam power. The social scientist may tell himself that by ignoring literature and symbolism he is merely stopping his ears against the siren song of unscientific imaginings. More likely, tied to the scientific mast or not, he is refusing to launch forth on any Odyssey of the mind at all. The virtue that has never been tried is of little worth, nor is a scientific disposition that cannot bear sophistication. Equally well, a literature that remains irresponsibly unmoved by modern science seems to be courting irrelevancy.

Every age finds its own, and generally unexpected, forte: Shakespeare, so the professors tell us, thought he was surrendering all claim to poetic fame when he took to playwriting. In similar fashion, every mature science has had to work out its own genius. Frazer's *Golden Bough* itself stands as warning that the crude imitative borrowing of one science's methodology by another is likely to be nothing more than a reversion to sympathetic magic. C. P. Snow thinks that the surest sign of vain "scientism" is delight in gadgetry. The social scientist's responsibility is to bring impartial objectivity to the analysis of human capabilities and conditions. This he is not likely to do if he is so preoccupied with issues of policy and frantically impatient for quick solutions that he restricts his efforts to tinkering with assumptions that for years have failed to pass the ultimate scientific test, prediction, and fails to seek new ones. De Tocqueville wrote a century and third ago that "Nothing is more necessary to the culture of the higher sciences . . . than meditation." It is

in meditation that science (physical, biological or social) and art (literary, plastic or other) find their common tap root. It is upon the foundation of Tocqueville's "slower and deeper combinations of the intellect" that the edifice of a true science, quantitative or qualitative, of society can be built. "Hear," O social scientist, "the voice of the Bard. . . ."

DWIGHT ROBINSON JR. was an editor of the LIT before graduating from Yale in 1936. He is now a Professor of Sociology at the University of Washington in Seattle.

Society / WILBUR SAMUEL HOWELL

As a FORMER MEMBER of the Faculty Committee on Public Speaking and Debate, I was for some twenty years assigned the task of conducting the Junior Oratorical Contest, the oldest event of its kind at Princeton. This contest originated around 1786 as a focus of the rivalry between the chief undergraduate literary organizations, the American Whig Society and the Cliosophic Society. In 1865 it was officially designated by the Faculty as a prize contest carrying awards of four gold medals. And later it was enriched by a legacy from Henry A. Stinnecke to enable "the orator who shall pronounce the best oration" to receive the Maclean Prize of $100. The orations to be delivered in this contest were original compositions, not excerpts from classical authors. Not unnaturally the winners over the past seventeen decades have included many illustrious Princeton graduates.

One of my problems in administering this contest was that of attempting to clear up among the contestants certain misunderstandings about the word "oratorical". Year after year the prospective competitors would ask what an oration was considered to be and what special standards the Junior Oratorical maintained. Year after year I would explain that an oration was considered to be a speech, and that this contest pitted good speakers and good speeches against each other. But the belief persisted that an oration was somehow different from a speech. The modern student would rarely attempt to establish this difference in terms of a firm distinction between the subject matters or the occasions of these forms of discourse, although a latent suspicion seemed to exist that an oration had a moderately exclusive claim to the more important of a speaker's themes and settings. What would finally become obvious was

that in the student's view the oration differed from the speech in having the more formal, the more elaborate, the more rhetorical style. There was even a suggestion, happily less prevalent now than in the nineteen thirties, that an oration was also to be delivered in a more declamatory and inflated manner than would be apparent in a speech intended for ordinary situations.

These distinctions are so deeply embedded in our culture that it would be surprising if the student of today did not subscribe to them. Indeed, he would find them in his dictionary as official formulations of his own opinions. That highly esteemed work, *Webster's New International Dictionary of the English Language,* would assure him, for example, that "SPEECH is the general term; an ADDRESS is a formal speech; an ORATION is an elaborate or rhetorical address, esp. one delivered on a notable occasion". And this would seem to dispose of the matter permanently, at least for those who regard their dictionary as the final arbiter of usage.

Unfortunately the matter cannot be dismissed thus easily. A dictionary definition is itself a product of cultural history, and at any given moment it merely indicates the meaning that a word has predominantly had in an immediately preceding era. So it is with the word "oratory". The kind of discourses delivered on formal occasions in nineteenth-century America were elaborate and ornate in style, and because of the necessity for speakers of that time to make themselves heard without the aid of electronic amplifiers, those discourses were pronounced in a manner that did not resemble the external aspects of normal conversation. Good illustrations of such discourses were afforded by Daniel Webster when he spoke at Plymouth in 1820 to commemorate the two-hundredth anniversary of the landing of the Pilgrims, or at Charlestown in 1825 to the vast crowd assembled to witness the laying of the cornerstone of the Bunker Hill Monument in the presence of General Lafayette and two hundred veterans of the Revolutionary War. To a young nation desperately in need of status in the world of literature and belles-lettres, Webster's orations seemed part of the blessings bestowed by Providence upon America to signalize her emergence as a cultural as well as a political force in the family of nations. And to our great great grandfathers, who made our first dictionaries, Webster's orations defined in a way that was to prove curiously durable the very nature of American oratory itself.

But not entirely and not without qualms. In 1863 at the dedication of

the national cemetery for soldiers killed at Gettysburg, Abraham Lincoln spoke for three minutes and delivered a 271-word speech which, although not elaborate, not ornate, and not declamatory, was hailed at once as a great address, far overshadowing the oration pronounced earlier on the same occasion by Edward Everett, the orator of the day, who in some 14,500 words occupying two hours and a quarter dealt gracefully with such topics as Greek funeral customs, Horation sentiments concerning the sweetness of dying for one's country, historical comment on the events of the Gettysburg campaign, legalistic rebuttal of the arguments of the South in justifying the current rebellion, and an urgent exhortation for all people, North and South, to resume the bonds of union. The difficulty presented to the critic by the speeches of Everett and Lincoln at Gettysburg is that Everett's is a masterpiece by the assumptions of our culture, and Lincoln's is a masterpiece by the verdict of our hearts. It is usual to explain this difficulty by condescending to observe that Everett composed a great oration, and Lincoln, a work of true literature. Somehow this explanation leaves us wondering whether we ought forthwith to abandon the quest for oratorical excellence if the best we can achieve in that direction falls short of literary excellence, or whether, as a possible alternative, we ought to re-examine the cultural assumptions that lead to the explanation itself.

The first principle in such a re-examination would be to recognize that discourses pronounced in public have always been allowed to vary between the plain style and the grand style, and that there is thus no good reason for declaring discourses in the grand style to be alone rhetorical. Aristotle's *Rhetoric* is essentially the theory of the plain rhetorical style and organization. Aristotle observes that a speech need have only two parts—statement and proof. Although he notices that speeches also have introductions and epilogues, he regards these parts as options rather than obligations. Then too he remarks that rhetorical style to be good must be clear and appropriate, avoiding both meanness and undue elevation; and he significantly adds that "poetical language is certainly free from meanness, but it is not appropriate to prose".[1] Aristotle's requirements for rhetorical form and style were extended by later writers to include the theory of the more elaborate oration and of the more varied style. Cicero, for example, thinks of a full-dress oration as having an introduction, a narration, a partition, a proof, a refutation, and a conclusion.[2] And in one of his later works, after pointing to

[1] *Rhetorica*, 1404ᵇ4-5. Trans. by W. Rhys Roberts. [2] *De Inventione*, 1. 14. 19.

the orator's need to prove, to please, and to sway, he says: "For these three functions of the orator there are three styles, the plain style for proof, the middle style for pleasure, the vigorous style for persuasion; and in this last is summed up the entire virtue of an orator."[3] Notice that it is in persuasion, not exclusively in the grand style, that Cicero places the whole power of oratory. But in our careless reading of him we have made it appear that oratory is predominantly a matter of stylistic elevation and ornateness.

The second principle in a re-examination of our cultural assumptions about oratory is that variations from elaborate to simple organization, from grand to plain style, bear a direct relation not only to technical variations between important and unimportant themes, and between notable and ordinary occasions, but also to historical changes from ceremonious to unceremonious centuries and from ritualistic to unritualistic cultures. In the Preface to the second edition of *Lyrical Ballads* (1800), Wordsworth says that the principal object "proposed in these Poems, was to choose incidents and situations from common life, and to relate or describe them throughout, as far as was possible, in a selection of language really used by men...." Literary critics, rightly dwelling upon the importance of Wordsworth in creating a plain subject matter and a plain style for poetry, rarely see that the same forces were at work in oratory, and that it was inevitable in the post-Renaissance world for oratory to come to express itself in the forms and the language really used by men in their everyday lives. Lincoln did much to accelerate this trend in American oratory; but it began well before his time in the field of American public utterance, as we can see in Thomas Jefferson's great work, "The Declaration of Independence", where the highest persuasiveness is achieved by a calculated abandonment of the tenets of the elaborate rhetoric that had flourished earlier in the eighteenth century.

The great American oratory of the twentieth century is of the sort that Jefferson and Lincoln anticipated, although keynote speakers at recent American political conventions have not yet assimilated this important fact. A fine example of the modern mode is the speech delivered by William Faulkner on December 10, 1950, in Stockholm, when he was awarded the Nobel Prize for Literature. Lest it be assumed, however, that only our literary men are capable of achieving the deepest persuasiveness by means of simple rhetorical structures and the plain

[3] *Orator*, 69. Trans. by H. M. Hubbell in The Loeb Classical Library.

style, we should remember Roosevelt's war message of December 8, 1941, which might well stand not only as the embodiment of the best modern habits of oratorical expression but also as the basis for the definition of oratory in our time.

This speech of 505 words, twenty-six sentences, and eighteen paragraphs, has the simplest possible chronological arrangement.[4] It contains no introduction. It consists basically of three closely related movements —a statement of the facts of the past twenty-four hours, an interpretation of the popular will in regard to those facts, and a request for Congressional endorsement of the popular will. Only on two occasions does the speech turn argumentative—where Roosevelt observes that the attack on Pearl Harbor had been deliberately planned many days or even weeks before, and that the Japanese had obviously undertaken a surprise offensive extending throughout the Pacific area.

Its style is that of a journalist reporting the news. Thus it reads, not like a page from the old-fashioned oratory described in our dictionaries, but like a page from good journalistic writing, from good modern history or biography, from good scientific writing in a popular vein. It contains only three superlatives. The cautious language of scholarship appears when Roosevelt declares that "American ships have been reported torpedoed on the high seas between San Francisco and Honolulu." And yet there are rhetorical figures, too, as if Roosevelt were following the logic of Wordsworth and seeking to throw upon events "a certain colouring of imagination, whereby ordinary things should be presented to the mind in an unusual aspect".[5] Thus there is prosopopoeia—"a date which will live in infamy". Thus there is metonymy—"the United States of America was suddenly and deliberately attacked". Thus (and most notably) there is epanaphora: "Last night. . . . Last night Last night Last night Our people . . . our territory . . . our interests With confidence . . . with the unbounding determination of our people" These and other figures, however, are not obtrusive or even noticeable, as they often became in orations of more ceremonious times than ours. They are rather part of the idiom of a culture that uses figures because speech is impossible without them.

The artistic excellence of Roosevelt's war message is that it did exactly what it was calculated to do. Congress and the public had been persuaded

[4] My word count is based upon the text as spoken by Roosevelt to the Congress. See the album, *F. D. R. Speaks*, Side 9. The published text contains 483 words.

[5] *Lyrical Ballads* (1800), Pref.

twenty-four hours before the speech was uttered; and they had been persuaded not by words but by the facts of the attack on Pearl Harbor. Nevertheless a speech was called for as a matter of tradition and solemn national ritual. The task of that speech was to measure up to the mood of the moment, to endow it with the permanence of a national resolve, and to do nothing to enfeeble or divert it. And Roosevelt's speech brilliantly performed that task. He gave the mood of the moment the power to shape history.

A final principle in a re-examination of our cultural assumptions about oratory is that this term and the term "literature" are not mutually exclusive, if only we keep in mind that the latter designates the literature of statement and the literature of symbol, whereas oratory by its very nature is part of the first but never of the second of these two families. The literature of statement, we may say, deals directly with the realities of human life, and it includes scientific exposition, history, and biography, as well as oratory, in its dominions. The literature of symbol, on the other hand, deals with reality, not in a direct way, but in terms of the invented situations that stand by symbol for the real situations of human life. In short, the words in works of fiction and narrative and drama refer to deputies or symbols of the reality that all of us know as human beings, whereas speeches and the other forms of statement refer to actual segments of that reality itself. Space does not here permit the full development of this important critical distinction between the two literatures, but its proper development would mean that oratory can be effectively differentiated from poetry without having to lose its rightful place among achievements of high literary worth.

In sum, our cultural assumptions about oratory are outdated and embarrassing. It is too much to hope that they will be soon abandoned, for scholars tenderly cherish the antiquated ideas of every field but their own, and oratorical criticism as a province largely unclaimed by exact scholarship is a natural repository of every shade of scholarly prejudice. But at least our assumptions about oratory can be properly criticized in this publication as it celebrates its 125th anniversary and recalls that in its faraway infancy our present definitions of oratory were being nurtured and prepared for what has become their stale and unproductive maturity.

WILBUR S. HOWELL became Professor of Rhetoric and Oratory at Princeton University in 1955. From 1948 to 1949 he was a Guggenheim Fellow. Two of his major studies are *Logic and Rhetoric in England 1500-1780*, and *Problems and Styles of Communication*.

THE ART OF POLITICAL LEADERSHIP

IF POLITICAL LEADERSHIP is either the rational and impersonal management of power or the adventuristic lusting after it, and art is aesthetic self-expression, then art and politics exist in two different worlds. Politics then lives either in the accounting office or the gutter. It is either too inhibited by rational disciplines to be creative or too anomic to be aesthetic. Actually, political leadership is neither so devoid of personal style nor so lacking of general standards to be judged aesthetically. Political leadership depends upon a sufficient degree of self-expression, requires a sufficient degree of creative talent, and can be judged as a performance by sufficiently general rules, for it to qualify as an art. It is not, to be sure, one of the established arts. It is so rooted in the imperatives of a society that judging it as an art will always seem to be trifling with the issues at stake. And looking at it *simply* as art can be irresponsible. Yet, usually, viewing political leadership as art can deepen ones understanding of politics. It may even add to the scope of ones aesthetic experience.

To do either it is helpful to be clear on the relationship of political leadership to the established arts. There are few absolute differences between them, but nonetheless important differences of emphasis and proportion. We fail to perceive politics as art more often than not because we overlook these differences between politics and the established arts. The full dimensions of politics go unperceived and the standards of art, unadapted, are misapplied.

Political leadership must be legitimate. The recognized arts have won

for themselves in Western society freedom from the requirement of legitimacy. They are not judged by traditional rules. They are autonomous in the sense that they generate their own aesthetic standards. Political leadership however, must cope in some way with the demands, of legitimacy. It must conform in some sense with established legal, social and moral standards. The requirement that it be legitimate imposes important conditions on the art and craft of political leadership; however, these conditions do not disqualify politics as art, for autonomy is not a requisite of art. The established arts have not always been autonomous, and are not now everywhere autonomous. Much of the world's art has been created in settings where no claim was made for autonomous judgement. Art worked within, or apparently within, the boundaries of conventional acceptability, which is what it continues to do in traditional, or non-modern social systems today (except, of course, for the modern elites in traditional societies). These societies require of it the tacit legitimacy of conformity. For the non-liberal, but modern, or modernizing society of today, such as (but not only) the Soviet Union, or the People's Republic of China, art often requires explicit legitimizing; it must contribute affirmatively to society, or to the goals of the state.

So it is with political leadership. It is nothing if it cannot claim to contribute to the ends of the state, (or at least of society if the legitimacy of the state itself is in doubt). The recognized arts may gain some degree of autonomy in any social system by claiming the legitimacy of self-expression. Political leadership, in the same manner, may gain some freedom from discipline by invoking the values of criticism and competition. The recognized arts may make the additional claim of being irrelevant to the interests of the defenders of tradition and sovereignty. Political leadership can make the same claim, though with different consequences. When art claims that what it does is irrelevant to the ends of the state or society it will either be asserting that its own ends happen to conform, or that it has no ends. When political leadership makes the same claim, it may similarly assert that its ends conform, or may deny its identity as political leadership. Herein is the essential difference between the recognized arts and politics: politics cannot be conceived apart from its non-artistic ends, while the recognized arts often can be. Yet the consequences of viewing politics only in relation to its ends are often unfortunate.

Politics is the art of the possible. The arena of political rivalry applies this rigid rule of relevancy with cold efficiency: Those who cannot bring

their ideals into relationship with reality are voted out of office. That is what Senator Connally meant by his response when once asked the flattering question, "What does it take to be a statesman?"

His answer was abrupt, turning flattery aside: "First he has to get elected," he said.

Not all 'statesmen' must, as Senator Connally did, get themselves elected. But at least someone has to 'get elected' for them.

It is easy to lose sympathy with this requirement of political leadership, to view the politician as an unprincipled adventurer, abandoning personal conviction to pursue the popular course or to cater to some special interest. In the orderly moral world of political reformism in the United States in the early part of this century such a man might have been referred to as a "trimmer" as though the world was made up of two kinds of people, the "trimmers" and the "non-trimmers"—those who stood by their principles and those who trimmed their sails to convenient winds. The term was used by men, like Newton D. Baker, who knew better, successful political leaders who had passed the tests of moral pragmatism imposed by American politics. Yet their own choice of words propagated a crude over-simplification of the relationship of morality to politics which, followed literally, could only lead to political disaster. It is true that American political careers have often thrived on authentic self-righteousness. To name only Presidents, Eisenhower, Wilson, and the Republican Roosevelt are surely three. Personal style in political rhetoric, however, should not be confused with political acumen. Wilson and Roosevelt both made mistakes about what was possible politically—mistakes which were indeed bad enough to be tragic for them personally. But while they may have on some occasions judged badly, there is no doubt that at their best they were both political craftsmen who tried to work within the limitations of what was possible.

When we have no large political responsibilities, when from behind our newspapers we look out upon the larger tasks of public life, it is easy to ignore the test of relevancy in politics, to overshoot with our expectations what is possible, and then to condemn political leadership as opportunistic, cowardly, or corrupt. It is also possible to undershoot in our expectations in individual cases, and generally, in two ways: by viewing politics simply as a game which people play for the distribution of favors, or by drawing artificial distinctions between the moral limitations of public business and the moral limitations of private affairs. Whether we underestimate or overestimate the prospects of achieving

moral purposes through political power, in the end, we are selling the moral stature of political leadership short if we miss our mark very much. Preoccupied with the relationship of politics to morality, we fail to appreciate the character of political leadership itself.

Politics is a milieu in which the observant eye is easily distracted from the essential. Political rhetoric will exaggerate the relevance of morality, as we have seen. But in a variety of other ways the observer can be misled. To view political leadership for its craftsmanship and its art is to ask, or at least to try to ask, the important questions of it. The craft can be appreciated for itself, as with any cultivated artistic skill. Leaving aside the larger questions, one can concentrate upon understanding the craft, on analyzing its elements. One can explore the economics of allocating political resources, the strategy of aggregating political power and the tactics of manipulating it. To say that politics is a craft is to say that it is a single kind of skill. It is not a branch of several business activities, such as public relations and administration. And it is no more an extension of the public bureaucracy than of private administrative skills. It is not, similarly, an appendage of the ministry or of a scientific discipline. It has its relationships, more or less fruitful, to all of these other things. But it is something by itself.

We let art stand off by itself, to be autonomous—governed, that is, by its own (aesthetic) standards—for reasons which are not all reducible to practical considerations. But we also justify the autonomy of art because it works, because, working within its own rules, it can add to what we know about ourselves and our world. Similarly, by limiting our consideration of political leadership to an understanding of the craftsmanship of it—by attempting to understand it for its own sake, we can then return to the wider questions about the ends for which this craft will be used with considerably more to go on than the crude notions by which we usually pass judgement upon it.

Just as art, thrusting morality aside, can return through artistic creation to a more profound understanding of ethics, so political leadership, appreciated for itself as art and craft, equips us to perceive more clearly the moral questions encountered in public life and to judge the performance of those who cope with them.

For those who are engaged—the political leaders—the narrow margins of choice confronted at any one time force them at least to be relevant. Those who are craftsmen enough to perceive the real stakes of politics will know that the choice is seldom whether or not to exercise leader-

ship, but instead, whose leadership will prevail. In a legitimate political system one must balance the costs of avoiding responsibility with the risks of using it. Normally, one can only play his role the best he can, as actor, as artist, as political leader. The beginning of political art is to take the playing of it seriously.

PAUL Y. HAMMOND is an Assistant Professor of Political Science at Yale. He received his Ph.D. from Harvard. He is a consultant to the Institute of Defense Analysis and has recently published *Organizing for Defense: The American Military Establishment in the Twentieth Century* with Princeton University.

A SCIENTIST'S VIEW

THE QUALITIES OF CRAFTMANSHIP and responsibility in a Work, whether in the sciences or the arts, connect it to the past and project it toward the future.

How are these qualities judged by a scientist? Against what touchstone does he try the craftsmanship; by what evidence the responsibility? In what ways are his judgments arbitrary—this student of Nature—; in what ways do logic, and experiment, and the deliverances of his senses guide this judgment?

His most consistent guide is Nature: the way the world behaves. Join to this an axiom and he has the means with which to answer our questions—at least to a first approximation. But in a few hundred words we can only suggest directions for thought, and give bald answers which lack the fine shadings needed to make us more satisfied with them.

Nature is asymmetric. Time's arrow points only in one direction; the egg cell, triggered by the sperm sets out on a one-way journey; the long-term trend of evolution is from the simply to the complexly organized; irrationality is discovered and recognized by the rational mind and not the other way around. All this and much more speaks of the asymmetry of Nature. This is the way the world is: asymmetric. It is a wonderful and heartening fact, for without directions, there can be no criteria. Good, better, best point a direction and confirm an asymmetry.

The axiom is, that wholeness is better than partialness when comparable qualities are compared. This, too, defines an asymmetry.

The scientific craftsman, working in the present, keeper at the door between the future and the past, is a modern Janus. With one face he looks to the past; with the other to the future. For it is a characteristic of

the scientist that truths of past experience are not destroyed, but must be subsumed under the new interpretations. At the same time he points to a future that he has scarcely begun to foresee.

In all of Einstein's work, for example, the past is remembered. In his *Autobiographical Notes* he terminates a discussion of scientific theory with the words "Newton, forgive me; you found the only way which, in your age, was just about possible for a man of highest thought and creative power. . . ." Einstein's theories comprehended those of Newton, and of his predecessors that were sound, while going far beyond them. The same is true of the work of all such great and responsible craftsmen: Newton, Darwin, Mendel and a host of others. They looked to the past for what was true and what remained true while they showed us the future. (Intellectual arrogance was not in them.) Science requires of its craftsmen this wholeness of temporal view, as a responsibility of the craftsman. Thus science, the great rational motive force of our culture today is both conservative and radical: it is a requirement for change that past good be conserved. The wise man sees both aspects at once and maintains the important balance between them.

What happens when the craftsman forgets these truths and turns in upon himself? Lord Dunsany has told us in the parable of the diamond cutters. If technique is valued for itself "we shall have diamond cutters valuing their tools more highly than the diamonds, with the result that, as long as they cut them in accordance with the rules of the craft, they will cease to care whether they cut diamonds or glass, and then they will cease to know." This is the triumph of technique over inspiration; of the present moment over future—past. It is the origin of Absurdity.

The best scientific craftsmanship displays also a wholeness of another kind. All Works whatsoever result from the interplay of three activities: the analytic, the synthetic, and reduction to practice. The first is primitive and fundamental. It is the activity of collecting, listing and cataloguing, experimenting, describing, reporting and putting into museums. However, as the analytical activity proceeds the thoughtful worker imperceptibly moves in a synthesis direction, for be begins to see subtle connections, and authentic differences, between his data. It is on these bases, indeed, that he can make a catalogue. The synthetic activity is that which sees relationships, discerns patterns, develops theory and law. It is usually most happily joined to the analytic. It always involves some kind of creative transformation by which experience and raw data are transformed into symbolic form so that manipulation according to the laws of

grammar, logic, mathematics, becomes possible. Synthetic activity leads to the building of conceptual schemes: blueprints for the structures built of data.

There is also the requirement of reduction to practice. If this step is well and truly taken then the work may become whole and complete. This is a step of communication; of embodiment. In this step the laws or other generalizations that result from synthetic activity are applied to individual instances. Here the worker comes back into contact with intransigent matter; he must deal with the exigencies of individual problems. If his laws and generalizations were sound, then he finds that he is in control of the phenomena at this step.

We require of the best scientific craftsmanship this kind of wholeness, especially with the inclusion of that engineering step that brings the comprehensive law face to face with an instance of its application. This is where responsibility meets its harshest test; where the requirements of verification make their ineluctable demands.

Here, then, is our touchstone, here our criteria. That scientific craftsmanship is better, that evidence of responsibility greater, which weaves past truths into present patterns—patterns which imply the future design. That craftsmanship is best and that evidence of responsibility greatest which combines this temporal wholeness with the wholeness of reason reduced to practice. There are, it must be repeated, many other qualities that should be discussed, and there are innumerable problems lurking in the shadows of all I have said.

In my first sentence I said that these qualities of craftsmanship and responsibility belong to The Arts and The Sciences. It follows, it seems to me, that best and greatest of all is that rare achievement, the union of art and science. This is so difficult and subtle that it may be exemplified only, I suspect, in the life of a human being.

HAROLD G. CASSIDY is a Professor of Chemistry at Yale. A recent book, *The Sciences and the Arts, their Relationships in Education and Life* will be published this Fall by Harper Brothers. He has written prolifically on chemistry and is now opening up a new field of polymer research.

THE YALE LITERARY MAGAZINE

EX PEDE HERCULEM. *The Yale Literary Magazine* of today can tell us much about the Yale of today, and the Yale of today something about America today.

Like Hercules, Yale and America do not identically resemble the visible sample. There are hands and head and heart as well as feet. But one may, with proper anatomical caution, construct the whole from the part.

The Yale Literary Magazine is the oldest monthly magazine in America—at least, if one accepts a charitable interpretation of "monthly" that allows for aestivation and occasional mensual lapses in moments of financial crisis. It first appeared in February 1836, and it has continued every year since then to represent aspects of the literary skill and interests of the undergraduates of Yale College.

That it has not always represented every aspect is quickly apparent from the long list of other Yale literary magazines that have risen, flourished, and died in opposition to the Lit.

In the very year of its birth, the Lit whelped a bitter offspring, the *Yale Literary Quidnunc,* devoted to attacks on the Lit and its editors. This did not survive the college year. There followed: *The College Cricket* and *The City of Elms* in 1846; *The Yale Review* in 1857; *The Yale Pot-Pourri* in 1865; *The Yale Record* in 1872; *The Yale Critic* in 1882; *The Yale Monthly Magazine* in 1906; *The Bohemian* in 1917; *Elihu* and *The Toasted Bun* in 1923; and the *Harkness Hoot* (of which the writer was an editor) in 1930. These are but a few of the publications, all professed rivals of the Lit, that rose about once a decade and did not last longer than a few years at most. But they did not live in

vain, for each outbreak of opposition spurred the sometimes-stagnant Lit into new life and often into an altered character that imitated the best in its rivals.

It is no secret, even beyond New Haven, that Yale is essentially a conservative institution, and the Lit has reflected this character. That fact has made inevitable the recurrence of radical, protestant magazines that opposed the Lit and died while that veteran carried majestically on.

The Lit today will not seem conservative to Yale men past 50, or to many of the same age elsewhere, but it is nevertheless a fair representative of the conservative wing of present undergraduates. It is now, we must forcibly remind ourselves, conservative (that is, not daringly experimental) to wear a beard, just as it would be violently radical to waltz. And so in recent issues there are verses of such steadfast lack of pattern as to suggest that freedom has almost become license; stream-of-consciousness stories with no beginning, no middle, and no end, but only the most private meaning; and typographical arrangements innocent of capitals and punctuation, as conscious of their shape as "The Mouse's Tale." But we older readers must remember that these are the battles of our own youth, won (or perhaps lost) so long ago that now their content of real struggle is as small as *The Illiad's*.

There is also much here that is new since our time. Concern for campus issues has been replaced by interest in world affairs. A genuine and unabashed lyricism, no longer hiding behind traditional verse forms, is often audible. In all media, these writers are much more familiar with and much closer to the best experimental writing of the professionals than we were.

Containing a retrospective section of past Lit pieces and a section on literary craftsmanship in addition to its middle section of current creation, this Lit is not typical of most issues, which are usually devoted chiefly to publishing Yale undergraduate writers. But it is well that this issue is the one to be so widely circulated, for it permits the reader to contrast the past with the present, and to compare writing now with the writers' hopes for the future of their craft.

These, it must be concluded on the evidence, are not lost young men, or angry young men, or beatnik young men, or even, God forbid, secure young men. They are young men of serious purpose, high ambition, and strong determination. If their hopes and aims are not what ours were, perhaps it is as well, and what counts most is their will to achieve their ends in their own ways. The nation whose poets and novelists have this

much vigor and resolution is likely to have soldiers and statesmen and scientists of equal energy; indeed, it is sometimes the writers who are also the men of action. Yale and America can be glad it is the magazine such young men have made that now goes forth to represent us here and abroad. These are the new voices; let those listen who would learn.

HERMAN LIEBERT, Yale 1933, is curator of the Rare Book Room of the Yale University Library and is active in 18th century publication projects. He has been a newspaper reporter and columnist, and worked during the war for the O.S.S.

125th Anniversary / RICHARD HOOKER

THE LIT AT THE TURN OF THE CENTURY

As THE POSSESSOR of the horrifying distinction of being the "oldest living member of the Lit," I have been asked to tell of its part in the encouragement of creative, undergraduate writing around the turn of the century. The University catalogue for 1960 describes a whole array of courses which appear designed to offer direct training in the various aspects of that art. In the far-off day of which I write, I recall nothing comparable in the undergraduate curriculum. The Lit gave the only encouragement to be found on the Yale campus in the form of direct challenge—as distinct from that which might come from exposure to the classics and to Shakespeare under the teaching of such scholars and great gentlemen as Dean Henry B. Wright and Professor Henry A. Beers.

What the Lit did was to tempt the undergraduate with the possibility of seeing himself in type—the always subtle poison of printer's ink—and the possibility of election to its board. Toward the beginning of the century, but for how long before and how long afterward I am unable to say, election came at a midwinter meeting of the whole academic junior class, or as many as were interested to attend, which was called for that special purpose. Nominations were made from among the class contributors. It is my somewhat uncertain recollection that votes were counted for all the nominees, the five highest becoming the Lit editors for the next year, beginning with the April issue. The board so elected chose its chairman and business manager.

The seriousness with which the Lit took itself is suggested by a once familiar campus gag. When the middle of the month approached it was customary to dismiss the question; "Is the Lit out?" by adding, as more

important; "What has it lit into?" The Lit did do some crusading in criticism of traditional Yale institutions, including Dwight Hall, but not as much, if my examination of old bound volumes is a safe guide, as that reminiscence might indicate. Yet in retrospect my regret has long been that it did not invoke its commission to attempt occasional criticism of Yale's one most important institution—its teaching. Fine as were Wright, Beers and many others, there were conspicuously weak spots, visible to an undergraduate, as probably there always will be in a great university.

At that time the weakest spot was the lecture course, an infliction to begin with because required instead of elective, in philosophy, conducted for seniors by Professor George Trumbull Ladd. It was doubly an infliction because the grapevine bought down from Cambridge news of the exhilarating adventure of studying under William James. Due apparently to Ladd's jealousy we were denied the privilege of hearing James as a guest lecturer, although when James lectured at Columbia before voluntary but crowded audiences he was received with extraordinary enthusiasm. In later years my reading in philosophy has been meagre but men to whom I look for authoritative verdicts in that field give me faith that our estimate of Ladd and his peculiar limitations was not far wrong despite the fame which he attained.

From such reports as come to me of present undergraduate matters, the Yale *News* is today the chief medium of campus criticism in which the Lit once shared. Whether the Lit, helpfully both for the University and itself, can in this respect resume the role it once played may be for those closer to the scene than I to judge. Yet I gather that there are some faculty bubbles still to prick and I should like to see the Lit prick them.

It has been a deep satisfaction to find, in the letters to the editor in the *Alumni Magazine,* a forum in which alert alumni have rushed to the defense of President Griswold's admirable article on the loyalty oath and to challenge the absurd position taken by some other graduates who do not agree with him, with President Pusey of Harvard, with many other educational leaders and with President Eisenhower. Yet it still seems to me that the university should have the benefit of all the serious undergraduate criticism, less mature but closer to the scene, that can be brought to bear.

The basic reason for the financial difficulties which have beset the Lit in recent years must be those which have created so many problems in the newspaper world—the multiplied costs of production—and which

have caused so many eliminations, consolidated ownerships and unhealthy reductions in newspaper competition. But, in relation to the point I have made, I wonder how the Lit's circulation today compares with that of other years and how it might be affected if the Lit should critically concern itself with university affairs to the degree it once did.

That recalls a helpful financial factor which, I believe, has long since disappeared. This was the tradition that the Lit somehow owned the publication right for the Yale *Banner*. In my bound volumes I find a notice from the Lit board of the class of 1897 calling for bids for the right to publish the *Banner*. It stated that no bids less than $325 would be considered. In our year, 1899, we sold the right for $500 and divided more than that for our year's distinguished literary labors. This slight excess above $500 was due to direct profits from circulation, possibly increased by the fact that we had engaged next year's football captain, a Sheff man, to solicit subscriptions, and that he had probably secured more subscriptions, in that supposedly non-literary precinct, than ever before or since.

My impression is that, not long after our time, some irreverent realist asked the question why the publication right for the *Banner* belonged to the Lit and that he went ahead to publish the *Banner* before the Lit board had recovered its breath.

Those of the class of 1899 who wrote for the Lit had, of course, the closest contacts with the 1898 board, although some of our contributions had managed to pass the 1897 board's stern inspection. The most gifted and promising of all three boards was undoubtedly Gouverneur Morris of the class of 1898. That should also include the 1900 board, for though Morris in his later career at Hollywood did not perhaps live up to his early promise, I have never heard *Stover at Yale* by Owen Johnson described, unless in suspected derision by Harvard friends, as one of the great products of American authorship.

In spite of Morris the 1898 board did not quite convince us in 1899 of its literary omniscience. In one of the evening sessions at which each board was then accustomed to discuss, with its superior authority, the effusions submitted to it by would-be contributors, I was told, concerning an attempted essay on Anthony Trollope, that if I were to write about someone less obscure my chances of success would be greater. Perhaps, if the whole truth could be told, worse things would be disclosed in regard to our board of 1899. But there was at least one thing that we escaped.

It seems to have been the custom, at least we were forewarned that

it might be tried on us, for the outgoing board, by using a fictitious name, to tempt the new board to use for its first issue some bit of English literature by a famous author. The hope was that the new board, having innocently accepted it, would list it on the sheet, anxiously scrutinized each month, which was pasted on the window of the Lit office in the basement of White Hall and which itemized the contents of the April and succeeding issues. In our case the 1898 board tried us out with one of Shakespeare's sonnets, hoping to jeer at us in our confusion before the issue went to press. Fortunately we did not fall into the trap.

If a year later, we tried the same thing on the 1900 board, we must have failed; otherwise the whole matter would not be blank in memory. But for our appointed term we had then played our part as editors and dreamed our dreams of what we might later do, if our luck held.

RICHARD HOOKER graduated from Yale in 1899, and then began a career in journalism with the *Springfield* (Massachusetts) *Republican* which lasted until his retirement in 1946. He was a Washington correspondent, literary editor and Editor and Publisher. From 1927 to 1934 he directed the Associated Press.

TIME AND PLACE

BECAUSE MY MEMORY does not go back much over a century, my impressions must cover less than the hundred and twenty-five years of the Lit's exciting life. I cannot trespass far into the nineteenth century. But my memory of the teaching at Yale around nineteen hundred is reasonably vivid. There were two definite categories of teaching: recitations (*not* classes) and lectures. The first consisted of groups of up to fifty victims, optimistically called students, who reported three times a week to be checked and evaluated on their mastery of assigned lessons. The instructor called on each in turn and quizzed him on the allotted work covered since the last meeting. The result was recorded by means of symbols in a small black book by the instructor in terms of a scale which ran from zero to four hundred, the mark of perfection, for which there was no place provided in the book. The lectures were preceded by a ten minute paper serving the same record-recording function as the recitation. With this necessary evil disposed of, the professor lectured for forty minutes while his hearers recorded in their note books the essential facts so far as they could grasp them, to be returned as nearly verbatim as possible on occasional tests and on the term examinations.

The actual performance was not as dreary as it sounds. An occasional instructor could not hold back illuminating comment on the material covered in his quizzes; an occasional professor was forced by his own enthusiasm to launch into exciting theories of his own on literature, the romance of science (*very* rarely) and the fascinating problems of philosophy, social science or history.

For the most part, teaching was factual. There were scholars of worldwide eminence at Yale, men such as Willard Gibbs, William Graham

Sumner, George Burton Adams, Thomas Day Seymour, Albert Stanborough Cook and many others. But the undergraduate was assumed (rightly or not) to be too slightly removed intellectually from his primitive ancestors to be entrusted with any but the smallest crumbs of their accumulated wisdom.

There was, however, a suspicion of change in the air. Victoria died and William McKinley too. A new generation of humanists was emerging at Yale. Hendrickson and Morris in the realm of Greek and Latin poetry, Phelps and Tinker (alike only in their humanism) in English letters, Keller, turning societatology into understandable sociology, Wheeler, making history vital with his cynical turn of humor, and Reynolds, bringing Greek tragedy to life again. These, with a handful of colleagues and a host of followers, remoulded the teaching of Yale undergraduates to bring it nearer to the hearts' desire of their awakening students. From them stemmed the change in teaching aims and methods which looked to the arousing of intellectual interest and creative thinking rather than to the accumulation of information.

The result was a philosophy of teaching which looked beyond the day by day discipline, with its sharp division between educator and educand (God save the mark) to an appreciation of what was studied and a consequent sharing of ideas between human beings, whether student or teacher. It aimed at the encouragement of individual thought and individual expression and (hopefully, tentatively) at the inspiration of creative thinking. It has resulted in the new generation of fruitful teachers like Bernard Knox and Cleanth Brooks and Maynard Mack and John Blum and John Smith and—but time would fail to tell of the host of well-grounded, enthusiastic faculty scholars who to-day are teaching the young idea not only how to absorb richness from the soil but also how to shoot.

To the Romans, "culture" meant primarily agriculture and agriculture (see Cato) meant first and foremost the free and abundant application of manure. Education has profited by a knowledge of the value of fertilization. Sceptics have made an unkind use of the analogy but the true teacher is not too proud to appreciate it.

And what of the results of this new Yale teaching in terms of creative production in the field of literature? In the first place, let us admit frankly that God's monopoly is not confined to the making of a tree but extends to the making of a true poet. Nevertheless, man may be useful in pruning and feeding the tree and a humble professor may play a part

in trimming and fertilizing a budding poet. It is true that a Brian Hooker could survive unscathed the curriculum of nineteen hundred, but there were not too many Yale poets before Billy Phelps made it respectable to read poetry and Johnny Berdan taught the value to a writer of self discipline and integrity. True, the new dispensation may produce a spate of uncurbed fancies which would pass themselves off as ideas or poetic truths, but the new dispensation consists of critics as well as cheer leaders. Four years will never suffice to cultivate to perfection another poet; they may, however, properly produce more candidates for poetic distinction and may give them far brighter hopes of ultimate success.

I find it very hard to believe that the sudden appearance of a galaxy of young Yale poets in the second and third decades of the twentieth century was wholly disconnected with the new freedom of thought within the curriculum. The names fairly tumble over each other in retrospect: Leonard Bacon, Tom Beer, Ken Rand, Steve Benet, Max Foster, Phelps Putnam, Thornton Wilder, John Farrar, Alfred Bellinger, Archie MacLeish, Tom Chubb, Phil Barry: even Bill Douglas and Henry Luce were writing poetry and Russell Davenport. No wonder that John Masefield when he visited that Yale hailed a new renaissance.

Has the renaissance continued in its pristine brilliance? Of course not. They never do. But the stream of young poets has never run dry. It has met many obstacles in the years of flagrant prosperity, chilling depression and unromantic war. But the stream would seem to be gaining new strength, approaching, let us hope, another spring freshet.

CLARE W. MENDELL, the "Grand Old Roman", on the Yale faculty for forty-five years, remains one of the country's leading Latin scholars. He graduated from Yale in 1904 and received his Ph.D. in 1910. He retired in 1952, Sterling Professor of Latin Languages and Literature. His publications include books of the Latin languages, volumes of poetry, and his latest *Tacitus: the Man and his Work*, was released in 1957.

125th Anniversary / LOUIS S. AUCHINCLOSS

YALE IN MY TIME (1935-1938) was an idyllic haven for the would-be writer. Or, at least, so it seemed to me. I had spent the six preceding years in a highly restrictive school (though I suppose we all think of our schools as such) run in the tradition of Arnold of Rugby by a headmaster whose magnificent idealism had a greater affinity to dead languages and violent sports than to the living arts. And in the New York financial world of which my family was a part, one was introduced to painting, music and literature as to alcohol—all right if used in moderation. Perhaps this attitude was a good thing. It may have helped to keep all but the dedicated from the precarious career of the artist. But what struck and intoxicated me in New Haven was the sudden vivid realization that a world at least *had* existed in which perfectly serious men and women had regarded literature as the most important thing in life. When I heard Chauncey Tinker choke over the death of Keats and Shelley, and Joseph Seronde describe the opening night of *Hernani* as an event of historic importance, I felt as if an analyst had exposed the baselessness of all my hidden guilts. The feeling, however, was attended with qualifications. I always knew that the world that had preceded Yale, the *real* world, would be lying in wait at the end of senior year. One had but four years for novels and poems and plays before returning to the long grey actuality of life. Yale, in other words, was a sort of fantastic interlude. My nearest disillusionment, in fact my only bitter moment, was when I learned that I could not "audit" Mr. Tinker's course in the age of Johnson because he allowed no "visitors" in his classroom. But except for this episode, I had no doubt that the faculty were on the side of the angels, and if I was not always sure of the existence of the latter, I was only too happy—at least for those years—to assume it.

The world was heading towards war, and in my little group, concerned though we were with Henry James and theatre weekends in New York, we were quite aware of it. That ivory tower had windows. But this awareness only intensified our sense of the preciousness of the present. Of social conditions around us, in which it was still then fashionable to be concerned, we had no interest, and as to communism, we felt about it as everyone feels today. I remember my surprise, years later, at the trial of William Remington, my contemporary at Dartmouth, when the prosecution pointed out, in the defendant's college letters to his mother, the constant references to strikes and labor troubles. The man next to me in the court room (those were McCarthy days) hissed in my ear: "You can see how early the rot set in." But remembering my letters to my own mother, and their jingle of parties and personalities, I felt ashamed. My only brush with politics at Yale was in being slapped by a policeman while brandishing a huge paper sunflower (the benign symbol of a Landon reaction) before the Packard that was bearing a campaigning F.D.R. through the streets of New Haven.

But today I have no regrets about the things that *didn't* interest me in college. I am simply glad for the things that did. I am glad that I was allowed to take all my courses (except for gentlemen's biology) in English and French. We had no "creative writing" courses then, but I belong to the skeptics in their regard. I believe that a writer must do his writing alone, that his only effective critic is himself—a year after composition. But reading need not be solitary; it is better shared. A Latin teacher at my preparatory school used to refer sneeringly to college life as "four years of drinking whiskey and reading *Jane Eyre*". But that happened to be just what I needed. Somewhere between the whiskey and Charlotte Brontë came the decision to write my own *Jane Eyre*. And there was time; that was the wonderful, indispensable thing. I wrote a long novel in sophomore year in what I conceived to be the style of Flaubert. It is true that my subsequent failure to sell my works in New York lead to a rash decision to abandon Yale and adapt myself without further delay to that waiting world of greater, grayer reality, but for that act of foolishness no college could be held responsible. Yale had done all that Yale could do: she had given me credit for reading novels and time for writing them. I had started work on the problem of how to reconcile my writing with that gray reality. The solution lay years ahead, but it was healthily born in New Haven.

LOUIS AUCHINCLOSS graduated from Yale in 1939; his works include *The Indifferent Children, Sybil, The Romantic Egoists,* and *Pursuit of the Prodigal.*

DATE DUE
